T0074130

The Structure of Style

Shlomo Argamon · Kevin Burns · Shlomo Dubnov
Editors

The Structure of Style

Algorithmic Approaches to Understanding Manner and Meaning

 Springer

Editors
Shlomo Argamon
Illinois Institute of Technology
Dept. Computer Science
West 31st Street 10
60616 Chicago, IL
USA
argamon@iit.edu

Kevin Burns
MITRE Corporation
01730 Bedford, MA
USA
kburns@mitre.org

Shlomo Dubnov
University of California, San Diego
Music Department
Gilman Drive 9500
92093-0326 La Jolla, CA
Mandeville Center
USA
sdubnov@ucsd.edu

ISBN 978-3-642-12336-8 e-ISBN 978-3-642-12337-5
DOI 10.1007/978-3-642-12337-5
Springer Heidelberg Dordrecht London New York

Library of Congress Control Number: 2010927157

ACM Computing Classification (1998): H.3, H.5.5, I.2, I.4.8, I.5, J.5

Cover design: Integra Software Services Pvt. Ltd., Pondicherry

Printed on acid-free paper

Springer is part of Springer Science+Business Media (www.springer.com)

Dedicated to our wives
Stefanie, Jill, and Lior,
without whose love, encouragement, and support
this project never could have come to fruition.

Preface

When we see a natural style, we are astonished and delighted;
for we expected to see an author, and we find a man.
—Blaise Pascal

What is it that distinguishes a Monet from a Picasso? A Mozart concerto from a Bach fugue? Ballet from hip-hop? Melville from Dickens? Jazz from bluegrass? Valley-speak from the Queen's English?

Style.

Every one of us can intuitively tell when the styles of two artworks, stories, songs, or buildings are similar or different, and this perception affects how we respond to them long before any thoughtful reflection. Judging people or things by their differing styles is nearly instantaneous—conscious reasoning only comes in after the fact, if at all. We size people up at a glance based on their style; we know which styles we like and which we don't; we connect styles of music, literature, and architecture in categories called "art deco" or "punk"; learned experts can even lecture with erudition on the evolution of various styles from historical antecedents. But what is it that underlies this ubiquitous and important yet obscure phenomenon?

By analogy to qualities such as "color" or "size," which can be directly seen and measured, we can use the word "style" to refer to a notional quality that underlies all these feelings and thoughts. A general understanding of how style works, however, is quite elusive; though we all intuitively recognize different styles when we see or hear them, it is difficult to say anything unified that relates the many diverse aspects of style.

The Structure of Style explores this question from a computational view of the nature of style, how it is perceived, and how it is used. The computational viewpoint is one which seeks understanding specifically in terms of how information is represented, organized, and transformed in the production and perception of different styles. By doing so, we hope to point towards more general and comprehensive understandings of style and how it works, as well as to enable development of more useful intelligent computer systems.

Research in this field of *computational stylistics* is currently growing, as more scholars, researchers, and technologists realize the importance of dealing explicitly with questions of style. In text analysis, style is key to understanding the feelings and

social relationships expressed in a text; in music and art, style is a major determinant of the character of a work; in design and architecture, function and style interact in intricate ways. New mathematical and computational techniques now make it possible to model the role of style in the creation and reception of human artifacts and thus to develop software systems that can directly use style in various ways. Ultimately, machines must be aware of different styles and their effects if they are to interact intelligently with people rather than through artificially constrained user interfaces as they do now.

Current applications of computational stylistics are diverse, including authorship attribution for criminal and literary investigations, information retrieval based on document genre or emotion, plagiarism detection, composition of new music in a given composer's style, realistic improvisational musical accompaniment, rendering animation in different motion styles, analyzing architectural styles for functionality and emotional resonance, and much more. Research on style in all areas shares the problem of formalizing what style means, and of developing a modeling language to represent the characteristics of different styles.

The common theme is that style is fundamentally about the *manner* in which something is done or made, which is separate from its primary intended effect, or its *function*. The possibility of different styles thus arises from the fact that every human creation may be put together in a great many different ways while still serving the same basic function. (Style, of course, is not always entirely distinct from function, as discussed further below.) Consider, for example, the fact that the simple function of restricting unauthorized access to a space can be performed by any one of a dizzying assortment of different kinds of locks, each with its own individual character.

This essential idea behind style, that a particular general function can be effected in many different ways, is just as applicable to behaviors, such as sports or dance, as it is to physical artifacts, such as sculptures, home appliances, or books. Indeed, when we examine style generally as a quality of various human creations, we begin to see that there really is no clear line between those creations that are artifacts (i.e., "things") and those that are behaviors (i.e., "actions"). Consider a piece of music—for concreteness, say, Beethoven's Moonlight Sonata (Fig. 1). On the one hand, it can be looked at as an artifact, a kind of thing, defined (more or less) as set of overlaid sequences of notes and harmonies, with given durations as well as relative tempo, loudness, etc. This is the representation provided by the score, itself a physical artifact.

On the other hand, any particular performance of the sonata is also an instance of the same creation, each one a complex behavior giving rise to an experience of the playing and the music in time. A performance contains details that the score does not, of course, and its style may be considered a sort of collaboration between the composer and the performer, with choices of interpretation as to what to bring out and how, and yet we may examine the style of the piece both by viewing it as an artifact, looking at the score, or as a behavior, listening to the performance.

Sonate

Sonata quasi una Fantasia ('The Moonlight')

L. van Beethoven Op 27 N o2

Fig. 1 The beginning of Beethoven's Moonlight Sonata

When we examine the sonata's style, then, we might look at the physical artifact of the score, noting that although its surface texture is very classical, similar to works by Mozart or Haydn, we also see Beethoven's distinctive style in the D-flat note in the third bar which forms a Neapolitan chord, surprising us after the dormant melancholy of the opening triplets. Then, in bars five and six, the juxtaposition of 16th notes in the melody against the triplets in accompaniment creates a structural tension between the initial lullaby and a more dramatic expression (characteristic of Beethoven). Alternatively, we might understand the style of the piece by listening to a particular performance and noting how these structural relations between notes and chords express feelings unfolding over time; different performers, of course, will emphasize or downplay different possible feelings by adjusting the speed, loudness, and other qualities of the performance.

There is thus an essential unity between human behaviors and human artifacts, which may both be viewed generally as kinds of *human creations*. Any such creation is an intricate arrangement of many interlocking parts whose detailed relationships enable an overall function. In the case of a behavior, such as a musical performance, the parts are all the myriad small actions (hitting piano keys, pressing pedals, etc.) that, in a precisely timed formation, together constitute the complete performance. In the case of an artifact, such as a piano, the physical properties and organization of its parts (keys, levers, hammers, strings, soundboard, etc.) enable it to perform its function.

So, since any given function can be effectively implemented in a great many different ways, the *specific* configuration of interlocking parts that comprises a given creation is not essential to its function. Rather, each of its many components has been chosen from a large set of different, but equally functional, elements. For example, an author may choose to describe a given event using formal words and syntax, or in more casual language; an architect may design in concrete or in steel. The aggregate effect of such choices (some large, most small) on a creation constitutes its style. When such choices are conscious and based on expertise, the style may be thought of as "artistic", but even less-consciously produced artifacts and behaviors have definable styles, to the extent that they express a consistent manner of construction.

It should not be thought, however, that style can be separated entirely from function and meaning. In fact, manner itself can convey meaning to observers. An artist paints a tree with bold strokes and bright colors because that is the way he wants viewers to see it—not simply as a tree, but rather as *his* tree. The similarities and differences between his vision of a tree and others' visions create resonances in the viewer's mind. As Virginia Postrel has eloquently argued [1], stylistic and aesthetic judgments are not merely optional add-ons to more essential functionality, but constitute part of the very essence of all human creations. As she notes, "the aesthetic . . . matters to people's sense of self." Surface appearances and sounds evoke the complex interplay of social and environmental context, and so give rise to social and personal meanings.

Yet in addition to patterns of surface characteristics and socially constructed meaning, style also includes a third dimension—it conveys feeling and emotion. For example, when the artist paints a tree with certain kinds of strokes, evoking particular meanings of "tree-ness", he also paints to evoke feelings of tension or pleasure in his audience. The fundamental challenge of stylistics, then, is to understand these three levels of stylistic expression and their interrelationships: patterns, meanings, and feelings.

Research on style thus differs fundamentally from most other computational work dealing with complex human artifacts, such as information retrieval or computer-assisted creativity. Although there is much we *can* understand by creating formal models of basic elements of text, music or images, such descriptions cannot possibly account on their own for what the author had in mind or what the audience gets from it. We must go beyond merely finding patterns or statistics that describe observable differences between genres—rather, we must pay equal attention to the role of the reader, listener or viewer, and try to grasp the meanings and feelings that constitute the reading, listening or viewing experience.

The research collected in this volume explores these questions from a variety of computational perspectives. *The Structure of Style* is an outgrowth of the American Association for Artificial Intelligence (AAAI) Fall Symposium on Style and Meaning in Language, Art, Music, and Design [2], held October 21–24, 2004 in Washington, DC. Chapters for this book were solicited from authors of selected papers presented at the symposium, as well as from other prominent researchers in the area, and were peer-reviewed.

The book as a whole is divided into three parts, according to the roles that computation can play in stylistics. The first part, *Production*, provides a conceptual basis for stylistic research by examining computer systems that produce artifacts (musical pieces, texts, artworks) in different styles. The second part, *Perception*, describes research on methods for analyzing different styles and gleaning useful information from them as part of an author-audience communication. The third part of the book, *Interaction*, deals with the reciprocal actions of style producers and perceivers as demonstrated in several state-of-the-art research projects.

The research described herein can also be divided, as shown in Table 1, into four domains: visual art and design (Chapters 1, 2, 8, and 9), language (Chapters 4, 5, 6, and 11), music (Chapters 3, 7, and 10), and gaming (Chapter 12).

Table 1 Organization of *The Structure of Style*. Chapter 13 cuts across these categories, dealing in a unified fashion with all roles and domains

	Production	Perception	Interaction
Visual Art/Design	Chapters 1 and 2	Chapter 8	Chapter 9
Language	Chapter 4	Chapters 5 and 6	Chapter 12
Music	Chapter 3	Chapter 7	Chapter 10
Gaming			Chapter 11

The first section of the book, *Production*, has four chapters. Chapter 1, by Harold Cohen, discusses the style of painters and their paintings, arguing that style results from the interplay of the artist's beliefs and their chosen materials and technologies. Cohen derives insight into what constitutes an acceptable understanding of a style from his own experience trying to understand the coloring style of AARON, the AI program he developed that paints original artworks. Chapter 2, by George Stiny, explores the nature of shape in visual design, seeing style as complex combinations of rules that change with time. The rules can be embedded and recursive and otherwise computationally complex, such that style emerges in an environment with no clear divide between design and calculation. Chapter 3, by Roger Dannenberg, analyzes familiar musical styles, such as Baroque and Classical, showing how they are distinguished both in terms of surface characteristics like ornamentation and in deeper levels of meaning and emotion. The chapter also surveys key computational approaches to musical style classification and generation. Chapter 4, by Ehud Reiter and Sandra Williams, describes how different writing styles can be generated by an automatic text generation system. Style implies making specific choices during the text generation process, either at the level of a generic style based on a large text collection (a genre), or at the level of the individual author. There are many similarities between Reiter and Williams's analysis of text and Dannenberg's discussion of style in music; many of aspects of style discussed reflect the idiosyncrasies of an individual person or genre, taking into account expectations or preferences of a particular user or genre.

The second section, *Perception*, has four chapters. Chapter 5, by Shlomo Argamon and Moshe Koppel, suggests that meaning can be found in textual style variation by considering aspects of the *communicative act* embodied by a text—including its

author's identity, its purpose, its medium, and its intended audience. Three case studies are presented to illustrate the framework: author profiling, authorship verification, and analysis of scientific rhetoric. Chapter 6, by Jussi Karlgren, highlights the importance of measures of variation and choice informed by readership analysis and formulated in terms that agree with reader experience of text. He examines different possible feature dimensions for analysis of statistical variation in style—which he suggests can be improved by a closer look at the purposes and preferences of writers and readers, including relevance and utility. In Chapter 7, Shlomo Dubnov introduces a communication-based model of musical listening, applying information-theoretic analysis based on probabilistic models of musical structure in time. Specific components of the "information rate" are related to expectancies and are translated into human feelings such as surprise and familiarity, which combine to create more complex emotions experienced over time. Chapter 8, by Julie Jupp and John Gero, proposes new models of similarity for analysis of visual designs, using semantic feature extraction and self-organizing maps, combining machine processing with human relevance feedback. The approach is evaluated on experiments using architectural design diagrams, highlighting the cognitive compatibility of the computed classifications.

The third section, *Interaction*, has five chapters. Chapter 9, by Sheldon Brown, puts forth a notion of *Troiage Aesthetics* in visual art, which includes collage, assemblage, and montage. This aesthetic is enabled by computing as a medium, and is illustrated by examples from Brown's series of artworks called *Scalable City*. Chapter 10, by Gerard Assayag, George Bloch, Arshia Cont, and Shlomo Dubnov, presents two computational architectures by which machine agents can learn from and interact with an improvising musician, using statistical modeling of musical style. In one framework the musician controls the interaction; in the other there is *active* machine learning. Chapter 11, by Kevin Burns, deals with strategic style from economic and psychological perspectives, analyzing competitive styles in a simplified version of poker. The study shows that cognitive style can be remarkably efficient, winning as much money as the optimal (Bayesian) strategy but with orders of magnitude less effort. Results are related to practical applications in war and risk by analyzing the evolution of terror networks and the escalation of system failures. Chapter 12, by Joseph Goguen and D. Fox Harrell, explores how poetry results from "blending" concepts, focusing on the principles that underlie an author's choices and describing how the principles of narrative structure go beyond those of conceptual blending in metaphor. The authors present a computational implementation of their system, showing how it performs in interactive generation of poetry.

The book concludes with Chapter 13, by Kevin Burns and Mark Maybury, which gives a survey of the future of style in artificial intelligence applications in the domains of language, music, design, and gaming, cutting across all three functions of style (production, perception, and interaction) and all three levels of style (patterns, meanings, and feelings). Findings suggest that applications of AI have thus far been focused mainly on the levels of pattern and meaning, for the functions of production and perception—this points to future research challenges in extending this work to addressing feelings and interaction.

Ultimately, we hope that the computational study of style will serve to both humanize computation and deepen our intellectual understanding of style in all areas of life.

Chicago, IL	Shlomo Argamon
Worcester, MA	Kevin Burns
San Diego, CA	Shlomo Dubnov

References

1. Postrel V (2003) The substance of style: how the rise of aesthetic value is remaking commerce, culture, and consciousness. Harper Collins, New York, NY
2. Argamon S, Dubnov S, Jupp J (2004) Style and meaning in language, art, music, and design. Papers from the 2004 AAAI Symposium, FS-04–07. AAAI Press, Menlo Park, CA

Contents

Part III Interaction

Contributors

Shlomo Argamon Department of Computer Science, Illinois Institute of Technology, Chicago, IL 60645, USA, argamon@iit.edu

Gerard Assayag Ircam-CNRS UMR 9912, 1 Place Igor Stravinsky, 75004 Paris, France, assayag@ircam.fr

George Bloch University of Strasbourg, 22 rue Rene Descartes, 67084, Stransbourg, France, gbloch@umb.u-strasbg.fr

Sheldon Brown Center for Research in Computing and the Arts, University of California, San Diego, 9500 Gilman Drive, La Jolla, CA 92093, USA, sgbrown@ucsd.edu

Kevin Burns The MITRE Corporation, 202 Burlington Road, Bedford, MA 01730, USA, kburns@mitre.org

Harold Cohen University of California, San Diego, CA, USA, hcohen@ucsd.edu

Arshia Cont Ircam-CNRS UMR 9912, 1 Place Igor Stravinsky, 75004 Paris, France, cont@ircam.fr

Roger B. Dannenberg Carnegie Mellon University, 5000 Forbes Avenue, Pittsburgh, PA 15213, USA, rbd@cs.cmu.edu

Shlomo Dubnov Department of Music, University of California, San Diego, CA, USA, sdubnov@ucsd.edu

D. Fox Harrell Digital Media Program, School of Literature, Communication and Culture, Georgia Institute of Technology, Atlanta, GA, USA, fox.harrell@lcc.gatech.edu

John Gero Krasnow Institute of Advanced Study and Volgenau School of Information Technology and Engineering, George Mason University, Fairfax, VA, USA, john@johngero.com

Joseph A. Goguen† Department of Computer Science and Engineering, University of California, San Diego, CA, USA

Julie Jupp Engineering Design Centre, University of Cambridge, Cambridge, UK; University of Technology Sydney, School of the Built Environment, Broadway NSW 2007, Australia, Julie.Jupp@uts.edu.au

Jussi Karlgren Swedish Institute of Computer Science, Box 1263, SE-164 29 Kista, Sweden, jussi@sics.se

Moshe Koppel Department of Computer Science, Bar-Ilan University, Ramat Gan, Israel, koppel@cs.biu.ac.il

Mark Maybury The MITRE Corporation, 202 Burlington Road, Bedford, MA 01730, USA, maybury@mitre.org

Ehud Reiter Department of Computing Science, University of Aberdeen, Aberdeen, UK, e.reiter@abdn.ac.uk

George Stiny Department of Architecture, Massachusetts Institute of Technology, Cambridge, MA 02139, USA, stiny@mit.edu

Sandra Williams Department of Computing Science, The Open University, Milton Keynes, UK, s.h.williams@open.ac.uk

Part I
Production

Chapter 1
Style as Emergence (from What?)

Harold Cohen

Abstract I argue that an exclusively formal description of a painting cannot pro-
vide an adequate description of its style, nor can it express its style so vividly that
the description can generate objects stylistically similar to the originals. While the
characteristics through which we identify style certainly involve the formal, physical
presence of the work, this is not without reference to the mindset of the artist and to
the history of decisions that result in the presence of the work. By way of example, I
will examine some original work that was generated, not with a computer program,
but by a computer program, named AARON. Its work has a distinctive appearance,
but one that lacks an obvious formal organizing principle. It would be impossible to
simulate AARON convincingly without access to its history because, as I will show,
it did not arise through any primary interest in formal configuration. In fact, the argu-
ment for purely formal analysis does not require that it uncovers the true history of
the original, simply that the presumptive history generates a convincing simulation.
Should we conclude from that argument that any given configuration could have
been the result of some number of alternative histories? A dubious conclusion: I
will argue that AARON's images result uniquely, not just from their making, but
also from the long history of perceived goals and intentions, paths and detours, that
resulted in the peculiarly idiosyncratic technology of their making.

I had the good fortune, in my student days, to take several art history seminars
with one of the greatest art historians of his time, Rudolf Wittkower. In one of them,
on attribution, Rudy told how he had once gone into a small country church in Italy
he'd never visited before, and sensed something oddly familiar about it; something
about it was reminding him of another, very different church. Searching through
the church's archives, then, he found a floor plan, and in the floor plan he found
pin holes. Pin holes meant that the plan had been traced. And when he went to the
archives of the other church, he found that its floor plan had corresponding pin holes.

H. Cohen (✉)
University of California, San Diego, CA, USA
e-mail: hcohen@ucsd.edu

S. Argamon et al. (eds.), *The Structure of Style*,
DOI 10.1007/978-3-642-12337-5_1, © Springer-Verlag Berlin Heidelberg 2010

Great detective work! But it's what preceded the detective work that's really impressive; because, after all, how many of us could recognize the stylistic signature of one architect carried over into a different building by a different architect when we were standing on the signature?

I came away from those seminars with some hesitation about using words like "style" and "creativity", words that seem to change their meaning from one conversation to the next, so that one can never be quite sure what's being discussed. I've always regarded "style", in particular, as arguably the most difficult word in the entire vocabulary of art history. So, having been silly enough to agree to writing on the subject, I think I'd better begin by saying what I understand by the word, and to make clear that I intend it to apply exclusively to style in the visual arts—painting, specifically—with no implication that it applies in other areas of the arts, concerning which I know very little.

First, what I understand to be the more general usage: when we talk about styles of painting—impressionist style, cubist style—we are implying that we can identify a set of characteristics common to the work of an entire community of artists. When we talk about an artist's style, on the other hand, we are referring to a set of characteristics unique to the work of an individual artist—the nuances that separate a Manet from a Monet, for example, or a Picasso from a Braque—even while they share all the common characteristics with their fellow impressionists or cubists.

In either case, what we appear to be addressing is a set of formal, physical, characteristics. That's understandable, given that the formal characteristics are what we can see, what we can classify and count and measure. But there are many things that can be measured in something as complex as a painting, and decisions about what to count and to classify and to measure may tell us more about the assumptions of the individual doing the measuring than about what the individual who made the painting had in mind.

As to my own understanding of the word: I propose to argue that the characteristics through which we identify style certainly involve the formal, physical presence of the work, but not without reference to the mindset of the artist and to the history of decisions that result in the presence of the work. I will argue that an exclusively formal description of a painting—that is, a description that does not take account of what the painter had in mind—does not, in fact, provide an adequate description of its style; that it cannot express its style so vividly that the description can generate objects stylistically similar to the originals.

Well, of course, the notion that a description should be able to generate objects equivalent to the originals—or, as we would say, simulations—is a very recent phenomenon, though hardly as recent as a session on style at a computer science colloquium rather than a College Art Association meeting. Until computer simulation came on the scene, stylistic analysis was the almost exclusive property of art historians, whose reputations would stand or fall on the plausibility of their conclusions. Plausibility required close consideration of what was known, of course, but conclusions were otherwise untestable. Only the art forger was saddled with the need to test his understanding of an artist's style by producing simulations, his success resting only to some degree upon duplicating the physical conditions, the

technology, of the original. As the famous example of the Van Meegheren Vermeer forgeries showed, success demanded that the forger could get inside the artist's head untrammeled by his own predilections; and that Van Meegheren was unable to do.

As an example of stylistic analysis in pre-computing days, I'm reminded of another of Wittkower's seminars, this one on proportion. A student had done a rather thorough analysis of a Titian painting, demonstrating Titian's consistent use of the golden mean in placing the elements of the composition. We were all quite impressed, until Wittkower remarked, very gently, that the proportions of the painting had been different when Titian painted it; someone had later cut a full-length figure off the left side, in order to have two paintings to sell instead of one.

The student hadn't done his homework, obviously, yet his analysis was still pretty convincing. How could we explain the fact that he did actually find the evidence he presented in the roughly 83% of the original painting? We weren't about to assume that Titian had carefully applied the proportions of the golden mean to the right-most 83% of the painting in anticipation of the greedy art-dealer. But, of course, we didn't have to. The simple fact is that if you're looking for something falling on the golden mean in anything as complex as a Titian painting, you're probably going to find it.

We asked, then, why the student had been looking for evidence of the famous golden mean in the first place. Why the golden mean, rather than the proportions of a root two rectangle, for example? It simply reflected what was then something of a fashion in formal analysis; books like those of Mathila Ghyka [6] were well-known to students of my generation and people had been drawing lines on paintings, pictures of Greek vases, photographs of beautiful women and just about anything else they considered worthy since the beginning of the 20th century, with the goal of demonstrating the universal link—and, as far as art was concerned, by implication the causal link—between this extraordinary golden number and physical beauty.

Now, given this 20th century fascination with the golden mean; and given the fact that there was a group of painters actually calling itself the 'Section d'Or' in Paris early in the century, we might reasonably regard the golden mean as a component of the cultural style of the early 20th century. But not of Titian's time.

The golden mean is an incommensurable number that crops up in all sorts of places; the proportions in the intersections of a star pentagon, for example, and in the well-known Fibonacci series, which begins as a simple additive series and then converges on a geometric series with a common factor of 1.618..., the golden number itself. Leonardo, at least, surely knew about them both. But there's no compelling evidence that Renaissance artists in general knew anything much about incommensurable numbers or placed any great significance on this one if they did know of it. And if you were to try to construct a star pentagon without a computer to help you, much less transfer the ratios of its parts to the layout of a canvas, I think you'd soon conclude that Titian would have been quite unlikely to have gone to all the trouble, even had he not lived and worked in a Neo-Pythagorean age, where everything from musical harmony to the layout of the stars was thought to rest upon the ratios of the squares and cubes of the first three whole numbers. Proportion was a matter of integer arithmetic, not incommensurable numbers.

Well, though, one might argue, what if Titian didn't consciously use the golden mean? Might it not still provide an objectively accurate description of an artwork? And if an objective description is the goal, isn't it entirely irrelevant to ask how the work got to be the way it is?

Yes, it is possible to give an objectively accurate description. It is objectively the case, we might say, that such and such a painting is exactly x inches by y inches; that Tolstoy used the definite article with frequency x, while A. A. Milne used it with frequency y.

But, no: if the issue is style, then a "pure, objective description" is not the goal, and how and why the work got to be the way it is, is not only relevant, it's critical. I don't mean to imply that formal analysis of this kind is completely useless: in text translation, for example, purely syntactic analysis is enjoying some rather impressive results these days. The question here is not whether purely statistical analysis can, in a practical sense, yield adequate translation, but whether it can tell us anything much about style; for it is surely obvious that the stylistic differences between "War and Peace" and "Winnie the Pooh" involve more than differences in word frequencies. Only semantic analysis will do that, just as only recourse to the reasons why a painting is the way it is will enable an adequate description of its style.

To put my position in another way, I'm arguing that where style is concerned there can be no clear line between description and explanation; that every description implies an explanation and what is at stake is whether that explanation is based upon what is known of the artist's beliefs and practices, or whether it is a fiction built upon a predilection for this system or that system of analysis entirely separate from what we know about the artist.

The first time I saw stylistic analysis in the new, computer-enhanced manner was at a conference on the new technologies and the arts staged by the recently formed National Endowment for the Arts in the early 1970s. One of the speakers was a physicist, if I remember correctly, who described how he had written a computer program that simulated the work of Mondrian ; and how he had shown the output to several of his colleagues, all of whom declared their preference for his simulations over the originals. On that basis, he told his audience, he concluded that he was a better artist than Mondrian.

He was probably making a silly joke, but we never had the chance to find out. Predictably, the audience hooted in derision; not only because this person evidently didn't know the difference between originality and plagiarism, but more importantly because, to the more artistically sophisticated eyes of the audience, the simulations he showed didn't look remotely like Mondrians.

Now it isn't hard to figure out why he chose Mondrian for his simulations. Mondrian offered—or appeared to offer—three advantages.

The first advantage, in all fairness, was that the simulation was technologically possible; the computing resources he'd have needed to simulate something like a Jackson Pollock , for example, simply didn't exist in the early 1970s.

The second was that Mondrian—like Pollock, in fact—established a genre so individual that it couldn't be adopted by other artists without being blatantly

plagiaristic. Consequently, only Mondrian made paintings that looked like Mondrians, and while it's actually rather difficult to generate images that look convincingly like Mondrians, it's trivially easy to generate images that don't look like anything else.

The third apparent advantage—it was, in fact, the error that earned him the scorn of his audience—was that he thought he could see what they looked like.

If he had ever looked at a real Mondrian, as opposed to printed reproductions, what he saw, evidently, was an arrangement of black lines and colored rectangles painted on a white ground. That view was then reflected in his simulations, which clearly proceeded on the assumption that the geometry was all there was; or, at least, all that he needed to simulate.

For obvious reasons I don't have access to the simulations he showed that day, so I thought I'd write a little program based on the same assumptions to see what they looked like, set against real Mondrians. But I didn't need to, because I found that among the 220,000 entries for Mondrian turned up by Google, a surprisingly large number offer interactive programs with which users can make their own fake Mondrians. Some of these are so bizarre that one wonders what the programmer thought he was looking at. But just about all of them proceed from the assumption that the geometry is what makes a Mondrian; that as long as you have a number of variably spaced horizontal and vertical black lines and colored rectangles on a white ground you've got a Mondrian.

Well, there's no question that the geometry constitutes a large part of what there is, but what controls the geometry? "Variably-spaced" is a fancy way of saying nowhere in particular, while we know that Mondrian was very particular indeed, constantly adjusting the positions of the lines with respect to each other until he had achieved a kind of vibration, a visual resonance , between them. "Visual resonance" is not something for which one could write an equation; I'm simply using the term to approximate a quality that Mondrian, and quite possibly only Mondrian, could recognize when he saw it.

It's also possible, of course, that an equation is lurking in the paint, but that nobody has found it yet; that a careful examination of a large body of his work would reveal some interesting consistencies in the proportions of the white rectangles between the lines, for example, or in the proportion of the space allocated to black lines and white areas, or in the total lengths of all the lines as a proportion of the overall area; or any of a number of features that might be regarded as defining characteristics of Mondrian's "visual resonance." But if one didn't know what he was after—if one didn't get inside his head—it's unlikely that one would be looking for precisely the geometry that generated it. Random placement doesn't come close.

In any case, however, and much more importantly, the geometry is not all that there is. The assumption that a Mondrian consists of black lines painted on a white ground is more deeply flawed in another way, because when you look closely at one of the paintings, you find that the white areas and the colored areas are painted as densely and as deliberately as the black lines. You get the sense that the lines are embedded in the white paint rather than sitting on it. It is only by looking, not at the geometry of the black lines, but at the micro-structure of the painting—the handling

of the paint at the edges where black and white meet—that you could say, not that a painting is a genuine Mondrian, but at least that it might be.

That sense of the physicality of the paintings is completely lost in all the screen-based simulations. Just how far that loss leads to false conclusions and incorrect descriptions is evident in a picture essay on Mondrian on the web site of Thayer Watkins of San Francisco State University [7]. Evidently, Watkins disapproves of Mondrian's late work, though he generously offers a list of mitigating circumstances. Most particularly he disapproves of the fact that Mondrian used oil paint, and to make his point he uses his own computer reconstructions of the paintings rather than reproductions of the paintings themselves.

> ... The reason for using this method of presenting Mondrian's painting (he says in another frame) is that it is more in keeping with the principles of Neoplasticism. The computer can produce the elements of his painting with a purity and uniformity that was only approximated with the use of canvas and paints.

Well, poor old Mondrian, being stuck with oil paint. He'd have done much better if he'd had a PC and a copy of Photoshop.

It's undeniable, certainly, that oil paint is inappropriate for doing what he did. It's very difficult to get flat, uniform surfaces or precise, clean lines with oil-paint, and painting sharp, square corners is a nightmare. All that shows up in Mondrian's rather laborious handling of the paint. But Watkins has fallen into the common—and curiously contemporary—misconception about the nature of creativity. It isn't true that the artist needs methods that give him what he wants without a struggle. To work continuously at his highest level he needs to be challenged continuously, and difficulty is an essential element in the creative process. Mondrian chose oil paint. There were other ways to get pure colors and clean black lines—lithography, for example—but he chose oil paint.

An artist's style results from the playing out of the individual's belief structure in terms of the materials and the technologies of choice.

I use the term "belief structure" to mean that long chain of concepts, ideas, and preferences reaching far back into our histories that control how we behave without, necessarily, ever examining too closely why we believe the things we believe and prefer the things we prefer. And I use the term "technology" here in its most basic sense—it is the logic of making. The constraints and imperatives imposed by that logic and by the materials of choice are crucial to style. Where a work presents no record of the physical manipulation of material in its making it can have no style; which is surely one reason that Photoshop, with its menu of arbitrarily applied micro-structures—charcoal, rough paint, airbrush—has never attracted any serious artist.

We can be quite sure that Mondrian wouldn't be using Photoshop if he were alive today, and his work wouldn't have looked anything like those web-based simulations. All major artists are in the business of pushing back boundaries and they frequently adopt new technologies in doing so, but the direction in which the boundaries are pushed back is anything but arbitrary. The choice of technologies and materials from among available technologies and materials may be the

most affective—or, at least, the most obviously affective—of all the determinants to an individual's style, because it sits at the point at which the individual comes to terms with the opportunities and the constraints imposed by the physical world. But the choice of materials and technologies is itself simply the last of the constraints imposed by the individual's belief structure.

There's nothing arbitrary, consequently, about the fact that the mature Mondrian never chose stone-carving, never chose watercolor, never made prints and never made a figurative painting: that Picasso, though he worked in a dozen different modes, and frequently used decorative motifs in his figurative paintings, never made an abstract painting: that the mature Matisse never painted a brown picture. There's nothing arbitrary about what a painter does, and the belief structure that controls the moves that identify the work as being uniquely his own does not give unconstrained scope to innovation. On the contrary, increasing maturity equates to increasing constraint, thanks to the increased precision of the ideas that inform the activity.

From the standpoint of stylistic analysis, that may not seem to be a very encouraging observation. If there can be no clear dividing line between description and explanation—virtually every description implying explanation—then the very thing I've invoked to account for an individual's style in art is also the thing that limits the adequacy of explanation. Only the individual has access—or rather, could have access—to what is in that individual's head, but none of us—artists included—spends much time researching how our beliefs influence our actions—why we choose the colors we do or paint the way we paint—much less why we hold the beliefs that we do.

How, then, are we to judge the adequacy of a stylistic analysis of an artist's work, if we can't show how the physical characteristics of an artist's work follow from that artist's intensely private history?

In principle, computer simulation should extend previous analytic modes—which could do no more than make a convincing case for the plausibility of the analysis—by doing what the forger is obliged to do; producing objects that can be viewed in the context of the original body of work. The forger would not get to first base, however, if he were not able to replicate the physical condition of the original. In this regard, computer simulation currently falls far short; no one has yet produced an output device able to produce an oil-painted simulation of an oil-painting. In practice—and this much was obvious from all those a-physical, web-based Mondrian simulations—simulations tend to simulate the things that can readily be simulated, and they elevate those things at the expense of other things.

Fortunately, the computer that makes computer simulation possible also offers at least a limited solution to the problem of physical replication. We now have at least a generation of artists who have worked with computers, and many of them have generated their work on currently available output devices. In those cases, the forger's need to replicate the physical identity of the work isn't a problem, since a simulation can use the same output device as the original.

By way of example I'd like to examine some original work that was, in fact, produced on one of these output devices; a wide-format digital ink-jet printer. It was also generated, not with a computer program, but by a computer program. The

program is AARON , which I began 35 years ago in an attempt, not to simulate any particular artist's style—least of all my own—but to model some common aspects of cognitive behavior as they show up in freehand drawing [1]. Thirty-five years is quite long enough, though, regardless of the initial intent, for anyone—or any program— to develop a distinctive style, and my goal here is to track the development of that style in terms of the program's history and my own. In other words, I aim to provide a partial explanation of the works the program produces.

To avoid misunderstandings I have to make clear that AARON isn't a "computer-art," photoshop-like program with which I make art. I wrote the program, but the program makes the art without any human intervention controlling its individual images. To that degree it's autonomous. I'll leave it running at night while I'm sleeping and in the morning I'll have 50 or 60 original images to review. Deciding which ones to print is difficult; the output is of a very high level, particularly with respect to the program's use of color. Color is the key defining element of AARON's style, and color, consequently—the history of AARON as colorist—is what I propose to examine.

I want to focus upon something I suggested earlier, in talking about Mondrian: namely, that an artist's style should show up more clearly in the micro-structure of the painting than in its overall formal organization. In AARON's case, the micro-structure—as seen in details of a few square inches—has a distinctive appearance (Fig. 1.1), but one that lacks any very obvious formal organizing principle. I am

Fig. 1.1 Example of the microstructure of a printed image

quite sure that it would be impossible to simulate it convincingly without access to the history because, as I will show, it did not arise through any primary interest in formal configuration. Indeed, I could never have imagined these configurations, much less devised a formal algorithm that could have generated them. My primary preoccupation, and the primary determinant to the formal configuration, has been with color, not with formal configuration.

Here's the story, the partial explanation.

A large part of AARON's development since its inception in the early 1970s has been determined by the need for output devices, a need that has rested heavily upon my own predilections as a painter. Painters exhibit; and it didn't take me long to recognize that the small Tektronix monitor on which I developed the first versions of the program was hopelessly inadequate as an exhibition device. Those early versions were not about color, they were about drawing, and I started building my first drawing machines not too long after I wrote my first program [2]. I still felt a painter's need for color, though, and some part of AARON's output was regularly colored by hand, some of it even turned into tapestries and murals.

As the program developed over the years my sense of what it should be doing gradually changed, however, and by the mid-eighties I was finding myself less concerned with simulating human cognitive performance than with discovering what a program could do for itself. And in that spirit I was finding it increasingly troubling that a program capable of making excellent drawings should need me to do its coloring. I didn't know what to do about it, though. Expert colorist though I was, I didn't see how my expertise could be given computational form and it took about 2 years of frustrating non-progress before I was able, finally, to see how to proceed.

The key, when it arrived, was an insight that had nothing specifically to do with color; it was simply the realization that we are all of us—people and programs alike—bound by our physical and mental resources; that programs may be able to do some of the things that expert humans can do, but they can't do them in the same way that human experts do them because they don't have the same resources. Big Blue could beat Kasparov, for instance, but not by replicating Kasparov's mental processes.

Human colorists are both enabled and constrained by their physical and mental equipment. On the enabling side we have excellent visual color discrimination; on the constraining side we have virtually no color "imagination," no way of building a stable internal representation of a complex color scheme. Significantly, we don't even have an adequate vocabulary for describing color schemes. The result of this duality is that, with remarkably few exceptions, coloring is essentially a hill-climbing affair for human artists; we put down one color, put a second next to it; go back and adjust the first; and keep on with this process of continuous adjustment until we have the sense that we've got it right. We couldn't for a moment say what "right" is, but with any luck—or accumulated expertise—we'll know it when we see it.

Well, my program had no visual system and consequently no holistic view of its developing images from which it might judge the interactions of neighboring

patches of color. So the near-universal human mode of feedback-supported trial and error was simply not an option. What the program did have, on the other hand, something the human colorist lacks almost entirely, is the ability to build a completely stable internal representation of a developing color scheme. I speculated that if I could provide the rules by which that color scheme could be generated, and an appropriate internal representation, AARON would not need to see what it was doing and would not need feedback [3].

What I might be able to derive from human experience, then, and from my own expertise, was not a methodology, but a set of goals based upon a clear understanding of what human colorists use color for.

Well, of course, human colorists use color for a whole slew of different purposes, and I opted for what I saw as the most fundamental. For reasons too complicated to detail here, involving the history of color use in the 20th century, my goal was not simply to have the program use color attractively, but to elevate color to function as the primary organizing principle of image-making. That being the case, and whatever else it might be used for, the program would first have to use color to clarify the structure of the image in relation to the world it represented; to allow the viewer to identify the different parts of the image and see how they fit together. On the most basic level, I concluded, that would mean using color to provide adequate differentiation, contrast, between the parts.

How does one control the level of contrast between two colors?

A color can be fully specified by three characteristics—the hue , the saturation and the brightness —which we can best understand by a simple physical model. If we plot wavelength against energy for any particular color sample, then the hue refers to where the color's dominant wavelength falls on the visible spectrum; on the horizontal axis. Saturation is a measure of the color sample's relative purity; in physical terms, it is measured by how much energy falls within how narrow a part of the spectrum. Brightness is a measure of how light or dark the sample is; it's the total energy of the sample, represented by the area under the graph, regardless of the dominant hue and saturation.

Of the three, and particularly from the perspective of building representational images, brightness has always been by far the most important: which follows from the fact that the eye functions primarily as a brightness discriminator. The other two components of color, hue and saturation, seem to have relatively little practical value in perception. Color blind people find their way around the world without much trouble, and we all used to watch black and white movies without feeling that anything was missing. Many animals don't have color vision at all. The bull attacks the red rag because it's moving, not because it's red.

And so AARON's career as a colorist began with the task of controlling the contrast between elements of its images, not exclusively in terms of brightness, but in terms of the combinations of all three of the defining characteristics. The program's strategies were a bit complicated, but they meant essentially that one could have two similar hues adjacent to each other, provided that one was light and the other dark; or two colors of similar brightness, provided they were sufficiently different in hue or saturation, or both.

The insight that led to this approach sounds very obvious in retrospect; insights frequently do. Yet I'm inclined to suspect that this one, and the vector of decisions that sprang from it, were so uniquely linked to my own history, first as a painter and as an expert colorist, and then as one of the few artists of my generation to become deeply involved in programming and in artificial intelligence, that I may have been one of the few people who could both have engineered AARON's ascendancy as a colorist and had a motive for doing so. That's a measure, I believe, of how very particularized the components of style can be.

The path was not a direct one, however; there were many influences at work on AARON's subsequent development, and they were not all driving unambiguously in quite the same direction. One of the more compelling of these influences was a feeling I'd had ever since I'd met my first computer, which was that if I was going to show something as bizarre as a computer making original art, then I owed it to my audiences to de-mystify the process to the greatest extent possible. In practice, that had always involved showing the art in the process of being made rather than showing finished artworks and it had resulted in my building several generations of drawing machines for exhibition use over the years (Fig. 1.2).

Those machines had proved to be very successful, and not only in making drawings. I once referred to them as philosophy machines for their success in persuading audiences to ask questions and to demand answers as they watched the drawings being made. Planning for AARON's development of expertise in coloring, then, it seemed to follow, much too logically to have been wise, that I should build a painting machine. In fact, I finished up building three of them over a 3-year period [4].

Fig. 1.2 The painting machine with arm, brushes, bottles, etc.

Looking back now, I have to regard this phase as something of a detour; at least in part because much of the work on later versions was devoted to correcting the shortcomings of my own clumsy learn-on-the-job engineering. But detours do happen and this one left an indelible mark on what was to follow. I want to describe these machines in some detail now because, as I just suggested, the developing technology, and the fact that I chose it, provides part of the explanation of AARON's subsequent style.

Like their predecessor drawing machines, these machines were built to be used in exhibitions and from that followed their substantial size. They were intended to provide an output device for AARON's use of color, but of course the colors AARON used on the screen were specified as red-green-blue mixtures, whereas the painting machines used physical material: a palette of 17 water-based dyes of unusually high saturation that I knew well from hand-coloring AARON's earlier work. Since the machines would have to dispense and mix these colors on demand, use brush-like implements to apply them and generally look after quite complicated housekeeping, they required many more degrees of freedom than their predecessors had needed to move a single pen around, and, in consequence thy were configured as small robot arms carried around on the beams of large flatbed devices.

Translating the screen specifications into instructions for mixing physical materials proved to be non-trivial, particularly in relation to controlling brightness. Mixing on the screen is additive—adding color components increases the brightness of the result—whereas all physical color mixing is subtractive: the individual colors act as filters to remove light, so that any mixture of colored material will be darker than the individual colors. Paint is made with solid pigments, so it is more or less opaque and one can make a color lighter by adding white. Dyes are liquid and transparent, and the only way to make them lighter is by diluting them with water. It turned out, annoyingly, that no two of the dyes—much less mixtures of the dyes—diluted in quite the same way.

So, with its palette of 17 dyes, and with infinite variation in mixing any two of them, a good deal of time had to be invested in rather tedious calibration before I was able to give AARON adequate control over dilution and hence relative brightness.

AARON's strategy was simply an extension of my earlier practice of coloring its black and white drawings by hand. It would begin each new image by making an outline drawing with black waterproof ink and then it would apply the colors with round discs of velvet-like material that served as the business end of the machine's brushes. There were several complications; one was that the brushes had to be big enough to fill in rather large spaces, while at the same time they had to be small enough to fill in most of the small concavities and irregularities in the outlines. As things turned out, that wasn't too critical, because it was essential to keep the color away from the black lines, to prevent the neighboring patches of wet colors bleeding into each other (Fig. 1.3).

More critical was the fact that the brushes would deliver a large wet blob immediately after they'd been dipped in the dye, but would get steadily drier until the next dip. Drying time would vary with the blobbiness. I didn't mind the result being blotchy, but I didn't want the dye drying up in one place while AARON was busily

Fig. 1.3 A machine painting

filling in somewhere else, leaving a line that was arbitrary with respect to what it was painting.

To get past this problem I developed a space-filling algorithm that worked pretty well in keeping a wet edge moving forward across the paper. The result was an un-mechanical look to the paintings that contrasted rather effectively with the thoroughly mechanical device that was making them. I liked that, and there was no question that the machines were highly effective, theatrically speaking, as devices for exhibiting. But two factors were emerging that led me, eventually, to see the machines more as a liability than as an asset and to abandon them.

The first was a growing realization that as long as the outlines were present, color couldn't get a look-in as the primary organizing principle of the image. That needs a little explanation. It has always seemed remarkable to me that we can read a simple outline as an abstraction of what is, in fact, a continuously varying visual field. Outlines don't exist in nature; they exist in our perception of nature, and they exist because a central task of visual cognition is edge-detection. I said earlier that the eye functions primarily as a brightness discriminator, but that was an understatement. In fact, it functions as a brightness-contrast-amplifier, the better to do edge-detection. This is evident in what is known as the Mach-band effect, in which the dark side of an edge appears to be a little darker than it actually is and the light side a little lighter.

In short, our cognitive system presents us with a fundamentally brightness-ordered model of the world. Outline drawings are a direct reference to that

brightness-ordered model; which is why I became increasingly to feel that they had to go.

The second factor, though certainly the less important of the two, was the growing feeling that the technology between the program and its output was sending the wrong message to its audiences [5]. They were interested in what was being drawn, to be sure, but that interest was nothing compared to the delight they showed when they saw the machine washing out its own cups and brushes. Washing cups is housework; a machine that does housework is a robot and this, unquestionably, was a robot! No, I'd say, you're watching a program using a painting machine, which is no more a robot that your desktop printer is a robot. Didn't help. Desktop printers don't wash cups, do they? they just make prints.

Well, maybe that was a clue about how to end the detour and get back on track. I sent the last painting machine to join its forbears at the Museum of Computing History and I acquired one of the new wide-format printers that were just then coming onto the market.

For those of you whose experience of printing with computers has been limited to user-friendly desktop printers, I need to explain that these professional, wide-format printers are not user-friendly; they're high-end devices, offering precise control in return for knowledgeable operation. I anticipated that I would be able to move the image from screen to paper without undue distortion, but I was unprepared for what I came to recognize as the first major revolution in color technology since the industrial revolution.

The machine I acquired uses archival colors of astonishing vividness, quite unlike anything I'd ever seen in traditional media, but even so it was not until I eliminated the black lines that AARON started, finally, to come into its own as a colorist. Of course, that wasn't done simply by leaving out the black outlines. The edges of forms still had to be adequately defined, but now it had to be done exclusively with color. The strategy I developed for this function goes a long way to explaining why the images look the way they do.

To begin with, I should explain that I'd wanted the printed images to retain, not exactly the blotchiness of the machine paintings, but rather the kind of color modulation one finds in a Bonnard painting. In fact, the program already provided a crude simulation of the blotchiness, since I'd wanted to see on the screen something like what I'd get on the painting machine. So I kept the space-filling algorithm, and consequently a simulation of the physical brushes the machine had used, thinking that I could get that color modulation I wanted by shifting the color slightly from stroke to stroke. But it quickly became clear that the algorithm couldn't handle edges properly for the same reason it hadn't been able to do so on the physical machine: that for any given brush size there would always be concavities and irregularities in a form's outlines that the brush couldn't fill.

The simple answer to this was to do a flood-fill of each area in advance of the space-filling algorithm. However, a flood-fill is simply an array of horizontal lines, and translated into a postscript file for printing the ends of each horizontal line showed up as a jagged outline to the form. To counter this unwanted artifact I needed

Fig. 1.4 A still life, showing modulation in the earliest prints

to draw a continuous outline three or four pixels wide around the form and limit the flood-fill to the space inside. And having ensured that no unpainted area remained, I could then proceed with the space-filling algorithm and get the color modulation I was after (Fig. 1.4).

What I wanted—and this, too, looking back now, seems to have been a small deviation from the main direction—was for the viewer to be aware of the modulation as a kind of color vibration, but without being aware of the structure that caused the vibration. To do that the program would have to shift the color very slightly but very precisely from stroke to stroke. The problem here was that the degree of shift required to give the smallest perceptible change varies considerably with the hue, the brightness and the saturation. So there's an effectively infinite number of special cases, and, without exhaustive calibration it was impossible reliably to generate a precise enough color shift over the entire gamut of color the program was capable of generating. In those images where it worked it worked as I'd hoped; but most of the time the modulation showed up as an unwanted pattern of lines within the color area. And I was obliged to abandon the strategy and get back on track, stressing color interactions exclusively at the edges of the forms.

In its current state, AARON generates a set of four color variants for each area of the image, one for the flood-fill, two more for localized modulation at the edges of the area and the fourth for the central, core color of the area. The space-filling algo-

rithm has been retained for this core color, but it's un-modulated now and its only function is to provide an un-mechanical transition from the center to the modulated edges.

The overall result is to focus most of the articulation on the edges of objects, just as black outlines did, but doing so now in a way that allows the core colors of the formal elements a more active role in the structure of the image; precisely what black outlines prevent (Fig. 1.5). That heightened role for color is evident in all of AARON's recent work and it is a defining characteristic of AARON's style.

So it turns out that the configurational structure at those edges—the microstructure—emerges from a history in which formal issues like configuration were never considered; from a central preoccupation with color, played out in the context of a choice of subject matter that leads to an elaborate overlapping of forms. Which serves as a reminder, then, that the history I've outlined here barely scratches the surface of a complete history and a complete explanation. I've said nothing about the choice of subject matter and where—and why—it is located in the space between representation and non-representation. I've said nothing about composition. I've said a little about where different colors go, and why, but nothing about an obviously crucial element in AARON's performance as a colorist; how the colors are chosen. I've said virtually nothing about the internal representation of color that makes program control of color choices possible, and nothing at all about why I would find the notion of elevating color to the primary organizing principle of image-making compelling enough to sustain 20 years of work.

Now, how likely is it that this complete history could have been divined from a purely formal analysis of some number of AARON's images?

Of course, the argument for purely formal analysis does not require that it uncovers the true history of the original, simply that the presumptive history generates a convincing simulation. Should we conclude from that argument that any given configuration could have been the result of some number of alternative histories? A dubious conclusion: I have argued that AARON's images result uniquely, not just from their making, but also from the long history of perceived goals and intentions, paths and detours, that resulted in the peculiarly idiosyncratic technology of their making. Given the key to this technology—my explanation of the microstructure, for example—it ought to be possible to generate an effective simulation. But then, it wouldn't have been generated by a purely formal analysis and it would be effective only with respect to that part of the history that has been described—the microstructure—not to the image as a whole. We might reasonably anticipate that the results would be no more like AARON's images than all those web-based simulations of Mondrian paintings are like Mondrian paintings.

And if a complete explanation of every aspect of AARON's style were possible and available, would we have simulations truly indistinguishable from the originals? (I wonder whether that question could have been posed meaningfully before today). A complete explanation is possible. It may be available only to me, but it is implicit in the AARON program. And, as with AARON, complete explanations don't make simulations, they make originals.

Fig. 1.5 A woman with a potted plant, showing subsequent treatment of edges

References

1. Cohen H (1973) Parallel to perception. Comput Stud IV:3/4
2. Cohen H (1979) How to draw three people in a botanical garden. Invited paper, Proceedings of IJCAI 1979, Tokyo
3. Cohen H (1999) Coloring without seeing: a problem in machine creativity. Proceedings of the Edinburgh conference on AI, Edinburgh, TX
4. Cohen H (2002) Making art for a changing world. Invited paper, Japan Society of Software Engineers, Annual conference, Tokyo
5. Cohen H (2004) A sorcerer's apprentice. Public talk at the Tate gallery, London
6. Ghyka M (1977) The geometry of art and life. Dover, Mineola, NY
7. Watkins T. Piet Mondrian, Neoplasticism and De Stijl. http://www.sjsu.edu/faculty/watkins/mondrian.htm. Accessed 13 July 2010

Chapter 2
Whose Style Is It?

George Stiny

Abstract Artworks are in that style if they answer to certain rules. This isn't as crude as it seems. Rules can be pretty creative. There's recursion, of course, but far more with embedding. Embedding lets me calculate without a vocabulary or units. What I see and do, and the units this implies depend on the rules I try.

2.1 What Makes a Style?

Drawings, paintings, pictures, and other kinds of artwork are in the same style if they're alike in some way. (I'm going to stick to visual art and design, including architecture and ornament, although what I have to say is pretty general and also goes, for example, for product design and brand identity.) Not everything counts equally for everyone when it's time to decide what's the same, but almost anything—seen and unseen—can make a difference to someone. This raises the important question of how styles are defined. What is and isn't meant to be included when it comes to saying why two things are alike, and how much can this vary? Are distinctive features or fixed traits that count for everyone needed to make a style, or is there another way to handle this with more generosity and flexibility—to welcome change no matter what it is, and not to prevent or discourage it? Do I always have to say what I mean to define a style, or anything else for that matter? Or can I wait and see how it goes?

Perhaps the easiest and possibly the best kind of definition is given by an example or examples. It's a gin martini if it's like this one—maybe we agree that Tanqueray and Cinzano are the same as Plymouth and Noilly Prat: similar taste, smell, look, feel, etc. Likewise, artworks are in a particular style if they look like the ones I'm pointing to, or if the way I look at them has something in common with the way I look at my examples. Either way, this avoids having to say what features are distinc-

G. Stiny (✉)
Department of Architecture, MIT, Cambridge, MA 02139, USA
e-mail: stiny@mit.edu

S. Argamon et al. (eds.), *The Structure of Style*,
DOI 10.1007/978-3-642-12337-5_2, © Springer-Verlag Berlin Heidelberg 2010

tive and what traits matter, and it lets me keep to whatever I find salient for the time being. Examples don't need additional analysis and discussion before they're used—that's why they're examples: no one knows for sure what to say about them. Once they're given to get things going, it's best to wait and see what happens. There's no reason for abstractions and formal arguments because experience takes care of what examples mean, not endless elaboration and explication ahead of time—it doesn't help to be prescient.

As a result, styles may be vague and their instances ambiguous. There's always a chance to see things differently. This implies, at least it seems to, that no style stays the same for very long. The ultimate style, if there ever is one, will depend first on what I see and say, and on how this changes, and then more broadly on the ongoing experience of myriad others—artists and designers and their critics, and anyone else who wants to see more and look again. It's not just what makes a style, it's also who's looking where, when, and how. This kind of open-ended definition is a pretty good thing, too, especially with my fickle style of thinking—I have a hard time making up my mind once and for all.

But even if you agree with this, it may not be enough. Examples alone rarely complete an academic essay. Then it usually pays to try the opposite extreme with an explicit definition, so that there's something to argue about. It's useful to disagree as a way of learning something new. (Maybe explicit definitions are like examples, and arguing is just another kind of ongoing experience like seeing?) My definition is this: artworks are in that style if they answer to certain rules. What I really want to show is that this stark appeal to rules—as abstract and rigorously formal as it may sound—isn't any different than giving examples to look at, without losing any of the advantages rules—explicit and unambiguous ones—have, in particular, for education and practice. If I can get rules to work in the way I want them to, then the definition of a style will be open-ended in exactly the same way it is when I merely point to different instances of it, and say nothing to influence what there is to see. My rules aren't limiting in the way you'd expect them to be. So what are rules all about? How do I show them? Will examples do? What does it take to get rules to see whatever catches my eye as it wanders haphazardly from here to there?

I sometimes think that rules are best when they do three interrelated things: ideally, rules should be defined to allow for (1) recognition, (2) generation, and (3) description. But rules may also allow for (4) change, so that the ones I have and the way I use them aren't fixed 100%. How does an artist's or a designer's work develop and evolve over time, and how does my impression of it alter? What makes this possible? After all, a style needn't be a staid and stable standard. It may expand or contract, or turn into something different. There may be many opportunities to go on in new ways, either continuously or with breaks and gaps. Perhaps working in a given style and being original are only a matter of degree—both take seeing in new ways, so that there are new things to try. If this goes too far astray, there may be a new style, or maybe not. There are many ways to be creative, so long as I can see what I want. Is this asking too much if I'm using rules? Well, no it isn't—the chance to go on in your own way follows immediately from what I have to say about recognition, generation, and description, and how rules work to achieve them.

Once there are rules of the kind I have in mind—rules that neither anticipate nor limit what I can see—change is inevitable from artwork to artwork within a style, and from one style to another. It's true, this is going to be an academic essay on style—I'm going to keep it rigorously formal—but there's no reason for style to be academic, as well. Why not be free and easy about it, and let style breathe? It isn't very hard to find more than a few romantic traits—and many that aren't—in what I'm trying to do with rules. Let's see how it goes.

Recognition involves saying whether or not something old or new is in a given style—it's the kind of connoisseurship that makes an attribution, and it takes a sensitive eye and a sharp wit, and may require some luck. Generation involves producing new things in the style—it encourages copying and forgery, and with copyright laws and other codified strictures what they are today, it may be illegal. But copying may be how artists and designers work. They may copy themselves—perhaps that defines a style—and they may also copy someone or something else in their own way. It may not matter what you're looking at, because it's yours for the taking.

Is this legit? Plagiarism is an offense to take seriously in art—it comes up in "The Richard Mutt Case," with Marcel Duchamp on Mutt's side in the editorial for the second issue of *The Blind Man*. Pilfering ideas and borrowing as you please are unsavory activities, too, in architecture, design, engineering, science, education, writing, journalism, music, film, etc. Knockoffs not allowed—but what would architecture be like if Vitruvius had patented the column and classical orders? Where would artists and designers get new ideas? And how would the orders evolve? There are tricky problems all around, but description is probably more important than any of them and may help to solve them all. This may even take care of plagiarism! In fact, description looks to be the most important of my four desiderata for rules, because of what it shows about how rules work when describing things is kept open-ended. And perhaps that's the answer.

Recognition and generation are one way to test the adequacy of rules to capture a style against what intuition and experience hold, at least for the time being—ideally, everything included in the style should be, and everything excluded is meant to be, as well. But with description, it's a question of pointing to what I see, and saying something about it. This may depend on recognition and generation—and it usually does when these are used to explain instances of a style—but recognition and generation aren't the whole story. What I see may be independent of what I do when I recognize an instance of a style or make something that's in one. And it's this kind of freedom that's just what's needed for real change—both for artists and designers, and for everyone else. If I see something in a new way, I've done something new, too, and I can go on in my own way that's ineluctably personal and idiosyncratic. So exactly how are rules implicated in recognition, generation, and description? And how do rules allow for things to change freely in the way they do when I try to see what's there?

One thing that rules are about is recursion, that is to say, rules are used to arrange predetermined units in some kind of combinatory process. Meaningful units always come first, and they're key. They're the smallest pieces out of which complex objects are made, and they provide the distinctive features that serve to identify them—

they're the smallest building blocks: maybe letters and symbols in an alphabet to spell things out or words in a vocabulary that combine when there are things to say. This is the standard view in logic, computer science, and linguistics, where recursion is a staple: units are the basis for calculating, as Turing machines confirm with 0's and 1's, and you can count units to measure information or to gauge the power and complexity of rules in the four-tiered Chomsky hierarchy. In fact, words, rules, and sentences in a language like English are a perfect example of how units and recursion work, with words (units) and sentences (complex objects) linked by rules that build things up in terms of what's already been done (recursion). And there's more, too.

I can understand (recognize) a sentence in a language (an instance in a style) if my rules let me combine words to make it, and I can utter (generate) new sentences in the language (instances in a style) when I use my rules to combine words in different ways. Moreover, my rules and how I use them determine what I can say about sentences—how I describe them or tell you what they mean. There's a kind of compositionality that goes from units to complex objects to descriptions via recursion. What I can say about what I've done depends on its parts (made up of units) and how they're put together according to my rules. And there's scant reason for art and design not to be like this, too. You're in this style or that one if your spelling is correct, or if your grammar is OK, so that you express yourself properly with the right words. What a wonderful idea—it's just like being in school: follow the rules! Maybe that's why "school" is another word for style, and why it's so easy to assume that every style is academic.

Word play aside, this is strong stuff when it comes to style. It can be very rich in what it says and does. But it all depends on having the right units before you start—well, at least description does. I guess I can use predetermined units for recognition and generation even if I don't see them or any arrangement of them in what I do. That's what description is for, to say what I see in what I do—so much for compositionality. But how are rules supposed to handle this without units? What if units don't add up in the right way to coincide with my ongoing experience? There are no words for it. Does this mean that what I see is ineffable, that recognition and generation are all there is to count on, whatever they miss? Are formal rules a dead end? Is this just something to get used to? Perhaps it's too soon to tell. Maybe I can think about it in another way. Style—at least in the visual arts—needs something extra for rules to do their job, so that I can see what I want to without units getting in the way. Description goes beyond predetermined units and their arrangements, and recognition and generation can, too. Style needs something in addition to recursion.

Embedding is a generalization of the identity relation that's used to distinguish units when they're combined according to rules. The difference between the two—embedding and identity—is easy to see for points and lines. Points are ideal units, and they show how all units work. Two points are embedded, the one in the other, whenever they're identical—embedding and identity are the same. But for lines, this won't do—there's more going on. Two lines are embedded, the one in the other, whenever the one is a segment of the other, and they're identical only if this goes both ways, that is to say, their endpoints match—they have the same boundaries and

extent. Now when I use embedding with recursion instead of identity, I'm free to dispense with units. This may come as a surprise—logic says otherwise, as Turing machines prove—but there's no mystery to it, because I don't need units and logic to go on (or information and complexity, for that matter)—I only need rules to try. Rules pick out parts as well as combine them in a smooth and continuous process. There's nothing to stop me from seeing and doing what I like, whether or not what I see is an arrangement of units. Parts aren't made up of letters or words—they're merely parts without finer divisions—and they can change as I try rules in alternative ways.

But what about salient features and traits—letters and words can be very useful, especially if I want to say what I see and explain it—are they gone forever? No, they're just waiting until I find out what happens. I can construct them retrospectively in terms of the rules I apply for recognition, generation, and description. Units aren't necessary for rules to work, no matter how they're used. There are no prerequisites. Units along with features and traits are afterthoughts. They're the byproducts that result as rules are applied. Maybe it makes more sense to show how rules work with embedding than trying to explain it in words. In many ways, embedding is inherently visual, and rules are how we see. A good example never hurts—it's seeing and believing.

What counts as a rule? Well, a rule is something of this sort

$$x \rightarrow y$$

where x and y are shapes—maybe a triangle and a square I can draw

The rule applies to a shape z if I can find x or something that looks like x (a copy of it) in z. Then I can replace x with y or something that looks like y (a copy of it)—I can erase a triangle and draw a square. All this takes is seeing and copying with a pencil and eraser. Or equivalently, as one of my students put it, "I trace what I like then change (redraw) what I don't, until my design is done."

(Formally, there's an assignment g to give specific shapes for x and y, a Euclidean transformation t to move these shapes around, reflect them, or alter their size, the part relation (\leq), that is to say, embedding, and sum (+) and difference (−)—for example, drawing and erasing lines—in a generalized Boolean algebra. The rule x → y applies to the shape z if

$$t(g(x)) \leq z \qquad (2.1)$$

to produce another shape

$$(z - t(g(x))) + t(g(y)) \qquad (2.2)$$

But there may be too many parentheses in this two step process—functions, functions of functions, etc. can get pretty tedious, so I won't go into any more of the details. I may, however, use the terms assignment, transformation, and part from time to time, or define sums and differences. It's easy to get away with this because I can always use drawings to show what's going on. And in fact, this is a good way to experiment with shapes and rules, without missing anything of any importance—draw shapes according to rules, and look at what your drawings do. Seeing makes the difference.)

One of my favorite rules is the identity

$$x \rightarrow x$$

because it gives an easy way to see how embedding works with shapes, and why embedding makes such a big difference. With recursion and units, the identity is rather silly, and it's pathologically idle—most people discard it gleefully, without a second thought. The identity simply says that a known unit or some arrangement of known units is there, but that's no surprise, because units are permanently fixed before I start. They always are. The identity doesn't say anything that I don't already know, and it certainly doesn't add anything to what I already have. It merely keeps things the same. But with recursion and embedding, the identity really works. It gives an example of what to look for in a shape—or maybe in an instance of a style. Once again, the identity says that a part is there, but this time, the part isn't implied beforehand. The identity picks out something that I may not have seen or thought of in advance. I may not know what I'm going to see until I've had a chance to look.

For example, suppose I have a triangle

and a chevron

and that I combine them to make a star

If triangles and chevrons are units, then a pair of identities, one for triangles

and one for chevrons

would find one triangle

and one chevron

in the star, because that's all there is—that's what I've combined. There's never any-thing more than what I've put together. Units are always independent when they're combined, ready to be picked out in the same old way whenever anyone looks. But if I use embedding instead, then there are five distinct pairs of triangles and chevrons

in the star, because that's what I can trace out when I look at the star. Now it's what you see is what you get. Recursion without units (embedding) allows for a lot more than recursion with units (identity) does. With units, there's next to nothing to see—the emphasis is on recursion, and it's blind. This isn't a problem to ignore. With units, things can be pretty spare—so spare, in fact, that they seem to have little if anything to do with art and design. Visual experience isn't limited in this way—then the emphasis is on embedding.

Not so fast, you say. I can fix the star. I can define units for five triangles and five chevrons, or any number of triangles and chevrons you want. Well, yes you can, but only after you've seen them. How can you do this in advance—and with-out muddling up triangles and chevrons? They were units to start and now they're probably made up of units in funny ways—a triangle isn't three sides and a chevron isn't four. And why bother, unless you're going to use triangles and chevrons a lot.

What if you see something new every time you look? That's why embedding is key—you don't have to worry about any of this and more. With embedding, neither triangles nor chevrons are defined. The parts of the star aren't there until I try my identities—even when a triangle and a chevron are put together to make the star. (If I don't see them combined, how do I know they're there? If the star is rotated when I'm not looking, how do I know where they are?) And when I use my identities again, the parts of the star may change. Parts fuse when they're put together and can be picked out in other ways. Alone, the star is just that—an undivided, unitary *that*. It's only after rules apply that there's anything to see and to say. I have to wait to find out what's there—a star and all that means: a Vitruvian man, Carl's Jr. logo, a pylon, or something else with definite parts I can name. But this won't do. What about salient features and traits? Don't they count for something?

Well, my answer isn't much of a surprise. I'm merely going to repeat what I've said before. Identities also work to define salient features and traits—but only retrospectively and always subject to change if there are more rules to try. To see how this works, suppose I apply the identity for triangles

to pick out this triangle

and this one

to divide the star into pieces. Then four units are implied, and they're related as shown in this lattice diagram

And I can provide more insight than this decomposition does in a series of different topologies for the star that depend on how I've used the identity, for example, I can define closure operations and Heyting algebras. In fact, this works for shapes and rules generally, but perhaps it's too contrived to be convincing—it's just something I've cooked up in theory. How about a concrete example that makes a palpable impression?

2.2 An Example You Have to See

In Fig. 2.1, there are some examples of traditional Chinese lattice designs for window grilles, from Daniel Sheets Dye's *The Grammar of Chinese Lattice*. These regular patterns are all pretty much the same—they're easy to recognize and generate as checkerboards with alternating black and white motifs in grid cells

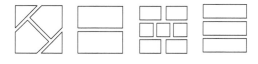

The motif for each lattice is oriented on a left diagonal (black)

and on a right one (white)

or horizontally (black)

and vertically (white)

to flip grid cells and alter their symmetry. That's all there is to it, and I like the lattice designs I get. Moreover, it's a safe bet that grid cells and motifs are salient features and traits. They're easy to see, and they go a long way when it comes to explaining lattice designs and the process that's used to design and make them. There's a certain style, and I seem to know a lot about it that's expressed nicely in rules. I can describe what I see, and recognize and generate designs.

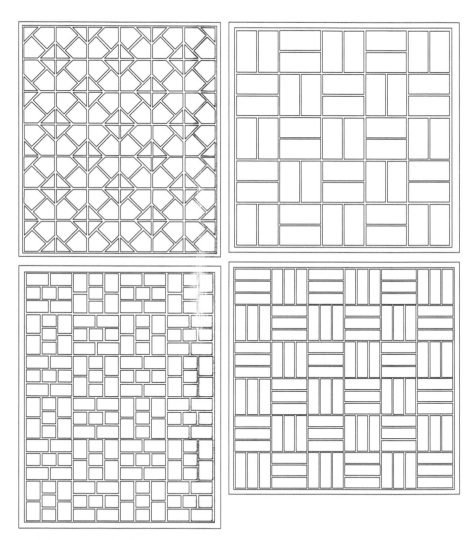

Fig. 2.1 Chinese lattice designs

And yet, there may be more in my first lattice design

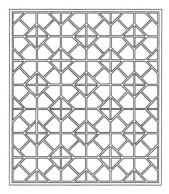

than rules for grid cells and motifs allow—maybe the alternating motifs in cells disappear in an array of Greek crosses or, reversing figure and ground, in a network of diamonds, so that crosses and diamonds are centered on orthogonal interstices in a checkerboard grid. These twin possibilities are easier to see when the grid is erased. Either way, there's this to look at

And what about the pattern

—is it in the same checkerboard style? Certainly, there's a grid, although this time it's been rotated 45°

and a motif

that works on diagonals of grid cells, switching back and forth between left and right. Nonetheless, the grid and the motif are hard to see—it takes a real effort even after you know they're there. I always have to pause a moment to find them—it takes time—and I'm apt to make mistakes. And in fact, Dye numbers this lattice and the Greek cross/diamond one consecutively in his *Grammar*, and classifies both of them differently than the remaining trio of examples in my original corpus of checkerboard patterns.

 What I actually see in the lattice, and I want to suppose that you do, too, are octagons

squares

and maybe Dye's "octagon-squares"

These are the salient features and traits. But if I've used grid cells and motifs as units in rules for checkerboard patterns, how is this going to be possible? There's no rule I can find for octagons or squares, when I'm stuck with the units I've got. I certainly don't want to give up on the way I make the octagon-lattice as a checkerboard pattern—the rules are just too easy not to be right. And I can't define alternative units until I know what there is to see—but then it's too late for rules to make a difference. I've already seen what I want to, without rules. New units after the fact don't help at all. So what should I do? Well, who says there are units? If I use embedding, I only need to have the identity

$$x \to x$$

and assignments to get the job done. The style has changed—now there are octagons and squares in addition to grid cells and motifs—but this doesn't mean my rules for making lattice designs have changed, as well. I'm simply able to see more with the identity.

Knowing how to make something may work perfectly for recognition and generation, but fail for description. All the same, styles welcome the added detail that description may bring. Salient features and traits needn't be there to start or have anything to do with identifying and making designs. There's far more to it— in fact, everything embedding allows. Well, perhaps that's too much, but at least anything you choose to see and to talk about now and whenever you look again, and anything you want to change.

2.3 Changing Styles

The way I use my rules gives me the freedom to stay within a style or to break out in new directions. A standard repertoire of rules may be all I need, with assignments and transformations providing variation and novelty—for example, I can use assignments to introduce motifs that transformations align on diagonals or on horizontals and verticals in grids. But what about the rules in my repertoire: what should they be?

Styles change when there's something new to see or do. With embedding, seeing and doing are independent. What I see has to match up with what I've got—true enough, I can always trace out what I see—but this doesn't have to recite or recapitulate what I've done. The triangle and chevron I combine to make the star

may not be what I see when I look at it, even if I'm looking for triangles and chevrons. This gives me the chance to try new rules or familiar ones in new ways to vary what I see and do. And rules show how seeing and doing are independent in some other ways, too.

I can see something new via the identity

$$x \rightarrow x$$

and do nothing at all. As I've already shown, this can be a neat way to change things without lifting a finger—and the change can be pretty dramatic. Or I can do something new with the rule

 $$\rightarrow y$$

where there's nothing to see at all—I can splash a wall with colors and go on from what I see in the various blots and stains, in the way Leonardo da Vinci recommends ("if you consider them well, you will find really marvelous ideas"). I may simply apply the rule \rightarrow y and then the identity $x \rightarrow x$ to get what I want—or I can try \rightarrow y and $x \rightarrow x$ any number of times and, if I wish, choose assignments and transformations to coordinate how I use these rules. (Isn't this action painting?) But usually, seeing and doing are connected in a rule

$$x \rightarrow y$$

so that x and y are different shapes I can see.

This gives three more possibilities—(1) seeing something new and doing something familiar, (2) seeing something familiar and doing something new, and (3) seeing something new and doing something new. But this extended taxonomy is idle—without units, every time I try a rule, I see something new. No matter what I find, it's going to be a surprise, because nothing is defined before I look—not even what I've done stands out. There isn't any memory. It's always seeing for the first time—that's what rules do, and that's why they work in art and design. (Taxonomies like mine are seductive—they're easy to set up and have the ring of truth. Designs can be routine and non-routine, novel and original, anticipated and not, etc. There's *mimesis* (imitation) and *fantasia* (imagination). But whatever truth these distinctions may hold is difficult to sustain with embedding—they're apt to collapse when rules are tried. It seems that words fail in many ways when it comes to art and design. Maybe that's the taxonomy to pursue.)

There may, however, be some useful relationships in the rule

$$x \rightarrow y$$

if x and y are expressed in common terms. In the identity

$$x \rightarrow x$$

x and y are the same to begin a series of rules that erase part of x

$$x \rightarrow prt(x)$$

or all of it

$$x \rightarrow$$

This allows for plenty of change in both seeing and doing. And these rules have inverses of interest, too. I may just do something

$$\rightarrow x$$

as I've already shown—in fact, $x \rightarrow$ and $\rightarrow y$ can be used in place of any given rule $x \rightarrow y$ when assignments and transformations are in sync—or if I see part of something, I can fill it in

$$prt(x) \rightarrow x$$

With a little more effort, I can show this with a boundary operation b

$$prt(x) \rightarrow prt(x) + b(x)$$

so that the rule is more like drawing—nothing is added to the part as I put in the outline of something it belongs to. And this isn't all.

Look at the rules in the lattice diagram

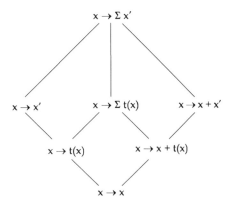

in which higher rules include lower ones. Now I have rules to change x via a Euclidean transformation t

$$x \rightarrow t(x)$$

For example, if t is the identity transformation, then I get the identity rule $x \rightarrow x$. Of more interest, though, I can use the rule

to rotate equilateral triangles in the pinwheel

so that the pinwheel is rotated about its center

But this can't be right—the center of an equilateral triangle is a fixed point when the rule applies, yet each of the three such centers in the initial pinwheel is rotated in the final one. How is this possible, or is it a paradox? Draw the triangles and see—and it really does depend on seeing. Then I can also add t(x) to x

$$x \rightarrow x + t(x)$$

in a rule that's recursive in an obvious way—after it applies to x, it applies to t(x)— and that may be recursive in surprising ways, too. The rule also applies again if $x + t(x)$ has a part like x that's neither x nor t(x). For example, the rule

applies to the small square. Moreover, if my transformations are the generators of a symmetry group, then symmetrical patterns or parts of them can be defined. In the same way, adding multiple transformations of x

$$x \rightarrow \sum t(x)$$

makes fractals—and a lot more than fractal (blind) recursion allows. Of course, transformations needn't always be Euclidean. I can extend them in the rule

$$x \rightarrow x'$$

in the rule

$$x \rightarrow x + x'$$

and conclude with multiple ones in a sum

$$x \rightarrow \sum x'$$

All the same, sums and transformations—Euclidean and not—aren't the only way to think about rules. Many useful rules are described outside of my lattice diagram—in particular, a rule to divide things

$$x \rightarrow \mathrm{div}(x)$$

with an inverse

$$\mathrm{div}(x) \rightarrow x$$

to reverse this process. Perhaps there's too much going on here—a few visual examples may help to see what some of these rules do.

I can do the kind of regular checkerboard lattices I started with

using x → x + t(x), and once I add the erasing rule x →, it's easy to agree that

is in the same style. What can't be seen makes a difference, and may even be a salient feature. Moreover, I can go on to another kind of traditional lattice. Designs called "ice-rays" are shown in Fig. 2.2. These patterns are beautifully irregular, and they're easy to define with a single rule x → div(x) when it's used to divide triangles, quadrilaterals, and pentagons into polygons of the same three kinds. This is possible, too, in a fractal sort of way, with the rule x → \sum x′. Then there's Paul Klee's perfectly wonderful "palm-leaf umbrella"

that I can do with x → x + x′ and div(x) → x. Notice especially in this process how the rule x → x + x′ lets me explore different kinds of movement or, more generally, any series of alternative views in a sum. This is also the case in Jacob Tchérnikhov's lively black and white drawing

in which quadrilaterals are arranged vertex to edge one either inside or outside another. And in much the same way, I can get a good start on Duchamp's notorious *Nude Descending a Staircase (No. 2)*. With rules, there are designs of all sorts— Palladian villa plans, Mughul gardens, Japanese teahouses, and designs described in building manuals like the *Yingzao Fashi*. Then there are Queen Anne houses and Hepplewhite chairs, and modern designs from Wright's prairie houses and Usonian ones to Aalto (try $x \rightarrow x + x'$ again) to Terragni to Siza and Gehry (they independently use $x \rightarrow div(x)$ in ice-ray fashion), and also ancient Greek pottery in the *Geometric* style, current design competitions and student projects, and, yes, painting and sculpture. The series seems endless—adding to it is a good way to prove that rules work. And if I stick to the rules I've been showing, for example, $x \rightarrow x + x'$ and $x \rightarrow div(x)$, this helps to reinforce the idea that opens this section: styles vary according to the assignments and transformations given to apply the rules in a standard repertoire. Nonetheless, there's another kind of example that highlights rules and embedding in a different sort of way.

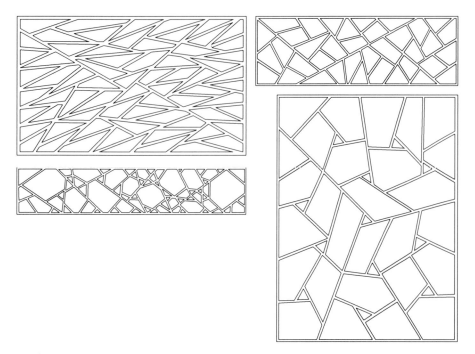

Fig. 2.2 Ice-ray lattice designs

Rules may also help to explore and bolster speculative accounts of art and its origins. Leone Battista Alberti seems to have been the one with the original idea. He sets things up in the opening lines of *De Statua*, around the middle third of the fifteenth century, when he considers the beginning of imitation (copying) in figurative art. It's in this marvelous passage—

I believe that the arts which aim at imitating the creations of nature originated in the following way: in a tree trunk, a lump of earth, or in some other thing were accidentally discovered one day certain contours that needed only a very slight change to look strikingly like some natural object. Noticing this, people tried to see if it were not possible by addition or subtraction to complete what still was lacking for a perfect likeness. Thus by adjusting and removing outlines and planes in the way demanded by the object itself, men achieved what they wanted, and not without pleasure. From that day, man's capacity to create images grew apace until he was able to create any likeness, even when there was no vague outline in the material to aid him.

Is this something to take at face value? To be sure, it's easy to find faces of superstars and deities in odd places, and animals, too—big dogs and Cheshire cats, and lions, tigers, and wild things are everywhere you look. But is there any more to say about these fanciful images? What can I do that works? Well, I can use the two rules $prt(x) \rightarrow x$ and $prt(x) \rightarrow prt(x) + b(x)$ to do what Alberti wants, or I can provide additional elaboration in the way he recommends with new rules using transformations, sums, and differences—I might try it in this way

$$prt(x) \rightarrow x' + y$$
$$prt(x) \rightarrow x' - y$$
$$prt(x) \rightarrow prt(x) + b(x') + y$$
$$prt(x) \rightarrow prt(x) + b(x') - y$$

to adjust and complete what I see to create a perfect likeness. My new transformations x' may also allow for perspective and the like, so that painting meets Alberti's scientific standard, or an artist can paint a model over there on a canvas right here—but there are many other ways to do this, too. Yet making rules more complicated isn't the point, even if it's fun. (It's worth noticing, too, that Alberti's "accidental discovery"—embedding—and "addition or subtraction" are exactly what's needed for rules.)

My last four rules are already over the top. It's so easy to define rules when you don't have to worry about units that it's hard to stop. There's always one more thing you can see to do. And maybe that's the key point: because every part is there without breaking it up into units, I can define rules independently—and teach them to you and teach you how to define them— without ever having to worry that they won't work when they're used together. In fact, I can guarantee that rules will work, whether they're yours or mine, no matter where they're tried—the way I've been using the identity $x \rightarrow x$ proves it. What's nice about this is that it makes art and design accessible to everyone without limiting what anyone sees. Whether you draw shapes in your own way or look at them as you please, you're part of the same ongoing process. No one is left out. Rules that apply without units, so that I can see things and their parts embedded in other things, seem right for art and design, and to be the way to talk about style.

But there's also something else. I can say a lot more about where art comes from and how to make it if I extend Alberti's idea in the obvious way: "a tree trunk, a lump of earth, or . . . some other thing" may just as well be a drawing, a painting,

a photograph, a sculpture, a building, or ... some other thing that leads to another artwork in the same style or in a new one. This sounds a lot like copying—it seems that plagiarism is hard to avoid when there's creative work to do. But this also seems right when there are rules to try like the ones I've given. Shapes in trees and shapes in drawings are the same. With trees and drawings, it's beginning with examples and trying rules to see where things go. And that's all I promised to show. (Trees, of course, are birches, eucalyptuses, maples, oaks, poplars, redwoods, spruces, etc., and not the abstract diagrams for hierarchies that logicians, computer scientists, and linguists love to use. Otherwise, my equivalence between shapes in trees and shapes in drawings would fail—I'd be back to units. And diagrams sometimes fail, too, as this one may for the sentence it describes

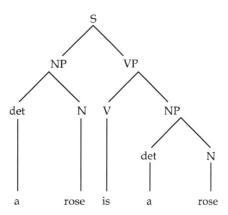

I can hear more than the tree shows—maybe, "A rose is Eros," or either of its two alternatives. Whatever Gertrude Stein was doing, she wasn't reiterating a logical identity—then one time is enough. But what I hear can change as I repeat the words. And in fact, what I see changes, too, when I look again. What does the tree look like as a perspective drawing or flattened out as an elevation? It seems architecture has a lot in common with animals and faces—it's everywhere you look—and that art can use anything experience holds.)

I'm not the only one who uses what Alberti says. I copied his passage in *De Statua* from E. H. Gombrich's classic, *Art and Illusion*—it's in the section on prehistoric cave art and "projection" in psychology, the *Rorschach* test being the key example of the latter. It's a safe bet that projection and embedding are the same, although Gombrich neither relies on embedding as heavily as I do, as the basis for rules and style, nor takes Alberti as far as I want to. But Gombrich is on the right track—"... the cave art we know may be anything but primitive. It may be a very developed style. And yet the priority of projection [in the initial cave drawing that's lost] may still determine the character of the style [we see]. We have frequently seen to what extent the artist's starting point will determine the final product." With rules, of course, embedding is never complete at the start but

goes on over and over again—in fact, every time a rule is tried. There's no way to avoid embedding when it comes to seeing. And Gombrich is ready to agree, even if being aware of embedding may make seeing seem a little fickle, something like opinion rather than fact—"When we are aware of the process...we say we 'interpret,' where we are not we say 'we see.' " But whether seeing is one way or another doesn't matter—this is probably one more of those easy distinctions that aren't worth keeping. What does matter, and matters a lot, is that seeing depends on embedding whatever way seeing is—whether it's self-conscious or not, things vary freely—and that embedding is what rules do whenever they're tried. Embedding is the same for seeing and applying rules. It melds style and change in an ongoing process that's evident in all kinds of art—ancient and not. And perhaps it's why art is art.

2.4 Whose Style Is It?

Usually, when this question is asked, it's about a given artwork, and the answer is supposed to identify the artist or designer, or some plausible point of origin that seems to explain things—perhaps it's a studio work with multiple artists (a master craftsman and apprentices), or maybe there's a fictitious artist (Richard Mutt comes to mind), or it's chance art with no artist at all. This takes trained experts to do right, and it's a very serious business. But this isn't the kind of question I want to pose, as interesting as the answer may be, especially with dates, records of ownership and sale, miscellaneous provenance, gossip, etc. Instead, I want to ask the question about styles themselves—who defines them, and how do they do it? Questions, like the things we see, can be looked at in alternative ways.

My answer, of course, is no surprise. I was pretty clear about it in the early paragraphs of this essay, before I started to show that it's perfectly feasible using rules and embedding—styles belong to all of us: artists and designers, critics, connoisseurs, copyists, plagiarists, forgers, Aunt Sophie and Uncle Al, the man in the street, and you and me. And no one in this list is privileged nor is anyone indispensable. The root of style is observational—everything depends on this. You have to look and then look again, whether you're an artist or a designer, or someone else. It's not about anyone special, but about having something special to see. This is an ongoing process in which nothing is fixed—everything can change and alter. In fact, what you see and what I see needn't coincide. We can talk about the same artwork—maybe one of us made it, or copied or found it— and not see eye to eye. What happens when we interact in this way and when others do the same adds to the style and changes it. Style is a community enterprise with everything this implies—commotion and confusion, hubbub and humbug, incoherence and inconsistency, madness and mayhem, and even understanding and agreement. It all goes together to make a style. That's why looking and then looking again are worthwhile. Whatever you see is a surprise. There's always something new.

All of this, no doubt, has been shown in other ways many times before. What hasn't been shown is that this is just what rules do—once embedding is added to recursion. And for me at least, that's what makes the proof. Rules work formally as mathematics and calculating, and visually, as well, to pick out whatever anyone wants to see, and to use it—nothing is decided at the start, and there may be differences and inconsistencies anywhere along the way. Less than this, well, it's just words—the identity relation is fine when it's merely a question of putting predetermined units together in a combinatory process, but this kind of counting (blind recursion) isn't enough when it comes to art and design. Then you need your eyes to see. Recursion and embedding don't keep us from seeing in any way we choose, they make this possible. And that's precisely what rules are for. That's where the art is and also the style. It's trying rules to see how it goes.

2.5 Background

A like account of style and stylistic change is given in Terry Knight's book, *Transformations in Design* (Cambridge, Cambridge University Press, 1994). Multiple versions of the rule $x \rightarrow \sum t(x)$ are used and transformed. Everything covered in this essay is considered more completely in my book—*Shape: Talking about Seeing and Doing* (Cambridge, The MIT Press, 2006). But my book includes much more on shapes and rules, on adding color and other material (concrete) and abstract properties to shapes, on how to get shapes and words to work together, and on why art and design—in the way I've been talking about them—are calculating. What I've tried to do in this essay is show that there's no divide between giving examples and trying rules, at least when there's embedding. In my book, the goal is pretty much the same, but perhaps the terms of the equivalence are more ambitious—there's no divide between design and calculating—and the proof is more elaborate. That there are two cultures—design and calculating—is an invidious distinction that diminishes all culture. Whatever we do is part of one continuous enterprise.

Chapter 3
Style in Music

Roger B. Dannenberg

Abstract Because music is not objectively descriptive or representational, the subjective qualities of music seem to be most important. Style is one of the most salient qualities of music, and in fact most descriptions of music refer to some aspect of musical style. Style in music can refer to historical periods, composers, performers, sonic texture, emotion, and genre. In recent years, many aspects of music style have been studied from the standpoint of automation: How can musical style be recognized and synthesized? An introduction to musical style describes ways in which style is characterized by composers and music theorists. Examples are then given where musical style is the focal point for computer models of music analysis and music generation.

3.1 Introduction

Computers are important in many aspects of music composition, production, distribution, and analysis. In contrast to domains such as natural language, speech, and even images, music rarely has a well-defined meaning, referent, or objective. Consider the sentence, "Tie your shoes." There is a basic, objective meaning that forms a well-understood command (at least to English-speaking humans). With spoken text and in different contexts, one can imagine all sorts of nuanced versions expressing anger, sympathy, embarrassment, impatience, authority, gentleness, and so on.

Now consider a short melody without words. There is no obvious objective meaning, story, or referent associated with a pure melody. Everything that we enjoy (or not) about the melody has to do with expectations, sound quality, performance nuance, and musical texture. Essentially every aspect of the melody that communicates something to the listener is an aspect of *style*.

R.B. Dannenberg (✉)
Carnegie Mellon University, 5000 Forbes Avenue, Pittsburgh, PA 15213, USA
e-mail: rbd@cs.cmu.edu

S. Argamon et al. (eds.), *The Structure of Style*,
DOI 10.1007/978-3-642-12337-5_3, © Springer-Verlag Berlin Heidelberg 2010

In that sense, style is everything in music. So music is a wonderful domain to think about style, but at the same time, style is so broad and vague that we will only make progress if we deconstruct style into more specific concepts. As one might hope, music theory and the many dimensions of music orchestration and performance offer many opportunities to investigate style. In addition to theoretical writings, there are many stylistic concepts that have been modeled with computers and studied more objectively.

In the next section, we will discuss the nature of style in music and talk about how one might describe or characterize musical style. This section is written for the musical novice. If you "don't know anything about music but you know what you like," perhaps this section will offer some terminology and help to understand how musicians think about music structure and organization as it relates to style. Section 3.3 presents a number of computer models of style for both analysis and generation. This section will assume some general knowledge of computer science including data structures, and algorithms.

3.2 What Is Musical Style?

In general, "style" means a distinctive quality, form, or type. A more specific definition that certainly applies to music is "a particular manner or technique by which something is done, created, or performed" [9]. In music, the term "style" is used in many ways:

- Historical periods of music are associated with styles. For example, we might say a composition by Mozart is in the Classical style, and one by Bach is in the Baroque style. These styles can be more or less specific: in the recording industry, the term "Classical" is so broad that Mozart and Bach are both "classical" composers, but a music scholar might speak of "late Classical" or "Neapolitan Baroque."
- Styles are associated with composers. We can speak of composing in the style of Beethoven. In this sense, "style" means "a set of characteristics generally found in the works of a particular composer."
- Performers, especially improvising performers, also have styles. The "ballad style of Miles Davis" refers to characteristics of Miles Davis's performances of ballads. Of course, great classical music players interpret music they perform even if the music is not improvised. One can speak of the expressive style of Itzhak Perlman, for example.
- Style can refer to aspects of musical texture. "Texture" is one of those words like "style" that is very difficult to pin down, and dictionaries do not consider the depth of meaning that texture has for composers. Basically, musical texture is a composite of many aspects of music that one would hear within a second or so. On longer time scales, melodic, rhythmic, and harmonic progressions stand out, but at shorter time scales, we hear timbre (violins?, electric guitars?, saxophones?), very short repeated patterns, many or few different pitches, loudness,

and brightness, all of which give a subjective impression we call texture. While composers usually consider texture to be something different from style, texture is at least a closely related concept. "Texture" usually refers to sound and the activity of making sound, while "style" is most often used to describe the general impression or intention provided by a texture. We speak of a "tonal style," a "heavy style," or a "big band style," all of which refer to texture-induced impressions. In these examples, the style is not so much the melody, rhythm, or harmony, but the *sound color* in which these elements are embedded.

- Music is often described in emotional terms: exciting, soothing, calm, scary, etc. Sometimes music causes listeners to experience emotions, and other times the listener may recognize an emotion without necessarily experiencing it. Either way, emotional associations are yet another way to describe the style of music.
- Style is often used to mean "genre," yet another difficult-to-define term. A genre is a category of music characterized by a particular style, but a genre can also be influenced by social conventions, marketing, association with a particular artist, and other external influences. Still, it is common to refer to something as "rock style," or "bebop style."

All of these definitions are related to the underlying idea that there are important characteristics of music that we perceive as common or related across certain collections—the work of a composer, the output of some historical period, or music of some genre. Musicians study the elements of music in detail and are familiar with ways in which these elements can be varied, giving rise to different styles. It is interesting that non-musicians can also perceive styles with great sensitivity, often with no ability to describe characteristics or differences. For these listeners, I will offer some terminology and discussion through examples. Do not expect to become a musical expert, and do not believe that experts have a complete formal model of style, but hopefully this discussion will explain some of the ways musical style can be treated objectively. For more details on music terminology, concepts, and history, the *New Grove Dictionary of Music and Musicians* [14] is an excellent reference.

3.2.1 An Example: Baroque vs. Classical Style

A good way to learn about musical style is to examine the differences between two well-known styles. In this section, we will compare *Baroque* and *Classical* styles. The Baroque period extends from about 1600–1750 and includes music by Monteverdi, Bach, Handel, and Vivaldi.

As noted above, "classical" is sometimes used to refer to a broad range of styles sometimes referred to as "Western art music," which includes Renaissance, Baroque, Classical, Romantic, and many modern styles. But to experts, Classical music is music from the Classical period, approximately 1750–1800. The most celebrated Classical composers are Haydn, Mozart, and Beethoven in his early years.

Baroque and Classical music differ along many dimensions as listed in Table 3.1. It should be noted that there are few absolutes in music, and certainly there are

Table 3.1 Characteristics of baroque and classical styles

Baroque	Classical
Contrapuntal	Homophonic
Ornamented	Internal Structure
Frequent, less meaningful modulation	Modulation becomes structural element
Single vivid feeling	Range of emotions
Constant intensity throughout	Dramatic climax and resolution

exceptions to every rule. However, scholars generally agree that the characteristics described here are important, real differences between the two styles. These differences are now presented in more detail.

The first difference is contrapuntal vs. homophonic writing for multiple voices. Here, "voice" is used in a technical sense that means a human voice *or* an instrument, so the difference is how composers combine multiple simultaneous sounds. Homophonic writing emphasizes harmony and a single dominant melody. Typically, the highest voice carries the melody, and concurrently with each melody note, the other voices sing harmonizing pitches. Most church hymns are homophonic. In contrast, contrapuntal writing emphasizes melodic motion over harmony. It is as if each voice is singing its own melody. Often one voice will sing a short melodic sequence and then hold a steady pitch while another voice sings an "answer" in the form of another melodic sequence. Two, three, or more melodies are thus intertwined to create what is called counterpoint. In more objective terms, at least one feature of contrapuntal writing is that fewer notes begin synchronously compared to homophony.

In Baroque writing, there is an emphasis on ornamentation, typically short, fast notes inserted above and below at the beginning of a "normal" note in the melody. The trill, where the pitch alternates between the melody note and the next one above, is another ornament. Some ornaments and their interpretations are illustrated in Fig. 3.1. If Baroque style tends to "decorate" melodic lines, the Classical style is plainer, with an emphasis on developing ideas and formal structure. For example, the sonata form that appears in the classical period is based on a structure consisting of two themes, their development, a return to the themes, and a conclusion.

Baroque and Classical music is based on musical scales. For example, the white keys of the piano (omitting the black ones) are used in the scale of C-Major. Any music can be *transposed* by adding an offset to each piano key. For example, if every note is played 7 keys to the right on the keyboard (counting white notes and black notes), the result will sound very similar, but the music has been translated to

Fig. 3.1 Some musical ornaments and their interpretations: Turn (*left*) and Mordent (*right*)

a new location. This is called a modulation. Modulation in Baroque music occurs frequently, but the modulations do not have much significance. In Classical music, modulations are often carefully resolved: a modulation up 7 steps is likely to come back down 7 steps, setting up an expectation in the listener. In the sonata form, modulation is used to announce the introduction of the second theme, and modulation is often carefully coordinated with other musical structure.

In terms of feeling, Baroque music typically portrays a single emotion at least through an entire movement or major section of a composition. Classical music is more likely to progress from one feeling to another in a narrative style, exploring a range of emotions. While Baroque music is more likely to maintain a feeling with a steady intensity, Classical music often develops into a climax of tension, excitement, and just plain loudness, and then settles into a state of calm and resolution.

To summarize, Baroque and Classical music differ along a number of dimensions. These differences can be difficult to formalize and even to describe to non-musicians, but at least it should be clear that most music lovers, with a little experience, can recognize these styles. Music scholars can go further by describing differences in specific terms. Music is one area where "style" has been deeply studied and where there are many examples and analyses of different styles.

3.2.2 Style in Popular Music

What makes a modern popular musical style? There are so many emerging styles that most people are not even familiar with many of them. What distinguishes Black Metal, Death Metal, Doom Metal, Hair Metal, and Power Metal? (Hint for Classical music purists: these are rock styles.) And if you are a hard-core metal enthusiast for whom these terms are familiar, what distinguishes Be-Bop, Hard-Bop, and Post-Bop? (Hint: think jazz.) Rather than tackle these questions specifically, we will look at some general characteristics of music. Style, especially in popular music, includes an important sociological component, so we should not expect style to be purely a matter of how something sounds. The composer, performer, geographic region, marketing, and public perception have an important influence on how music is categorized.

As always, popular music style has many meanings and interpretations. We could talk about singing style, genre, rhythmic feel, dance styles, and others. Without getting too specific, imagine scanning a radio dial looking for a favorite style of music. Experiments by Perrot and Gjerdigen [12] indicate that we can recognize style in a fraction of a second. What elements of music allow us to quickly determine if we have found something in the style we are looking for?

In popular music, one very important element is the instrumentation. If we hear nothing but guitar, bass, and drums, this might be hard rock, but if we hear a saxophone and trumpet, this might be a blues band. Strings might indicate pop music or a rock ballad. In addition to instruments, the quality of instrumental sounds is important. An acoustic guitar or pure guitar sound might indicate soft rock or country music, while a highly distorted electric guitar is more typical of heavy metal. As we

shall see, automatic genre classifiers can be based purely on the average frequency spectrum of music audio.

Vocal quality and the number of vocalists (with harmony) also tell us something. Steady clear vocals, spoken words (as in Rap), screaming, falsetto singing, and the use of pitch inflections and vibrato could all be described as vocal styles, and all tell us something about the style of music. You would not hear an operatic voice singing country music or four-part harmony singing on a techno track.

Rhythm is very important because most popular music is very rhythmic. There are rhythmic patterns associated with different styles of music as well as with dance styles. Rock is characterized by strong beats in groups of four, with accents on 2 and 4: one-TWO-three-FOUR. Compare this to Reggae, which also follows the general rock pattern, but often with a slower tempo, a subdivision of beats (e.g. one-and-TWO-and-three-and-FOUR-and), and emphasis on rhythmic bass patterns. Reggae is a good example of the importance of not only the rhythm but *how* the rhythm is established by different instruments including different types of drums and other percussion.

3.3 Computational Approaches to Music Style

In recent years, many advances have been made in the analysis of musical style and the generation of music according to certain styles. Some of these advances can be attributed to advances in statistical machine learning, which seems to be well-suited to the capture of style information where data is more representative of trends than hard-and-fast rules.

3.3.1 Learning to Recognize Improvisational Styles

A standard task is a forced-classification of music into one of a set of style categories. The general approach is seen in Fig. 3.2. The input is music data in the form of audio. The first step is to extract features from the audio signal. While it is theoretically possible that a system could learn to classify styles directly from digital audio signals, this is not practical. Instead, we perform some analysis on the sound to obtain a small set of abstract features that will hopefully contain useful information for discriminating styles. Next, a classifier is used to estimate the style of the sample. The classifier can be based on any number of machine learning models. For this discussion, we will only be concerned with the general nature of these systems. Basically, a classifier begins with a number of labeled examples called the *training set*. Each example contains a set of features obtained from an excerpt of

Fig. 3.2 Style classification

music and a *label*, which gives the correct style for this excerpt. There may be many thousands of examples. From the examples, the classifier learns to output the correct label given a set of feature values. Learning is usually accomplished by iteratively adjusting parameters within the classifier to improve its performance on the training set. For details, consult a textbook on machine learning [10].

The features obtained from the music are critical to machine learning, especially when something as abstract as style must be determined from something as concrete as an audio waveform. Surprisingly, style classification does not always require high-level features like pitch and rhythm, but let us start there anyway.

Belinda Thom and I created what may be the first music style classification system [5]. Our goal was to detect different improvisational styles. There is no list of standard improvisation styles, so at first glance, this problem may seem to be poorly defined. How can we know if the classifier works? We avoided the need for absolute, objective definitions by letting the improviser define style categories and give training examples. A classifier was then trained to recognize these categories. To test the classifier, a computer would display the name of a style category, the improviser would play in that style, and the classifier would attempt to recognize the style. If the classifier output matched the displayed style category, then we claimed that recognition had indeed occurred. The beauty of this experiment is that, to the improviser, the different styles remained purely subjective concepts, and yet we were able to make objective ratings of classifier performance.

For this classifier, the input was assumed to be monophonic audio, that is, the sound of one instrument. This sound was analyzed to extract pitches, note onset times, note durations, overall note amplitude, and time-varying amplitude and pitch. We organized this data into 5-s "windows" because we wanted a system that could respond to changes in style. There is a tradeoff here: longer windows give more reliable statistical information but reduce the responsiveness to changes. We guessed that 5 s would be long enough to collect useful information and short enough to be useful in real-time interactive music systems that would respond to performers' styles.

The features we used included the average (mean) pitch, number of notes, average loudness, average duration, and average duty cycle. The "duty cycle" is the fraction of total time that a note is sounding. In addition, we computed standard deviations of pitch, duration, and loudness. Additional statistics were computed on pitch changes and loudness changes. All of these statistics refer to a 5-s period of playing. We analyzed a 5-s period starting at every second, so the windows overlapped both in training and in testing the classifier.

We worked with a set of 4 distinctive styles that were labeled *lyrical*, *pointillistic*, *syncopated*, and *frantic*. These categories are easily distinguishable by humans and our machine classifiers, which in one case recognized over 99% of the test cases correctly. It is interesting that *syncopated*, which literally means placing notes on upbeats (between beats) rather than downbeats, can be recognized without the need to detect tempo and beats. Evidently, there is a characteristic manner of playing syncopations that manifests itself through other features, including the ones that we detected.

We also tested the system on a more difficult set of 8 styles. In addition the four listed above, we used *blues*, *quote*, *high*, and *low*. In practice, these "styles" are not mutually exclusive. One could easily play "lyrical blues" or "high and frantic." Also, *quote* means to play a familiar tune from memory. It would seem impossible that the computer could detect quotes without a memory of popular tunes, but in fact the computer recognition of this category was still better than chance. As with *syncopated*, we believe that quotes are played in a manner that can be detected through low-level features. Overall, the computer recognized 90% of these styles correctly, whereas random guessing would get 12.5% correct.

Questions these experiments cannot answer include "does *frantic* have a 'true' nature?" and "what is it?" Perhaps like *syncopation*, there is a deeper human notion of each of these styles, and we are just measuring superficial features that happen to be correlated with the "true" styles. Our simple features certainly do not capture all the kinds of musical information that human listeners hear and process, so it does seem likely that *frantic* and other categories *do* have deeper and richer meanings and associations than indicated by our computer models. However, it is still interesting how well simple machine models can learn to recognize stylistic differences in musical performance.

3.3.2 Genre Classification

The same basic ideas of feature extraction, labeled training examples, and machine learning have been used for the task of automatic genre classification. The goal here is to label music audio according to *genre*, such as rock, pop, country, jazz, and classical. Much of the research in this area investigates features.

Surprisingly (at least to this author), the average spectrum is quite effective for genre classification. How could this be? After all, the average spectrum does not convey any information about beats, harmonic progressions, or melodic shape. Aren't these the things that differ among different genres? It turns out that, for example, rock music has a very broad spectrum with a lot of energy at high-frequencies (think penetrating, distorted guitars and snare drums) compared to classical music. Thus, a binary rock/classical music detector should be quite simple to create.

Other spectrally related correlations can be found. For example, rock music tends to stay in one key, whereas jazz and classical music are more likely to modulate to different keys. This affects the distribution of energy in the frequency spectrum. Trying to apply reasoning and rules to genre classification might be partially successful, but a much better approach is to use machine learning, where hundreds or thousands of features can be considered systematically. Typically, researchers use more than just the spectrum, although for the most part, the features do not involve any kind of high-level music perception. One might think that by detecting high-level features such as tempo, meter, orchestration, and even music transcription (what pitches are played when), that genre classification could be improved. In practice, these higher-level features are very difficult to detect, and detection errors limit their usefulness in genre classification.

Some features that can be obtained automatically include average amplitude, beat strength, and harmonicity. Average amplitude is just a measure of the audio energy within each short time window, say, 10 ms. A histogram of amplitude values or just the standard deviation can tell whether the music stays mainly at the same level, typical of popular music, or has a wide dynamic range, typical of classical music. The beat strength is a measure of whether amplitude variations tend to be periodic or not. A measure of tempo and tempo variation might be even more useful, but tracking tempo reliably is a difficult problem. Harmonicity is an indication of how well the spectrum can be modeled as a set of harmonically related partials. Harmonic spectra arise from single tones or sets of harmonically related tones. Harmonicity may also be viewed as periodicity in the frequency domain.

All of these features help to capture audio qualities that give clues about genre. "Genre" is not a very specific term, so "genre classifiers" are also useful for other tasks. Depending on the training set, a genre classifier can be trained to recognize genre [17], recognize different styles of dance music [6], find music "similar" to an example [2], or find music that I like as opposed to music I do not like. Classifiers are potentially useful for music search, but there is considerable interest in using classifiers and similarity metrics to create music recommendation services [8], generate playlists [11], and organize personal music libraries [16].

3.3.3 Markov Models

Many more techniques are available to model music and style when the data consists of discrete (or symbolic) notes as opposed to audio recordings. Discrete representations of music are generally in the form of a list of notes, where a note is a tuple consisting of pitch, starting time, duration, and loudness. Pitch is often represented using an integer representing the corresponding key on a piano, while time and duration can be represented either in terms of seconds or in beats. Other attributes are also possible. The Standard MIDI File format is a common example of a discrete music representation. Standard MIDI Files can be used to control music synthesizers, thus a MIDI file can be "played" on most computers [13].

An interesting way to think about style is to look for commonalities in discrete music data. One model, proposed by Alamkan, Birmingham, and Simoni [1], is the Markov Model applied to what these researchers call "concurrencies." A concurrency is a set of pitches and a duration. To extract concurrencies from music, the music is first segmented at every time point where a note begins or ends. (See Fig. 3.3) It follows that within a segment, some set of pitches is sounding, and the set does not change within the segment. (Otherwise, the segment would be divided further where the note starts or stops.) The space of all concurrencies is huge: it is $2^{|p|} \times |d|$, where $|p|$ is the number of possible pitches, and $|d|$ is the number of possible durations. In practice, a given piece of music will contain relatively few concurrencies, and due to repetition and similarity within a given composition, many concurrencies will occur often.

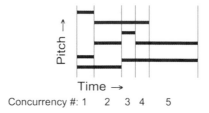

Fig. 3.3 "Piano-roll" depiction of music with concurrencies marked

Alamkan, Birmingham, and Simoni used Markov Models of concurrencies to model Beethoven and Mozart piano sonatas. A Markov Model is a set of states (in this case, each concurrency is a state) and transition probabilities. Transitions probabilities are estimated based on the number of actual transitions observed in a piano sonata or set of sonatas. A measure of similarity between Markov Models was developed. Using this approach, it can be shown that early Beethoven sonatas are more similar to Mozart sonatas than to late Beethoven sonatas. This is consistent with the music history view that Beethoven's early music is Classical (like Mozart) and his later works belong to the period known as "Romantic."

Markov Models can also be used for music *generation*. One approach is to simply follow transitions according to their probabilities, assembling the resulting sequence of concurrencies into a new composition. The resulting music is often strikingly good at the local level, because every transition is not only plausible but was used at least once in a master work. On the other hand, Markov Models have no higher-level sense of direction or form, so the music typically meanders without any sense of purpose.

3.3.4 Cope's Experiments in Musical Intelligence

One of the most successful attempts to capture and model Western musical styles is the work of David Cope referred to as EMI, or Experiments in Musical Intelligence [4]. A great deal has been written about this work by Cope and others, so we will give only a brief summary of the nature of this work.

One interesting idea in EMI is the use of short patterns of melody to represent the essence of what characterizes composers and compositions. Within a piece, recurring patterns tell us about themes and motives that are specific to the composition. When many compositions by the same composer are analyzed, we can discover patterns that are characteristic of the composer, especially if we first rule out the patterns that are specific to individual pieces. These "composer patterns" can be used as building blocks for a new piece in the style of the composer.

Another important idea in EMI is the use of Augmented Transition Networks, or ATNs, a type of formal grammar [18]. ATNs were originally developed to describe natural language, including not only grammatical syntax, but semantic constraints as well. In EMI, Augmented Transition Networks are used to guide the generation of music so that there is some global coherence, not just local plausibility as produced

by Markov Models. Overall, EMI works by reassembling patterns from example music to form new compositions that are stylistically similar.

Evaluation of this sort of work is very difficult. There are no standards to measure whether a piece is really in the style of some composer. For the most part, this work must be evaluated by subjective listening. Cope has set up a sort of "musical Turing test" where listeners are asked to rate a phrase as original Mozart or "artificial" Mozart. Many people are unable to distinguish the two, but experts seem to have little difficulty. A critic might argue that listeners are confused by the fact that at least fragments of what they hear really *were* composed by Mozart and only recombined to form the "artificial" Mozart examples. On the other hand, EMI shows that Mozart himself reuses small "composer patterns," so any convincing Mozartean music arguably *must* use these patterns.

The debate over computers, creativity, intelligence, and style is certainly not over. Cope makes the interesting point that "artificial" music composed by EMI sounds much more convincing when performed by humans. The next section explores some stylistic aspects of musical performance.

3.3.5 *Emotion and Expression in Music*

The previous sections on Markov Models and EMI examine style as an aspect of music composition. In those studies, we looked for style in the selection of pitches, rhythms, and their transitions and organization. At least with Western music, which is strongly tied to music notation, the notated "composition" is viewed as separate from the *interpretation* of the composition by a performer. Performance interpretations also have style. A performance is not a precise, mechanical rendition of the printed notes, which would sound very unmusical. A performer adds slight variations to tempo, loudness, note "shape" or articulation, slight pauses, vibrato, and many other details that are at best sketchy in the printed music. Through all these details, a performer brings life to the printed page.

Researchers have discovered that performance nuance can impart emotional meaning to music. Although we often think of a particular song as being happy or sad, it turns out that the performance has as much to do with the emotional impact as the composition. Given a "neutral" melody, one can perform the melody in such a way as to express joy, sadness, anger, or serenity, for example. Juslin and Sloboda [7] have published an excellent reference on emotion in music.

One of the more interesting findings is that computers can alter music performances to express different emotions. A good example is the work of Bresin and Friberg [3]. This work began with Sundberg's pioneering work on expressive music performance [15]. Sundberg studied how to make "musical" performances from music in standard notation. The input is assumed to be a discrete representation where note times and durations are quantized to exact beat boundaries, no tempo variation is indicated, and no loudness variation or note articulations are specified. In other words, the input contains the information that a human performer would encounter in ordinary printed music. The goal is to add variation in loudness and timing to make the performance more musical. To accomplish this, rules were

developed. For example, one rule says that if the melody leaps upwards, add a small pause before the leap. Another rule says that if the melody goes up by a run of small steps, the notes should get progressively faster and louder.

Getting back to emotion, at least one way to impart emotion to a performance is to change some overall performance parameters and also to change the weights on these performance rules. For example, to make music sound angry, increase the overall loudness, decrease note duration so that there is more space between notes, and decrease the effect of rules that vary tempo. To impart the feeling of fear, increase the effect of rules that vary tempo, and play the music slower and softer overall. There are many more rules, so these prescriptions only touch on a much larger set of carefully worked out rules and parameters.

To evaluate Bresin's results, listeners were asked to choose which of 6 emotions were strongest in different computer renditions of well-known folk songs. The renditions were generated automatically by Bresin's system. The human subjects were able to identify the "correct" emotions significantly above chance levels. With only simple and short folk melodies, it is not clear whether subjects truly felt these emotions or whether the "emotional intent" was recognized but not felt. Of course, the most interesting goal is to give computers the ability to create "real" emotion. There are plenty of opportunities for emotionally expressive music, especially in interactive settings such as video games. Even cell phone ring tones may some day be used to express the caller's emotion. It seems likely that future computer music systems will have the ability to give emotional performances.

3.4 Summary and Conclusion

As in other disciplines, *style* in music is used in many ways with many shades of meaning. A musical style can refer to a period in history, a composer, a performer, a texture, a genre, or an emotion. While style tends to include all those ill-defined characteristics that we cannot quite grasp, musical styles have been carefully studied, partly because style and subjective impressions are at the heart of musical communication. We saw in the comparison of Baroque and Classical styles that the differences can be described quite explicitly.

Style can be recognized and even learned by computer programs. We considered style and genre classifiers that use standard machine learning techniques to discriminate different styles on the basis of a wide range of features that can be computed from audio signals. Discrete representations have been used, for example with Markov models, to represent and compare musical styles. Markov models have shown some promise for stylistic music generation. Music patterns can be detected and recombined to "compose" music in the style of a particular composer, as illustrated by David Cope's EMI. Music can also be performed with consideration for style. For example, programs can perform melodies in ways that convey a wide range of emotions that are understood by human listeners.

Music analysis by computer is a very active research field, in part because of the enormous amounts of musical data being stored in databases and either sold or

shared over the Internet. This has motivated research that will allow computers to understand and compare music based on music *content* as opposed to titles, artist names, and other textual labels. In the future, we expect to see more computer applications that make use of music style for automatic music analysis, music search, and even music generation.

References

1. Alamkan C, Birmingham B, Simoni M (1999) Stylistic structures: an initial investigation of the stochastic generation of tonal music. University of Michigan, Technical Report CSE-TR-395–99
2. Berenzweig A, Logan B, Ellis D, Whitman B (2004) A large-scale evaluation of acoustic and subjective music similarity measures. Comput Music J 28(2):63–76
3. Bresin R, Friberg A (2000) Emotional coloring of computer-controlled music performance. Comput Music J 24(4):44–62
4. Cope D (1991) Computers and musical style. (The computer music and digital audio series, 6.) A-R Editions, Middleton, WI
5. Dannenberg RB, Thom B, Watson D (1997) A machine learning approach to musical style recognition. In: 1997 international computer music conference. International computer music association, San Francisco, CA, pp 344–347
6. Dixon S, Pampalk E, Widmer G (2003) Classification of dance music by periodicity patterns. In: 4th international conference on music information retrieval (ISMIR 2003), Baltimore, MD, pp 159–165
7. Juslin PN, Sloboda JA (2001) Music and emotion. Oxford University Press, London
8. Magno T, Sable C (2008) A comparison of signal-based music recommendation to genre labels, collaborative filtering, musicological analysis, human recommendation, and random baseline. In: ISMIR 2008, Proceedings of the 9th international conference on music information retrieval, Philadelphia, PA, pp 161–166
9. Merriam-Webster (2007) Merriam-Webster Online. http://www.m-w.com/dictionary/style. Accessed 26 Nov 2008
10. Mitchell T (1997) Machine learning. McGraw Hill, New York
11. Pauws S, Eggen B (2002) PATS: realization and user evaluation of an automatic playlist generator. In: Proceedings of the 3rd international conference on music information retrieval (ISMIR'02), Paris, pp 222–230
12. Perrot D, Gjerdigen R (1999) Scanning the dial: an exploration of factors in identification of musical style (abstract only). In: Proceedings of the society for music perception and cognition, Evanston, IL, p 88
13. Rothstein J (1995) MIDI: a comprehensive introduction, 2nd edn. A-R Editions, Middleton, WI
14. Sadie S, Tyrell J (2001) The new grove dictionary of music and musicians, 2nd edn. Oxford University Press, Oxford
15. Sundberg J (1988) Computer synthesis of music performance. In: Sloboda JA (ed) Generative processes in music. The psychology of performance, improvisation, and composition. Clarenden, Oxford, pp 52–69
16. Torrens M, Hertzog P, Arcos JL (2004) Visualizing and exploring personal music libraries. In: 5th international conference on music information retrieval, Barcelona, pp 421–424
17. Tzanetakis G, Cook P (2002) Musical genre classification of audio signals. IEEE Trans Speech Audio Process 10(5):293–302
18. Woods WA (1970) Transition network grammars for natural language analysis. Commun ACM 13(10):591–606

Chapter 4
Generating Texts in Different Styles

Ehud Reiter and Sandra Williams

Abstract Natural Language Generation (NLG) systems generate texts in English and other human languages from non-linguistic input data. Usually there are a large number of possible texts that can communicate the input data, and NLG systems must choose one of these. This decision can partially be based on style (interpreted broadly). We explore three mechanisms for incorporating style into NLG choice-making: (1) explicit stylistic parameters, (2) imitating a genre style, and (3) imitating an individual's style.

4.1 Introduction

Natural Language Generation (NLG) systems are computer systems that automatically generate texts in English and other human languages, using advanced techniques from artificial intelligence and/or computational linguistics. In this chapter we focus on NLG systems whose goal is to present, summarise, or explain non-linguistic input data to users (the generation of poetry and other fictional material is discussed by Goguen and Harrell in Chap. 11). Example applications include generating textual weather forecasts from numerical weather prediction data [10, 25]; producing descriptions of museum artefacts from knowledge bases and databases that describe these artefacts [19]; providing information for medical patients based on their medical records [7, 8]; and creating explanations of mathematical proofs based on the output of a theorem prover [13].

The challenge of NLG is making choices about the content and language of the generated text. Considering content, for example, how much detail should a weather forecast text go into (e.g., *Sunday will be wet* or *There will be heavy rain on Sunday afternoon*); and considering language, should a weather forecast be in normal English or abbreviated "weatherese" (e.g., *There will heavy rain on*

E. Reiter (✉)
Department of Computing Science, University of Aberdeen, Aberdeen, UK
e-mail: e.reiter@abdn.ac.uk

S. Argamon et al. (eds.), *The Structure of Style*,
DOI 10.1007/978-3-642-12337-5_4, © Springer-Verlag Berlin Heidelberg 2010

Sunday afternoon or *Heavy rain on Sunday afternoon*). Sometimes these choices can be explicitly based on usefulness criteria; for example content choices can be motivated on the basis of user needs (e.g., farmers typically need more detailed information than lorry drivers), and linguistic choices can be motivated by readability considerations (e.g., short common words are usually read more quickly than long unusual words). But usually explicit usefulness criteria can only motivate some of the choices an NLG system must make; we need other criteria for making the remaining choices.

In this chapter we suggest that many NLG choices can be made on the basis of *style*, by which we mean the expectations or preferences of a particular user and/or document genre. There are many similarities between our analysis and and Dannenburg's discussion of style in music in Chap. 3; many of the detailed decisions in both textual and musical composition reflect the idiosyncrasies of an individual person and/or genre.

We focus here on how style can influence linguistic choices, because these are better understood than content choices. In particular, we present three techniques that have been used in NLG to adjust generated texts according to individual or genre characteristics: giving users explicit control over features of the generated text (so they can make it conform to their preferences); generating texts which are similar to a corpus of human-written texts in a particular genre; and generating texts which imitate the writing style of a specific individual. Our emphasis is on choices that affect words, syntax, and sentences; we do not discuss visual aspects of text such as layout [6].

A major problem with all of the above techniques is acquiring the necessary knowledge about the typical choices of a particular user, genre, or individual writer. Some information about these choices can be acquired using the computational stylistics techniques developed to analyse texts (for example, the author identification techniques discussed by Argamon and Koppel in Chap. 5), but unfortunately feature sets which are adequate for identifying an author are usually inadequate for reproducing his or her style. For example, we may be able to identify an author on the basis of frequency of function words, but an NLG choice-making system needs much more information than just function word frequency.

4.2 SkillSum

In order to make the following discussion concrete, we will use examples from SKILLSUM [32], an NLG system which was developed by Aberdeen University and Cambridge Training and Development Ltd (now part of Tribal Group). SKILLSUM generates feedback reports for people who have just taken an on-line screening assessment of their basic literacy and numeracy skills. The input to the system is the responses to the questions in the assessment (an example assessment question is shown in Fig. 4.1), plus some limited background information about the user (self-assessment of skills, how often he/she reads and writes, etc). The output is a short report (see example in Fig. 4.2), which is intended to increase the user's

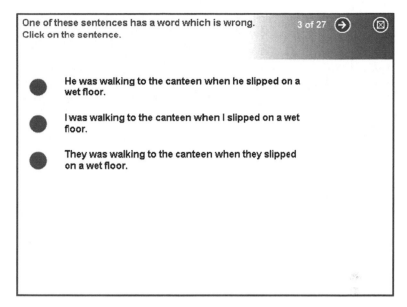

Fig. 4.1 Example SkillSum assessment question

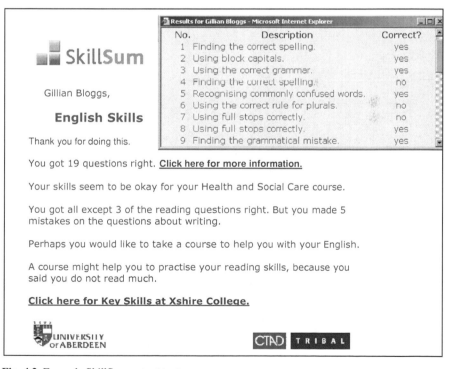

Fig. 4.2 Example SkillSum output text

knowledge of any problems that he or she has, and (if appropriate) encourage the user to enrol in a course to improve his or her basic skills.

SKILLSUM, like most NLG systems, must perform three basic tasks [22]: decide on content and structure (document planning), decide how information should be expressed linguistically (microplanning), and generate an actual text based on the above decisions which is linguistically correct (realisation). Briefly (see architectural description in Fig. 4.3):

- *Document planning:* SKILLSUM uses schemas [17] to choose content. That is, it chooses content by applying a set of rules which were originally devised by analysing and "reverse engineering" a set of human-written feedback reports, and which were then revised in accordance with feedback from domain experts (basic-skills tutors) and also from a series of pilot experiments with users [30].
- *Microplanning:* SKILLSUM uses a constraint-based approach to make expression choices. The SKILLSUM microplanner has a set of hard constraints and a preference function [31]. The hard constraints specify which choices and which combinations of choices are linguistically allowed. The preference function rates the choice sets; SKILLSUM chooses the highest scoring choice set allowed by the hard constraints. As discussed below, style seems especially useful in the context of the SKILLSUM preference function.
- *Realisation:* SKILLSUM includes two realisers, one of which one operates on deep syntactic structures [15] and the other on template-like structures

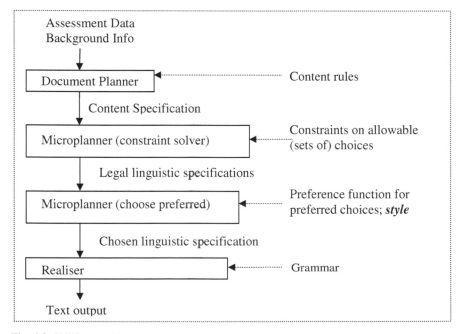

Fig. 4.3 SkillSum architecture

In this chapter we focus on microplanning, as this is where many NLG systems make linguistic choices. To take a simple example of microplanning, suppose that the SKILLSUM document planner has decided to tell a user that he got 20 questions right on the assessment, and that this is a good performance. A few of the many ways of saying this are:

- *You scored 20, which is very good.*
- *You scored 20. This is very good.*
- *You got 20 answers right! Excellent!*
- *Excellent, you got 20 answers right!*
- *20 questions were answered correctly; this is a very good score.*

The above examples illustrate some of the choices that are made in the microplanning process:

- *Lexical choice:* Which words should be used to communicate information? For example, should the first verb be *scored, got,* or *answered*?
- *Aggregation:* How should information be distributed among sentences? For example, should the above information be communicated in one sentence or in two sentences?
- *Ordering:* What order should information be communicated in? In the above example, should the numerical score (*20*) or the qualitative assessment (e.g., *excellent*) come first?
- *Syntactic choice:* Which syntactic structures should be used? For example, should sentences have active voice (e.g., *You answered 20 questions ...*) or passive voice (e.g., *20 questions were answered ...*).
- *Punctuation:* For example, should full stops (".") or exclamation points ("!") be used?

The above list is of course not exhaustive; for example it does not include deciding on referring expressions (e.g., *The big dog* vs. *Fido* vs. *it*), which is not very important in SKILLSUM, but it is in many other NLG applications. Also it does not include content choices made by the document planner, such as the decision to give the user a numerical score.

4.3 Using Style to Make Microplanning Choices

One appealing way to make decisions about lexical choice, aggregation, and so forth is to appeal to psycholinguistic knowledge about the impact of texts on readers. For example, if an NLG system is trying to generate texts which are very easy to read (as was the case with SKILLSUM), it would be nice to base choices on psycholinguistic models of the impact of different words, sentence lengths, and so forth on reading speed and comprehension [11]. Similarly, if an NLG system is trying to generate texts which motivate or persuade people as did STOP [23], which generated

personalised smoking-cessation letters, it seems logical to base these choices on psycholinguistic models of how texts motivate and persuade people.

Unfortunately, our knowledge of psycholinguistics is not detailed enough to serve this purpose. Also in practice context (such as how much sleep the reader had the previous night) can affect the psycholinguistic impact of different choices; and such contextual knowledge is usually not available to NLG systems. SKILLSUM in fact tried to base some of its choices on psycholinguistic models of readability, and while this worked to some degree, overall this strategy was less effective than we had hoped.

Another way to make choices is to look at frequency in large general English corpora, such as the British National Corpus (BNC) (http://www.natcorp.ox.ac.uk/) or one of the newspaper article corpora distributed by the Linguistic Data Consortium. Such corpora play a prominent role in much current research in Natural Language Processing.

For example, the average length of sentences in the BNC is 16 words. Hence we could base aggregation decisions on sentence length; for example we could say that two pieces of information should be aggregated and expressed in one sentence if and only if this aggregation brings average sentence length closer to 16 words/sentence. Of course aggregation decisions must consider other factors as well, such as semantic compatibility (for example, *John bought a radio and Sam bought a TV* is better than *John bought a radio and Sam bought an apple*).

A perhaps more basic problem is that rules based on a corpus which combines many types of texts intended for many audiences, such as the BNC, may not be appropriate for the context in which a specific NLG system is used. For example, because SKILLSUM users are likely to have below-average literacy skills, they should probably get shorter sentences than is normal; indeed SKILLSUM sentences on average are only 10 words long.

Another problem with relying on a general corpus such as the BNC is that in many contexts there are strong conventions about choices, and these should be respected. For example, one version of SKILLSUM generated reports for teachers instead of for the people actually taking the test, and this version referred to test subjects as *learner*, because this is the standard term used by adult literacy tutors to refer to the people they are teaching. The perhaps more obvious word *student* is much more common in the BNC (it occurs 16 times more often than *learner*), and probably would be used in texts which used choice rules based on BNC frequency; but this would be a mistake, because teachers in this area have a strong convention of using the word *learner* instead of the word *student*.

Hence a better alternative is to try to imitate the choices made in a corpus of human-authored texts which are intended to be used in the same context as the texts we are trying to generate. This can be done in two ways: we can either collect a corpus of texts written by *many* authors and representative of human-authored texts in this domain, or we can collect a corpus of texts from a *single* author, perhaps someone we believe is a particularly effective writer. In other words, we can try to imitate the *style* of texts in the genre as a whole, or the *style* of a particular individual author.

Yet another approach to making microplanning choices is to allow the reader to directly control these choices. In practice this seems most successful if choices are presented to the user as *stylistic* ones, such as level of formality.

These approaches are summarised in Table 4.1.

Table 4.1 Three ways of using style to control choices in NLG

Explicit control	Allow the user to specify the choices that she prefers
	Choices are usually presented as stylistic ones
Conform to genre	Imitate the choices made in a corpus of genre texts
Imitate individual	Imitate the choices made by an individual writer

4.4 Style 1: Explicit Stylistic Control

Perhaps the most obvious solution to the choice problem is to allow users to directly control some stylistic parameters when they run the generator. After all, software that presents information graphically usually gives users many customisation options (colours, fonts, layout, etc), so why not similarly give users customisation options for linguistic presentations of information?

It is not feasible to ask users to directly specify microplanning choice rules, because there are too many of them; for example, SKILLSUM has hundreds of different constraints, and its preference functions contain dozens of components. Hence users are usually asked to specify a few high-level parameters which the NLG system then takes into consideration when making the actual low-level microplanning choices.

For example, rather than directly specify aggregation rules, a SKILLSUM user could specify a preferred average sentence length (either numerically or via a linguistic term such as *short, medium,* or *long*). This length could be used by the aggregation system as described above (Sect. 4.3). Similarly, rather than specify specific lexical choice rules for individual concepts, the user could specify whether he wants informal, moderately formal, or very formal language; whether he prefers common words with many meanings (such as *got*) or less common words with fewer meanings (such as *answered*); and so forth. These general preferences could then be examined by SKILLSUM's detailed lexical choice rules. Such general preferences are usually perceived by users as *stylistic* preferences.

This approach was used in the ICONOCLAST system [21]. ICONOCLAST users could specify a number of high-level parameters, such as paragraph length, sentence length, and pronominalisation, by manipulating slider bars in a graphical user interface; see Fig. 4.4 for an example. ICONOCLAST varied the style of the output by searching for solutions to a constraint satisfaction problem formulated from lower-level parameters and solutions were ordered according to a cost function derived from a user's slider bar selections. ICONOCLAST also grouped style preferences into higher-level style profiles such as "broadsheet" and "tabloid", which users could select.

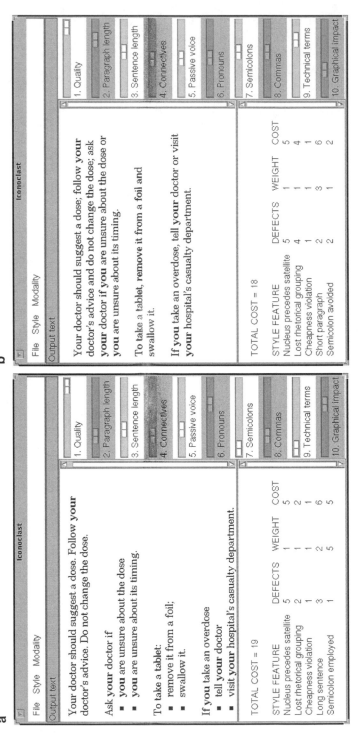

Fig. 4.4 User control examples from Iconoclast (from www.itri.brighton.ac.uk/projects/iconoclast/walk/trial.html)

A key question with this type of interface is the level of detail at which stylistic information should be specified by users; is it reasonable to expect users to specify values for parameters such as sentence length, or is it better to ask them to select from higher-level concepts such as "tabloid", or indeed for more detailed information about specific microplanning choices? This is a human-computer interaction question, which can only be answered by detailed user studies (ideally studies which involve different types of users). Unfortunately, to the best of our knowledge no such studies have yet been done.

In the case of SKILLSUM, although some of its internal choice rules did refer to general preferences such as frequency vs. number of meanings, SKILLSUM users were not allowed to directly specify these. Instead, the developers refined the rules and preferences in accordance with feedback and suggestions from literacy teachers and students. In other words, users requested changes from a developer instead of directly controlling the system [27]. This is not ideal, but it meant we did not have to deal with user-interface issues. Also it made SKILLSUM easier to debug, as we did not need to ensure that it would generate appropriate texts for any values of the stylistic preferences, no matter how bizarre.

From an algorithmic perspective, both ICONOCLAST and SKILLSUM incorporated user-specified stylistic preferences into a preference function which was used by the microplanner to make specific decisions. Another approach was used by WebbeDoc [9] which, like ICONOCLAST, allowed users to specify values of stylistic parameters using a GUI. WebbeDoc used the user-specified preferences to select and adapt material from a manually-authored Master Document, which specified different ways in which information could be expressed linguistically.

Yet another approach was taken by Paiva and Evans [20], who based their stylistic features on factor analysis of texts [5], instead of on features which were intuitively meaningful to users. This analysis produced two dimensions; the first seemed to capture whether texts involved the reader or were distant from the reader, and the second focused on the type of references used (e.g., pronouns or full noun phrases). Paiva and Evans then built an NLG system which could produce texts with user-specified values of their two dimensions. This system was based on a model of how individual microplanner choices affected these dimensions; this model was created by statistically analysing the ratings (in the two dimensions) of texts generated with random microplanner choices.

It is unfortunate that ICONOCLAST, WebbeDoc and Paiva and Evan's system were not properly evaluated by users. Without such an evaluation, it is difficult to know which approach is most promising for producing appropriate texts, and which stylistic features users are willing to specify.

4.5 Style 2: Conform to a Genre

Another approach to making choices is to imitate a corpus written for a particular genre. As mentioned above, imitating a very general corpus such as the BNC is problematical because it contains documents from a variety of different domains

and genres that were written for a variety of different audiences. If it is important that generated texts conform to a genre (which is often the case), an alternative is to analyse a corpus of human-written texts in the target genre; learn the words, syntactic structures, and so forth that human writers select in the genre; and program the NLG system to imitate those choices.

4.5.1 Genre Modelling with Manual Corpus Analysis

This imitation can be done in a number of different ways. In particular, we can manually analyse the corpus and extract choice rules from it; we can automatically extract choice rules using statistical corpus analysis and statistical generation techniques; or we can use a combination of these techniques. In some cases it may even be possible to extract rules directly from published style guidelines, such as those used by newspapers (e.g., www.guardian.co.uk/styleguide). Most of these guidelines are probably too vague to be of much use to NLG, but there are some exceptions which are more detailed, such as AECMA Simplified English [1].

For example, when building SKILLSUM we collected a small corpus of 18 human-written feedback reports; these were written by two tutors (one of whom specialised in literacy and one in numeracy). We analysed it, mostly by hand (since the corpus was quite small), primarily to create hard constraints for SKILLSUM's microplanner. In other words, we tried to get SKILLSUM to generate appropriate genre texts by only allowing it to make choices which we observed in the corpus.

To take a concrete example, the corpus texts used the verbs *scored*, *answered*, and *got* (e.g., *you answered 20 questions correctly*); but they did not use the verbs *responded* (e.g., *you responded to 20 questions correctly*) or *aced* (e.g., *you aced 20 questions*). Hence a hard constraint on SKILLSUM is that it should not use *responded* or *aced*. In a sense, this suggests that SKILLSUM reports should be moderately formal; and if style was being explicitly specified as in Sect. 4.4, then this level of formality might be explicitly specified. But in the genre-corpus approach we don't specify such high-level stylistic parameters such as level of formality; instead, we directly specify low-level choices such as which verbs can be used when communicating numerical performance on an assessment.

In a few cases we allowed SKILLSUM to deviate from the corpus; but this often proved ill-advised. For example, we programmed SKILLSUM to use *right* instead of *correct* or *correctly*, for example *you got 20 questions right* instead of *you got 20 questions correct*. We did this because *right* is much more common in the BNC, and hence we thought it would be easier to read. Although the tutors agreed that *right* could be used, when we asked 25 students enrolled in a literacy course about this choice, 23 (92%) preferred *correct* over *right*, and 24 (96%) preferred *correctly* over *right*. This suggests that allowing SKILLSUM to use a word which was not in the corpus, at least in this example, was a mistake.

Of course the SKILLSUM microplanner needs a preference function (to choose between allowable options) as well as hard constraints (to say which options should

be considered). In theory preferences between choices can be specified by looking at frequencies, but this is more controversial. For example, in the SKILLSUM corpus *scored* is more common than *answered* or *got*, so *scored* should be preferred under a pure frequency-based metric. However, frequencies are not always a good guide [25], because they may reflect the writing habits and preferences of a few individual corpus authors. In fact, *scored* was only used in reports written by one tutor, but it has the highest frequency because this tutor contributed the most texts to the SKILLSUM corpus. Hence in this case corpus frequency is really telling us about the linguistic preferences of the biggest contributor to the corpus; as we have no a priori reason to believe that this person is a better writer than the other corpus contributor, we need to interpret corpus frequency with caution.

Perhaps the most ambitious attempt to create genre-tailoring rules based on manual corpus analysis was Pauline [12]. Figure 4.5 shows two texts produced by Pauline, one formal and the other informal. These differ in numerous ways, including lexical choice, syntactic choice, use of pronominal referring expressions and aggregation. Although Pauline's output is very impressive, it relied on extensive hand-crafted knowledge bases which only covered a few scenarios. It would be difficult to build a system based on Pauline's approach which could robustly handle any plausible input data set in a realistic application domain.

Formal text

In early April, a shantytown – named Winnie Mandela City – was erected by several students on Beinecke Plaza, so that Yale University would divest from companies doing business in South Africa.
Later, at 5:30 am on April 14, the shantytown was destroyed by o cials; also, at that time, the police arrested 76 students. Several local politicians and faculty members expressed criticism of Yale's action. Finally, Yale gave the students permission to reassemble the shantytown there and, concurrently, the University announced that a commission would go to South Africa in July to investigate the system of apartheid.

Informal text

Students put a shantytown,Winnie Mandela City, up on Beinecke Plaza in earlyApril. The students wanted Yale University to pull their money out of companies doing business in South Africa.
O cials tore it down at 5:30 am on April 14, and the police arrested 76 students. Several local politicians and faculty members criticised the action. Later, Yale allowed the students to put it up there again.The University said that a commission would go to South Africa in July to study the system of apartheid.

Fig. 4.5 Formal and informal texts from Pauline (Hovy, 1990)

4.5.2 Genre Modelling with Machine Learning and Statistics

In terms of methodology, SKILLSUM and Pauline were based on manual inspection of a corpus. Another possibility is to use machine learning techniques to automatically create rules or decision trees from a corpus; these can then be manually

inspected by developers, who can modify the rules if necessary. This approach was used in SUMTIME [25], which generated weather forecasts. SUMTIME's microplanning rules (which focused on lexical choice, aggregation, and ellipsis) were based on careful analysis of a corpus of human-authored weather forecasts. Although most of these analyses were initially done using machine learning or statistical techniques, the rules suggested by the analyses were examined by developers and discussed with domain experts before they were added to the system [26]. This was especially important in cases where the corpus analysis showed that there was considerable variation in the different choices that individuals made; feedback from domain experts in such cases helped us decide which choice was most likely to be appropriate for the largest number of readers. An evaluation with forecast users showed that the texts produced by SUMTIME were very good, indeed in some cases they were perceived as being better than the human-written texts in the corpus.

Genre-specific microplanning rules can also be produced purely by machine learning and statistical analysis techniques, without having rules inspected by human developers or domain experts. This approach was used by Belz [2], who reimplemented some of SUMTIME's functionality using a pure learning approach. An obvious advantage of this approach is that it is cheaper, since less human input is needed. Another advantage is that the rules do not have to be understandable by humans, as is the case with SUMTIME's semi-automatic approach. However, a disadvantage is that developers, domain experts, and users cannot suggest that rules be modified in accordance with their experience. An evaluation that compared Belz's system, SUMTIME, and the human-written corpus texts [3] suggested that SUMTIME's texts were on the whole better than Belz's texts, but Belz's texts were still quite good and in particular were sometimes better than the human-written corpus texts.

Perhaps the biggest problem we have faced in using machine learning techniques (whether semi-automatic or fully automatic) to learn microplanning choices in our NLG projects is obtaining a sufficiently large corpus. Although a few NLG systems such as SUMTIME generate texts which were previously written by humans, it is more common for NLG systems to generate texts which are not currently manually written. In such cases it is not possible to get large corpora of naturally-occurring texts. In principle, one could analyse the microplanning choices made in related naturally-occurring texts, but this would require knowing which microplanning choices observed in the related texts could be applied to the NLG texts, and which could not.

In the SKILLSUM context, for example, domain experts (tutors) do not currently write reports about the results of assessments, instead they orally discuss results with their students. We could in principle obtain a corpus of transcripts of discussions about assessments between tutors and students, and use learning and statistical techniques to analyse the choices made in the transcripts. But this is of limited utility unless we know which microplanning choices observed in the oral transcripts are also appropriate for written reports (lexical choice?), and which are not (aggregation?).

In other words, it would be much easier to use machine learning techniques to learn microplanning choices if we had a good understanding of which choices were stable across "substyles" in a genre and which were not. Unfortunately, little currently seems to be known about this topic.

4.6 Style 3: Imitate a Person

A final style-related approach to making linguistic decisions is to imitate either an individual *author*'s style, or to imitate the style of the texts that an individual *reader* prefers.

4.6.1 Imitate an Author

As mentioned above, one problem with imitating a multi-author corpus is that different authors have different preferences (in other words, different styles). Hence the frequencies in a corpus may reflect the choices of only a few authors who contributed the most texts rather than the consensus choice, as mentioned above. Also, if the system selects the most frequent choice every time, this may lead to inconsistencies which users dislike, essentially because it will mix the styles of multiple authors [26].

An alternative is to try to imitate the linguistic choices made by a single person, perhaps someone who is known to be an effective writer in this genre. Imitating a single author increases consistency between choices, and also is likely to increase the quality of the generated texts if this person is an exceptionally good writer. However, a corpus from one individual is likely to be smaller and have worse linguistic coverage than a corpus with contributions from many people. Also, very good writers are likely to be very busy, which can make it difficult to discuss style issues directly with them.

SKILLSUM partially followed this approach when making decisions about content. More precisely, SKILLSUM generates two kinds of reports, literacy and numeracy, and the SKILLSUM corpus contains reports from two authors, of whom one is a literacy expert and the other one is a numeracy expert. When making some high-level decisions about the content of SKILLSUM's literacy reports, we tended to favour the choices made in the texts written by the literacy tutor; similarly we used the numeracy tutor's preferences when making choices about SKILLSUM's numeracy reports.

McKeown, Kukich. and Shaw [18] used this approach when building PlanDoc, an NLG system which produced summaries of the results of a simulation of changes to a telephone network. They interviewed a number of people to establish the general requirements of PlanDoc, but they asked a single very experienced domain expert to write all of the texts in their corpus. They do not give details of how they analysed

and used the corpus, but it seems to have been a manual analysis rather than one based on learning or statistical techniques.

4.6.2 Imitate the Style of the Texts That a Reader Prefers

Another approach to individual style is to try to imitate the style of the texts that a *reader* likes to read—that is, to ask the reader to choose between texts written in different styles, and generate the style that the reader prefers. Different people have different preferences. For example, some people may prefer texts with many pronouns, while others prefer texts with more explicit references (perhaps because of differences in their working memories [14]). We could directly ask people about their preferences, as discussed in Sect. 4.4. However this approach is limited in that many people will probably not be aware of the linguistic implications of their style preferences, nor may they be willing to explicitly specify more than a small number of preferences.

Perhaps the most advanced work in this area is that of Walker and her colleagues [29]. They asked users to explicitly rate 600 texts generated by their NLG system with random microplanning choices. They employed learning techniques to determine which sets of microplanning choices produced texts preferred by each user, and from this created a preference model for each user, which predicted how users would rank texts produced with different microplanner choices. Figure 4.6 shows examples of preferred texts for different users. Their experiments suggested that users did indeed prefer texts generated using their personal preference models. Walker et al. also commented that they believed reasonable individual choice models could be extracted from ratings of 120 texts, and getting this number of ratings is probably more realistic than getting 600 ratings from each user.

Walker et al. did not really consider lexical preferences, which is a shame because we know that there are substantial differences in the meanings that different individuals associate with words [24]. This has been reported in many contexts, including weather forecasts [25], descriptions of side effects of medication [4], and interpretation of surveys [28]. It was also an issue in SKILLSUM. For example, while developing SKILLSUM we asked 25 people enrolled in a literacy course to tell us what kind of mistake occurred in the sentence *I like apple's* (instead of *I like apples*).

Preferred text according to User A choice model:
Chanpen Thai is a Thai restaurant, with good food quality. It has good service. Its price is 24 dollars. It has the best overall quality among the selected restaurants.

Preferred text according to User B choice model:
Chanpen Thai has the best overall quality among the selected restaurants since it is a Thai restaurant, with good service, its price is 24 dollars, and it has good food quality.

Fig. 4.6 Texts generated from different personal preference models (Walker et al., 2007)

72% said this was a *punctuation* mistake but 16% said this was a *grammar mistake* (the rest didn't think there was anything wrong with this sentence).

Perhaps the key problem in doing this kind of tailoring is getting sufficient data about the individual; how do we actually find out how he or she uses words? If we only need data about a small number of lexical choices, then we could use an approach similar to Walker et al.; but this is unlikely to be feasible if we need information about many different lexical choices.

An alternative approach might be to analyse a large corpus of texts that the user has written, on the assumption that the style used in texts the user writes is similar to the style preferred by the user in texts that he or she reads. Lin [16] looked at one aspect of this in her investigation of distributional similarities of verbs in a corpus of cookery writing to find alternatives for how different recipe authors expressed the same concept (e.g., "*roast* the meat in the oven" vs. "*cook* the meat in the oven"). To the best of our knowledge larger-scale investigations of more comprehensive sets of style choices have not yet been tried; one concern is that many people (including most SKILLSUM users) do not write much, which would make it difficult to collect a reasonable corpus of their writings.

Data-scarcity becomes an even larger problem if we want to create models of individual linguistic preferences in specific genres. Ideally we would like not just a fixed set of linguistic preferences for a particular individual, but rather a mechanism for creating preference rules that express how text should be written for a particular individual in a specific genre. Again we are not aware of any existing research on this issue.

4.7 Research Issues

As should be clear from the above, there are numerous research issues in this area that can be explored, for both technological reasons (building better NLG systems) and scientific reasons (enhancing our understanding of style). A *few* of these challenges are:

- *Explicit stylistic controls:* What stylistic controls make sense to human users, and how can these be "translated" into the very detailed choices and preferences that control NLG microplanners?
- *Conformity to a genre:* How are rules derived from a genre corpus most likely to differ from rules derived from a general corpus? In other words, how do genre texts actually differ from non-genre texts? Are there rules which are unlikely to vary, and hence could be derived from a general corpus?
- *Individual stylistic models:* How can we get good data about an individual's language usage and preferences? What aspects of language usage are most likely to vary between individuals? How can we combine a (non-user-specific) genre language model with a (non-genre specific) individual language model?
- *Impact of style:* Generated texts can be evaluated in many different ways, including preference (e.g., do people like a text), readability (e.g., how long does it take

to read a text), comprehension (e.g., how well do people understand a text), and task effectiveness (e.g., how well does a text help a user to do something). Which of these measures is most (and least) affected by adding stylistic information to an NLG system?

To conclude, we believe that style is an important aspect of generating effective and high-quality texts, and we are very pleased to see that an increasing number of NLG researchers are investigating style-related issues, and an increasing number of computational stylistics researchers are interested in NLG. We hope this research will lead to both better NLG systems, and also to a deeper scientific understanding of style in language.

Acknowledgements We would like to thank our colleagues in Aberdeen and Milton Keynes, the anonymous reviewers, and the tutors we worked with in SKILLSUM for their insightful comments and suggestions. We also thank the attendees of the AISB 2008 Symposium on "Style in Text: Creative Generation and Identification of Authorship" (where we presented an earlier version of this paper) for their help and suggestions. This work was funded by PACCIT-LINK grant ESRC RES-328-25-0026.

References

1. AECMA (1986) A guide for the preparation of aircraft maintenance documentation in the international aerospace maintenance language. BDC Publishing Services, Slack Lane, Derby
2. Belz A (2005) Statistical generation: three methods compared and evaluated. In: Proceedings of ENLG-2005, Aberdeen, pp 15–23
3. Belz A, Reiter E (2006) Comparing automatic and human evaluation of NLG systems. In: Proceedings of EACL-2006, Trento, pp 313–320
4. Berry D, Knapp P, Raynor T (2002) Is 15 percent very common? Informing people about the risks of medication side effects. Int J Pharm Pract 10:145–151
5. Biber D (1988) Variation across speech and writing. Cambridge University Press, Cambridge, MA
6. Bouayad-Agha N, Scott D, Power R (2001) The influence of layout on the interpretation of referring expressions. In: Degand L, Bestgen Y, Spooren W, van Waes L (eds) Multidisciplinary approaches to discourse. Stichting Neerlandistiek VU Amsterdam and Nodus Publikationen, Munster, pp 133–141
7. Buchanan B, Moore J, Forsythe D, Carenini G, Ohlsson S, Banks G (1995) An interactive system for delivering individualized information to patients. Artif Intell Med 7:117–154
8. Cawsey A, Jones R, Pearson J (2000) The evaluation of a personalised health information system for patients with cancer. User Model User-Adapt Interact 10:47–72
9. DiMarco C, Hirst G, Hovy EH (1997) Generation by selection and repair as a method for adapting text for the individual reader. In: Proceedings of the workshop on flexible hypertext, 8th ACM international hypertext conference, Southampton, NH
10. Goldberg E, Driedger N, Kittredge R (1994) Using natural-language processing to produce weather forecasts. IEEE Expert 9(2):45–53
11. Harley T (2001) The psychology of language, 2nd edn. Psychology, Hove
12. Hovy E (1990) Pragmatics and natural language generation. Artif Intell 43:153–198
13. Huang X, Fiedler A (1997) Proof verbalization as an application of NLG. In: Proceedings of IJCAI-1997, vol 2. Nagoya, pp 965–972

14. Just M, Carpenter P (1992) A capacity theory of comprehension: individual differences in working memory. Psychol Rev 99:122–149
15. Lavoie B, Rambow O (1997) A fast and portable realizer for text generation. In: Proceedings of the 5th conference on applied natural-language processing (ANLP-1997), Washington, DC, pp 265–268
16. Lin J (2006) Using distributional similarity to identify individual verb choice. In: Proceedings of the 4th international natural language generation conference, Sydney, pp 33–40
17. McKeown K (1985) Text generation. Cambridge University Press, Cambridge, MA
18. McKeown K, Kukich K, Shaw J (1994) Practical issues in automatic document generation. In: Proceedings of ANLP-1994, Stuttgart, pp 7–14
19. O'Donnell M, Mellish C, Oberlander J, Knott A (2001) ILEX: an architecture for a dynamic hypertext generation system. Nat Lang Eng 7:225–250
20. Paiva D, Evans R (2005) Empirically-based control of natural language generation. In: Proceedings of the 43rd annual meeting of the association for computational linguistics (ACL'05). Association for Computational Linguistics, Ann Arbor, MI, pp 58–65
21. Power R, Scott D, Bouayad-Agha N (2003) Generating texts with style. In: Proceedings of the 4th international conference on intelligent text processing and computational linguistics (CICLing'03), Mexico City, pp 444–452
22. Reiter E, Dale R (2000) Building natural language generation systems. Cambridge University Press, Cambridge, MA
23. Reiter E, Robertson R, Osman L (2003) Lessons from a failure: generating tailored smoking cessation letters. Artif Intell 144:41–58
24. Reiter E, Sripada S (2002) Human variation and lexical choice. Comput Linguist 28:545–553
25. Reiter E, Sripada S, Hunter J, Yu J (2005) Choosing words in computer-generated weather forecasts. Artif Intell 167:137–169
26. Reiter E, Sripada S, Robertson R (2003) Acquiring correct knowledge for natural language generation. J Artif Intell Res 18:491–516
27. Reiter E, Sripada S, Williams S (2003) Acquiring and using limited user models in NLG. In: Proceedings of 2003 European natural language generation workshop, Budapest, pp 87–94
28. Schober M, Conrad F, Fricker S (2004) Misunderstanding standardized language in research interviews. Appl Cogn Psychol 18:169–188
29. Walker M, Stent A, Mairesse F, Prasad R (2007) Individual and domain adaptation in sentence planning for dialogue. J Artif Intell Res 30:413–456
30. Williams S, Reiter E (2005) Deriving content selection rules from a corpus of non-naturally occurring documents for a novel NLG application. In: Proceedings of corpus linguistics workshop on using corpora for NLG, Birmingham
31. Williams S, Reiter E (2005) Generating readable texts for readers with low basic skills. In: Proceedings of ENLG-2005, Aberdeen, pp 140–147
32. Williams S, Reiter E (2008) Generating basic skills reports for low-skilled readers. Nat Language Eng 14:495–535

Part II
Perception

Chapter 5
The Rest of the Story: Finding Meaning in Stylistic Variation

Shlomo Argamon and Moshe Koppel

Abstract The computational analysis of the style of natural language texts, *computational stylistics*, seeks to develop automated methods to (1) effectively distinguish texts with one stylistic character from those of another, and (2) give a meaningful representation of the differences between textual styles. Such methods have many potential applications in areas including criminal and national security forensics, customer relations management, spam/scam filtering, and scholarly research. In this chapter, we propose a framework for research in computational stylistics, based on a functional model of the communicative act. We illustrate the utility of this framework via several case studies.

5.1 Introduction

When we speak of the "style" of a work, we may be referring to any one (or several) of a diverse set of concepts. We have seen, for example, views of style as being an individual's personal, historically-influenced mode of artistic expression (Chap. 1, by Cohen), a concept organizing how observers tend to interpret a work (Chap. 2, by Stiny), a means of conveying emotion (Chap. 3, by Dannenberg), and a means of implicitly contextualizing a work as part of a certain genre (Chap. 4, by Reiter and Williams).

In this chapter, we will explore textual style, via the automated analysis of written texts, known as *computational stylistics*. In this effort, we have two primary goals: (a) to develop methods to automatically distinguish texts with a certain stylistic character from those of another, and (b) to distill an interpretable representation of the difference between such stylistic characters. We ultimately seek an inclusive view of the nature of style, endeavoring to cover the individual style of a genius as well as the generic style of a collective, style's communicative functions as well

S. Argamon (✉)
Department of Computer Science, Illinois Institute of Technology, Chicago, IL 60645, USA
e-mail: argamon@iit.edu

S. Argamon et al. (eds.), *The Structure of Style*,
DOI 10.1007/978-3-642-12337-5_5, © Springer-Verlag Berlin Heidelberg 2010

as its social determinants, and the intentions of the author as well as the potential reactions of the reader.

We approach this question from semantic and pragmatic perspectives, taking the "style" of a text to cover the broad range of meanings that lie beyond what is conventionally thought of as the text's "content". Such content may be thought of as the "denotational meaning" of the text, roughly covered by the proverbial "Six Ws": Who, What, Where, Why, When, and How. By "style", then, we mean pretty much everything else that we can know from a text about the communicative act that it embodies. The basic idea is that the text's *style* may be defined as the particular way in which the author chose to express her desired content, from among a very large space of possible ways of doing so. We may broadly contrast, therefore, the *manner* or *method* of a text (style) from what the text is *about* (content). It is important to keep in mind that any stylistic characterization is essentially *counterfactual*, in that a particular style gains its meaning by virtue of its difference from other styles that might have been chosen instead.

Style, thus construed, includes interpersonal aspects of meaning such as affect, sociolinguistic categories such as genre and register, idiolectic aspects such as author identity and personality, and specifics of the individual speech act such as the medium of transmission and the purpose of the text. These notions relate the details of a text's construction to its larger context, as fleshed out in Sect. 5.2 below. These form a rather diverse set of characteristics; we argue that they can be usefully considered together for the purposes of computational textual analysis.

The diversity of stylistic textual characteristics is reflected in the large number of possible applications for style analysis that are already being explored. Current areas of application include authorship attribution and profiling [5, 14, 22, 31, 60, 80, 84, 96, 98], genre-based text classification and retrieval [36, 57, 58], sentiment analysis [88, 99], and spam/scam filtering [1, 67, 89]. Other potential applications include criminal and national security forensics [24, 82], mining of customer feedback [18, 81], and aiding humanities scholarship [7, 51, 53, 75]. Automated stylistic analysis thus promises new tools that may help with the ever-increasing number of texts available in all topics and application domains.

In this chapter we present a framework for research in computational stylistics based on a model of the *communication act*, in which stylistic analysis is framed as the task of figuring out the determinative aspects of that act from a text, as opposed to figuring out its denotative meaning. We then consider three specific case studies: profiling the age and sex of an author, verifying authorship of disputed texts, and analyzing differences in scientific reasoning based on linguistic clues. These case studies show some of the range of what can now be done as well as point towards future research and applications.

5.1.1 Features

Perhaps the key issue in computational stylistic analysis is the choice of textual features to use for modeling documents' styles. While topic-based text categorization typically work well using models based on "bags of content words", style is more

elusive. We start from the intuitive notion that style is indicated by features representing the author's choice of one mode of expression from a set of equivalent modes for a given content. At the surface level, this may be seen in the specific choices of words, syntactic structures, discourse strategies, and so forth in a document. The underlying causes of such variation are similarly heterogeneous, including the genre, register, or purpose of the text, as well as the educational background, social status, and personality of the author and audience. What all these kinds of variation have in common, though, is an independence from the "topic" or "content" of the text, which may be considered to be those objects and events that it refers to (as well as their properties and relations as described in the text). Furthermore, textual features of style (as opposed to content) tend to function mostly in the aggregate— no single occurrence of a word or syntactic structure indicates style, but rather an aggregate preference for certain choices in a text rather than others.

Most work on computational stylistics to date has been based on hand-selected sets of content-independent features such as function words [75, 84, 100], parts-of-speech and syntactic structures [96], and clause/sentence complexity measures [29, 105]; such features have been catalogued in surveys by Karlgren [57], Juola [56], and Koppel et al. [64]. While new developments in machine learning and computational linguistics have enabled larger numbers of features to be generated for stylistic analysis, it is still difficult to articulate strong linguistic motivations for any preferred input feature set that relates it directly to particular stylistic concerns. Rather, the general methodology that has developed is to find as large a set of content-independent textual features as possible and use them as input to a generic learning algorithm (preferably one resistant to overfitting, and possibly including some feature selection). Some interesting and effective feature sets have been found in this way, such as [57, 65]; function words have also proven to be surprisingly effective on their own [5, 11, 80].

In the long term, however, a clear foundation in a linguistic theory of meaning will be needed to gain true insight into the nature of the stylistic dimension(s) under study. One effort in that direction is the development of linguistic-functional feature sets for analyzing texts, such as that presented in Sect. 5.3.3 below. As will be discussed, differences between classes of texts in usage of these features will often have direct linguistic interpretations in terms of their different communication functions. Such an understanding can help elucidate the nature and causes of stylistic differences between texts created in different contexts and circumstances.

We should note that at times textual features that mainly indicate topic (e.g., "content words") may be useful for a form of "stylistic discrimination". This is a fine point, but we distinguish based on the goal of the analysis. If the goal is to characterize aspects of the text essentially *extraneous* to its denotation, then even if this analysis examines (say) variation in preferences between words like "king" and "love" (certainly content-bearing), we may say that our analysis has a fundamental relation to style. Certainly in non-textual media, such as music and (abstract) art, the concept of the 'denotation' of a work as opposed to its stylistic content is vague to nonexistent. We will thus examine content-related features in some of our analyses of style, while remaining wary of potential methodological pitfalls.

5.1.2 Overview

Our goal in this chapter is to provide an initial framework for such study, and show how some useful insights can be gleaned from computational stylistic analyses. After outlining a model of the communicative act as a framework for research in computational stylistics (Sect. 5.2), we describe a general computational framework for stylistic analysis of texts (Sect. 5.3). We then discuss three case studies using these methods: profiling blog authors by age and sex (Sect. 5.4), verifying the authorship of a single disputed text (Sect. 5.5), and analyzing scientific writing to see how writing style may reflect diversity in scientific methodology (Sect. 5.6). Finally, we discuss how these various results all contribute to the overall research framework we are developing, and what we believe the next fruitful steps to be in this work.

5.2 Style and the Communicative Act

To develop a meaningful characterization of stylistic variation, as derived from computational analysis of texts, we first discuss the nature of the "communicative act" which a text embodies. This is by way of conceiving a "generative model" for purposes of stylistic analysis; our research goals will be to extract information about the specific processes that generated a certain text or set of texts. The idea is that among the components of the communicative act, we can tease apart the aspects of what we call "style". We seek therefore to model how various factors constituting the communicative act influence (in various ways) the composition of a text. Given such a "generative" model, the goal of computational stylistics is to determine, to the extent possible, the unobserved features of a communicative act from its observed product—the text. Again, by "stylistic" we mean those aspects that are (relatively) independent[1] of the chosen "content".

Figure 5.1 depicts the fundamental elements of the communicative act. The most basic influences on the character of any communicative act are its participants: the *Author* (equivalently, the "writer" or "speaker") who is the source of the text, and the *Audience* (equivalently, the "reader", "listener", or "recipient") to whom the text is conveyed. Of course, when analyzing a non-conversational text, the text itself gives no possible access to the nature of the actual Audience, hence we are interested in the Audience that the Author had in mind; it is that intended Audience to which we must refer. The identities and characteristics of the Author and Audience can affect the nature of the text communicated between them—hence the classical stylistics problem of authorship attribution, for example.

[1] We note that insofar as preferences for certain topics may be intimately related to other aspects of the communicative act that we consider within the purview of style, variation in content variables may be a legitimate and useful object of study. In particular, see the discussion in Sect. 5.4.

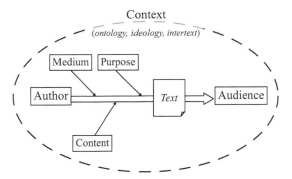

Fig. 5.1 Schematic diagram of the communicative act

Three other elements are also directly implicated in the composition of the text. First, a text is seen to encode some *Content*, normally conceived of as some sort of propositional content denoted by the text. For example, the declarative clause "The red book is on the table," denotes the proposition that a book which is red and whose identity is assumed known, is on a table whose identity is also assumed known; the propositional meaning of questions or requests is trickier (and still debated by semanticists), but for our purposes questions can be thought of as underspecified propositions and requests can be thought of as representing potential future events. For example, the request "Please give me the book," represents a possible future event of the Audience giving a book, whose identity is known, to the Author.

Second, in addition to such propositional Content, the *Purpose* of the communication affects the form of the text, by expressing its Content in a speech act designed to accomplish that purpose [13, 94]. Thus, in the previous example, the form of the imperative sentence is dictated by its Purpose as a request. So we see that the Purpose specifies, to some extent, the grammatical and rhetorical form of the text. The overall form and texture of an essay geared to informing a student about the effects of monetary policy on inflation will differ noticeably from that of one geared to convincing voters of the advantages of a particular policy, even though the Content of both may be very similar.

Third, the *Medium* through which the text is expressed can affect its composition in both overt and subtle ways. To take two modern extremes, the Medium of a book affords greater possibilities of depth and options for variety of expression than does the Medium of an instant message (IM), while the implicit intimacy and speed of sending an IM offers possibilities that writing a book may lack. Certainly, texts in these two Media are distinguishable based on a few key surface features (e.g., text length, certain abbreviations, syntactic "well-formedness").

Finally, in addition to these five direct influences on the character of a particular text, we must also consider the larger *Context* in which the communicative act takes place. This includes its direct social context, the organization(s) or institution(s) sanctioning the communication, which may impose constraints on the form of the text (in an extreme case, through specific editorial guidelines). We may also consider

the less-direct influence imposed by the context of the enclosing culture, as mediated through various overlapping communities: *communities of practice* [52, 101], formed of people engaged together in a given activity (e.g., a project team, or a club), *communities of association*, formed of people sharing location and resources (e.g., a neighborhood), and *discourse communities* [48, 97], comprising groups of people with a shared textual history.

Without entering into existing debates on the exact nature of such communal groupings, their relationships with each other, and their precise influences on textual form, we may identify (in a neutral fashion) three mediating factors for context's effect on the form of communicative act realized as a text. First, we identify the role of *ontology*, or a theory of what is [28, 43, 44]. Different cultural contexts may entail different commitments to the sorts of objects that exist, how they are referred to in the language, and the taxonomic relationships that may obtain between them. Examples of ontological differences include, for example, the variation in food items available in different regions, and in other everyday items—modern urbanites are more likely to have reference to automobile care than farm animal care. As well, specialized fields such as science or metaphysics may reify certain abstract concepts and processes, treating them as tangible objects in their discourse.

Second, we consider the role of an *ideology*, which establishes a set of possible social roles and assumed relationships between them of prestige and of power [71]. It is the ideological context that provides the background for the interpersonal relationship(s) between the Author and the Audience which affects the nature of the text, in terms of its formality, politeness, level(s) of epistemic commitment, and so on.

Third, we must also consider the *intertext*, or background of all pre- and co-existing texts that may have influenced the composition of the text under consideration. This may be by direct quotation or citation, by the incorporation of similar thematic elements or rhetorical structures, or by the use of particular phraseology. Much or even most such intertextual reference may not be conscious, but rather incorporation of textual elements "floating" in a background knowledge of a body of texts. A community of discourse is distinguished primarily by its having a particular intertextual history to which its texts make reference; prime examples are traditional religious communities whose texts often refer back to the community's acknowledged canonical religious texts.

In terms of this model (cf. Fig. 5.1), the goal of an inclusive stylistic analysis is, given a text, to glean as much as possible about the various components of the communicative act it embodies, apart from its denotative Content (we will term these the *stylistic facets* of the act). Thus, authorship attribution and profiling, identifying the genre of a text (i.e., its purpose and place in some community), and determining social power relations realized in a body of texts thus all involve forms of stylistic analysis in our terms. Certainly there are correlations between these different facets—particular authors will have idiosyncratic topical preferences, certain topics are largely embedded in communal discourses that come with particular stylistic commitments (e.g., scholarly disciplines), different media may be more or less appropriate for various types of content or purpose, and so on. Furthermore, how a text expresses its purpose, for example, depends on its particular content and

context. Thus no one stylistic facet can be considered entirely in isolation apart from all the others. However, in the context of a specific research question, one or another facet may be usefully considered in relative isolation, provided that appropriate caution be exercised in drawing general conclusions. In particular, although preferences for certain topics would typically be considered content rather than style, they may, in appropriate circumstances, be taken as stylistic as well. This is when such topical preferences are (a) strongly correlated with certain communicative circumstances (e.g., author characteristics, or particular ideologies), and (b) have semantic associations with those same circumstances.

The model described above cannot be considered in a vacuum, and is closely related to systemic functional models of register, context, and culture, such as those discussed by Martin [71], Halliday [46], Gregory [42], and Fawcett [34], among others. For example, in terms of systemic register theory, our notion of Content parallels Halliday's "field" (though Ontology is also relevant), while the conjunction of Author and Audience determines Gregory's "personal tenor" (included with Purpose in Halliday's "tenor"), and the Medium is essentially the "mode". Genre effects are embedded in our model as as realizations of different Purposes within a discourse community (or community of practice); the communal dimension foregrounds aspects of Context in genre analysis—as Halliday and Martin (among others) have noted, ideology is a key player in the construction of genre. Note that we are not proposing here any new linguistic theory of these phenomena, but merely suggest a model that is useful for organizing research on automated style analysis.

The three case studies discussed below in this chapter examine several different stylistic facets and their interrelationships within this framework. First, we examine aspects of the Author, considering textual correlates of the age and sex of blog authors; as we will see this also implicates Content and Context. Our second case study deals with other aspects of the Author, in examining how to verify the authorship of a disputed text; this also potentially involves Purpose, insofar as deception may be involved. Finally, we consider two results in analyzing scientific writing to seek textual correlates of different scientific methodologies. This involves the interaction between Content and Purpose, within particular disciplinary Contexts. Before discussing these case studies, however, we will first describe the main methods of computational stylistics.

5.3 Computational Stylistics

Research in *computational stylistics* seeks effective models of language style by applying machine learning algorithms to stylistically meaningful features. The roots of the field go back to the studies of Mendenhall [83] and Mascol [73, 74] in the late 19th century on the use of word-length statistics for determining authorship. In the 20th century, the foundations of such "stylometric analysis" were further advanced by Yule's statistical studies of word-length and part-of-speech

distributions in literary prose [105, 106], and Mosteller and Wallace's authorship study of *The Federalist Papers* [84], based on a Bayesian analysis of function word frequencies. Due to the high cost of computing and analyzing such features before the wide availability of powerful computers, stylometrics researchers had, until recently, traditionally sought relatively simple statistically valid models of stylistic distinctions, based on a small number (dozens, at most) of easily-computed textual statistics, such as word-frequencies [84], phrase-type frequencies [14], or sentence-complexity [106].

5.3.1 Text Classification

Recent research on machine learning techniques for text classification, however, has developed more sophisticated learning algorithms which can use combinations of many thousands of features to classify documents according to topic (see Sebastiani's [95] excellent survey). Working systems that have been developed use a variety of modern machine learning techniques such as Naïve Bayes [68, 69], Winnow [27], and Support Vector Machines [55]. Recent work on applying machine learning and statistical methods for text classification to stylometric features for style analysis has achieved useful techniques for authorship attribution [4, 8, 96], genre analysis [12, 19, 33, 75], and other applications [41, 51, 61].

Text categorization is a key problem in the field of machine learning [95]. The task is, given two or more classes of 'training' documents, to find some formula (a "classification model") that reflects statistical differences between the classes and can be used to classify new documents. For example, we might wish to classify a document as being about one of a number of possible known topics, as having been written by a man or a woman, as having been written by one of a given set of candidate authors and so forth.

Figure 5.2 depicts the basic architecture of a text categorization system in which we are given examples of two classes of documents, Class A and Class B. The first step, document representation, involves defining a set of text features which might potentially be useful for categorizing texts in a given corpus (for example, words that are neither too common nor too rare) and then representing each text as a vector in which entries represent (some non-decreasing function of) the frequency of each feature in the text. Optionally, one may then use various criteria for reducing the dimension of the feature vectors [37, 104].

Once documents have been represented as vectors, there are a number of learning algorithms that can be used to construct models that distinguish between vectors representing documents in Class A and vectors representing documents in Class B. Yang [103] compares and assesses some of the most promising algorithms, which include k-nearest-neighbor, neural nets, Winnow, Support Vector Machines, etc. One particular class of learned model which is easy to understand and analyze, and which we use here, is the linear separator. The basic idea is that each feature x_i is assigned a weight w_i^c for each possible text class c; these weights collectively form

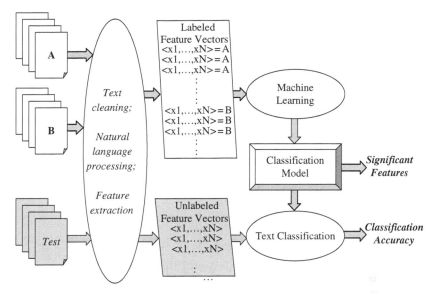

Fig. 5.2 Generic text categorization system architecture. Training texts from categories "A" and "B" are first processed to clean extraneous material (such as HTML), compute linguistic features (parts-of-speech or syntactic phrases), and compute feature frequencies. The resulting labeled vectors are fed into a machine learning algorithm that creates a classification model that can then be applied to test documents to evaluate accuracy. The model can also (in many cases) be examined to determine which features are most significant for classification

several weight vectors \mathbf{w}^c. The dot-product of weight vector \mathbf{w}^c with a text's feature vector \mathbf{x} gives the text's score for class c; the class with the highest score is assigned to the text.

A number of different methods with somewhat different properties are currently used for computing such linear text classification models. Naïve Bayes [69, 79] is a computationally efficient method which computes an optimal classification model based on strong statistical assumptions, primarily that feature frequencies are conditionally independent of each other given the output class. While these assumptions are nearly never satisfied for real problems, in practice the method often works quite well. Another popular method is that of Support Vector Machines (SVMs) [54], in which optimization techniques are used to find a weight vector defining a hyperplane separating the classes maximizing the distance between positive and negative examples, as measured perpendicular to that hyperplane. Though training them is often computationally expensive, SVMs have the important property of being able to learn well in the presence of very many irrelevant features (resistance to overfitting). Extensions of the Winnow algorithm [70] have also been used for text classification [27]. This algorithm uses multiplicative updating of model weights to quickly home in on those features which are relevant to the classification problem and discard those which are not. A fourth method of growing importance is Bayesian logistic regression [38], in which a zero-mean Bayesian prior distribution on the model parameters is used to reduce its dimensionality, and so reduce the risk of

overfitting. In general, many learning algorithms will give similar performance for any given text categorization task, provided that features are chosen well.

5.3.2 Classical Features

For stylistic text classification, learning algorithms which do not require feature independence and are robust to presence of irrelevant features (such as Winnow, SVMs, and Bayesian logistic regression), all tend to work well. The main current research issue in the field, therefore, is the question of what kinds of textual features are good style discriminators, especially with the use of algorithms that can effectively deal with very large numbers of such features. Features for stylistic discrimination must be invariant as to topic but vary with the specific stylistic dimension under study.

Our results and those of others [5, 8, 36, 41] have shown that using just relative frequencies of several hundred function words often gives excellent results. The intuition behind the use of function words for stylistic analysis is that due to their high frequency in the language and highly grammaticalized nature, they are unlikely to be subject to conscious control by the author. At the same time, their frequencies are seen to vary greatly amongst different authors and genres of text. However, the highly reductionistic nature of such features seems unsatisfying, as it can be difficult at times to distill real insights into the underlying nature of stylistic variations.

Adding syntactic features can be advantageous as well, both for efficacy and for developing understanding. A simple method for that has been used for syntactic stylistic analysis is to use as features the frequencies of short sequences of parts-of-speech (nouns, verbs, and the like); such parts-of-speech (POS) can be assigned to words in a text with upwards of 95% accuracy. Various researchers [14, 66, 96] have used POS n-grams for authorship attribution; they have also been used for genre analysis [10] and determining author sex [61]. Full syntactic parsing has also been applied with some success. Some work has shown [30, 35] that syntactic features can help for texts such as e-mails, which are highly informal and relatively short.

Often a great deal of insight into the underlying stylistic dimension being studied can also be found by using content-related features, as we will see in some of the case studies below.

5.3.3 Functional Lexical Features

A novel feature set that we have recently developed is based on Systemic Functional Grammar (SFG), a functional approach to linguistic analysis [47]. The idea is to model explicitly functionally-relevant distinctions in language use. SFG models the grammar of a language by a network of choices of meanings that can be expressed [76], and so all lexical and structural choices are represented as the realizations of particular semantic and contextual meanings. The theory takes a

primarily *sociological* view of language, and has developed largely in the context of its use by applied linguists for literary/genre analysis and for studying language learning. (See Butler [23] for an excellent overview of SFG and its relation to other functional linguistic theories.)

Briefly put, SFG construes language as a set of interlocking choices for expressing meanings, with more general choices constraining the possible specific choices. A choice at one level may open up further choices at other levels, choices that may not otherwise be possible. For example, English does not allow one to distinguish between masculine and feminine third-person plural nominal references—only the pronoun "they/them" is available (see the partial system network for English pronouns in Fig. 5.3). Furthermore, any specific choice of lexical item or syntactic structure is determined by choices from multiple systems at once, as, e.g., the choice between "I" and "me" is determined by the independent choice of grammatical case placing the pronoun as either a syntactic subject or object, respectively.

For our purposes, it suffices to assign attributes to relevant lexical items, where each such attribute takes on a value from a system taxonomy defined by SFG. For simplicity, we require that each such taxonomy be represented as a tree, with a single root and with each entry condition either a single option or a conjunction of options. This simplifies computational issues, though it only approximates the full SFG representation which essentially allows system networks to be general AND/OR graphs; see [76] for a full discussion.

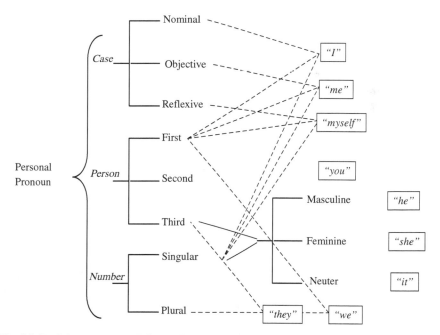

Fig. 5.3 Partial system network for English personal pronouns. Note that choices are made simultaneously for each of case, person, and number, and some combinations give rise to other possible choices

To compute textual features based on such a taxonomy, we first build a lexicon of various lexical items representing different nodes within such the taxonomy. Numeric features for a given text may then be computed based on the lexical items occuring in it, where each feature is the relative frequency of some option O_1 with respect to some other option O_2. Given a text d, we define $N_d(O_1)$ to be the number of occurrences lexical items in d with type O_1, similarly we define $N_d(O_1, O_2)$ to be of occurrences with both types O_1 and O_2. Then the *relative frequency of O_1 with respect to O_2* is defined as

$$RF_d(O_1|O_2) = \frac{N_d(O_1, O_2)}{N_d(O_2)}$$

The key point here is that the frequency of sibling options relative to their shared parent allows direct comparison of how different texts prefer to express the parent via its different options.

This leads to a straightforward "variational" interpretation of a linear classification model, in which certain nodes in the taxonomy correspond to features indicating one document class, and other nodes to features indicating the other document class. The idea then is to find all *oppositions* , where an opposition is defined as a pair of sibling nodes where one indicates one class and the other indicates the other class. To take a simple example, if PRONOUN-NUMBER/Singular (i.e., RF_d(Singular|PRONOUN-NUMBER)) is indicative of class A and PRONOUN-NUMBER/Plural of class B, we would have the opposition:

Condition	Class A	Class B
PRONOUN-NUMBER	Singular	Plural

Oppositions given by such analysis provide direct information about linguistic differences between two document classes, in that the two classes have differing preferences about what sorts of entities are referred to by pronouns. In the example, Class A contains relatively more reference to singular individuals, whereas Class B contains relatively more references to collectives.

The remainder of this subsection outlines the main system networks which we have used for analyzing textual style. They are divided into three categories, denoting the general "stylistic goals" that these textual features relate to: *Cohesion*, referring to how a text is constructed to "hang together", *Assessment*, meaning how a text construes propositions as statements of belief, obligation, or necessity, contextualizing them in the larger discourse, and *Appraisal*, how the text adjudges the quality of various objects or events. The relevant taxonomies are only summarized here due to space considerations; a fuller description can be found in [9].

5.3.3.1 Cohesion

Cohesion refers to linguistic resources that enable language to connect to its larger context, both textual and extratextual [45]. Such resources include a wide variety of referential modalities (pronominal reference, deictic expressions, ellipsis, and more), as well as lexical repetition and variation, and different ways of linking clauses together. How an author uses these various cohesive resources is an indication of how the author organizes concepts and relates them to each other. Within cohesion, we consider here only conjunctions, which are easiest to deal with computationally. Automated coreference resolution [16, 87], for example, is a difficult unsolved problem.

Words and phrases that conjoin clauses (such as "and", "while", and "in other words") are organized in SFG in the CONJUNCTION system network. Types of CONJUNCTION serve to link a clause with its textual context, by denoting how the given clause expands on some aspect of its preceding context [76, pp. 519–528]. The three top-level options of CONJUNCTION are Elaboration, Extension, and Enhancement, defined as:

- Elaboration: Deepening the content in its context by exemplification or refocusing (*for example, in other words*, i.e.);
- Extension: Adding new related information, perhaps contrasting with the current information (*and, furthermore, on the other hand*);
- Enhancement: Qualifying the context by circumstance or logical connection (*and then, because, similarly*).

5.3.3.2 Assessment

Generally speaking, *assessment* may be defined as "contextual qualification of the epistemic or rhetorical status of events or propositions represented in a text". Examples include assessment of the likelihood of a proposition, the typicality of an event, the desirability of some fact, or its scope of validity. Two important systems in SFG that address assessment are MODALITY, enabling expression of typicality and necessity of some fact or event, and COMMENT, enabling assessment of the writer's stance with respect to an assertion in the text.

The system of MODALITY enables one to qualify events or entities in the text according to their likelihood, typicality, or necessity. Syntactically, MODALITY may be realized in a text through a modal verb (e.g., "can", "might", "should", "must"), an adverbial adjunct (e.g., "probably", "preferably"), or use of a projective clause (e.g., "I think that . . .", "It is necessary that . . ."). Each word or phrase expressing MODALITY has a value for each of four attributes:

- Type: What kind of modality is being expressed?

 - Modalization: How "typical" is it? (*probably, seldom*)
 - Modulation: How "necessary" is it? (*ought to, allowable*)

- Value: What degree of the relevant modality scale is being averred?

- Median: The "normal" amount. (*likely, usually*)
- Outer: An extreme (either high or low) amount. (*maybe, always*)

- Orientation: Relation of the modality expressed to the speaker/writer.

 - Objective: Modality expressed irrespective of the speaker/writer. (*maybe, always*)
 - Subjective: Modality expressed relative to the speaker/writer. (*We think..., I require...*)

- Manifestation: How is the modal assessment related to the event being assessed?

 - Implicit: Modality realized 'in-line' by an adjunct or modal auxiliary. (*preferably..., maybe..*)
 - Explicit: Modality realized by a projective verb, with the nested clause being assessed. (*It is preferable..., It is possible..*)

The system of COMMENT provides a resource for the writer to "comment" on the status of a message with respect to textual and interactive context in a discourse. Comments are usually realized as adjuncts in a clause and may appear initially, medially, or finally. We use the eight categories of COMMENT listed by Matthiessen [76]: *Admissive*, message is an admission (e.g., "*we concur...*"), *Assertive*, emphasis of reliability (e.g., "*Certainly...*"), *Desiderative*, desirability of the content (e.g., "*Unfortunately...*"), *Evaluative*, judgment of the actors involved (e.g., "*Sensibly...*"), *Predictive*, coherence with predictions (e.g., "*As expected...*"), *Presumptive*, dependence on other assumptions (e.g., "*I suppose...*"), *Tentative*, assessing the message as tentative (e.g., "*Tentatively...*"), and *Validative*, assessing scope of validity (e.g., "*In general...*").

5.3.3.3 Appraisal

Finally, *appraisal* denotes how language is used to adopt or express an attitude of some kind towards some target [72]. For example, in "I found the movie quite monotonous", the speaker adopts a negative *Attitude* ("monotonous") towards "the movie" (the *appraised object*). Note that attitudes come in different types; for example, "monotonous" describes an inherent quality of the appraised object, while "loathed" would describe an emotional reaction of the writer. The overall type and orientation of appraisal expressed in the text about an object gives a picture of how the writer wishes the reader to view it (modulo sarcasm, of course). To date, we have developed a lexicon [20] for appraisal adjectives as well as relevant modifiers (such as "very" or "sort of"). The two main attributes of appraisal, as used in this work, are Attitude, giving the kind of appraisal being expressed, and Orientation, giving whether the appraisal is *positive* (good, beautiful, nice) or *negative* (bad, ugly, evil). (There are also other attributes of appraisal, discussed in the Appendix.) The three main types of Attitude are: *affect*, relating to the speaker/writers emotional state (e.g., "happy", "sad"), *appreciation*, expressing evaluation of supposed

intrinsic qualities of an object (e.g., "tall", "complex"), and *judgment*, expressing social evaluation (e.g., "brave", "cowardly").

5.4 Case Study: Author Profiling

In our first case study, we analyze a large corpus of blogs to see to what extent writing style and topic preferences vary with age and sex of the author [6], and what this variation may tell us. The main stylistic facet from our framework that is addressed, therefore, is the Author, with the relation between Author and Content implicated as well. More subtly implicated are the contextual ontology and ideology, as they inform the societal roles played by individuals of different ages and sexes. However, we do not yet here have the tools to address these aspects directly, and must leave tantalizing questions for future research.

The weblog, or *blog*, has emerged as a very popular medium for textual self-expression in recent years—in April 2007, the Technorati blog aggregation site was tracking over 70 million blogs, which even so constitute only a fraction of the whole. Blogs therefore constitute a particularly rich data source for authorship profiling, particularly as many have user-provided profiles of their authors. We note that blogs per se have their own distinctive stylistic characteristics, and come in multiple genres, including "personal journals" reporting the (more or less) daily life of the blogger, "filters" which present sets of links to selected web-documents to readers, and "knowledge-logs" which host discourse about a project or activity [49].

In this study, we applied two different machine-learning algorithms to age and sex classification: Bayesian multinomial logistic regression (BMR [38]) and multi-class balanced real-valued Winnow (WIN [27, 70]), to construct classification models for author age and for author sex.

5.4.1 The Corpus

The corpus for this study included all blogs on `blogger.com` in mid-August 2004 that had both author-provided indication of sex and age and at least 200 occurrences of common English words. The unit of analysis was the collected writing of each blogger from the blog's inception date until harvest; we do not distinguish between different posts by a given blogger. Each blog was labeled for sex and age based on the blogger's self-identification. For purposes of analysis, formatting and non-English text was removed from each blog. To enable reliable age categorization (since a blog can span several years of writing), all blogs for boundary ages (ages 18–22 and 28–32) were removed. Each blogger was categorized by age at time of harvest: "10s" (ages 13–17), "20s" (ages 23–27) and "30s" (ages 33–47), and also by sex: "male" and "female". To decouple sex from age effects, the numbers of blogs of each sex within each age category were equalized by randomly deleting surplus blogs from the larger sex category. The final corpus contained 19320 blogs

(8240 in 10s, 8086 in 20s, and 2994 in 30s), comprising a total of 681288 posts and over 140 million words; there were 35 posts and 7300 words per blog on average.

Each blog was represented by a vector containing the frequencies in it of 377 pre-identified function words as well as of the 1000 words with highest information gain for age and sex, respectively (as computed on the holdout set). These latter comprise essentially those content words most correlated with the age and sex categories. We consider content words here to see to what aspects of content choice may be influenced by the Context-based facets of author age and sex.

5.4.2 Classification Accuracy

Classification accuracies under ten-fold cross-validation for author age (over all three age classes) were 77.4% (BMR) and 75.0% (WIN). Results for author sex were accuracies of 79.3% (BMR) and 80.5% (WIN), consistent with classification studies on author sex in other corpora [5, 31]. When one takes into account that self-identified sex and age information by bloggers may often inaccurate and that blogs commonly include much quoted text, these results might be considered surprisingly high, clearly showing that author sex and age are indicated by word usage.

5.4.3 Significant Features

What may such differences in language use tell us, however? First, consider the 1000 most frequent words in the corpus overall and how different classes of bloggers differ in their use. These 1000 words contain 323 different function words and 677 different content words, accounting for 59.4 and 21.7%, respectively, of all word occurrences. In order to understand underlying patterns of language variation, we considered naturally occurring word classes.

Function words, the most directly stylistic features considered here, can be divided straightforwardly into a number of grammatical classes, such as Personal-Pronouns, Articles, Conjunctions, and so forth. For content words, a straightforward way to identify natural word classes for a given corpus is to perform factor analysis. A maximum likelihood factor analysis with equimax rotation and Kaiser normalization [39] on the rate of use of each of the 677 most frequent content words yields twenty coherent factors that depict different content-related themes, each containing between 13 and 32 words. We assigned intuitive names to the factors: *Conversation, AtHome, Family, Time, Work, PastActions, Games, Internet, Location, Fun, Food/Clothes, Poetic, Books/Movies, Religion, Romance, Swearing, Politics, Music, School, Business.*

5.4.3.1 Age

Frequencies of the twenty factors' usage for each age, as well as the same data for function words broken down by parts of speech, indicate meaningful differences in

both content and style among bloggers of different ages. Among function words, use of PersonalPronouns, Conjunctions, and AuxiliaryVerbs decreases ($p < 0.001$) with age, while use of Articles and Prepositions increases ($p < 0.001$) with age. Among the twenty "content-based" factors, use of words associated with Family, Religion, Politics, Business, and Internet increases ($p < 0.001$) with age, while use of words associated with Conversation, AtHome, Fun, Romance, Music, School, and Swearing decreases ($p < 0.001$) with age. Use of other factors either doesn't vary monotonically or shows no significant differences.

The function word and content word effects noted here are highly correlated: use of multiple regressions indicates that controlling for style effects essentially eliminates content effects and vice versa. This is not surprising, as we would expect these feature clusters to be correlated. The function-word features indicate that blogs by younger authors have a more interpersonal-oriented focus as against a more objectivized focus in blogs by older authors. The semantic character of the distinguishing factors shows a similar distinction between a focus on personal thoughts, feelings, and actions, and a focus on external social issues and the outside world.

Two notes of caution about interpreting these results are in order, however. We must not ignore the fact that since this study is synchronic, we cannot separate generational effects from age effects. Moreover, since there are many fewer older bloggers, they may represent an atypical demographic as early adopters of technology.

5.4.3.2 Sex

Similarly distinctive feature groupings were found when considering author sex. Among function words, Articles and Prepositions are used more ($p < 0.001$) by male bloggers, while PersonalPronouns, Conjunctions, and AuxiliaryVerbs are used more ($p < 0.001$) by female bloggers. These results are virtually identical to our previous results showing textual correlates of male and female authorship in English-language published fiction and non-fiction from the British National Corpus [5].

Among the "content-based" factors, Religion, Politics, Business, and Internet, are used more ($p < 0.001$) by male bloggers, while the factors Conversation, AtHome, Fun, Romance, and Swearing are used more ($p < 0.001$) by female bloggers. As in the case of age, multiple regression indicates that controlling for style effects essentially eliminates content effects and vice versa.

5.4.3.3 Correlating Age and Sex

It is immediately apparent that with just three exceptions, the textual features that distinguis older from younger bloggers are just those that distinguish male from female bloggers, and vice versa. The sole exceptions to this pattern are Family, used more by older bloggers and by females, Music, used more by younger bloggers and by males, and School, for which there is no significant difference between male and female usage.

These results therefore suggest a single underlying factor distinguishing inner- and outer-directed communication (both style and topic) that can explain both

sex-linked and age-linked variation in language use. The findings thus serve to link earlier observations regarding age-linked and sex-linked writing variation that have not previously been connected. Previous studies investigating gender and language have shown gender-linked differences along dimensions of involvedness [5, 19] and contextualization [50]. Other studies have found age-linked differences in the immediacy and informality of writing [90]. We suggest that these two sets of results are closely related.

To properly elucidate the meaning of these findings, more extensive research is needed to look at larger and more varied corpora to see how consistently author age and sex are linked to inner-directed and outer-directed communication feature sets. For example, recent results on sex-linked variation in 18th to 20th century French literature [3] appear to support the generality of this result. As more texts in different languages from different cultures and from different historical periods become available, we should be able to compare more directly the constellations of features that indicate author sex and age in different milieus. The use of functional lexical features in this work may be crucial, as this will enable meaningful comparison of feature sets between different languages—specific lexical items may not always be comparable, due to the frequent lack of exact unambiguous translations.

5.5 Case Study: Authorship Verification

The second problem we consider is that of authorship verification [62, 63]. In the authorship verification problem, we are given examples of the writing of a single author and are asked to determine if given texts were or were not written by this author. This question also involves the Author, but specifically personal style as compared with those of all other potential authors, and also potentially aspects of the Purpose of the text, insofar as deception may be an issue.

As a categorization problem, verification is significantly more difficult than attribution and little, if any, work has been performed on it in the learning community. When we wish to determine if a text was written by one of several known authors, it is sufficient to use their respective known writings, to construct a model distinguishing them, and to test the unknown text against the model [21, 84, 92, 100]. If, on the other hand, we need to determine if a text was written by Author A or not, it is very difficult, if not impossible, to assemble an exhaustive, or even representative, sample of not-A. The situation in which we suspect that a given author may have written some text but do not have an exhaustive list of alternative candidates is a common one.

The particular authorship verification problem we will consider here is a genuine literary conundrum. We are given two nineteenth century collections of Jewish rabbinic responsa written in a combination of Hebrew and Aramaic. The first, RP (*Rav Pe'alim*) includes 509 documents authored by an Iraqi rabbinic scholar known as Ben Ish Chai. The second, TL (*Torah Lishmah*) includes 524 documents that Ben Ish Chai, claims to have found in an archive. There is ample historical reason to

believe that he in fact authored the manuscript but did not wish to take credit for it for personal reasons [17]. What do the texts tell us?

The first thing we do is to find four more collections of responsa written by four other authors working in roughly the same area during (very) roughly the same period. These texts are *Zivhei Zedeq* (ZZ; Iraq, nineteenth century), *Sho'el veN-ish'al* (SN; Tunisia, nineteenth century), *Darhei No'am* (DN; Egypt, seventeenth century), and *Ginat Veradim* (GV; Egypt, seventeenth century). We begin by checking whether we are able to distinguish one collection from another using standard text categorization techniques. We select a list of lexical features as follows: the 200 most frequent words in the corpus are selected and all those that are deemed content-words are eliminated manually. We are left with 130 features. After pre-processing the text as in the previous experiment, we constructed vectors of length 130 in which each element represented the relative frequency (normalized by document length) of each feature. We then used Balanced Winnow as our learner to distinguish pair-wise between the various collections. Five-fold cross-validation experiments yield accuracy of greater than 95% for each pair. In particular, we are able to distinguish between RP and TL with accuracy of 98.5%.

One might thus be led to conclude that RP and TL are by different authors. It is still possible, however, that in fact only a small number of features are doing all the work of distinguishing between them. The situation in which an author will use a small number of features in a consistently different way between works is typical. These differences might result from thematic differences between the works, from differences in genre or purpose, from chronological stylistic drift, or from deliberate attempts by the author to mask his or her identity.

In order to test whether the differences found between RP and TL reflect relatively shallow differences that can be expected between two works of the same author or reflect deeper differences that can be expected between two different authors, we invented a new technique that we call unmasking [62, 63] that works as follows. We begin by learning models to distinguish TL from each of the other authors including RP. As noted, such models are quite effective. In each case, we then eliminate the five highest-weighted features and learn a new model. We iterate this procedure ten times. The depth of difference between a given pair can then be gauged by the rate with which results degrade as good features are eliminated.

The results (shown in Fig. 5.4) could not be more glaring. For TL versus each author other than RP, we are able to distinguish with gradually degrading effectiveness as the best features are dropped. But for TL versus RP, the effectiveness of the models drops right off a shelf. This indicates that just a few features, possibly deliberately inserted as a ruse or possibly a function of slightly differing purposes assigned to the works, distinguish between the works. We have shown elsewhere [63], that the evidence offered in Fig. 5.4 is sufficient to conclude that the author of RP and TL are one and the same: Ben Ish Chai.

For example, the frequency (per 10000 words) of the word *zeh* [= *this*] in RP is 80 and in TL is 116. A cursory glance at the texts is enough to establish why this is the case: the author of TL ended every responsum with the phrase *vehayah zeh shalom* [= *this shall be farewell*], thus artificially inflating the frequency of these

Fig. 5.4 Accuracy (*y*-axis) on training data of learned models comparing TL to other collections as best features are eliminated, five per iteration (*x*-axis). *Dotted line* on bottom is RP vs. TL

words. Indeed the presence or absence of this phrase alone is enough to allow highly accurate classification of a given responsum as either RP or TL. Once features of this sort are eliminated, however, the works become indistinguishable—a phenomenon which does not occur when we compare TL to each of the other collections. In other words, many features can be used to distinguish TL from works in our corpus other than RP, but only a few distinguish TL from RP. Most features distribute similarly in RP and TL. A wonderfully illustrative example of this is the abbreviation *vkhu'* [= etc.], the respective frequencies of which in the various corpora are as follows: TL:29 RP:28 SV:4 GV:4 DN:41 ZZ:77. Note that this similarity is unlikely to be due to regional and chronological dependencies, since GV and DN have widely differing values, though they were both written in seventeenth century Egypt.

Further experiments with the unmasking technique [63] indicate that the method can be used succesfully for authorship verification over a range of genres and languages. Future analyses may examine the nature of the artificially added features in such cases of deceptive authorship, and ask what, if any, generalizations may be made about their nature. In some cases, these "deception features" may be based on general principles (choosing a distinctive new "signature line", for example). Alternatively, the deceptive author may intentionally choose words and catch-phrases associated with other sociological groups to mislead the reader (such as a conservative Republican author referring to themself as "pro-choice", thus constructing a deceptive persona as a liberal Democrat). Thus work on such deceptive texts will be

important, as we work towards developing methods and corpora that enable us to directly examine influences of ideology and ontology on textual construction.

5.6 Case Study: Scientific Rhetoric and Methodology

A third type of texts that we have studied are peer-reviewed scientific articles [2, 9]. Our motivation in doing so is to see what, if any, stylistic realization there may be to likely methodological differences between different scientific fields. Our analysis here thus relates to questions of genre, specifically to the interaction between the facets of Content and Purpose within a certain disciplinary Context. By restricting our attention away from content-bearing features (as discussed below), we seek to find clues about Purpose and perhaps Ideology as independent of the clearly diverse Ontologies assumed in different fields.

Each scientific field forms a distinct community of discourse, with a shared textual history in textbooks and the scientific literature; each is also a community of practice (or an intertwined collection of several), in that scientists in a given field undertake similar/related research activities in the pursuit of communally-defined research goals. For these reasons, we might indeed expect that the language used in articles from one discipline differ from those in another; our goal is to verify this intuition, and to see if analysis of any differences found can shed any light on how scientists in different fields construe their arguments in different ways and for different purposes.

5.6.1 Scientific Methodologies

In the early study of the history and philosophy of science, it was generally assumed that there was a particular "Scientific Method" which informed scientific investigations (as opposed to less-reliable speculative methods). This method (variously formulated) was modelled essentially on the theoretico-experimental practices of physics, and tended to devalue sciences such as geology and paleontology, in which different sorts of reasoning were typically necessary [59, 78, 93]. In recent years, however, historians and philosophers of science have begun to distinguish between *experimental sciences* such as physics, which attempt to formulate general predictive laws, and so rely heavily on repeatable series of controlled experiments which test hypotheses, and *historical sciences* such as geology, which study specific contigent past phenomena in an attempt to find unifying explanations for effects caused by those phenomena [25, 32, 77, 78, 93]. Reasoning in historical sciences, it is said, consists largely of 'synthetic' reconstructive reasoning (*retrodiction*), as compared with more explicitly *predictive* reasoning from causes to possible effects characteristic of experimental science [15, 32, 40, 102]. We summarize here results of our earlier studies [2, 9] on articles in several fields of experimental and historical

Table 5.1 Journals used in the studies, giving number of articles per journal in the corpus and the average length (in words) per article

	Journal	# Art.	Avg. length
H_1	Journal of Geology	93	4891
H_2	Journal of Metamorphic Geology	108	5024
H_3	Biological Journal of the Linnean Society	191	4895
H_4	Human Evolution	169	4223
H_5	Palaeontologia Electronica	111	4132
H_6	Quaternary Research	113	2939
E_1	Physics Letters A	132	2339
E_2	Physical Review Let.	114	2545
E_3	Journal of Physical Chemistry A	121	4865
E_4	Journal of Physical Chemistry B	71	5269
E_5	Heterocycles	231	3580
E_6	Tetrahedron	151	5057

sciences, which show how analysis of style differences can give insights into how scientific rhetoric reflects methodological differences among the sciences.

The two studies we will discuss analyze a corpus of recent (2003) articles drawn from twelve peer-reviewed journals in both historical and experimental sciences; the numbers of articles used from each journal and their average (preprocessed) lengths in words are given in Table 5.1. They are:

Journal of Geology (geology, historical) includes research on the full range of geological principles including geophysics, geochemistry, sedimentology, geomorphology, petrology, plate tectonics, volcanology, structural geology, mineralogy, and planetary sciences.

Journal of Metamorphic Geology (geology, historical) focuses on metamorphic studies,[2] from the scale of individual crystals to that of lithospheric plates.

Biological Journal of the Linnean Society (evolutionary biology, historical) publishes work on organic evolution in a broad sense, particularly research unifying concepts of evolutionary biology with evidence from genetics, systematics, biogeography, or ecology.

Journal of Human Evolution (evolutionary biology, historical) covers all aspects of human evolution, including both work on human/primate fossils and comparative studies of living species.

Palaeontologia Electronica (paleontology, historical) publishes papers in all branches of paleontology as well as related biological or paleontologically-related disciplines.

Quaternary Research (paleontology, historical) publishes research in diverse areas in the earth and biological sciences which examine the Quaternary

[2] Metamorphism refers to changes in mineral assemblage and texture in rocks that have been subjected to temperatures and pressures different from those under which they originally formed.

period of the Earth's history (from roughly 1.6 million years ago to the present).

Physics Letters A (physics, experimental) publishes research in a wide range of areas, including : condensed matter physics, theoretical physics, nonlinear science, statistical physics, mathematical and computational physics, atomic, molecular and cluster physics, plasma and fluid physics, optics, biological physics and nanoscience.

Physical Review Letters (physics, experimental) also covers a wide range of physics research, including: gravitation and astrophysics, elementary particles and fields, nuclear physics, atomic, molecular, and optical physics, nonlinear dynamics, fluid dynamics, plasma and beam physics, and condensed matter physics.

Journal of Physical Chemistry A (physical chemistry, experimental) publishes chemical research at the level of molecules (including dynamics, spectroscopy, gaseous clusters, molecular beams, kinetics, atmospheric and environmental physical chemistry, molecular structure, bonding, quantum chemistry, and general theory).

Journal of Physical Chemistry B (physical chemistry, experimental) publishes research on materials (including nanostructures, micelles, macro-molecules, statistical mechanics and thermodynamics of condensed matter, biophysical chemistry, and general physical chemistry), as well as studies on the structure and properties of surfaces and interfaces.

Heterocycles (organic chemistry, experimental) publishes research in the areas of organic, pharmaceutical, analytical, and medicinal chemistry of heterocyclic compounds.

Tetrahedron (organic chemistry, experimental) publishes general experimental and theoretical research results in the field of organic chemistry and applications in related disciplines especially bio-organic chemistry.

5.6.2 Experimental and Historical Science

The first study we will discuss compares writing styles between experimental and historical science journals [2]. We first considered if a difference between the types of science could be identified, examining the 10-fold cross-validation accuracy of models built by an SVM (SMO with a linear kernel [91]) for classifying articles as "experimental" or "historical", using SFL features of EXPANSION, COMMENT, and MODALITY over the entire corpus of articles from 12 journals. Average accuracy was 81.6%. To calibrate results, we then ran the same discrimination test for all 462 different partitions of the twelve journals into two groups of six journals each. This gave a mean accuracy of only 65.4% (range 55.4–81.6%), indicating that the division into experimental and historical sciences is well supported by differences in style between writing in different journals.

Given this result, we can now consider what consistent pattern of distinguishing features, if any, emerges. That is, what features can be said to consistently indicate

either historical or experimental science articles? To do this, we used all training data for each pair of a historical science journal with an experimental science journal (36 pairs in all), and ranked the features by their weight for one or the other journal in the weight vector computed by the SMO learning algorithm. We summarize here the main results; for more detail, see [2].

First, in the system of EXPANSION, we see an opposition between Extension, which is an indicator for historical science articles, and Enhancement, an indicator for experimental science articles. This implies that historical science articles generally have a higher density of separate informational items, whereas experimental science articles tend to have fewer discrete information items, though the information items they do have may have their meaning deepened or qualified by informationally-related clauses. This may reflect differing principles of rhetorical organization—experimental scientists preferring a single coherent "story line" focused on enhancements of a small number of focal propositions, with historical scientists preferring a multifocal "landscape" of connected propositions. This supports the hypothesis that contrasts contextual examination of various and highly unique entities by historical science with a more universalist, hence narrowly focused, examination of generic entities by experimental science.

Further support for such methodological distinctions between kinds of science are further supported by preferences for types of COMMENT. Validative and Admissive Comments are indicators for historical science articles compared to a very strong consistent indication of Predictive Comments for experimental science articles. The latter result is a clear consequence of the experimental scientist's focus on predictive accuracyx. Historical sciencex, on the other hand, evinces a rhetorical need (via Validative Comments) to explicitly delineate the scope of validity of different assertions, likely as a consequence of synthetic thinking [15] about complex and ambiguous webs of past causation [25]. An Admissive comment marks a clause as the opinion (perhaps strongly held) of the author; this too appears indicative of a more hedged and explicitly comparative argumentation style.

Finally, we may consider some aspects of variation in expressions of MODALITY between the two classes of articles. The primary opposition is in modality Type. Experimental science writing has a preference for using Modulation (assessing what "must" or "is able" to happen), which is consistent with a focus on prediction and manipulation of nature. Concurrently, historical science writing shows a preference for Modalization (assessing "likelihood" or "usuality"), consistent with the outlook of an observer who usually cannot directly manipulate or replicate outcomes, and so (i) cannot make unqualified statements of what must (or must not) happen, and (ii) uses therefore the method of "multiple working hypotheses".

These results show how variations in language use between articles from different disciplines can be directly linked with the particular modes of reasoning posited by philosophers for these different kinds of science. Stylistic text analysis thus can lend some empirical weight to the argument for a multiplicity of methods in science, rather than a single monolithic "scientific method".

5.6.3 Geology and Paleontology

In another study [9], we consider if stylistic differences between articles in geological and paleontological journals may be found, and if so, what they may mean. As above, we applied the SMO system to learn classification models and measured accuracy by 10-fold cross-validation. We found that using Conjunction, Modality, and Assessment features resulted in low classification accuracies (all below 68%), while Appraisal features gave a higher 77.4%. Using function words together with all the systemic feature types gave the highest accuracy of 87.5%, higher than using just function words at 84.9% ($p < 0.05$). Together, these results indicate that while paleontology and geology have similar preferences for rhetorical structure (measured by Conjunction) and epistemic commitments (measured by Assessment), there are definite stylistic differences, a portion of which relate to the use of evaluative language.

To understand better the differences between geological and paleontological language, we next consider oppositions among the top twenty systemic features from the model constructed for the two article classes using the full feature set, shown in Table 5.2. Appraisal is the most important, yielding the largest boost in classification power, as noted above, and accordingly generating many highly ranked oppositions. ORIENTATION is most important overall—geologists appear to prefer Positive appraisal, while paleontologists prefer Negative. This opposition is also seen within JUDGEMENT and ATTITUDE. Such appraisal often appears when describing the results of the current, or of previous, research. Geology appears to prefer positive appraisal, stressing the cooperative and incremental nature of the research enterprise, as in, e.g., "...collectively and *consistently* point to a single conclusion..." On the other hand, paleontology tends to prefer negative orientation, seeming to stress inadequacies of the evidence or of previous work, as, for example, in, "...records are *unfortunately* much more fragmented...". As well, we see cases where a researcher will discredit previous work based on new evidence, as in "...the approach taken is fundamentally *flawed*." It seems that, in a sense, geologists more often express positive views of previous work as they often apparently view their work as adding to it, while paleontologists are more often negative, seeing themselves as replacing old 'truths' with new ones.

Next, oppositions in APPRECIATION indicate a distinction between a geological focus on Reaction (i.e., the effect of the object on an observer) and a paleontological focus on Composition (i.e., qualities of how the object is put together). This may indicate that paleontologists are more concerned with analyzing configurations of complex, multi-part entities (fossils of various sorts), whereas geologists tend somewhat towards more qualitative evaluations of specimens.

A similar distinction is seen in SOCIALSANCTION and in COMMENT. In SOCIALSANCTION, we see geologists more concerned with Propriety, i.e., how a methodology or a piece of evidence may fit with others, whereas paleontologists are more concerned with Veracity, in terms of how reliable particular methods or bits of evidence are on their own.

Table 5.2 Oppositions from the twenty highest-ranked systemic features in geology and paleontology articles, from the model learned using function words plus all systemic features

Condition	Geology	Paleontology
ORIENTATION	Positive	Negative
JUDGEMENT/SocialEsteem	ORIENT/Positive	ORIENT/Negative
JUDGEMENT/SocialSanction	ORIENT/Positive	ORIENT/Negative
ATTITUDE/Judgement	ORIENT/Positive	ORIENT/Negative
ATTITUDE/Affect	ORIENT/Positive	ORIENT/Negative
APPRECIATION	ReactionQuality	CompositionComplexity
	ReactionImpact	CompositionBalance
SOCIALSANCTION	Propriety	Veracity
COMMENT	Assertive	Validative
	Desiderative	Presumptive
ENHANCEMENT	SpatioTemporal	CausalConditional

Similarly, we see two COMMENT types descriptive of geological prose: Assertive COMMENTs (e.g., "There is *surely* more to it…"), and Desiderative COMMENTs (e.g., "In doing so, *we hope* to deduce"), which is consistent with the apparent focus of geologists on 'fitting in' noted above. Paleontologists, on the other hand, tend more to use Validative COMMENTs, expanding or contracting the scope of validity of a claim (e.g., "Holocene shells *generally* lack…"), and Presumptive COMMENTs, evaluating new claims in light of general background knowledge (e.g., "…which *apparently* are linked with…").

Finally, the single opposition we find within the CONJUNCTION system is in ENHANCEMENT, where geology prefers SpatioTemporal, while paleontology prefers CausalConditional. Geological uses of SpatioTemporal conjunction tend to describe rock configurations and development over time, as well as discourse organization (in a sort of descriptive "story-line"). Paleontologists, however, are more often explicit about hypothesized causal links between specimens and historical events (as in, e.g., "…perhaps *as a result* of migration…").

5.7 Discussion

In this chapter we have presented a view of style as the semantics of the diverse non-denotational aspects of the communicative act that the text realizes. This view subsumes previous work in computational stylistics, such as authorship attribution and genre analysis, as well as suggesting possible new avenues for research, such as automatic detection of rhetorical purpose, or identification of ideological facets, as encoded in a given text.

In this framework, there are three fundamental questions to be addressed by a computational stylistic analysis:

1. Is there indeed an identifiable stylistic distinction between the text categories of interest? This question can be answered by machine learning as we do here, or by related statistical techniques such as discriminant analysis or principal

components analysis [22]. If reliable discrimination of out-of-sample documents can be achieved, then we can legitimately claim to have found a real distinction. (The significance of the results compared to other possible partitions may need to be evaluated as well, of course.)

2. What are the textual features most characteristic each of the different classes of interest? These may be identified by examining the learned classification models (as here), or by other techniques such as finding high information-gain features or the like. Examination of these features should reveal if the distinction identified is indeed stylistic in nature, or if it is primarily content-based (in which case possible stylistic significance of topic variation should be considered). Also, different methods for choosing features may give different results; a possible reliability check is to see if these different feature sets are mostly the same, or if they are fundamentally different. If the latter, then this difference should be explained.

3. How do these "indicator features" relate to the fundamental facets of communication that are involved in the stylistic question being considered? Do these features fall into well-defined categories based on linguistic or sociological criteria? If they can be so organized, then we must see to what extent such groupings accord with the distinctions we might expect between the texts based on the differences in the facets involved in their production. So when we see that (roughly speaking) women use an "involved" style and men an "informative" style, we ought to relate this discovery both to variation between men and women in the typical Content they write about and also to any documented differences in how maleness and femaleness are construed in the underlying Context of the discourse. This may be a very involved process, of course, and may require may analyses of multiple corpora to answer this question with real depth and certainty.

This methodology is exemplified in this chapter by three relatively focused case studies. While there is certainly a great deal more work to be done, the analyses and their results enable some general conclusions, and demonstrate the usefulness of our framework for understanding style.

5.7.1 Case Studies

Each of the three case studies presented here serves to isolate certain stylistic facets for investigation. Overall, they show how discrimination analysis of controlled corpora with properly chosen feature sets enables semantic/pragmatic characterization of stylistic differences between groups of text that can be linked back to significant differences in facets of the relevant communicative acts. The case studies, taken together, address primarily the facets of Author, Purpose, Content, and Context (specifically ideology and to a lesser extent ontology), with some consideration of the effects of Medium on textual style. More systematic study relating textual effects of these facets, together with Audience and a more complete treatment of Medium and Context, is certainly needed. Yet

even these relatively focused analyses point towards some general conclusions about communication style.

Our first case study shows that the text of a blog carries reliable cues as to both the age and sex of its author. These results directly bear on influences of the Author facet on textual style. Less obviously, these results also appertain to the ideology underlying the text, insofar as age and sex are socially-relevant categories of being. Our main finding is that the main textual influence of both age and sex of the author is variation between more inwardly-directed (younger, female) and more externally-directed (older, male) textual foci. For the case of gender, our results are consistent both with common stereotypes and with other research on language and gender (e.g., [26, 61, 85, 86]). There is less work on the influence of age on language use, though our results are consistent with results showing a correlation between increasing age and more focus on future events as opposed to less focus on past events and first-person reference [90]. The connection between gender and age evident in our results may indicate a fundamental aspect of how the constructions of gender and age in our culture's ideology are linked, though more work will be needed to elucidate the nature of any such connection.

The second case study we discuss here shows how deceptive features inserted by the Author can be filtered out, to achieve more reliable authorship attribution. The fact that such a technique works is strong evidence that there are fundamental invariants in authorial style. Our admittedly anecdotal examination of the deceptive features that the unmasking technique filters out gives us reason to believe that stylistic deception is on a rather coarse level, involving words and phrases with specific semantic and pragmatic features that the author can consciously recognize as not occurring in his own writing. But more subtle grammatical constructions (such as the use of the Hebrew for "etc." in the texts we examined) will give the author away.

The third case study we examined looks not at authorship, but at issues of disciplinary genres in journal articles from different sciences. There, our focus was on analyzing how differences in scientific methodology, i.e., differences in Purpose and Context (mainly ideology), show up in the linguistic construction of the texts of different kinds of science. Our results show first of all that experimental and historical science articles have clearly distinct characteristic writing styles. Furthermore, we see how these styles are directly linkable to meaningful, previously-posited, methodological differences between the kinds of science, in terms of preferences for certain cohesion strategies and modal assessments. These indicate that the main methodological differences are in questions of focus and of evidentiary reasoning.

More fine-grained distinctions can also be observed, as in our comparison of geological and paleontological articles. Here we too saw clear stylistic distinctions between the fields, but the meaningful distinguishing features were mainly in Appraisal, indicating that methodological differences between the fields likely lie more in the relationship construed between the researcher and their "knowledge base", whether consisting of prior research results or newly observed evidence.

5.7.2 Future Directions

In our view, a key research goal for computational stylistics is the development of feature sets which both enable effective stylistic classification and also allow meaningful characterization of the relevant textual styles. The functional lexical feature set described in this chapter is a first step towards this goal. The idea is that functionally meaningful taxonomies of computable features allow discovery of meaningful oppositions between sets of texts; these oppositions in turn give insight into the various underlying causes of the stylistic differences, in terms of (e.g.) different Author characteristics or Purposes.

Developing more extensive and sophisticated such feature sets is but the beginning, though, as relating these features to specific aspects of the communicative act is non-trivial in general. A key problem is that the textual realizations of these different aspects overlap in the text. For example, pronoun use is known to be affected by characteristics of a text's Author, its Purpose, and its Medium (cf. [6, 19]). How to properly deal with these complex interdependencies remains a central open research question. The question is crucial for applications such as authorship attribution, where it is necessary to determine whether a stylistic difference between two texts is due to differing authorship or whether it may be due to differences in genre or purpose. Progress on this question will require the development of larger and more complex corpora including texts of many different types by many different authors.

Our breakdown of the communicative act into component influences may also prove fruitful for organizing stylistic analyses in expressive media other than text. The fact that characteristics of the Author and Audience influence style are clear in all media, though the specific expressive correlates and relevant characteristics may vary. Harold Cohen, in Chap. 1, has forcefully made the point that understanding an artist's choice of Medium for a particular artistic Purpose are essential to a true understanding of artistic style. Similarly, aspects of musical style can be best understood by relating them to Purposive goals of eliciting emotional responses, as discussed by Dubnov in Chap. 7, or of serving particular social functions (accompanying dances or the like). Context is also relevant—in all media, the artistic/expressive history and background, the analogue of the intertext, is certainly a major influence on style; social ideology is an important influence; and more-or-less elaborated medium-specific ontologies may also be relevant. We suggest therefore that this schema, or something like it, could serve as a framework to integrate, to some extent, work on stylistic analysis in disparate media.

References

1. Androutsopoulos I, Koutsias J, Chandrinos K, Paliouras G, Spyropoulos C (2000) An evaluation of Naive Bayesian anti-spam filtering. In: Proceedings of the workshop on machine learning in the New Information Age, Barcelona.

2. Argamon S, Dodick J, Chase P (2008) Language use reflects scientific methodology: a corpus-based study of peer-reviewed journal articles. Scientometrics 75(2):203–238
3. Argamon S, Goulain J-B, Horton R, Olsen M (2009) Vive la différence! text mining gender difference in French literature. Digital Humanit Q 3(2). http://digitalhumanities.org/dhq/vol/3/2/
4. Argamon S, Koppel M, Avneri G (1998) Routing documents according to style. In: Proceedings of int'l workshop on innovative internet information systems, Pisa, Italy
5. Argamon S, Koppel M, Fine J, Shimony AR (2003) Gender, genre, and writing style in formal written texts. Text 23(3):321–346
6. Argamon S, Koppel M, Pennebaker JW, Schler J (2007) Mining the blogosphere: age, gender and the varieties of self-expression. First Monday, 12(9). http://firstmonday.org/issues/issue12_9/argamon/index.html
7. Argamon S, Olsen M (2006) Toward meaningful computing. Commun ACM 49(4):33–35
8. Argamon S, Šarić M, Stein SS (2003) Style mining of electronic messages for multiple author discrimination. In: Proceedings of ACM conference on knowledge discovery and data mining
9. Argamon S, Whitelaw C, Chase P, Dhawle S, Garg N, Hota SR, Levitan S (2007) Stylistic text classification using functional lexical features. J Am Soc Inf Sci 58(6):802–822
10. Argamon S, Koppel M, Avneri G (1998) Routing documents according to style. In: First international workshop on innovative information systems, Pisa
11. Argamon S, Levitan S (2005) Measuring the usefulness of function words for authorship attribution. In: Proceedings of the 2005 ACH/ALLC conference, Victoria, BC, Jun 2005
12. Argamon-Engelson S, Koppel M, Avneri G (1998) Style-based text categorization: what newspaper am i reading? In: Proceedings of AAAI workshop on learning for text categorization, Madison, WI, pp 1–4
13. Austin JL (1976) How to do things with words. Oxford University Press, Oxford
14. Harald Baayen R, van Halteren H, Tweedie F (1996) Outside the cave of shadows: using syntactic annotation to enhance authorship attribution. Lit Linguist Comput 7:91–109
15. Baker VR (1996) The pragmatic routes of American quaternary geology and geomorphology. Geomorphology 16:197–215
16. Bean D, Riloff E (2004) Unsupervised learning of contextual role knowledge for coreference resolution. Proceedings of HLT/NAACL, Boston, MA, pp 297–304
17. Ben-David YL (2002) Shevet mi-Yehudah (in Hebrew). No publisher listed, Jerusalem
18. Berry MJ, Linoff G (1997) Data Mining techniques: for marketing, sales, and customer support. Wiley, New York, NY
19. Biber D (1995) Dimensions of register variation: a cross-linguistic comparison. Cambridge University Press, Cambridge
20. Bloom K, Garg N, Argamon S (2007) Extracting appraisal expressions. In: HLT/NAACL 2007, Rochester, NY, April 2007
21. Burrows J (2002) 'Delta': a measure of stylistic difference and a guide to likely authorship. Lit Linguis Comput 17(3):267–287
22. Burrows JF (1987) Computation into criticism: a study of Jane Austen's novels and an experiment in method. Clarendon, Oxford
23. Butler CS (2003) Structure and function: a guide to three major structural-functional theories. John Benjamins, Amsterdam
24. Chaski CE (1999) Linguistic authentication and reliability. In: National conference on science and the law, National Institute of Justice, San Diego, CA
25. Cleland CE (2002) Methodological and epistemic differences between historical science and experimental science. Philos Sci 69(3):447–451
26. Coates J (2004) Women, men and language: a sociolinguistic account of gender differences in language. Pearson Education, New York, NY
27. Dagan I, Karov Y, Roth D (1997) Mistake-driven learning in text categorization. In: Cardie C, Weischedel R (eds) Proceedings of EMNLP-97, 2nd conference on empirical methods in

natural language processing, Providence, US, 1997. Association for Computational Linguistics, Morristown, TN pp 55–63

28. D'Andrade RG (1995) The development of cognitive anthropology. Cambridge University Press, Cambridge

29. de Vel O (2000) Mining e-mail authorship. In: Workshop on text mining, ACM international conference on knowledge discovery and data mining, Boston, MA

30. de Vel O, Anderson A, Corney M, Mohay G (2001) Mining email content for author identification forensics. ACM SIGMOD Rec 30(4):55–64

31. de Vel O, Corney M, Anderson A, Mohay G (2002) Language and gender author cohort analysis of e-mail for computer forensics. In: Proceedings of digital forensic research workshop, Syracuse, NY

32. Diamond J (2002) Guns, germs and steel: the fates of human societies. W.W. Norton, New York, NY

33. Dimitrova M, Finn A, Kushmerick N, Smyth B (2002) Web genre visualization. In: Proceedings of the conference on human factors in computing systems, Minneapolis, MN

34. Fawcett RP (1980) Cognitive linguistics and social interaction: towards an integrated model of a systemic functional grammar and the other components of a communicating mind. John Benjamins, Amsterdam

35. Feiguina O, Hirst G (2007) Authorship attribution for small texts: literary and forensic experiments. In: Proceedings of the conference of the international association of forensic linguistics, Seattle, WA

36. Finn A, Kushmerick N, Smyth B (2002) Genre classification and domain transfer for information filtering. In: Crestani F, Girolami M, van Rijsbergen CJ (eds) Proceedings of ECIR-02, 24th European colloquium on information retrieval research, Glasgow, Springer, Heidelberg, DE

37. Forman G (2003) An extensive empirical study of feature selection metrics for text classification. J Mac Learn Res 3(7–8):1289–1305

38. Genkin A, Lewis DD, Madigan D (2006) Large-scale Bayesian logistic regression for text categorization. Technometrics 49(3):291–304

39. Gorsuch RL (1983) Factor analysis. L. Erlbaum, Hillsdale, NJ

40. Gould SJ (1986) Evolution and the triumph of homology, or, why history matters. Am Sci Jan.–Feb.:60–69

41. Graham N, Hirst G (2003) Segmenting a document by stylistic character. In: Workshop on computational approaches to style analysis and synthesis, 18th international joint conference on artificial intelligence, Acapulco

42. Gregory M (1967) Aspects of varieties differentiation. J Linguist 3:177–198

43. Gumperz JJ, Levinson SC (1996) Rethinking linguistic relativity. Cambridge University Press, Cambridge

44. Hacking I (2002) Historical ontology. Harvard University Press, Cambridge, MA

45. Halliday MAK, Hasan R (1976) Cohesion in English. Longman, London

46. Halliday MAK (1978) Language as social semiotic: the social interpretation of language and meaning. Edward Arnold, London

47. Halliday MAK (1994) Introduction to functional grammar, 2nd edn. Edward Arnold, London

48. Harris J (1989) The idea of community in the study of writing. Coll Compos Commun 40(1):11–22

49. Herring SC, Scheidt LA, Bonus S, Wright E (2004) Bridging the gap: a genre analysis of weblogs. In: Proceedings of the 37th Hawai'i international conference on system sciences (HICSS-37), IEEE Computer Society, Los Alamitos, CA

50. Heylighen F, Dewaele JM (2002) Variation in the contextuality of language: an empirical measure. Found Sci 7(3):293–340

51. Holmes DI (1998) The evolution of stylometry in humanities scholarship. Lit Linguis Comp 13(3):111–117

52. Holmes J, Meyerhoff M (2000) The community of practice: theories and methodologies in language and gender research. Lang Soc 28(02):173–183
53. Hoover D (2002) Frequent word sequences and statistical stylistics. Lit Linguis Comput 17:157–180
54. Joachims T (1999) Making large-scale SVM learning practical. In: Schölkopf B, Burges C, Smola A (eds) Advances in Kernel methods—support vector learning. MIT, Cambridge, MA
55. Joachims T (1998) Text categorization with support vector machines: learning with many relevant features. In: Nédellec C, Rouveirol C (eds) Proceedings of ECML-98, 10th European conference on machine learning, number 1398, Chemnitz, DE. Springer, Heidelberg, DE pp 137–142
56. Juola P (2008) Authorship attribution. Found trends Inf Retr 1(3):233–334
57. Karlgren J (2000) Stylistic experiments for information retrieval. PhD thesis, SICS
58. Kessler B, Nunberg G, Schütze H (1997) Automatic detection of text genre. In: Cohen PR, Wahlster W (eds) Proceedings of the 35 annual meeting of the association for computational linguistics and 8th conference of the European chapter of the association for computational linguistics, Association for Computational Linguistics, Somerset, NJ, pp 32–38
59. Kitcher P (1993) The advancement of science. Oxford University Press, New York, NY
60. Kjell B, Frieder O (1992) Visualization of literary style. In: IEEE international conference on systems, man and cybernetics, Chicago, IL, pp 656–661
61. Koppel M, Argamon S, Shimoni AR (2003) Automatically categorizing written texts by author gender. Lit Linguist Comput 17(4):401–412
62. Koppel M, Mughaz D, Schler J (2004) Text categorization for authorship verification. In: Proceedings of 8th Symposium on artificial intelligence and mathematics, Fort Lauderdale, FL
63. Koppel M, Schler J (2004) Authorship verification as a one-class classification problem. In: Proceedings of Int'l conference on machine learning, Banff, AB
64. Koppel M, Schler J, Argamon S (2008) Computational methods in authorship attribution. J Am Soc Inf Sci Technol 60(1):9–26
65. Koppel M, Akiva N, Dagan I (2003) A corpus-independent feature set for style-based text categorization. In: Workshop on computational approaches to style analysis and synthesis, 18th international joint conference on artificial intelligence, Acapulco
66. Kukushkina OV, Polikarpov AA, Khmelev DV (2001) Using literal and grammatical statistics for authorship attribution. Prob Inf Trans 37(2):172–184
67. Kushmerick N (1999) Learning to remove internet advertisement. In: Etzioni O, Müller JP, Bradshaw JM (eds) Proceedings of the 3rd international conference on autonomous agents (Agents'99), ACM Press, Seattle, WA, pp 175–181
68. Lang K (1995) NewsWeeder: learning to filter netnews. In: Proceedings of the 12th international conference on machine learning, Morgan Kaufmann, San Mateo, CA, pp 331–339
69. Lewis DD (1998) Naive (Bayes) at forty: the independence assumption in information retrieval. Proceedings of ECML-98, 10th European conference on machine Learning, 1998, Berlin, Springer, Heidelburg, pp 4–15
70. Littlestone N (1987) Learning when irrelevant attributes abound. In: Proceedings of the 28th annual symposium on foundations of computer science, October 1987, Los Angeles, CA, pp 68–77
71. Martin JR (1992) English text: system and structure. Benjamin's, Amsterdam
72. Martin JR, White PRR (2005) The language of evaluation: appraisal in English. Palgrave, London
73. Mascol C (1888) Curves of Pauline and Pseudo-Pauline style I. Unitarian Rev 30:452–460
74. Mascol C (1888) Curves of Pauline and Pseudo-Pauline style II. Unitarian Rev 30:539–546
75. Matthews RAJ, Merriam TVN (1997) Distinguishing literary styles using neural networks, chapter 8. IOP publishing and Oxford University Press, Oxford

76. Matthiessen C (1995) Lexico-grammatical cartography: English systems. International Language Sciences Publishers, Tokyo
77. Mayr E (1976) Evolution and the diversity of life. Harvard University Press, Cambridge, MA
78. Mayr E (1985) How biology differs from the physical sciences. In: Evolution at the crossroads: the new biology and the new philosophy of science, MIT, Cambridge, pp 43–46
79. McCallum A, Nigam K (1998) A comparison of event models for Naive Bayes text classification. AAAI-98 workshop on learning for text categorization, 752, pp 41–48
80. McEnery A, Oakes M (2000) Authorship studies/textual statistics, Marcel Dekker, New York, NY, pp 234–248
81. McKinney V, Yoon K, Zahedi FM (2002) The measurement of web-customer satisfaction: an expectation and disconfirmation approach. Info Sys Res 13(3):296–315
82. McMenamin G (2002) Forensic linguistics: advances in forensic stylistics. CRC press
83. Mendenhall TC (1887) Characteristic curves of composition. Science 9(214s):237–246
84. Mosteller F, Wallace DL (1964) Inference and disputed authorship: the federalist. Series in behavioral science: quantitative methods edition. Addison-Wesley, Reading, MA
85. Mulac A, Lundell TL (1986) Linguistic contributors to the gender-linked language effect. J Lang Soc Psychol 5(2):81
86. Newman ML, Groom CJ, Handelman LD, Pennebaker JW (2008) Gender Differences in language use: an analysis of 14,000 text samples. Discourse Process 45(3):211–236
87. Ng V (2004) Learning noun phrase anaphoricity to improve coreference resolution: issues in representation and optimization. Proceedings of the 42nd annual meeting of the association for computational linguistics (ACL), Barcelona, pp 152–159
88. Pang B, Lee L, Vaithyanathan S (2002) Thumbs up? sentiment classification using machine learning techniques. In: Proceedings of EMNLP conference on empirical methods in natural language processing, Philadelphia, PA, pp 79–86
89. Patrick J (2004) The scamseek project: text mining for financial scams on the internet. In: Simoff SJ, Williams GJ (eds) Proceedings of 3rd Australasian data mining conference, Carins, pp 33–38
90. Pennebaker JW, Mehl MR, Niederhoffer K (2003) Psychological aspects of natural language use: our words, our selves. Ann Rev Psychol 54:547–577
91. Platt J (1998) Sequential minimal optimization: a fast algorithm for training support vector machines. Microsoft research technical report MSR-TR-98-14, Redmond, WA
92. Rudman J (1997) The state of authorship attribution studies: some problems and solutions. Comput Human 31(4):351–365
93. Rudolph JL, Stewart J (1998) Evolution and the nature of science: on the historical discord and its implication for education. J Res Sci Teach 35:1069–1089
94. Searle JR (1989) Expression and meaning: studies in the theory of speech acts. Cambridge University Press, Cambridge
95. Sebastiani F (2002) Machine learning in automated text categorization. ACM Comput Surv 34(1)
96. Stamatatos E, Fakotakis N, Kokkinakis GK (2000) Automatic text categorization in terms of genre, author. Comput Linguist 26(4):471–495
97. Swales JM (1990) Genre analysis. Cambridge University Press, Cambridge
98. Torvik VI, Weeber M, Swanson DR, Smalheiser NR (2005) A probabilistic similarity metric for Medline records: a model for author name disambiguation. J Am Soc Inf Sci Technol, 56(2):140–158
99. Turney PD (2002) Thumbs up or thumbs down? semantic orientation applied to unsupervised classification of reviews. In: Proceedings 40th annual meeting of the ACL (ACL'02), Philadelphia, PA, pp 417–424
100. Tweedie F, Singh S, Holmes D (1996) Neural network applications in stylometry: the federalist papers. Comput Human 30(1):1–10
101. Wenger E (1999) Communities of practice: learning, meaning, and identity. Cambridge University Press, Cambridge

102. Whewell W (1837) History of the inductive sciences. John W. Parker, London
103. Yang Y (1999) An evaluation of statistical approaches to text categorization. Inf Retr 1(1):69–90
104. Yang Y, Pedersen JO (1997) A Comparative study on feature selection in text categorization. Proceedings of the 14th international conference on machine learning table of contents, Nashville, TN, pp 412–420
105. Yule GU (1994) Statistical study of literary vocabulary. Cambridge University Press, Cambridge
106. Yule GU (1938) On sentence length as a statistical characteristic of style in prose with application to two cases of disputed authorship. Biometrika 30:363–390

Chapter 6
Textual Stylistic Variation: Choices, Genres and Individuals

Jussi Karlgren

Abstract This chapter argues for more informed target metrics for the statistical processing of stylistic variation in text collections. Much as operationalized relevance proved a useful goal to strive for in information retrieval, research in textual stylistics, whether application oriented or philologically inclined, needs goals formulated in terms of pertinence, relevance, and utility—notions that agree with reader experience of text. Differences readers are aware of are mostly based on utility—not on textual characteristics per se. Mostly, readers report stylistic differences in terms of genres. Genres, while vague and undefined, are well-established and talked about: very early on, readers learn to distinguish genres. This chapter discusses variation given by genre, and contrasts it to variation occasioned by individual choice.

6.1 Stylistic Variation in Text

Texts are much more than what they are about. Authors make choices when they write a text: they decide how to organize the material they have planned to introduce; they select amongst available synonyms and syntactic constructions; they target an intended audience for the text. Authors will make their choices in various ways and for various reasons: based on personal preferences, on their view of the reader, and on what they know and like about other similar texts. These choices are observable to the reader in the form of stylistic variation, as the difference between two ways of saying the same thing.

On a surface level this variation is quite obvious, as the choice between items in a vocabulary, between types of syntactical constructions, between the various ways a text can be woven from the material it is made of. A consistent and distinguishable tendency to make some of these linguistic choices can be called a *style*. It is the information carried in a text when compared to other texts, or in a sense compared

J. Karlgren (✉)
Swedish Institute of Computer Science, Box 1263, SE-164 29 Kista, Sweden
e-mail: jussi@sics.se

S. Argamon et al. (eds.), *The Structure of Style*,
DOI 10.1007/978-3-642-12337-5_6, © Springer-Verlag Berlin Heidelberg 2010

to language as a whole. It is not incidental but an integral part of the intended and understood communication, and will impart to the reader a predisposition to understand the meaning of text in certain ways. Managing stylistic choice is the mark of a competent author—learning how to do so well is a craft which requires training and experience. Recognising stylistic choice is an important component of reading competence—a proficient reader will be sensitive to stylistic variation in texts.

Consistent situationally motivated strategies for making the appropriate stylistic choices is a functional strategy on the part of the author, and enables readers to identify likenesses across individual texts or utterances, thus guiding the reader in understanding them. Such consistent bundled observable occurrence patterns of linguistic items are easily observable and recognisable by statistical analysis and constitute a useful tool for achieving the communicative purposes of the author.

6.2 Detecting Stylistic Variation in Text

It is easy enough to establish that there are observable stylistic differences between texts we find in document collections. However, while statistical analysis of stylistic differences between texts is mostly uncomplicated in every particular instance, it is difficult to provide general solutions, without descending into specifics or idiosyncracies. Using the textual, lexical, and other linguistic features we find to cluster the collection—without anchoring information in usage—we risk finding statistically stable categories of data without explanatory power or utility.

A more linguistically informed approach is to start from established knowledge (or established presumption, as it were) and to work with a priori hypotheses on qualities of textual variation. The observations we are able to make from inspection of the linguistic signal are limited by the quality of the analysis tools we have recourse to. The features we find are often on a low level of abstraction and are simultaneously superficial and specific. To abstract to a higher level of abstraction from the observable surface features it is useful to understand them as the exponents of some underlying or latent dimensions of variation within the space of possible texts—Douglas Biber, for example, whose work has informed much of the work on computational stylistics, has posited dimensions such as Involved vs Informed, Narration vs Argumentation, Personal vs Impersonal [2, 3].

Investigating such underlying dimensions of variation, establishing hypotheses about which dimensions are reasonable and effective, based on study of the material at hand, on knowledge of human linguistic and communicative behaviour, on understanding of computation and processing constraints, is the main task for computational stylistics today—and a task which only to some extent can be accomplished using purely formal, data-oriented methods, without studying either textuality or readership.

If we wish to contribute to better text handling tools and to a better understanding of human textual practice by the statistical processing of stylistic variation in

text collections we need principled hypotheses of human linguistic processing and communicative behaviour to base our experimentation on. We need to understand what consequences our claims have on representation, processing, and application, and we need a research methodology which invites the systematic evolution of new results. Much as operationalized relevance has proven a useful goal to strive for in information retrieval, research in textual stylistics, whether application oriented or philologically inclined, needs goals formulated in terms of pertinence, relevance, and usefulness.

Such notions agree with reader experience of text: the differences readers are aware of are mostly based on utility—not on textual characteristics per se.

6.3 Genres as Vehicles for Understanding Stylistic Variation

Stylistic differences vary by author preferences and by constraints imposed by situation the text is produced in. This is reflected when readers are asked about texts.

In questionnaires or interviews, readers mostly report stylistic differences either by describing the *source* of the text, or in terms of categories of text, in terms of *genres*. Readers describe genres in terms *utility*, in terms of perceived *quality* of the text in some prescriptive terms, or in terms of *complexity* of the text and subject matter. On follow-up questioning readers will bring up subjective qualities such as *trustworthiness* of the text or further discuss *readability* or other specifics related to complexity, both lexical and syntactic (and specifically making claims in both dimensions simultaneously, typically claiming that leader articles are difficult and long-winded or that sports features are inane and simplistic). Readers will describe genres by describing situations in which the genre is relevant, through experiences of reading a genre, by typical topics or content, and only in some very specific cases do readers give examples of lexical or other linguistic features of the text [4].

Demarcation of stylistic variation to topical variation is of course impossible: the content and form of the message cannot be divorced. Certain meanings must or tend always to be expressed in certain styles: legal matters tend to be written in legal jargon rather than hexameter; car ownership statistics in journalistic or factual style. Drawing a clean distinction between meaning and style, between form and content, is in practice impossible except for certain special cases; it is worth questioning whether there are any formally identifiable styles at all beyond the distinctions that topical analysis already give us [5].

Genre is a vague but well-established notion, and genres are explicitly identified and discussed by language users. Early on in their reading career, readers learn to distinguish texts of different genres from each other: children's books from encyclopedias, news from magazines, handbooks from novels. Genres have a reality in their own right, not only as containers or carriers of textual characteristics.

Genre analysis is a practical tool for the analysis of human activity in many ways in many different fields loosely related to each other, some more formal than other. In recent years, genre analysis has been extended to typologies of communicative

situations beyond the purely textual [1, 13], with genres ranging much further than would be afforded by analysis of written text: the range of possible human communicative activities is much wider than the range of possible texts. (This present discussion is mostly concerned with written texts, but it should be noted that generalisations to other communicative situations are obvious and obviously interesting.) Each such communicative sphere can be understood to establish its conventions as to how communicative action can be performed. When these conventions bundle and aggregate into a coherent and consistent socially formed entity, they guide and constrain the space of potential communicative expressions and form a genre, providing defaults where choices are overwhelming and constraints no choices should be given.

A text cannot stray too far the prototypical expression expected within the genre, or its readers will be confused and hindered in their task of understanding it. Genre conventions form a framework of recurrent practice for authors and readers alike and a basis of experience within which the communication, its utterances and expressions are understood: participants in the communicative situation use style as a way of economizing their respective communicative effort. This basic premise, that of effective communicative practice on part of participants, should be kept in mind during the study of stylistic variation in text: they will form be the basis on which hypotheses of latent dimensions of appropriate explanatory power can be built.

The perceptions of readers may be interesting, elucidating, and entertaining to discuss, but are difficult to encode and put to practical use. While we as readers are good at the task of distinguishing genres, we have not been intellectually trained to do so and we have a lack of meta-level understanding of how we proceed in the task. To provide useful results, whether for application or for the understanding of human communicative behaviour, research efforts in stylistic analysis must model human processing at least on a behavioural level at least to some extent. We need to be able to address the data on levels of usefulness, and we need to observe people using documents and textual information to understand what is going on.

6.4 Factors Which Determine Stylistic Variation in Text

Stylistic choices are governed by a range of constraints, roughly describable in terms of three levels of variation: firstly, and most obviously observable, choices highly bound and formalized into situation- and text-independent rule systems such as spelling, morphology or syntax, taught in schools and explicitly mentioned in lexica, grammars, and writing rules; secondly, choices that are conventional and habitual, bound by context, situation, and genre, mainly operating on the level of lexical choice and phraseology; thirdly, choices on the level of textual and informational organisation where the author of a text operates with the least amount of formal guidance (cf. Table 6.1).

Constraints in the form of language rules are studied by linguists and are understood as obligatory by language users; linguistic conventions, bound by situation are

Table 6.1 Characteristics of different levels of stylistic constraints

Rule	Language	Syntax, morphology
Convention	Situation or genre	Lexical patterns, argumentation structures, tropes
Free	Author	Repetition, organisation, elaboration

more difficult to pinpoint and formulate, except as guidelines to an author in terms of appropriateness or even "politeness"; constraints on informational organisation are few and seldom made explicit, but are what distinguishes a well-written text from a badly written one.

The conventions that a genre carries are sometimes explicitly formulated, consciously adhered to by authors, and expected by readers. Other times they are implicit and not as clearly enforced. They may even be misunderstood by the parties of a discourse without causing a complete breakdown.

For the purposes of descriptive analysis of texts, genres can be described through (a) the communicative purpose which should be somewhat consistent within the set of texts that constitute it; (b) the shared and generalised stylistic and topical character of the sets of documents, which also should be somewhat consistent; (c) the contexts in which the set of texts appear; (d) the shared understanding between author and reader as to the existence of the genre.

This last aspect does not need to be explicit to all readers or even all authors, but in typical cases, the genre is something that can be discussed by experienced authors and experienced readers, and which is intuitive and helpful to both parties. Items belonging to a genre are recognized through their appearance in specific contexts and the presence of some identifiable and characteristic choices. Phrases such as "Once upon a time", "In consideration thereof, each party by execution hereof agrees to the following terms and conditions"; rhyming or alliteration; expressions of personal judgment, opinion and sentiment; explicit mention of dates and locations are all examples of surface cues which are easy to identify. Presentation of texts printed in book form, as hand written pamphlets, read aloud at a fireside or at a lectern in a congress hall are contextual cues that afford us licence to assume them to belong to families of other similar items.

Establishing a genre palette for further studies can be a research effort in its own right. Understanding how genres are established and how they evolve in the understanding participants have and acquire of a communicative situation is a non-trivial challenge and requires elaborate methodological effort. Examples of such studies are studies of communicative patterns in distributed organisations [10, 16] or studies of how genres can be used to understand communication on the web [6].

However, understanding the social underpinnings of genres is not necessary for most computational approaches. The genres used as target metrics must have some level of salience for their readers and authors, but they must not cover all possible facets and niceties of communication to be useful for the fruitful study and effective application of stylistic variation in text. In many experiments made on computational stylistics, in the case of many experimental collections, and in fact

in the minds of many readers, genre has mostly been equated with or based on text source. Since genres are strongly dependent on context, and authorship analysis is one of the prime applications for stylistic analysis, this is a fair approximation. More usage-based and functionally effective approximations than source can be high level categories such as "narrative" vs "expository"; "opinionated" vs "neutral"; "instructional and factual" vs "fiction and narrative" vs "poetry and drama"; or alternatively, specific categories such as "legal", "technical", "commercial" as might be found in some specific collection such as a corporate document archive. categories chosen must have some base in usage rather than in statistically determined differences: the latter can be overspecific, underdetermined, and lead the study astray.

6.5 Individual Variation vs Situational Variation

Seasoned authors are likely to feel free to break many of the conventions of a genre, in effect creating a voice or style of their own (or even a style specific to some specific text or situation), where a novice author will be more likely to follow conventions, falling back on defaults where experience gives insufficient guidance, using unmarked cases where choice between alternatives is difficult. (Consider Burns discussing style as a guiding mechanism for poker players in Chap. 12, and Cohen discussing style in art in Chap. 1.) In this sense, genre gives us a benchmark or a water-line with which to judge individual choice, measuring contrast between *functional style*, which forms the identifying characteristics of the genre, in contrast with *individual style* on the level of specific texts or sources [15].

The span of variation, from variation occasioned by individual performance to that constrained by the expectations given by genre, gives us several targets for stylistic study: we may wish to explore the general characteristics of communicative situations of some specific type, domain or topic; or we may wish to understand the character of a specific author or individual source. After selecting a linguistic item—some lexical item, some construction, some observation— we can study if its occurrence pattern in some sample set of texts varies from the expected occurrence of that specific item (with prior information taken into account). This is a mark of individuality and can be used in the process of identifying author, genre, or indeed, topic.

6.6 Concrete Example: Newsprint and Its Subgenres

Newsprint, while a special register of human language use in itself, is composed of several well-established subgenres. While newsprint is —together with scientific and intellectual text—over-represented as an object of empirical philological study as compared to other forms of human linguistic communication, it possesses some quite useful qualities for systematical study of linguistic characteristics, chief among them that the texts are most often intended to be the way they are. The textual material has passed through many hands on its way to the reader in order to best

Table 6.2 Sub-genres of the Glasgow Herald, with the number of articles in each

Article type		*n*
Tagged		17 467
Advertising	522	
Book	585	
Correspondence	3 659	
Feature	8 867	
Leader	681	
Obituary	420	
Profile	854	
Review	1 879	
Untagged		39 005
Total		56 472

conform to audience expectations; individual variation—worth study in itself—is not preserved to any appreciable extent in most cases; the audience is well trained in the genre. In short, the path is well-trod and as such easy to study. In this example 1 year of Glasgow Herald is studied, and many of the texts are tagged for article type—see Table 6.2.

It is easy enough to establish that there are observable differences between the genres we find posited in the textual material. Trawling the (morphologically normalized) texts for differences, comparing each identified category in Table 6.2 with the other categories we find for a 1 month sample of text some of the most typical words for each category as per Table 6.3. "Typical" is here operationalized as words with a document frequency deviating from expected occurrence as assessed by χ^2. This sort of analysis can be entertaining, at times revealing, but cannot really give us any great explanatory power. Even the handful of example terms shown in Table 6.3 are clearly coloured by the subject matter of the sub-genres and only to some extent reveal any stylistic difference between them.

Table 6.3 Typical words in sub-genres of 1 month of the Glasgow Herald

Article type	Typical words
Advertising	Provide, available, service, specialist, business
Book review	Novel, prose, author, literary, biography, write
Correspondence	(Various locations in Scotland), overdue, SNP
Feature	Say, get, think, put, there, problem, tell
Leader	Evident, government, outcome, opinion, even
Obituary	Church, wife, daughter, survive, former
Profile	Recall, career, experience, musician
Review	Concert, guitar, piece, beautifully, memorable

6.7 Measurements and Observanda

Measurement of linguistic variation of any more sophisticated kind has hitherto been hampered by lack of useful tools. Even now, most measurements made in text categorisation studies, be it for the purposes of authorship attribution, topical clustering, readability analysis or the like, compute observed frequencies of some lexical items, or some identifiable constructions. These measurements are always *local*, inasmuch they only take simple appearances of some linguistic item into account. Even when many such appearances are combined into an average or an estimate of probability of recurrence, the measurement in question is still local, in the sense that they disregard the structure and progression of the communicative signal. An observed divergence in a text sample from the expected occurrence rate of that specific item (with prior information taken into account) is a mark of specific character and can be used in the process of identifying, e.g., topic, genre, or author.

The examples given above in Table 6.4 are of this kind. A systematic tendency to pursue certain choices on the local level may be symptomatic of an underlying dimension, but is hardly likely to have any more far-reaching explanatory or predictive power. It is difficult to systematically explore, find, and formulate sensible or adequate dimensions on any level of abstraction above the trivial if the features we have at our disposal are limited to average occurrence frequency of pointwise observations of simple linguistic items.

Textual variation might instead profit from being measured on levels on which authors and readers process information, not on the level of whitespace separated character strings. Tentative candidates for more textual measurements could be using term recurrence rather than term frequency [8]; term patterns [12]; type-token ratio [14]; rhetorical structure; measures of textual cohesion and coherence; measures of lexical vagueness, inspecificity, and discourse anchoring; and many other features with considerable theoretical promise but rather daunting computational requirements.

Table 6.4 Some measurements of linguistic items per sub-genre of 1 year of the Glasgow Herald. Statistical significance ($p > 0.95$) by Mann-Whitney U

	Personal pronouns	Demonstratives "that" &c	Utterance & private verbs	Opinion & argument	Characters per word
Advertising	−	·	+	·	+
Book review	+	+	+	+	−
Correspondence	−	−	−	−	+
Feature	+	+	+	+	−
Leader	−	+	·	+	+
Obituary	−	−	·	−	−
Profile	+	+	+	+	−
Review	−	−	−	−	+

Key:

+ Significantly higher values

− Significantly lower values

· Non-significant value distribution

Leaving the simple lexical occurrence statistics and reaching for features with better informational potential proves to be rather unproblematic. We know from past studies and judicious introspection that interview articles contain quotes and that leader articles contain argumentation; both are to be expected to contain pronouns and overt expressions of opinion. Table 6.4 shows some such measurements.[1] The explanatory power of this table—again, while interesting in some respects and worth discussion—is rather low, and application of the findings for prediction of genre for unseen cases will be unreliable. A more abstract level of representation is necessary to be able to extract useful predictions and to gain understanding of what textual variation is about.

6.8 Aggregation of Measurements

A text will typically yield a number of observations of a linguistic item of interest. Most experiments average the frequency of observations and normalise over a collection of texts, or calculate odds and compare to estimated likelihoods of occurrence, as the example given above. Aggregating observations of linguistic items by averaging local occurrence frequencies over an entire text does not utilise the specific character of text, namely that it is a non-arbitrary sequence of symbols.

There is no reason to limit oneself to pointwise aggregation of observations: the inconvenience of moving to other aggregation models is minimal. In another experiment using the same data as above we have shown that *text configurational* aggregation of a feature yields better discriminatory power than pointwise aggregation does [7].

To obtain simple longitudinal patterns each observed item is measured over sliding windows of one to five sentences along each text, and the occurrence of the feature is recorded as a *transition pattern* of binary occurrences, marking the feature's absence or presence in the sentences within the window. The first and last bits of text where the window length would have extended over the text boundary can be discarded. The feature space, the possible values of the feature with a certain window size consists of all possible transition patterns for that window size—yielding a feature space of size 2^n for a window size of n. For windows of size two, the feature space consists of four possible patterns, for windows of size five, thirty-two.

6.9 Concrete Example: Configurational Features

Our hypothesis is that author (and speaker) choice on the level of informational structuring and organisation (see, again, Table 6.1) is less subject to pressure from

[1] The "PRIVATE" type of factual verb expresses intellectual states such as belief and intellectual acts such as discovery. These states and acts are "private" in the sense that they are not observable... Examples of such verbs are: *accept, anticipate ... fear, feel, ... think, understand* [11]. Opinion expression is counted by adverbials such as *clearly, offend, specious, poor, excellent.* and argument expression by counting argumentative operators such as *if ... then, else, almost.*

conventionalisation and grammaticalisation processes.[2] This is both by virtue of wide scope, which limits the possibilities of observers to track usage, as well as by the many degrees of freedom open for choice, which makes rule expression and rule following inconvenient.

We believe that configurational aggregation of observations might improve the potential for categorisation of authors, since they preserve some of the sequential information which is less constrained by convention and rules. The experiment is designed to investigate whether using such longitudinal patterns improves the potential for author identification *more* than it improves the potential for genre identification: these transition patterns can then be compared for varying window lengths—the operational hypothesis being that a longer window length would better model variation over author rather than over genre.

Using the same data from Glasgow Herald, we calculated a simple binary feature, noting the occurrence of more than two clauses of any type in a sentence. Each sentence was thus given the score 1 or 0, depending on whether it had several clauses or only one. This feature is a somewhat more sophisticated proxy for syntactic complexity than the commonly used sentence length measure.

The measurements are given in Table 6.5 for all genres, and the authors with the highest and lowest scores for each variable. As seen from the table, genres are more consistent with each other than are authors: the range of variation between 0.52 and 0.96 is greater than that between 0.78 and 0.93.

Expanding the feature space four-fold the relative presence for the various sequences of multi-clause sentences, in a window of size two, are shown in Table 6.6 for the genres labeled in the data set and for some of the more prolific authors.

This table cannot be directly compared to the measurements in Table 6.5, but using the frequency counts as probability estimates, we can use Kullback-Leibler divergence measure [9] as a measure of differences between measurements. The Kullback-Leibler divergence is a measure of distance between the states in the probability distribution, a large divergence indicating better separation between states–which is desirable from the perspective of a categorisation task, since that would

Table 6.5 Relative presence of multi-clause feature "clause" in sentences

Category	Single-clause (f_0)	Multi-clause (f_1)
Advertising	0.90	0.10
Book	0.83	0.17
Correspondence	0.92	0.08
Feature	0.93	0.07
Leader	0.93	0.07
Obituary	0.78	0.22
Profile	0.92	0.08
Review	0.87	0.13
Author A_M	0.96	0.04
Author A_m	0.52	0.48

[2] This experiment is reported in full in [7]. This section is an excerpt of that paper.

Table 6.6 Relative frequency of multi-clause sentence sequences for genres and some authors, window size 2

Genre	f_{11}	f_{10}	f_{01}	f_{00}
Advertising	0.011	0.072	0.039	0.88
Book	0.038	0.084	0.069	0.81
Correspondence	0.066	0.15	0.051	0.73
Feature	0.022	0.078	0.056	0.84
Leader	0.016	0.055	0.023	0.91
Obituary	0.0079	0.072	0.023	0.90
Profile	0.016	0.056	0.040	0.89
Review	0.041	0.13	0.072	0.76
Author	f_{11}	f_{10}	f_{01}	f_{00}
A_1	0.013	0.071	0.052	0.86
A_2	0.021	0.050	0.018	0.92
A_3	0.018	0.11	0.088	0.78
A_4	0.19	0.097	0.032	0.68
A_5	0.013	0.11	0.052	0.82
A_6	0.0062	0.071	0.020	0.90
A_7	0.018	0.063	0.038	0.88
A_8	0.0067	0.047	0.032	0.91
A_9	0.010	0.064	0.027	0.90

indicate better potential power for working as a discriminating measure between the categories under consideration. Since the measure as defined by Kullback and Leibler is asymmetric, we here use a symmetrised version, a harmonic mean (Johnson and Sinanović, 2001, Symmetrizing the Kullback-Leibler distance, unpublished). In this experiment, with eight genre labels and several hundred authors, we perform repeated resampling of eight representatives, fifty times, from the set of authors and average results to obtain comparable results with the genre distribution.

For each window length, the sum of the symmetrised Kullback-Leibler measure for all genres or authors is shown in Table 6.7. The figures can only be compared horizontally in the table—the divergence figures for different window sizes (the rows of the table), cannot directly be related to each other, since the feature spaces are of different size. This means that we cannot directly say if window size improves the resulting representation or not, in spite of the larger divergence values for larger window size. We can, however, say that the *difference* between genre categories and author categories is greater for large window sizes. This speaks to the possibility of our main hypothesis holding: a larger window size allows a better model of individual choice than a shorter one.

Table 6.7 Window size effect

Window size	Genre	Author
1	0.5129	0.7254
2	0.8061	1.3288
3	1.1600	2.1577
4	1.4556	2.3413
5	1.7051	3.0028

6.10 Conclusion: Target Measures

Our example experiment shows how the choice of observed linguistic item, choice of aggregation method, and choice of target hypothesis all work together towards making sustainable statements about stylistic variation.

The experiment shows that one method of aggregation gives different results from another set; they also show that modelling author behaviour can profitably be modelled by different features than genre—presumably, in the one case, identifying conventions, in the other, avoiding them.

In general, only if useful target measures of pertinence, relevance, and utility can be found for evaluation, couched in terms derived from study of readership and reader assessment of texts for real needs can we hope to accomplish anything of lasting value in terms of understanding choice, textual variation, and reading. This, in turn, can only be achieved beginning from an understanding that stylistic variation is real on a high level of abstraction, in the sense that readers, writers, editors all are aware of genres as an abstract category; that genres are a useful mid-level category to fix an analysis upon, and that there is no independent non-arbitrary genre palette outside the communicative situation the study is modelling.

Results of any generality can only be achieved with more informed measures measures of variation and choice, couched in terms of linguistic analysis rather than processing convenience, and aggregated by computational models related to the informational processes of the author and reader.

References

1. Bakhtin MM (1986) The problem of speech genres. In: Emerson C, Holquist M (eds) Speech genres and other late essays (trans: McGee VW). University of Texas Press, Austin, TX
2. Biber D (1988) Variation across speech and writing. Cambridge University Press, Cambridge, MA
3. Biber D (1989) A typology of English texts. Linguistics 27:3–43
4. Dewe J, Karlgren J, Bretan I (1998) Assembling a balanced corpus from the internet. In: Proceedings of the 11th Nordic conference of computational linguistics, University of Copenhagen, Copenhagen, January 1998
5. Enkvist NE (1973) Linguistic stylistics. Mouton, The Hague
6. Herring SC, Scheidt LA, Bonus S, Wright E (2004) Bridging the gap: a genre analysis of weblogs. In: Proceedings of the 37th Hawai'i international conference on system sciences (HICSS-37), IEEE Computer Society, Los Alamitos, CA
7. Karlgren J, Eriksson G (2007) Authors, genre, and linguistic convention. In: Proceedings of the SIGIR workshop on plagiarism analysis, authorship identification, and near-duplicate detection, Amsterdam
8. Katz S (1996) Distribution of content words and phrases in text and language modelling. Nat Lang Eng 2:15–60
9. Kullback S, Leibler RA (1951) On information and sufficiency. Ann Math Stat 22:79–86
10. Orlikowski WJ, Yates J (1994) Genre repertoire: examining the structuring of communicative practices in organizations. Adm Sci Q 39:541–574
11. Quirk R, Greenbaum S, Leech G, Svartvik J (1985) A comprehensive grammar of the English language. Longman, London

12. Sarkar A, de Roeck A, Garthwaithe PH (2005) Term re-occurrence measures for analyzing style. In: Textual stylistics in information access. Papers from the workshop held in conjunction with the 28th international conference on research and development in information retrieval (SIGIR), Salvador, Brazil, August 2005
13. Swales J (1990) Genre analysis: English in academic and research settings. Cambridge University Press, Cambridge, MA
14. Tallentire D (1973) Towards an archive of lexical norms: a proposal. In: Aitken A, Bailey R, Hamilton-Smith N (eds) The computer and literary studies. Edinburgh University Press Edinburgh, TX
15. Vachek J (1975) Some remarks on functional dialects of standard languages. In: Ringbom H (ed) Style and text—studies presented to Nils Erik Enkvist. Skriptor, Stockholm
16. Yates J, Orlikowski WJ (1992) Genres of organizational communication: a structurational approach to studying communication and media. Acad Manage Rev 17:299–326

Chapter 7
Information Dynamics and Aspects of Musical Perception

Shlomo Dubnov

Abstract Musical experience has been often suggested to be related to forming of expectations, their fulfillment or denial. In terms of information theory, expectancies and predictions serve to reduce uncertainty about the future and might be used to efficiently represent and "compress" data. In this chapter we present an information theoretic model of musical listening based on the idea that expectations that arise from past musical material are framing our appraisal of what comes next, and that this process eventually results in creation of emotions or feelings. Using a notion of "information rate" we can measure the amount of information between past and present in the musical signal on different time scales using statistics of sound spectral features. Several musical pieces are analyzed in terms of short and long term information rate dynamics and are compared to analysis of musical form and its structural functions. The findings suggest that a relation exists between information dynamics and musical structure that eventually leads to creation of human listening experience and feelings such as "wow" and "aha".

7.1 Introduction: The Pleasure of Listening

In previous chapters we have seen how determination of style is related to different aspects of production, focusing on questions of how rather then what, distinguishing manner from content. But style and its rules cannot be fully understood without considering how the information about these rules is encoded in the music and decoded by the listener. Modeling music listening in terms of information processing may reveal how stylistic rules are represented, why they are chosen, what makes them influence the listener, or in general suggest a framework for understanding how style production is related to perception. Moreover, the question of content versus manner in music carries special significance, since music has no clear "content", and its meaning is usually related to emotions that are closer to manner then to content. So is everything in music a question of "manner" and thus style?

S. Dubnov (✉)
Department of Music, University of California, San Diego, CA, USA
e-mail: sdubnov@ucsd.edu

S. Argamon et al. (eds.), *The Structure of Style*,
DOI 10.1007/978-3-642-12337-5_7, © Springer-Verlag Berlin Heidelberg 2010

In this chapter we will outline the principles according to which a machine, and possibly our brain, might be able to experience and possibly derive pleasure from listening to music. Music is a complex phenomenon that has structure on many levels and parameters. The ability to listen to music in an aesthetic or experiential manner is related to ability to discover and follow these structures. But following itself is not enough—we assume that in order to create feelings there needs to be some sort of relevance measure that tells how informative the contents are and how well they suit our expectations. In some sense, the ability to form expectations and the ability to judge relevance are closely linked. By forming expectations the listener in fact tries to encode more efficiently the next event. In such case the act of listening can be considered as information processing, where expectations are used to reduce the uncertainty about the future. Considered over many instances, the average uncertainty can be used to measure the relevance of events relative to prediction rules or expectations, thus expressing preferences for particular types of musical structure. Accordingly, style plays a central role in creating preferences by framing our expectations towards these structures. It had been suggested that during listening we perform an appraisal of the "successes" and "failures" of such expectations. In this chapter we address the question of modeling average performance of expectancies by using a measure of mutual information between past and present of musical contents. When this information is measured over different times and its changes are tracked over time, we shall call it *musical information dynamics.*

Our current model estimates information dynamics using mathematical methods such as linear prediction and Markov modeling. The musical structures are analyzed after short listening to a musical fragment or as a result of a single prior listening to the complete piece that creates expectancies about the musical form. These types of analysis are still not be capable of capturing complex rules of style that might have been acquired over long process of exposure to musical materials or learning. Despite these limitations, we hope that the model we suggest will offer conceptual and mathematical framework for a more general modeling of the "meaning" of style and will serve to develop better understanding how aspects of information dynamics are related to musical perception.

7.1.1 Structure of Fun?

But pleasure or fun are such abstract notions that we might wonder whether they can be actually measured or modeled? Can pleasure or fun be designed, predicted or planned by artists? And how are they realized during the act of listening?

Oxford American dictionary defines pleasure as "enjoyment and entertainment contrasted with things that are done out of necessity". So we may play music because it is fun to do so, and the reasons for this seem to go well beyond musicology or musical rules and practices. While engaged in art or play we tend to forget about our daily routines, substituting the "real" experiences by artificially produced sounds, colors and imaginary situations. Not only do these experiences rarely have concrete meaning or make sense in the "real" world, they also carry gratification that is difficult, if not impossible to define since it depends on cultural background

and emotional and aesthetic sensibilities of the individual. Even the mere fact of engaging in an activity that has no necessity and no evident gratification is puzzling, especially since it requires and consumes intellectual, emotional and even physical resources that come at some cost to the artist and to the listener. So what are the reasons for doing so?

The structure of music can be seen as a network of short and long-time relations between music structures, established through repetition, similarity and so on, all within a larger stylistic and cultural framework. In order to evoke an experience or create enjoyment and fun in music, one has to take into account how the listener appraises music and what are the cognitive or computational mechanisms that might be involved in this process. Our familiarity with different musical structures constitutes a framework in which our perception operates. Familiarity with this framework is a prerequisite to creation of music that can evoke a listening experience. This experience might be considered as a type of behavioral response that, although possibly evolved from, in our view is much more complex and different from those occurring in nature, such as the "freeze, fight or flee" reaction that arises out of survival necessity [11]. Response to music is unique in the sense that its meaning is assigned to it by the working of memories, forming expectations and activation of various cognitive mechanisms in a framework of a specific style. So understanding of music is ultimately linked with a specification of the listening system, such as a computer audition system or the brain, that has been trained in a certain style. Accordingly, we shall define "music" as *organization of sounds that creates an experience.*

7.1.2 Planning and Style: Is Music Emotional or Rational?

In philosophy, rationality and reason are the key methods used to treat information that we gather through empiricism. For instance, in economics, sociology, and political science, human thinking is usually modeled by rational choice theory that assumes that human behavior is guided by instrumental reason. Accordingly, individuals behave by choosing the best means to achieve their given ends. In doing so, the person is assumed to know the "utility" of different alternatives, so that he can weigh every choice and be aware of all possibilities.

Listening, and of course creating music involves making choices. There are many alternatives confronting a composer in his choice of music materials and their composition. The listener builds expectations, experiences surprise, interest or boredom. But is there an instrumental reason in preferring one musical "solution" to another? Artists know very well that their audiences do not want to hear schematic progressions, at least not all the time. The deviation or "breaking" of rules is a must in almost any artistic expression since it is a tool for building tension and resolution that are essential for creation of drama, story or musical form. This leads to conclusion that even though the utility of artistic choices cannot be directly measured, it still can be identified through its *influence* on the listener within a framework of a specific style. An implicit knowledge of this influence allows composers to make rational decisions about the design of their music.

7.1.3 Influential Information and Framing

It is known that the manner in which choices are presented to humans influences their decisions. This effect, called *framing* [23] is usually applied to logical situations, such as profit or loss decisions or moral judgments. It has been also used to label "schemata of interpretation" that allow people to identify and perceive events, thus rendering meaning, organizing experiences, and guiding actions [10]. When applying the concept of framing to music, one might consider the ways style can manipulate our "judgement", "feeling" or "preference" about music data. Framing preparation becomes a way to guide the listening outcome, encoded in the data as part of the overall information "transmitted" with the music. In fact, when music in a totally new style is presented to a listener, his ability to express feelings or preferences towards what he hears become extremely limited. In such a case a listener can resort to very simple mechanisms or "natural" expectations derived from actions such as prediction of the future based on the immediate past, or forming expectancies related to long term repetitions. Even in such limited cases, one can say that these natural schemes are framing our perception of musical materials. This will be in fact the case in our simulations, where simple mathematical models will be used to form expectations, to be discussed in the following sections. Before doing that, let us consider the concept of framing a little further.

Musical theorists suggest that meaning in music is related to emotions that arise through the process of implication-realization [16]. In that sense, past musical material is framing our appraisal of what comes next, such as expecting a resolution after a leap in short term melodic movement. These expectations are of course cultural and style specific. Going beyond melodic expectations, larger scale framing can be established through conventions of style, known to the listener in terms of familiarity with typical patterns (schematic expectations), large scale repetition structure related to musical form, and even expectations framed as recognizable references to other musical works (veridical expectations) [11]. Causal relations between expectations and the outcomes, their validation or violations and explanations are also used as computational models of Aristotelian aesthetics [2], and more [1].

The phenomenon of framing is not the only evidence for the existence of close relations between choices and emotions. It is interesting to note that the ability of information to influence its receiver has been noted already in the first days of information theory. More than 50 year ago, in an introduction to Shannon's classic paper, Warren Weaver claimed that the mathematical theory of communication does not touch the entire realm of information processing, which he suggested that exists on three levels: (1) a technical level that concerns the quantification of information and dealt with by Shannon's theory; (2) a semantic level dealing with problems relating to meaning and truth; and (3) what he called the "influential" level concerning the impact and effectiveness of information on human behavior. Technical problems are related to aspects such as compression by efficient representation or coding, and error correction that can be done in the process of transmission. Semantic aspects have to deal with denotative meaning of the data which could be derived from processes of recognition, prediction or logic. The idea behind influential aspects of

information is that the meaning of signals is determined from actions taken as a result of interpreting the information. So "influential" contents of a message might be considered as the aspects of data that act to alter the state of the system that processes information. This in turn alters the way the system perceives, processes and eventually judges information contents of the message. The "meaning" of information thus depends on it relevance to the system that receives it, as it becomes increasingly evident that information does not have an objective or universal definition.

Realizing that all three aspects of data are present during information processing is basic to our theory of listening experience and its relation to style. It should be noted that style-related framing differs from mere expectation since it goes beyond considering an immediate past or nearby context and can depend on longer term repetitions, feeling of familiarity or aspects of musical form and so on. In that sense, style creates a framework of normative relations between musical materials on many levels of musical structure. These relations are actively sought by the listener who allocates mental resources in order to create some sort of "explanations" to what he hears. The influential aspect of style then becomes a way of guiding listener's actions in terms of his allocation of mental resources, as well as affecting his ability to successfully process information within a certain stylistic framework. This mechanism is schematically depicted in Fig. 7.1 where we suggest a sort of self-reflective process in which a "slow brain" monitors the listening actions performed by a "fast brain", that uses "natural" as well as learned schema such as rules of style to produce the "framing" that is needed for creation of musical tension, resolution and etc (Fig. 7.2).

This model leads to an additional definition of the role of style in music: *Style provides a framework of alternative schema of musical materials that require different allocations of mental resources during the listening action.* The influence of style is exerted by altering the amount of resources that a listener allocates during

Fig. 7.1 The role of framing in listening experience. Style, as well as natural schemata provide a framing according to which "slow brain" makes appraisals of "fast brain" performance, resulting in experience of musical tension, resolution and etc

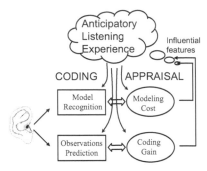

Fig. 7.2 Processing that creates a listening experience: monitoring of successes and failure of recognition and prediction processes can be done through appraisals of coding gain and model selection costs

the listening act, which is in turn done by controlling the extent to which music actually fits the stylistic schemata.

7.2 Listening as Analysis of Information Dynamics

Listening to music, and maybe experiencing other types of art and artistic performances, involves activation of various information processing functions that try "to make sense" of the incoming data. In the previous paragraph we developed a model that considers musical *experience* as an "influence" of the music data on a listener, causing him to allocate mental resources and eventually alter his feelings (conscious states) according to the way materials fit the schema that are framed by different (natural or stylistic) rules. In order to construct a formal mathematical model of such a general concept of listening, we must take a somewhat radical view of music and consider it as an *information source*. Information source can be considered as a black box that generates symbols in a random fashion according to some predetermined statistics. When a sequence of symbols, such as text, music, images, or even genetic codes are considered from an information theoretic point of view, it is assumed that the specific data the we observe is only one of many possible realizations that can be produced by that source. This approach allows description of many variations or families of different sequences through a single statistical model. The idea of looking at a source, rather than at a particular sequence characterizes which types of sequences are probable and which are rare, or in other words, we care more about what *types* of data are more or less likely to appear rather then a specific realization.

7.2.1 Our Model

Considering music as an information source we can model the listening process in terms of a communication channel where listener is the receiver. In a physical

communication channel, the source could be a voice of a person on one end of a phone line, and the sink would be the voice emerging form the other end. In our model music is transmitted to a listener (either human or machine) over time. In a channel, the data at the sink and at source ideally would be identical, but in practice they are not. In physical communication channel the presence of channel noise causes errors that alter the source when it arrives to the sink after transmission. The uncertainty about what was transmitted, once we have received the signal at the receiver, is a property characteristic of the channel.

In our musical listening model the channel noise is no longer a physical one. What we consider "noise" in a musical channel is the variation that creates uncertainty about the future once the past is known. In some sense, a composer who deviates from expectations is the one who creates this "noise", but the overall effect and influence of these deviations on the listener depend also on an initial uncertainty of the music material as determined by style and the ability to form expectations within the common stylistic framework in which the composer and the listener operate. We shall discuss this model in detail in the next paragraph, but before that we would like to introduce some mathematical details.

Properties of communication channel are mathematically described using the concept of mutual information, which represents the difference between a-priori uncertainty (entropy) that we have about the source and the remaining uncertainty when the distorted message arrives at the sink. Denoting source and sink as two random variables x and y, mutual information can be described as the cross-section between their entropies, as shown in Fig. 7.3.

$$I(x, y) = H(x) - H(x|y) = H(y) - H(y|x) \tag{7.1}$$

$$= H(x) + H(y) - H(x, y) = \sum P(x, y) \log \frac{P(x, y)}{P(x)P(y)}$$

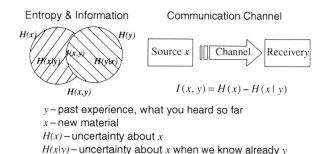

Entropy & Information

$H(x)$ $H(y)$ $H(x|y)$ $I(x,y)$ $H(y|x)$

$H(x,y)$

Communication Channel

Source x | Channel. > Receivery

$I(x, y) = H(x) - H(x \mid y)$

y – past experience, what you heard so far
x – new material
$H(x)$ – uncertainty about x
$H(x|y)$ – uncertainty about x when we know already y
$I(x,y)$ – how much the past tells us about the future

Fig. 7.3 Mutual Information describes the cross-section between entropies of two random variables x and y. The circles depict the Entropy of each variable. Conditional entropy is the remaining Entropy of one variable when the second variable is known. Mutual information is used to described information passing in a channel, when one of the variables is the source and the other is the signal received

7.2.2 Information Rate as Transmission over a "Time-Channel"

Using the notion of entropy $H(x)$ from previous paragraph we define two terms relevant to a listening experience: *structure* is defined as the aspect of musical material that the listener can "explain", and *noise* or *randomness* is the part of musical signal that the listener would consider as unpredictable or uncertain aspect of the data. By "explaining" we mean using information contained in the past of the signal to reduce uncertainty about the present. Mathematically it means that the entropy of what we hear can be reduced by taking into account some prior information. In terms of our time-information channel, structure and noise translate into new relations between the musical present and musical past that is already available to listener, as will be explained below.

In our model will consider a particular type of channel, shown in Fig. 7.4 that is, as we said above, different from a standard communication model in two important aspects. First, the channel is a time channel and not a physical transmission channel. The input to the channel is the current segment of music, while the history of the signal up to certain point in time is available at the sink. The communication act is described as a process where the listener/receiver is trying to reduce the uncertainty about present (data emitted from the source) by applying algorithms that will "explain" the current observations in terms of the past. In mathematical notation, the information at the sink y consists of the signal history $x_1, x_2, \ldots, x_{n-1}$ available to the receiver prior to him receiving or hearing x_n. The transmission process over a noisy channel now has the interpretation of anticipation in time. The amount of mutual information depends on the "error" that the time-channel introduces compared to the ability of the listener to predict it.

This notion of information transmission over time-channel can be captured by variation on the idea of mutual information that we cal *information rate* (IR). IR is defined as the relative reduction of uncertainty about the present when considering the past, which equals to mutual information between the past

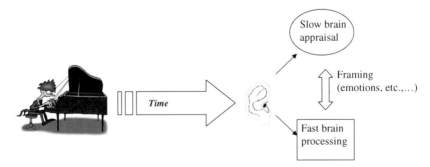

Fig. 7.4 Cognitive Listening Model: Music is considered as an information source that is transmitted over a time-channel to the listener. The "errors" introduced by the time-channel represent the discrepancy between what the listener expects and the actual incoming musical events. The successes and failures of expectations formed by "fast brain" are appraised by the "slow brain"

$x_{past} = \{x_1, x_2, \ldots, x_{n-1}\}$ and the present x_n

$$\rho(x_1, x_2, \ldots, x_n) = H(x_n) - H(x_n|x_{past}) = I(x_n, x_{past}). \qquad (7.2)$$

One can interpret IR as the amount of information that a signal carries into its future. This is quantitatively measured by the number of bits that are needed to describe the next event once prediction based on the past has occurred. Let us now discuss the significance of IR for the delineation of structure and noise by showing some examples:

- *Relevant music materials*: It is well known in music that materials that are constant or completely random (noise) are not interesting for composition. Usually this is explained by the fact that such materials cannot be organized or composed. From statistical perspective, a purely random signal cannot be predicted and thus has the same uncertainty before and after prediction, resulting in zero IR. An almost constant signal, on the other hand, has a small uncertainty $H(x)$, resulting in an overall small IR. High-IR signals have large differences between their uncertainty without prediction $H(x)$ versus the remaining uncertainty after prediction $H(x|\text{past } of \ x)$. One of the advantages of IR is that in the IR sense, both constant and completely random signals carry little information.
- *The relative meaning of noise*: Let us consider a situation in which two systems attempt to form expectations about the same data. One system has a correct model, which allows good predictions for the next symbol. In the case when the uncertainty about the signal is large but the remaining uncertainty after prediction is small, the system manages to reveal the signals structure and achieves its information-processing task, resulting in high IR. Let us consider a second system that does not have the capability of making correct predictions. In such a case, the quality of prediction, which can be measured by the number of bits needed to code the next symbol, remains almost equal to the amount of bits required for coding the original signal without prediction. In such a case, the discrepancy between the two coding lengths is zero, and no information reduction was achieved by the system, resulting in a low IR.
- *Determinism versus predictability*: An interesting application of IR is characterization of chaotic processes. Considering for instance a chaotic equation call logistic map $x(n + 1) = \alpha x(n) \cdot [1 - x(n)]$. It is evident that knowledge of x(n) provides complete information for the prediction of $x(n + 1)$. A closer look at the problem reveals that if the precision of measuring $x(n)$ is limited, the measurement error increases with time. For $\alpha = 4$ (chaos), the error approximately doubles every step, increasing the uncertainty by factor two, which amounts to a loss of one bit of information. This example shows that even complete knowledge of system dynamics might not suffice to make perfect predictions and that IR is dependent on the nature of measurement as well.

In [5] it was shown how IR can be effectively computed from existing measures of signal structure, such as spectral flatness or compression gain. It is important to note that it is impossible to analyze the musical signal directly in terms of

the variations of the air pressure or samples of the electrical signal captured by a microphone. Multiple features are required to describe musical data. Moreover, due to so called "transparency" property of music, all musical sources are present simultaneously and IR analysis is required to separate the music data into individual sources, or at least into approximately independent features that can be used to describe the overall signal.

7.2.3 Data-IR Versus Model-IR

In the above formalization of IR, the analysis of the relations between the past and the present was done under the assumption that complete statistics are available to the listener for purposes of reducing the uncertainty about the present. By "complete statistics" we meant that all underlying dynamics, such as repetitions, redundancies or other dependencies between past and future realizations of the data are available to the listener or to an information processing system at all times. We made no distinction between observations and models and did not take into account different time scales and categories of perception. This assumption is not practical for two reasons: (1) musical signals are non-stationary so the "ways of listening" change over time, and (2) knowledge about the past is probably "stored" in our memory in terms of some abstract models that capture what we consider to be the most relevant information about the world, without attaining all possible data statistics.

Trying to formalize this further, we add to our IR analysis the ability to recognize models that describe the signal, so that the prediction of the observation is done in context of a model. This description, called "parameterization of the signal distribution", is represented mathematically by parameter θ, so that the probability of $\{x_1, \ldots, x_n\}$ is factorized into probability of the observations (data) in context of a model and probability of the model itself

$$P(x_1, \ldots, x_n) = \int P(x_1, \ldots, x_n | \theta) P(\theta) d\theta \tag{7.3}$$

As an example, let us think of $P(x_1, \ldots, x_n)$ as the probability of hearing some musical piece in a concert. Then, if θ describes the name of the piece, $P(x_1, \ldots, x_n | \theta)$ becomes the probability that what we hear is a performance of a specific piece, and $P(\theta)$ is the probability that the performer had chosen that piece for his repertoire.

Using expressions for approximations of entropy in the case of parametric distribution [17], information rate becomes a sum of several factors

1. IR of the observations given a model $\rho_\theta(x_1, \ldots, x_n)$
2. Mutual information between individual observations and the model $I(x_n, \theta)$

3. Penalty factor in the form of a distance[1] $D(\theta||\theta^*)$ between the empirical distribution of the observations and the most likely model known for this data.

These three factors are summarized in one equation for model-based IR, which is derived in the Appendix[2]

$$\rho(x_1, \ldots, x_n) \approx E[\rho_\theta(x_1, \ldots, x_n)]_{P(\theta)} + I(x_n, \theta) - E[D(\theta||\theta^*)]_{P(\theta)}, \quad (7.4)$$

with $E[.]_{P(\theta)}$ denoting averaging with respect to parameter θ.

What is interesting now is that different measures of information dynamics can be cut from this single unifying IR expression depending on what aspect of the overall information is relevant for the listening system, or what is its "way of listening". For instance, if the listener assumes a fixed model without trying to consider alternative possibilities, then he is considering only the first factor of information dynamics given a model $\rho_\theta(x_1, \ldots, x_n)$ that we call *data-IR*.

On the other hand, if a listener decides to disregard the details of the observations and care only about recognition or selection of the most likely model from a set of possible models, he might then"summarize" all observations into a single parameter such as pitch register, tonality, mean spectral shape, or any other category that captures an overall property of the observations, discarding fine details. In such a case the data-IR factor vanishes, (mathematically this can be considered a case of constant data where all observations are replaced by one representative example), leaving us with the remaining part of the equation that we call *model-IR*. Normally, a single parameter carries little information about the model so that $I(x_n, \theta) \approx 0$, leaving us with a penalty factor $-E[D(\theta||\theta^*)]$ due to discrepancy between the actual model and the most likely model.[3]

The significance of this results is in showing that information derived during listening act comprises of two factors - one related to observations being interpreted or encoded in the context of a model given by data-IR, and second due to situating of that model relative to other models in the space of models given by model-IR. Going back to our previous concert example, the model-IR factor becomes analogous to aspects of listening related to musical interpretation, such as considering the information in performance inflections when a piece is known (or if more then one piece "explains" the data, it is averaged over all possible pieces). The parallel to the second, model-IR factor, will be the ability of a listener to recognize a piece by measuring "how far" it falls from other works in similar repertoire. Accordingly, every new observation carries with it two types of information - one about the ability to make predictions in a current model, and another about how new evidence changes the model, causing "shifts" towards alternative models. So in our example every listening instance is processed in a twofold way—interpretation-wise and

[1] This is known as relative entropy, or Kullback-Leibler distance.

[2] This derivation summarizes and corrects a sign error of a derivation that appeared in [5].

[3] If a single observation carries a lot of information about the model, then $I(x_n, \theta) \approx H(\theta)$ and model-IR becomes $H(\theta) - E[D(\theta||\theta^*)]$.

repertoire-wise, each "influencing" the listener through separate listening mechanisms and having different assessments in terms of listener's ability to perform the listening function.

7.2.4 Model Likelihood and Musical Form

In the concert example we referred to a model in terms of pianist's selection of repertoire, or ability to recognize an entire piece. This was a useful metaphor in order to explain the concept, but when we come to apply IR theory to music signals we need to consider musical information structure on a much finer time scale. Music organization consists of many elements—it deals with organization of units of structure from its smallest elements of sound, melodic figure, motive and phrase, to large scale ordering of musical sections. These principles of larger scale organization, called *musical form*, determine important aspects of style in music. To keep our discussion as general as possible we shall consider form as an aspect of data that is related to organization into larger information units, such as choice of types of music materials or models, their sequencing or other principles of organization, but without specifying the exact size or even the type of these materials.

In psychology, and lately in music practice, the concepts of "perceptual present" was used to mark the boundary between two types of temporal processing. Paul Fraisse [9] defined the perceptual present as "the temporal extent of stimulations that can be perceived at a given time, without the intervention of rehearsal during or after the stimulation". In music this concept has been used to constitute the threshold of ones short term memory where one is not yet concerned with that moments relationship with past and future events. This concept was used to denote the minimum duration within which structural aspects of music should be presented during a composition [19].

Comprehension of musical form in terms of detailed psychological mechanisms requires modeling of perceptual grouping processes, abstract musical knowledge structures and event structure processing. To approach this understanding theoretically and experimentally, musical cognition researchers [14] defined the notion of "form-bearing dimension" that characterizes different musical parameters such as pitch, duration, dynamics and timbre, in terms of their ability to "carry musical form". The properties of such a dimension should be: (1) that it would be susceptible to being organized into perceptual categories and relations among these categories should be easily encoded, (2) that a system of salience or stability relations should be learnable through mere exposure, and (3) it should affect the perception of patterns along this dimension. The practical implications of these properties are that sequential patterns along these dimensions should be easily learned as a kind of lexicon of forms. Translating these assertions to our framework means that (1) the parameters describing the form need to be perceptually meaningful, (2) their distribution can be learned and distances between them can be measured, and (3) change in the form parameters will affect the ability to make predictions and thus alter the perception of acoustic data.

In order to describe aspects of form in terms of our mathematical model of communication, we need to adopt yet another somewhat radical approach to music and consider form parameters as a part of "information source", i.e. we assume that the form itself is generated through a random process that selects types of musical materials. Then a sequence of these random selections comprises an instance of form for a specific musical piece. We will show in Sect. 7.3.3 how a Markov model that generates the form and its stationary distribution $P^*(\theta)$ can be obtained from the so-called "recurrence matrix" that represents the repetition structure of musical units over the complete duration of a piece. What is interesting to note here is that from this definition of form we can estimate the model-IR in terms of probability of musical types, considering this as a penalty or cost of being in different mental states in which the listener recognizes various possible types of musical materials.

If a listener recognizes the current musical type in terms of a model parameter α and assumes that this model remains constant, then this assumption can be considered in terms of narrowing the distribution space of parameters θ to a delta distribution $\delta(\theta - \alpha)$ centered at the current model. It can be shown that in such a case the distance between the current parameter and the form parameters of the Markov model equals to the likelihood of parameter α. In other words, the model-IR becomes

$$D[\delta(\theta - \alpha)||P^*(\theta)] \approx -log P^*(\alpha) \tag{7.5}$$

This represents the reaction of a listener to a choice of model α versus changing to some other parameter according to the stationary distribution of model parameters by Markov process that generated the musical form. It can be also considered as "surprise" experienced by a listener when he chooses state α from a distribution P^*. It should be noted that $-\log P^*$ is the Shannon coding length of the parameter θ, or in other words the cost, measured in terms of number of bits, of representing the model parameters.

7.3 Surface and Form: Two Factors of Musical Experience?

The relation between form and style is traditionally addressed in musical texts [12, 22] in terms of a need to identify larger musical units that are subject to rules of repetition, contrast and variation. The development of music over the last century lead to changes in the approach to organization of music. Composers having personal sensibilities and individual schemata for designing their musical works often find it necessary to reinterpret and redefine music concepts and terms which were traditionally taken for granted [20].

Using the two components of IR described above, namely the data-IR and model-IR, allows us to approach musical structure in terms of short-term patterns that are closer to notions of musical surface, such as style aspects related to musical "licks" and variations, versus longer-term probabilities of models that generate these patterns, with long terms structure capturing aspects of musical form.

These two measures, namely data-IR and model-IR, were quantitatively examined in [21], by comparing them to human cognitive judgments of listening to music that were experimentally collected in a live concert performance setup. It was found that data-IR and model-IR explain significant portions (between 20 and 40 %) of human behavioral responses of Familiarity and Emotional Force.

In order to appreciate better these two different aspects of music information dynamics, we conduct below two experiments. First we compare data-IR analysis of the same piece using two different music representations, one of audio recording and the other symbolic (MIDI) representation. It is expected that at least qualitatively the IR analysis would be independent from the choice of representation, which indeed appears to be the case. Next, we consider repetition properties of music materials in terms of model-IR and show that it captures a different type of information then data-IR.

7.3.1 Spectral Anticipations

Spectral anticipation is a method of IR analysis of audio recording based on spectral features. Justification for this choice of features is that spectral information is an important descriptor of the audio contents and that listening apparatus should be able to recognize, classify or predict spectral properties. Spectral representation, as shown in Fig. 7.5, is achieved by applying Fourier analysis to blocks of audio samples using a sliding-window that extracts short signal segments (also called frames) from the audio stream. It is often desirable to reduce the amount of information in spectral description so that it captures only essential spectral shapes. In doing so a balanced tradeoff between reducing the dimensionality of data and retaining the information contents can be achieved.

Various researchers working on audio description schemes [3, 13, 15] have proposed features based on a low dimensional representation of spectral features using carefully selected set of basis functions. One such scheme is Audio Basis representation that uses dimension reduction followed by an independent components transformation. Another common representation of spectral contents of audio signals is the cepstrum [18] that has the ability to easily control the amount of spectral detail by selection of the number of cepstral coefficients.

Fig. 7.5 Spectral representation uses a sliding window to do Fourier analysis over blocks of audio samples, followed by dimension reduction. A feature extraction stage usually follows this step and is not shown in the figure

The algorithm for IR analysis using Audio Basis (AB) is explained in detail elsewhere [7]. In Fig. 7.6 we compare IR analysis to overall sound energy in a recording of J. S. Bach's Prelude in G major from Book I of the Well Tempered Clavier. The IR and Energy graphs are overlaid on top of a spectrogram that shows distribution of sound energy at different frequencies (y-axis) as a function of time (x-axis). The audio recording was created by synthetic playback using a MIDI file. It should be noted that most of the energy in spectrogram appears in higher partials or harmonics of the notes being played. The frequencies of the keyboard keys (pitches) occupy only the lower portion of the frequency range and can be observed as darker points appearing below 1000 Hz.

The synthetic nature of the computer playback of a MIDI file is such that the resulting acoustic signal lacks almost any expressive inflections. Moreover, the use of a synthesizer piano creates a signal with little spectral variation. As can be observed in Fig. 7.6 data-IR nonetheless detects significant changes in the music. Analysis of similarities between IR curves and the main sections of the score derived from a music-theoretical analysis seem to indicate that data-IR profile captures meaningful aspects of the musical structure. For instance, the first drop of the IR graph corresponds to the opening of the prelude, ending at the first cadence with

Fig. 7.6 Spectral anticipation and energy profiles estimated from an audio recording of a MIDI playback of Bach prelude, shown on top of a spectrogram

modulation to the dominant. The following lower part of IR graph corresponds to two repetitions of an ostinato pattern. Then the two peaks in IR seem to be related to reappearance of the opening theme with harmonic modulations, ending in the next IR valley at the repeating melodic pattern on the parallel minor. The next increase in IR corresponds to development section on the dominant, followed by a final transition to cadence, with climax and final descent along the cadential passage.

7.3.2 Note Anticipations

The method of data-IR can be applied to symbolic sequences using estimators of entropy and conditional entropy over finite alphabet of note values. By symbolic representation we mean a representation of music as a set of notes, which is equivalent to music notation created through the playing actions of a musician (pianist in our case) who performs the piece. This information is stored in MIDI files. Note numbers (corresponding to keys on the piano keyboard) were presented in the order of their appearance, disregarding their exact onset times, durations or dynamics (so called MIDI velocities). Short time estimates of entropy and conditional entropy were performed using blocks of 40 notes, with overlap of 30 notes between successive blocks [6]. The choice of block size was such that the duration of the musical segment corresponded approximately to 3 s, which is similar to the size of the time-sliding window that was used for analysis of Spectra Anticipation on the audio signal generated from the same data, as described before. Fig. 7.7 shows results of data-IR analysis of the sequence of notes (score) of Bach Prelude.

It is interesting to compare between note anticipations calculated directly from MIDI and spectral anticipation derived from audio file that contains synthetic rendering of the MIDI information. The two graphs of note and spectral anticipation are shown together in Fig. 7.8. We see that although the audio and note sequence representation of music and their respective statistical models are so different, the IR graphs exhibit high similarity. The y-axis corresponds to IR values of the note analysis (note anticipation). Spectral anticipation graph was scaled to match the range of the note anticipation values. The background of the figure show qualitatively the note distribution of the Prelude over time.

7.3.3 Form, Recurrence and Modeling of Familiarity

Modeling the perception of musical familiarity requires retrieval of longer term units (models) that are stored in the listener's memory. In order to do so we need to define a distance measure between instances of data at different times. Recurrence matrix is a method for showing such relations by displaying a matrix of similarities between all pairs of sound features vectors at different times. Given an analysis of the complete musical piece in terms of average cepstral vectors that represent the spectral contents over some period (window) in time, the matrix shows the

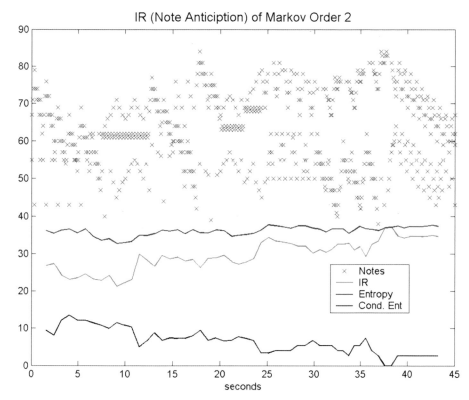

Fig. 7.7 Note anticipations of Bach's Prelude. Data-IR was estimated from MIDI data by computing the difference between entropy and conditional entropy of notes over blocks of 40 note value observations. Entropy, Conditional Entropy and Information Rate estimates are shown at the *bottom* of the graph. *Top* part shows distribution of the notes in terms of MIDI numbers over time. Information about note durations and dynamics was not taken into account. See text for more detail

similarity across all those time instances. This results in a matrix whose indices are pairs of times of the two windows being compared. The name Recurrence is used to emphasize the use of similarity matrix for visualization and discovery of long term recurrences in the data. Two common methods for construction of similarity matrix are (1) normalized dot product of the feature vectors [8], or (2) $\exp(-\beta d)$, where d is a distance function and β is a scaling factor that controls how "fast" increasing distance translates to decreasing similarity.

Figure 7.9 shows a similarity matrix of an example sound based on dot product of cepstral feature vectors. The bright red areas in the matrix display correspond to high similarity and dark or blue areas are different. We use this similarity matrix as a basis for partitioning the sound into perceptually similar groups, and will relate it to aspects of familiarity, recognition and model-IR.

Converting similarity matrix S_{ij} into Markov probability matrix is done by assuming that instead of continuing from a current location to the next segment, a jump to another location in the piece is possible if the contents of those target

Fig. 7.8 Comparison of Note and Spectral Anticipations of Bach's Prelude. Although the audio and MIDI representations are very different, their Information Rate graphs seem similar. The graph showing information rate from audio signal was scaled so as to match the range of the information rate profile coming from analysis of MIDI data

segments are similar. This approach puts the similarity measure in a generative framework [24], instead of a linear progression through the piece, the musical form is viewed as a Markov process where every segment can have multiple targets, with probability of jump being proportional to the distance between the next step and all other segments in that piece

This matrix represents statistics of the data in terms of probability of transition from frames i to j. This model has been used to model signals that could be broadly described as sound texture, or sounds that consists of a set of interchangeable clips whose chances of appearance are governed by Markov statistics.

We use such approach to describe musical from based on similarity between instances of sounds (marco-frames) whose duration is of the order or magnitude of "perceptual present", i.e. between 3 or 7 s for short chamber works (solo or small ensemble) and up to 10 or 12 s in the case of large scale orchestral works. At this point, the choice of the macro-frame size is done manually. Each perceptual present instance is represented by a single feature vector obtained by some averaging the detailed features in that time unit (macro-frame).

Fig. 7.9 Audio similarity matrix of a recording of Bach's Prelude. The similarity is estimated by taking a dot product between cepstral feature vectors at different times in the musical piece. The *red* areas correspond to high similarity and *blue* areas are different

Denoting by X_i the feature vector that summarizes the observations in macro-frame i, we derive probability for transition from frame i to j from similarity matrix as follows

$$\mathbf{P}_{ij} = P(j|i) = \frac{S(X_{i+1}, X_j)}{\Sigma_j S(X_{i+1}, X_j)}. \tag{7.6}$$

A stationary vector can be derived through eigenvector analysis of of the transition matrix \mathbf{P}_{ij}, finding a vector P^* so that $P^* = P^*\mathbf{P}$.[4] The meaning of stationary distribution is that we are looking at a situation where the transitions between the states settle into a "stable" set of probabilities. In terms of IR analysis, we assume that P^* represents the knowledge of the listening system about the musical form. This knowledge is used accordingly as a form-prior for estimation of model-IR.

The following Fig. 7.10 shows a stationary distribution vector P^*, which we shall call Spectral Recurrence, plotted together with Spectral Anticipation of the Bach Prelude. Both profiles were derived using a macro-frame of 6 s in duration

[4] Note that due to the indexing convention chosen for the transition matrix, Markov process operates by left side matrix multiplication. The stationary vector then is a left (row) eigenvector with an eigenvalue that equals to one.

that was advancing in time at steps of 1.5 s (overlap factor 4) and smoothed by a filter in order to smooth fluctuations shorter then 5 s.[5] It is evident from the graphs that both profiles have very different behavior as they capture different aspects of information dynamics present in the recording.

7.4 IR Analysis of Beethoven's Piano Sonata No. 1

Analysis of musical form is a study of the formal structure of musical compositions from various historical periods and in different styles. This type of study, done commonly in musical schools, is meant not only to teach the formal design of musical works, but is also to investigate the principles, processes and function that lead to specific types and choices of organization that are used by composers in their musical design.

Trying to find the parallels between the computational approach and traditional analysis of form may require additional refinements to the IR theory. It should be noted that questions of form are tied both to specific musical parameters and to the ways of organizing these parameters. Considering what we have discussed so far, it seems interesting to see what are the common underlying principles in organization of musical structire from the musical theoretical, cognitive and computational points of view.

In order to do so, we present here an analysis of a classical sonata form. We chose Beethoven's sonata No. 1 due to its clear and well defined structure. Before proceeding with IR analysis, let us define briefly these different structural functions in classical sonata

7.4.1 Structural Functions in Sonata Form

Sonata form is commonly considered as one of the most important principles, or formal types of musical organization, from the Classical period well into the 20th century. As a formal model, a sonata movement is divided into sections comprising sometimes of an introduction, followed by exposition, development and recapitulation, that might be also followed by a coda. It is also characterized by its thematic material, comprising of one or two themes bridged by a transition. Sonata form is unique in the sense that it comprises of different parts that could be assigned "dramaturgical" functions, with various musical materials serving different "roles" in developing the musical piece. One such characterization can be summarized as follows:

[5] The smoothing was done using a liner phase low pass filter with frequency cutoff at 0.3 of the window advance rate

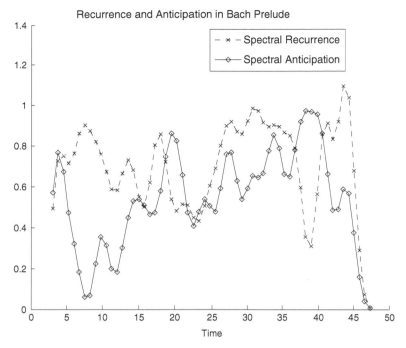

Fig. 7.10 Recurrence and Anticipation profile of an audio recording of Bach's Prelude. The figure shows a stationary distribution vector P^*, that we call spectral recurrence profile and data-IR that we call spectral anticipation profile. Both profiles are smoothed in order to remove fluctuations faster then 5 s. These profiles capture different aspects of information dynamics present in the audio recording

- Expository function: The purpose of expository units is to "expose" musical materials that are important in the context of the complete structure's organization. Expository units are typically characterized by clear phrase structure that is often periodic. In tonal music, harmonic activity that serves to establish a prevailing tonality reinforces the perception of expository function.
- Transitional function: Serves as a connecting function between sections of relative repose in the musical context. Transitional passages, therefore, may possess attributes that support the perception of movement, such as: unpredictable fragmentary structural units, rhythmic agitation, dynamic contrasts, and frequent changes in other structural phenomena. In tonal music, they are characterized by harmonic activity that serves to dissolve the previously established key and to establish a new one. This function is mostly harmonic in nature, thus related to larger scale structure.
- Developmental function: The primary attribute of developmental passages is the presentation of motivic material heard previously in changed, or varied, form. Such passages are often tonally unstable and thus share some of the attributes associated with transitional function. This function is mostly melodic, thus related to short term structure.

- Terminative function: The function of these passages is to bring sections of complete works to a close. Primary attribute: tonal activity that confirms and reinforces an established key. Continuous cadential activity and static tonality typically mark such sections. Terminative passages may exhibit the clear phrase structure of expository units, or they may be more fragmentary in nature. Also, such units may involve the variation of previously exposed motivic material, and thus be partially developmental in function.

Considering these structural attributes, we will examine in the next section how they are reflected in the spectral properties of data information rate, measured by spectral anticipation (SA) and model information rate, measured by spectral recurrence (SR).

7.4.2 IR Analysis of Sonata Form

We present analysis of a Beethoven sonata in terms of the two features of SR and SA (data and model-IR). Both features were derived using analysis of an audio recording, so that IR is estimated using data-IR algorithm using spectral features (the spectral anticipation algorithm), and SR uses signal recurrence profile estimated from the eigenvector of the stationary distribution. Since functional description of form makes specific references to phrase structure, harmonic activity, motivic varia- tion, rhythmic agitation, an so on, it is impossible at this point to capture the specifics of these form function from the two information dynamic features using spectral information. Nevertheless, since these musical parameters are eventually reflected in the organization of the musical signal, we should be able, at least in principle, to extract some aspects of the structural information by looking into information contents of the signal spectrum.

Music theoretic analysis of musical form shows some interesting correspon- dences to IR analysis. The recording of Beethoven sonata used in this analysis is by Xenia Knorr, available from Classical Archives.[6]

A global regard on the sonata form reveals two repetitions, each approximately 50 sec. in duration that correspond to the exposition section being played twice (Da Capo), followed by a development section starting at 107 s and recapitula- tion section starting little at 153 s. It can be seen that SR and SA profiles repeat almost identically in the two repetitions of the exposition. The development section (approx. 107–153 s. in the recording and in the graph) seems to be characterized by a quick drop in SA once the first theme has been repeated and the materials from second theme enter at bar 55 and keep modulating, creating a texture of falling quarter notes in right hand and eight note repeated patterns in the left hand. This type of musical treatment creates spectrally slower changes or lower SA, while creating longer blocks of spectral types with relatively high SR. This situation reverses in bar 69 where the falling quarter notes are in the bass, and the repeating eighth notes become the middle (alto) voice, with call and response between upper voice and bass

[6] http://www.classicalarchives.com/artist/4028.html

in half notes. In the audio recording this reversal occurs around 122 sec., marked by a gradual drop in SR (these are new materials) and fluctuating but increasing SA. Inside this area, marked in Fig. 7.11 as transitional, a change in musical texture occurs at 135 s. (bar 81) when the bass part takes up the eighth note runs and the upper part does some little fragments leading to a cadence in bar 93, at 146 s. At this point there is a drop in dynamics (pianissimo) and the left hand creates a pulsation by repeating and slowly descending single or double notes, while the 30 s note idea from the first theme comes in fragments with music modulating back to F minor, with recapitulation occurring in bar 101, at 153 s. This transition to recapitulation is characterized by drop in SA values and increase in SR. The recapitulation (terminative) section of the sonata (from 153 s till the end) shows a pattern of fast drop and then fluctuating fast increase in SR, and fluctuating medium range SA that peaks at the last fluctuation.

What is interesting to observe is that (1) there is an opposite gap created at 160 sec. where SA is higher then SA. This is a rare behavior, corresponding to some sort of a climax where new materials are presented (low SR) with high anticipation

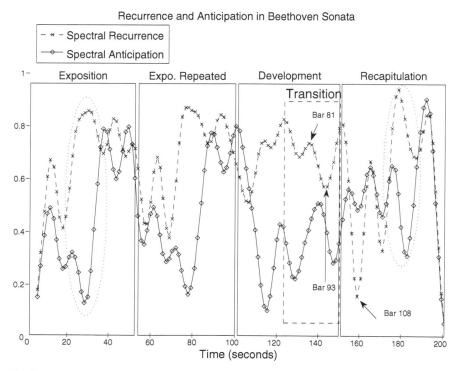

Fig. 7.11 Beethoven Sonata analyzed in terms of Information Dynamics. The figure shows the relations between musicological analysis and information rate derived from analysis of spectral statistics: two repetitions of exposition, development, transition and recapitulation. See text for more information

in terms of short range spectral change. (2) both SR and SA fluctuate in synchronic-ity, a situation that did not occur before that in the piece.

Observation (1) occurs in the score in bar 108, where a silence with fermata delin-eates the point where the first theme reaches a half cadence, from which it is being played in the bass. In fact these are exactly the same materials as in the exposition (except for the fact that there is no modulation to a new key). What makes this part distinct is the interpretation of the pianist who emphasizes the pause, creating spec-trally new material of silence which was not present so far. This explains the drop in SR and also suggest an interesting thought that not playing or taking a long breath can create a very dramatic effect in term of introducing new an unexpected spectral element on the global level of SR.[7] The second phenomenon of "phase-locking" between fluctuations of SA and SR is harder to explain. A closer look actually reveals that the one before last peak is SR actually arrives slightly before SA and drops after SA. This is a repetition of a similar effect that occurs in the exposition and is marked in the figure by a dotted ellipse. The main change is the alignment of the last peak of SR and SA. This occurs at 192 s, bar 136, which in terms of the music material is similar to the second long descending eights notes run in bar 37 of the exposition (36 s). The main difference between exposition and recapitulation is that this second melodic run in recapitulation is an exact repetition of the previous one, while in the exposition left hand drops an octave below and also some of the melodic materials at the end of the passage are different. It could be that this change, mostly in left hand of the second passage in the exposition creates a drop in SA in the exposition, while in recapitulation the lack of such change maintains the SA, allowing both SR and SA to peak at the same instance. The closing theme enters on bar 140 at 195 s, already "down the hill" towards the end of the piece.

Although our analysis is very rough, it is interesting that such significant part of musical structure coincides with changes in IR. This suggests that some interesting correspondence might exists between musical theory, especially in terms of form functions, and the aspect of musical information dynamics as captured by data and model-IR analysis.

7.5 Summary and Discussion

As we mentioned in the paper outset, our goal was to develop a model that captures aspects of listening that are related to feelings of pleasure, interest or even fun. To have such feelings we assumed that the listening system has certain preferences towards the musical data that it hears. Artists who are aware of such sensibilities can use them to influence the listener into different mental states. One can think of two type of preferences—those related to the data itself, such as consonant versus

[7] The dramatic power of a silence is of course well known to performers, creating a suspense by delaying a continuation. What is new here is the fact that this effect is captured by SR in terms of introduction of new spectral contents.

dissonant chords, certain combinations of instruments and so on. Then there is another set of preferences that are related to the context or the manner in which data is presented. In this paper we focused on the second method, i.e. on the ways of influencing the listener by controlling the schema of interpretation of music material, an effect known in psychology as framing. So even if same musical materials are presented to the listener, conforming equally to rules of harmony, counterpoint, orchestration and so on, the effect of these materials on the listener might differ depending on the manner in which these rules "play out". Style in music creates such framework that establishes an implicit set of expectations, conventions and familiarity with particular structures or forms. These expectation can be either "natural" or learned from exposure to a cultural corpus of musical materials in a certain style.

We suggested musical frame analysis in terms of two distinct measures derived from the concept of information rate (IR). Information rate measures the amount of mutual information between the past and the present in a musical signal. Assuming two separate listening mechanisms related to prediction of immediately forthcoming musical materials and a different mechanism responsible for recognizing the type of music on a larger time scale, we derived two distinct measures, namely data-IR and model-IR. We also developed separate estimators for data and model-IR for the case of spectral features, namely Spectral Anticipation and Spectral Recurrence.

The IR approach implied a certain cognitive listening model based on ideas from information theory and communications. Our model describes the listening act as a process of compression by prediction, followed by an appraisal step that evaluates the remaining error. The effect of this process is reduction in uncertainty about newly arriving data based on the past, measured in terms of conditional entropy between prior knowledge and the incoming data. The process has a significant effect when a new data, initially complex or uncertain, is compressed or "simplified" as a result of such coding, i.e. a situation when allocation of listening resources achieves a significant reduction of uncertainty.

When data and model-IR analyses were performed on actual musical works, an interesting correspondence was found between musical structure and these two measures. Although the formulation of IR was general enough to account for any kind of prior information, in practice we limited ourselves to using information within a single musical work. The process of prediction or forming expectations was done using the immediate past within so called "perceptual present", or by taking into account repetitions over the complete duration of a musical piece. Extending the methods of uncertainty reduction to include information for external corpuses of musical works is a formidable task left for future research. Achieving such goal would allow taking into account learned schemata specific to a certain style, in addition to the presently used "natural" ways of prediction or utilizing the repetition structure.

One question that remains open is how these measure of musical information dynamics eventually give rise to feelings or emotions. Framing of musical materials in terms of establishing Spectral Anticipation and Spectral Recurrence conditions is more of a dramaturgical or compositional tool, rather then a direct emotional

effect. In the epilog to this chapter we will consider some criteria for establishing the relations between long and short term information dynamics and feelings.

7.5.1 Afterthoughts: Feeling of Memory and Anticipation

In the previous paragraphs we described a model where listener self-monitors the effectiveness of allocation of his mental resources such as anticipation and familiarity during listening act, and how this process can be estimated from information dynamics, namely data-IR and model-IR. But one might still wonder whether high versus low values of data-IR imply certain feelings, such as arousal or excitement, or whether different values of model-IR translate into certain emotional attributes?

Retrieval of memory, such as recognizing familiar faces or understanding spoken words, is a fast procedure that combines recognition of gross features and recall of details, done in conjunction with each other. Finding a model that best represents the data in terms of some model space, or placing the observations in some proximity to other known concepts is one basic action that a listening system might perform. Another action is finding a compact representation of the observations using redundancies in the data, as captured by such concept or model.

It is important to distinguish between recognition of a concept or finding a model versus specific coding of the observations. This distinction is done in terms of the way observations are processed and treated over time. In order for the listening system to recognize the most likely model, it does not have to go into detailed coding of each observation, but once a model is established, the act of recognition carries with it a certain sense of gratification that is intuitively expressed as "Aha!". Situations that sound familiar, concepts that suddenly struck us as something that we already know, or insights that link two situations in a manner that explains one in terms of the other, raise such exclamation. Does it mean that we really know the details of the situation? Not necessarily. This feeling of a general confirmation, familiarity or convenience provides only a rough insight into situations. This recognition might help us understand the present or predict the future, but often the detailed "coding" of the observations is missing.

Another important expression is "Wow!". It represents appreciation or surprise related to demonstrating a certain skill, such as predicting a trajectory of a fast flying ball. In terms of our IR model, we claim that "Wow" arises during the spectral anticipation stage (data-IR). The amount of surprise, and possibly the level of emotional arousal associated with it depends on the initial complexity of the signal and the skills of the listening system on the short term. It could happen that when a challenging musical task is accomplished with sufficient proficiency and precision, such as listening to a virtuoso performance, a reaction of "Wow" will occur (this reaction will not happen when the music is over reptitive or if it so chaotic that the listener cannot make sense out of it).

What is important to realize is that feelings of Wow and Aha can happen independently of each other or together. If both happen together, there is a stronger sense of confirmation. When these feelings occur in other combinations, this

might lead to emotions ranging from excitement, anxiety or worry to feelings of relaxation or boredom.

Mental model known as "flow experience" is used to describe the motivational states of humans in the process of dealing with challenging situations, such as learning, work or gaming [4]. The model suggests that an optimal experience occurs when there is a balance between the person's skills and the challenges he faces. It defines so called "flow channel" where the two aspects are balanced. Moving outside of this optimal range can lead to boredom (when skill are significantly higher then challenge) or anxiety (when skills are significantly lower then the challenge).

We suggest an analogous model that creates an optimal musical flow experience by balancing of Wow and Aha. These two dimensions create a space of musical functions, as suggested by the analysis of Beethoven Sonata in Sect. 7.4. This flow might occur during the listening process when listeners are experiencing the interplay between familiarity with the musical task and arousal related to short term activation of their listening mechanisms. Instead of mental categories borrowed from the original "flow space", we map the trajectory of information dynamics in terms of dramaturgical roles or structural functions.

In Figs. 7.12, 7.13, and 7.14 we show information dynamics in three sections of Beethoven sonata, exposition, development and recapitulation, represented in terms of a three dimensional curve in a space of SR and SA over Time (up). A projection of the curve on SR and SA plane is given in order to show the different regions that musical materials occupy in each section. Based on the analysis in Sect. 7.4

Fig. 7.12 Musical information dynamics of Beethoven sonata, represented as a trajectory in a two dimensional space – data-IR (Spectral Anticipation axis) and model-IR (Spectral Recurrence axis). The analysis shows an exposition part of Beethoven's Sonata

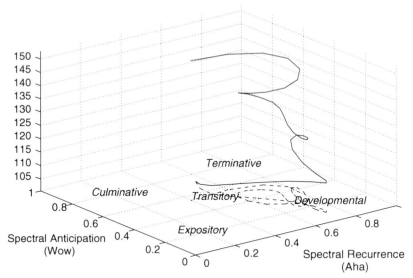

Fig. 7.13 Musical information dynamics of a development part of Beethoven's Sonata

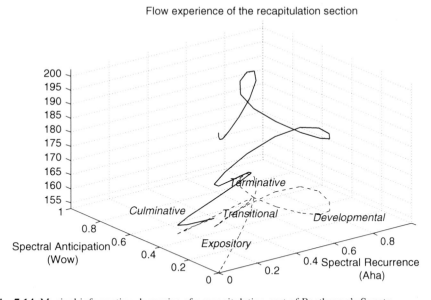

Fig. 7.14 Musical information dynamics of a recapitulation part of Beethoven's Sonata

we labeled the different quadrants of the SR-SA plane in terms of their musical functions. In addition to the four functions described in Sect. 7.4.1, we suggest that a culmination or climax should exhibit high SA and low SR values, i.e. having predictable materials on the short term but novel or unfamiliar materials on the

larger scale of musical form. Initial experiments reported in [5] suggest that musical climax or points of maximal interest can indeed be found by a difference between SA and SR values.

Appendix

Probability of the observations (data) depends on a parameter that describes the distribution and probability of occurrence of the parameter itself

$$P(x_1, \ldots, x_n) = \int P(x_1, \ldots, x_n | \theta) P(\theta) d\theta. \tag{7.7}$$

Considering an approximation of probability around an empirical distribution θ, [17],

$$P(x_1^n) = P(x_1^n | \theta) \int \frac{P\left(x_1^n | \alpha\right)}{P\left(x_1^n | \theta\right)} P(\alpha) d\alpha \tag{7.8}$$

$$= P(x_1^n | \theta) \int \exp\left[-\log \frac{P\left(x_1^n | \theta\right)}{P\left(x_1^n | \alpha\right)}\right] P(\alpha) d\alpha$$

$$\approx P(x_1^n | \theta) \int e^{-nD(\theta||\alpha)} P(\alpha) d\alpha,$$

the entropy of a block of samples can be written in terms of conditional entropy given model θ and logarithm of partition function[8] $Z_n(\theta) = \int P(\alpha) e^{-nD(\theta||\alpha)} d\alpha$,

$$H(x_1^n) = -\int P(\theta) \int P\left(x_1^n | \theta\right) \log P\left(x_1^n | \theta\right) dx_1^n d\theta \tag{7.9}$$

$$- \int P(\theta) \int P(x_1^n | \theta) \cdot \log\left[\int e^{-nD(\theta||\alpha)} P(\alpha) d\alpha\right] dx_1^n d\theta$$

$$= H(x_1^n | \theta) - E_\theta[\log Z_n(\theta)],$$

where we used the fact that $\int P(x_1^n | \theta) dx_1^n = 1$ independent of θ. With entropy of a single observation expressed in terms of conditional entropy and mutual information

$$H(x_n) = H_\theta(x_n | \theta) + I(x_n, \theta). \tag{7.10}$$

we express IR in terms of data, model and configuration factors

[8] Partition function gives a measure of spread of configuration of the different signal types.

$$\rho(x_1^n) = H(x_n) + H(x_1^{n-1}) - H(x_1^n) \tag{7.11}$$

$$= \rho_\theta(x_1^n) + I(x_n, \theta) + E_\theta \left[\log \frac{Z_n(\theta)}{Z_{n-1}(\theta)} \right]$$

Assuming that the space of models comprises of several peaks centered around distinct parameter values, the partition function $Z_n(\theta)$ can be written through Laplace's method of saddle point approximation in terms of a function proportional to its argument at an extremal value $\theta = \theta^*$. This allows writing the right hand of (7.11) as

$$\log \frac{Z_n(\theta)}{Z_{n-1}(\theta)} \approx -D(\theta||\theta^*). \tag{7.12}$$

resulting in equation of model-based IR

$$\rho(x_1^n) \approx \rho_\theta(x_1^n) + I(x_n, \theta) - E_\theta[D(\theta||\theta^*)]. \tag{7.13}$$

References

1. Berns G (2005) Satisfaction: the science of finding true fulfillment. Henry Holt, New York
2. Burns K (2006) Bayesian beauty: on the art of eve and the act of enjoyment. In: Proceedings of the AAAI06 workshop on computational aesthetics
3. Casey MA (2001) Mpeg-7 sound recognition tools. IEEE Trans Circuits Sys Video Technol 11(6):737–747
4. Csikszentmihalyi M (1990) Flow: the psychology of optimal experience. Harper & Row, New York, NY
5. Dubnov S (2008) Unified view of prediction and repetition structure in audio signals with application to interest point detection. IEEE Trans Audio Speech Lang Process 16(2):327–337
6. Dubnov S (2006) Analysis of musical structure in audio and midi using information rate. In: Proceedings of the international computer music conference, New Orleans, LA
7. Dubnov S (2006) Spectral anticipations. Compu Music J 30(2):63–83
8. Foote J, Cooper M (2001) Visualizing musical structure and rhythm via self-similarity. In: Proceedings of the international computer music conference, pp 419–422
9. Fraisse P (1957) Psychologie du temps [Psychology of time]. Presses Universitaires de France, Paris
10. Goffman E (1974) Frame analysis: an essay on the organization of experience. Harvard University Press, Cambridge, MA
11. Huron D (2006) Sweet anticipation: music and the psychology of expectation. MIT Press, Cambridge, MA
12. Kohs EB (1976) Musical form: studies in analysis and synthesis. Houghton Mifflin, Boston, MA
13. Lewicki MS (2002) Efficient coding of natural sounds. Nature Neurosci 5(4):356Ð363
14. McAdams S (1989) Psychological constraints on form-bearing dimensions in music. Contemp Music Rev 4:181–198
15. Moreau N, Kim H, Sikora T (2004) Audio classification based on mpeg-7 spectral basis representations. IEEE Trans Circuits Syst Video Technol 14(5):716–725

16. Narmour E (1990) The analysis and cognition of basic melodic structures: the implication-realization model. University of Chicago Press, Chicago, IL
17. Nemenman I, Bialek W, Tishby N (2001) Predictability, complexity and learning. Neural Comput 13:2409–2463
18. Oppenheim AV, Schafer RW (1989) Discrete-time signal processing. Prentice Hall Upper Saddle River, NJ
19. Reynolds R (2005) Mind models. Routledge, New York, NY
20. Reynolds R (2005) Form and method: composing music. Routledge, New York, NY
21. Reynolds R, Dubnov S, McAdams S (2006) Structural and affective aspects of music from statistical audio signal analysis. J Am Soc Inf Sci Technol 57(11):1526–1536
22. Stein L (1962) Structure and style: the study and analysis of musical forms. Summy-Birchard, Evanston, IL
23. Tversky A, Kahneman D (1981) The framing of decisions and the psychology of choice. Science 221:453–458
24. Zhang H-J, Lu L, Wenyin L (2004) Audio textures: theory and applications. IEEE Trans Speech Audio Process 12(2):156–167

Chapter 8
Let's Look at Style: Visual and Spatial Representation and Reasoning in Design

Julie Jupp and John Gero

Abstract This chapter explores the perception and modeling of style in design relating to visuo-spatial representation and reasoning. We approach this subject via cognitive and contextual considerations significant to the role of style during designing. A designer's ability to represent and reason about design artifacts visually and spatially allows meaningful "chunks" of design information to be utilized relative to the designer's task and context. Central to cognitive and contextual notions of style are two issues, namely the level of semantic interpretation, and the comparative method's degree of contextual sensitivity. This compound problem requires some explicit and cognitively plausible ordering principle and adaptive measure capable of allowing for dependencies in reasoning about similarities. This chapter first investigates the perception of style in relation to these modeling requirements before demonstrating and testing their implementation. We then discuss style in relation to design tasks and how they can be supported via the classification and retrieval of designs from large databases of visuo-spatial information.

8.1 Introduction

The term style is polysemous and can refer to ideas concerning the product, process, modality, period, region, society, culture, etc. The conceptualization of style explored in this chapter is based on the visual and spatial perception of an artifact's style. That is, when we are consciously aware of the similarity between artifacts it becomes a concept in its own right and is what we referred to as "style" [1]. Our study of style therefore proceeds using a product or object-based viewpoint. A well accepted definition of this perspective, characterizes style as an ordering principle that allows artifacts to be structured according to some set of criteria [2].

J. Jupp (✉)
Engineering Design Centre, University of Cambridge, Cambridge, UK; University of Technology Sydney, School of the Built Environment, Broadway NSW 2007, Australia
e-mail: Julie.Jupp@uts.edu.au

S. Argamon et al. (eds.), *The Structure of Style*,
DOI 10.1007/978-3-642-12337-5_8, © Springer-Verlag Berlin Heidelberg 2010

In design, the comparison of artifacts and assignment of formal or ad-hoc styles plays a crucial role. Across a range of different design domains, such as architecture, industrial design and graphic design, an individual's abilities to perceive, (detect and recognize) shapes, their spatial relationships and the similarities between them are important cognitive "mechanisms". These cognitive abilities are integral to, for example, Architectural and Art History in enabling the formal recognition and labeling of styles such as "Romanesque", "Gothic" and " Baroque".

However, these abilities also play an essential role in the design process allowing ad-hoc styles to be applied so as to structure information and create categories of visuo-spatial information whilst designing. Two-dimensional (2D) design diagrams, such as architectural plan and elevation diagrams, are an interesting instance of the artifacts that designer's typically reason about and between during designing. Architectural design diagrams are an attractive application area for studying style via visual and spatial representation and reasoning because they capture and convey designs of the built environment using properties of constituent geometric components, allowing tractable investigations and modeling.

Accordingly, this chapter explores the perception and modeling of style in design, and asks: what makes the style of a design diagram perceptible and how can we model style such that the automated analyses of designs are sensitive to (and therefore useful within) the designer's context?

We approach the first part of this question, from a qualitative feature-based standpoint. The perception of design style requires judgments of visuo-spatial similarity such that two or more artifacts can be decomposed into elements in which they are the same and elements in which they are different. Researchers have shown that the information utilized by human observers during visuo-spatial reasoning is typically qualitative in nature [3]. In other words, in judgments of physical similarity, reasoning is typically intuitive and based on the individual's commonsense knowledge [4–6].

The second part of the question, how can we model style, is a computational analysis problem that depends largely on the design domain of interest, the database in question, and the amount of a priori information available. We approach this analysis-based problem in light of a number of cognitive and contextual considerations which are significant to how the boundary of a style can be drawn differently according to the design task. In building on the foundation of qualitative re-representation we underscore the importance of the preservation of salient design feature semantics. Our approach therefore also emphasizes the contextual properties of comparative visuo-spatial analyses. Accounting for context is important since during designing, designers are capable of perceiving a design artifact's physical characteristics, interpreting their feature semantics, assigning higher importance/weighting to certain features and comparing each design using a number of different visual and spatial dimensions—and all relative to their design task. How similarities are perceived and where the boundaries of a design style are drawn by a designer may be influenced by the designer's intentions and goals. Interpreting a

diagram and distinguishing some design style can be dependent on the relevance of physical characteristics relative to the designer's context.

In considering both cognitive and contextual aspects of style this chapter's main objectives are highlighted, namely to (1) bridge the gap between the low-level structural features of design artifacts and the high-level semantics used by designers to understand design content; and (2) develop a model of style which is cognitively plausible and sensitive to context. Addressing these issues is critical to creating a digital characterization of style which is useful to designers.

8.1.1 Overview

The remainder of the chapter presents our investigation into the visuo-spatial perception and modeling of style. Section 8.2 continues with an examination of style in relation to the properties of similarity, explores the case for qualitative reasoning and presents our earlier research on computational stylistics in design. Section 8.3 outlines a digital characterization of style and method of analysis. Section 8.4 briefly presents the details of the approach. This section firstly reviews the basics of a qualitative encoding schema for representing visual and spatial information and deriving feature and shape semantics. Secondly we present the technique for assessing design diagrams using multi-dimensional datasets and an artificial neural network. Section 8.5 tests the model's cognitive plausibility and contextual sensitivity so as to investigate the qualitative, multi-dimensional and context-dependent approach to visuo-spatial reasoning. Lastly, in Sect. 8.6 we discuss the results of our experiments in relation to an object-viewpoint of style and current perspectives within and outside the design field. The aim of this discussion is to analyze our results and the insights that can advance our understanding of style with regard to how designers may be assisted in visual and spatial reasoning design tasks. Whilst a number of hypotheses and results are validated, others suggest specific areas for future experimentation.

8.2 Perception of Design Style

Identifying the style of a design is a judgment process. Human observers are able to search for, recognize, and interpret salient features in design diagrams (as well as all other visually and spatially perceptible artifacts) enabling the detection of physical resemblance and ultimately the identification of a member or many members of a style. Design artifacts can be described as belonging to the same style to the degree that they have a particular dimension in common and are not differentiated by any distinctive one, that is, the degree of their similarity. An object viewpoint of style can therefore be closely coupled to the concept of similarity; and approaching style via this related concept raises important

properties surrounding visuo-spatial similarity detection and the nature of reasoning used in making comparisons.

8.2.1 Style and Similarity

The last 40 years of research surrounding the concept of similarity has provided a variety of insights on both theoretical and empirical levels; see [7–10]. However, ongoing debate persists regarding the cognitive (or psychological) and contextual properties of similarity. Many studies centre on the analysis of whether similarity satisfies properties of triangle inequality, symmetry and minimality in relation to the metric distance function utilized for comparative analysis; whilst others focus on contextual aspects related to visual and spatial reasoning.

Triangle inequality is one of the most common properties of similarity explored by researchers; see [7, 8, 11, 12]. Triangle inequality implies that if a is similar to b, and b is similar to c, then a and c cannot be very dissimilar from each other. Looking at an example of this property, if the Frank Lloyd Wright plan shown in Fig. 8.1a is similar to the Louis Kahn plan in Fig. 8.1b; and if the Louis Kahn plan in Fig. 8.1b is similar to the Alvar Alto plan shown in Fig. 8.1c, then the Frank Lloyd Wright plan must be somehow similar to the Alvar Alto plan. However whilst it is possible to recognize similarities between plans in Fig. 8.1a, b and between plans in Fig. 8.1b and c intuitively, this statement is hard to accept, as can be seen in the case of the plans shown in Fig. 8.1a, c.

This example illustrates that similarity is not always transitive and triangle inequality fails due to the different emphasis on features and dimensions that are used to evaluate similarity [11, 12]. In the example above plan topology is the basis of the similarity between the Frank Lloyd Wright plan (Fig. 8.1a) and the Louis Kahn plan (Fig. 8.1b); whereas plan morphology is the basis of similarity between the Louis Kahn plan (Fig. 8.1b) and Alvar Alto plan (Fig. 8.1c).

Further, similarity is not always a symmetric relation [7]. That is, the similarity between a and b does not always equal the similarity between b and a. In the naïve view of the world, similarity defined in terms of conceptual distance is frequently asymmetric [13]. Asymmetry of similarity may result from the type of features characterizing two objects [11]. Returning to the example in Fig. 8.1 we can see

(a) (b) (c)

Fig. 8.1 Frank Lloyd Wright, Louis Kahn, and Alvar Alto residential plan design diagrams

that the shape features that make up all three plans differ. Figure 8.1a is composed of rectangles and complex L-shapes, and in Fig. 8.1b varying sizes of square shapes are dominant, whereas in Fig. 8.1c there are a combination of squares and rectangles.

Another property of similarity distance models is minimality. The property of minimality implies that the distance in similarity between a and itself will be less than the distance in similarity between a and b. Although most studies assume that similarity satisfies minimality, Testy [7] argues that the same self-similarity for all objects implied by the minimality property does not hold for some similarity evaluations. For example, the variation of self-similarity may be related to prototypical characteristics of the design artifact within the domain. Consequently, the measure of similarity between a design and itself may be related to the status of the artifact within the domain [11]. Here we assume that similarity most often satisfies the minimality property, because what matters is that the self-similarity must be larger than the similarity between two different objects.

In addition to these cognitive properties of similarity, there are also related contextual aspects. Studies have found that the similarity of representations is influenced by contextual dependencies [14]. Context in a design environment is a set of circumstances or facts that surround a particular design task.

Other studies have demonstrated that similarity processing often depends on context [15] and increasing consensus therefore regards similarity as a context dependent property [10, 16]. These views are particularly relevant in design since the designer operates within a context and their perception and judgment of design similarities are influenced by it. Yet they have largely been overlooked in modeling an object view of style and its analysis [17, 18].

Correspondence refers to when subjects pay more attention to those features that are similar in the assessment of objects, or pay more attention to distinctive features in the assessment of difference [7, 11]. Applying this notion to design, the similarity between two diagrams is only be established when their features are placed in correspondence, which is determined by their distribution. The degree of correspondence will depend on their consistency in relation to other diagrams in the set, as demonstrated by the example plan diagrams of Fig. 8.1. The matching of corresponding features has a greater contribution to the similarity rate than the matching of features that do not correspond [19, 20].

Another contextual aspect that can influence similarity assessment is classification itself. The diagnostic value of a feature is determined by the frequency of its classification that it is based on. Thus, similarity has two faces, causal and derivative. It serves as a basis to classify objects, but can also be influenced by the adopted classification [7]. The effects of the range and frequency of similarities are also associated with categorical judgments along any single dimension.

8.2.2 Style and Reasoning

How human observers reason about and between the similarity of artifacts is a main concern in an understanding the perception of style. Psychologists and cognitive

scientists have pursued questions of how people classify objects, form concepts, solve problems and make decisions based on perceived similarity [see: 7–10, 15, 16, 21, 22]. Much of this debate has surrounded the investigation of the variables used for reasoning and the different forms of reasoning.

However, in design research, there is still a lack of understanding of how designers classify, form concepts and make decisions based on the similarity perceived between two or more designs. Tversky [23] has shown in cognitive experiments that when reasoning about design diagrams, individuals are able to make comparisons across a variety of dimensions intuitively using abstraction, approximation, aggregation and other techniques to generate manageable spatial descriptions. However, a deeper understanding of the nature of visuo-spatial comparisons and forms of visuo-spatial reasoning in the design domain is lacking [24].

Our own cognitive studies in the design domain investigating the process of visuo-spatial categorizations have shown that during designing, ad hoc visual sorting of 2D design diagrams largely depends on an initial similarity assessment which is then later revised [24]. From this regard, the high-level semantic content contained in design diagrams often results in the initial assessment being revised a number of times in light of the designer's task. The process may be intuitive and yet meta-cognitive as an awareness of the similarities between each diagram's features emerges on subsequent revisions of initial assessments. Further, when designers judged the similarity of two diagrams the dimensions themselves or even the number of dimensions were not known and what might have appeared intuitively to be a single dimension were in fact be a complex of several [17].

Thus, the information used to perceive information exists on a number of different visuo-spatial dimensions. There are two general criteria, which have been distinguished by Shapiro [25] as significant to the characterisation of style and are therefore considered here as essential: (i) shape elements and attributes; and (ii) spatial relationships. The approach to re-representation in a computational model plays an important role in providing cognitively plausible comparisons not only from the perspective of what and how many dimensions are represented but also how they are re-represented. Qualitative approaches to representation are a common analysis paradigm in design reasoning applications because they provide a mean to map on to feature semantics. Using such common-sense descriptors supports the identification and comparison of designs that are not only structurally or spatially close but also conceptually close, whilst not being identical.

Yet, the qualitative encoding of a design diagram using multiple spatial ontologies so as to obtain a rich variety of feature semantics is a complex re-representation problem. Due to the complexity of imputing semantics relevant to a specific domain, this approach has been less prominent in models of style.

Furthermore, an important issue not addressed in style related research in design, is the issue of the cognitive validity of spatial representation languages and their ability to capture information significant to reasoning tasks. For example, in the field of computer vision, claims that qualitative reasoning is akin to human reasoning have typically not been supported with empirical justification.

Exceptions to this can be found in contributions made by Gould et al. [26] of a calculus for representing topological relations between regions and lines, and by Knauff et al. [27], who investigated the preferred Allen relation. Until recently, no such studies existed in design research to support the validity of a proposed qualitative language for re-representing visuo-spatial information and its significance in the assessment of style. In previous research we have sought to address this gap, see [17, 24]. We shall return to this issue in the first experiment in Sect. 8.5.

8.3 Computational Stylistics

Other chapters of this book, namely the semantic analysis of texts discussed (Chap. 5 by Argamon and Koppel), and the relation of musical perception to the rule-based prediction (Chap. 7 by Dubnov), both approach style via the assessment of the composition of information contained in some artifact. Whilst text and music analysis fields are more common research domains in computational stylistics, in design, there is also a growing interest in its application. Despite the lack of cognitive studies and model validation, in design a variety of computational models have been developed. Here we shall look at related models within design before presenting our own digital characterization of style.

8.3.1 Previous Research in the Design Domain

A number of frameworks and models providing automated analysis of design artifacts have been developed [28–33]. These models are typically based on a re-representation of either 2D or 3D design artifacts and some function of similarity that allows those artifacts to be compared and ordered. These models have been developed as design support systems to aid in decision making, analogy and the perception of Gestalts. Most have directly applied or adapted similarity functions from other fields of research, such as psychology and cognitive science as well as information analysis and retrieval systems. However these existing approaches are limited since comparison ultimately depends on quantifying common elements independent of a designer's task. They therefore present limitations in relation to the cognitive and contextual properties of similarity.

As a result, computational models of style have inherited an emphasis on linear analysis, which focus on distance measures that maintain a static world assumption, that is, where style is treated as unrelated to its locus of application. It is necessary to reformulate approaches to comparative by moving away from the idea of style as the outcome of a direct comparison and move towards the idea that it is a process whose outcome is reported in a post-hoc fashion.

Toward this aim, researchers have sought the benefits of artificial neural networks. Utilizing artificial neural networks has many advantages in the treatment of

design style as a multi-dimensional, contextually sensitive similarity measure. The underlying mathematical properties of most neural networks used in categorization are scalar distance-based algorithms. Of these, the Self-Organizing Map (SOM) is a typical representative. SOMs can be used in a variety of ways, with a number of different configurations available [34]. Whilst extensively used in other fields of research such as text and image retrieval, SOMs have not been widely utilized in design categorization systems.

One application known to the authors is a model proposed by Colagrossi et al. [35] for categorizing works of art. Colagrossi and his colleagues measured the similarity of Mondrian's Neoplasticist paintings according to a selection of features. By consolidating algebraic functions a variety of parameters were processed with only a few neurons in both the input and output of the SOM. Those parameters considered useful by the authors included line type, line weight and color. Yet, the application of the SOM by Colagrossi does not address the many of the cognitive and contextual properties of similarity discussed in Sect. 8.2.1. This is in part due to Colagrossi's restricted application domain, i.e., distinct design corpus, lack of semantics and contextual relevancies. Under this and other existing approaches to similarity assessment in design, contextually relevant categorizations, are unable to be obtained.

SOMs as a measure of design similarity can be improved by utilizing both qualitative descriptions and contextual input. On the one hand, the visuo-spatial information that can be derived from un-annotated diagrams requires rich re-representations at successive levels of abstraction [21] and neural networks are able to process multiple data sets based on qualitative re-representations. On the other hand, the designer may be an inseparable part of the assessment process and neural networks are capable of integrating query by pictorial example (QBPE), which is a common retrieval paradigm in content-based image retrieval applications [36] or via inputting relevance feedback. That is, design queries can be based on an example design diagram available either from the database itself or as a result of the designer's task. The designer classifies an example diagram as relevant or non-relevant to the current classification task, allowing selection of such styles the designer is most likely to be interested in.

QBPE and relevance feedback (RF) is commonly used in text classification and retrieval systems [37]. Yet there appears to be no model of similarity in design that integrates relevance feedback in this way. The implementation of SOM and RF presents a unique approach to computational stylistics in design. Since an analysis of style in the context of some design task may not be capable of returning the relevant style in its first response, the classification process becomes an iterative and interactive process towards the desired style and outcome. The assessment of style may therefore be treated not as a fixed and irreducible concept, but as a process, which takes place over some more-or-less open and variable dimensions of the designs being represented and compared. Under this treatment, the style of a design diagram is contextually-dependent. This view gives less explanatory force to style because it demands analysis of the design attributes whose similarity it computes in relation to context.

8.3.2 Our Research on Computational Stylistics

Our previous research on a computation model to analyze an artifact's design style has approached style assessment as transient, where the perceived similarities may depend on the corpus in question, the amount of a priori information available, the order of design comparison and, when considered in relation to a task specific context, may also depend on design objectives and requirements.

The model, called Q-SOM:RF, [18] has three main components, which are illustrated in Fig. 8.2, including: (i) Qualitative feature-based re-representation; (ii) Self-organizing maps; and (iii) Relevance feedback (RF).

Within the three main components are five consecutive stages: (1) recognition, extraction and encoding of three different levels of spatial attributes, (2) initial feature selection of encoded spatial attributes and combination of feature lists, (3) categorization via unsupervised learning of design diagrams based on available features, (4) positive and negative feedback processes via the observer's input, and (5) resulting weight adjustment and re-categorization of design diagrams.

In stage one, each diagram in the design corpus is encoded using a qualitative schema capable of describing sets of higher-level semantics corresponding to three prescribed spatial ontologies. During stage two, feature sets undergo a selection process as part of input pre-processing. A feature subset is produced using either principal component analysis or manual feature selection by the observer. The third stage utilizes the feature subset as input to the SOM and categorization occurs via unsupervised learning. How distances in various feature spaces are weighted and combined to form a scalar suitable for minimization, creates an opportunity to integrate contextual dependencies in the architecture of the SOM [38, 39]. The fourth stage continues as an interactive process that moves from unsupervised categoriza-

Fig. 8.2 Q-SOM:RF, stages of un-annotated 2D diagram categorization

tion to one which is guided by the observer. The final stage re-categorizes diagrams which are similar to the observer's target diagram, meeting some set of target criteria, by ordering those diagrams whose distance to the target is minimal in any or all feature sets. The model is therefore capable of automatically structuring a large design corpus according to selected features or feature semantics as an iterative process, which adapts to an observer's requirements and preferences. Adaptation is based on the relevance of clusters which are judged in relation to some design task.

8.4 Computational Analysis

This section presents additional detail on the computational approach to style explored in this chapter. We briefly summarize the qualitative representation schema for describing a hierarchy of spatial ontologies and self-organizing maps (SOM) as the method for design comparison. For more detail see [17] and [18, 40].

8.4.1 Qualitative Re-representation

Design diagrams are an explicit representation of the artifact's geometry, and it is reasonable to expect that categorization be based on 2D criterion that incorporates geometric properties which are: (i) generic—so that they have applicability over a wide spectrum of application domains, characterize as many physical dimensions of the diagram as possible including orientation, distance and topology; (ii) have both local and global support, i.e., they should be computable on shape primitives and spatial relations; (iii) provide descriptions capable of higher-level semantic mapping, (iv) are invariant over ranges of viewpoint and scale; and (v) are robust, and readily detectable by procedures that are computationally stable.

To satisfy these requirements the process of encoding follows from physicality to symbol to regularity to feature, where: (i) *Physicality*—refers to the graphic descriptions of diagrams indicating the geometric information and is the pre-representation, upon which a process of information reduction is applied successively over three levels of abstraction; (ii) *Symbol*—refers to the unrefined symbolic encoding of graphic information, whereby spatial attributes are recognized and converted into qualitative symbol values; (iii) *Regularity*—is the syntactic matching stage in which regular or repetitious patterns of encodings are identified and grouped; where detecting characteristics relies on "chunking" [41]; and (iv) *Feature*—involves matching pre-determined syntactic patterns with meaningful design semantics.

Figure 8.3 shows an example of an encoded design diagram labeled according to the principles of physicality to symbol to regularity to feature defined within the qualitative encoding schemata. The example is a simple 2D residential plan drawing of the Farnsworth House, designed by Mies van der Rohe.

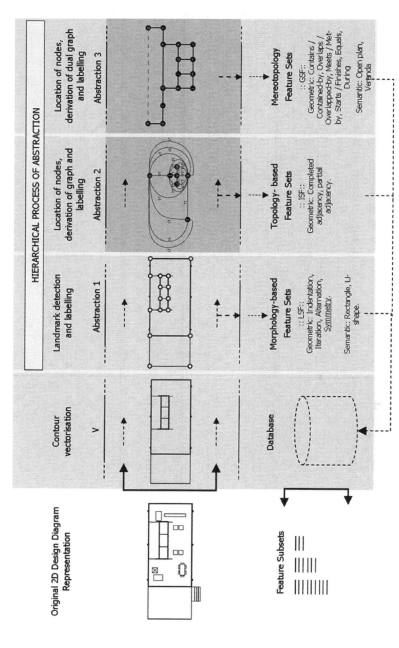

Fig. 8.3 Example of physical to symbol to regularity to feature mapping for the Farnsworth House by Mies van der Rohe

The first of four stages commences from the original representation of the design diagram is transformed into vectorial format. After contour vectorization, three consecutive encoding stages then follow. The mapping from physicality to symbol to regularity to feature involves detecting regularities and matching features from the geometric information so that specific patterns correspond to known feature semantics [41].

This process illustrated above is summarized in the following two sections describing firstly, diagram decomposition and re-representation and secondly, abstraction and re-representation.

8.4.1.1 Diagram Decomposition and Re-representation

Decomposition and representation (DeREP) divides the problem into smaller more tightly constrained sub-problems by partitioning shapes into vertices and contours. To achieve this, the process eliminates the primary source of complexity by separating unrelated variables into distinct shapes. This process results in a compact and easily understandable description of the structure of the diagram.

The sequence of vertex labeling occurs as an iterative process: contour traversal, vertex detection, value assignment, contour traversal . . . until circuit completion (shape closure). The problem of computing all possible circuits in the diagram so that each circuit contains all vertices exactly once is achieved by finding all Hamiltonian circuits [42]. A contour cycle (i.e., closed loop) algorithm is implemented where the agent starts the cycle from each point in the diagram and visits each adjacent vertex exactly once until a closed shape is generated or until a maximum branch limit is reached. This process iterates until all possible shapes are found. Once all closed shapes are found starting from all points in the diagram, the final set is filtered to eliminate shapes containing other shapes so that the resulting set contains only the smallest shape units. The perimeter shape is then found as the sum of all of the smallest shape units. Figure 8.4 shows a sample diagram and the resulting closed shapes detected.

As line contours are scanned vertex by vertex, the angle and length magnitudes of the previous line segment become the landmark point for the following segment, i.e., landmarks and intervals are set each time a new contour is compared. This enables a description of shape morphology to be obtained.

Morphology Descriptors

Sign values for specifying specific qualities of isolated shape structures are based on a description of attributes encoded at a landmark vertex (intersection) where properties for line contours are divided into two separate codes. The first is a primary code and represents the relative angle of the line contour. The second is an auxiliary code and represents the relative length of the line contour. The formal definitions of primary and auxiliary codes are presented in Table 8.1. Also see [4].

Where an angular change occurs, landmarks are initially set to π, separating convex and concave angles. The scanning order for each vertex is set to a

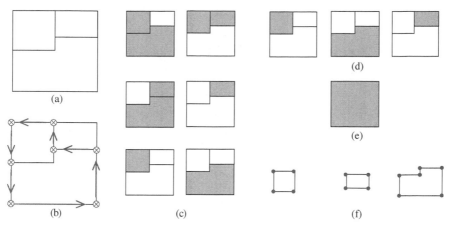

Fig. 8.4 (**a**) Original diagram, (**b**) Hamiltonian circuit, (**c**) all closed shapes found (**d**) smallest shape units (**e**) perimeter or boundary shape and (**f**) landmarks for labeling

Table 8.1 Definition of qualitative syntax for morphology

	Angle codes	Length codes
Numeric value range	$0 \leq \theta \leq 2\pi$	$-\infty \leq 1 \leq \infty$
Landmark set	$\{0, \pi\}$	$\{-\infty, 0, \infty\}$
Interval set	$\{(0,\pi),(\pi,0)\}$	$\{(-\infty,0),[0,0],(0,+\infty)\}$
Q-code set	$\{L, \Gamma\}$	$\{L, \Gamma\} \wedge \vee \{-, =, +\}$

counter-clockwise direction and the magnitude of the vertex is also measured in this direction. The addition of codes capturing the relative length of contours provides a description capable of distinguishing between shapes without increasing the number of primitives unnecessarily. The two primary codes L and Γ represent a vertex so that individual shapes can be described qualitatively.

Encoding results in a symbol string and a syntactic handling method employing a simple pattern recognition technique is used to group structural and identify semantic aspects of regularities. That is, patterns of symbol sequences denoting specific categories of features that are familiar in contour or identify some particular shape semantic are identified. The descriptions of simply patterns reflect basic repetitions and convexity and simple semantic labels, including: indentation, protrusion, [43], iteration, alternation and symmetry [44] are identified. From these more complex semantic mappings are then defined including primary shape types such as "rectangle", "square", "L-shape", "U-shape", "T-shape", and "cruciform". Ever more complex semantics that incorporate domain specific knowledge can also be obtained which provide a description of the design concepts, for example, "chambers" and "niches".

These shape patterns are derived from low level structural primitives and describe what we shall refer to from this point as local shape features, or LSF. Features already stored in a database identify syntactic patterns and where the search and

matching process examines the type and occurrence of "chunks" and their structure as a sequence is then labeled. A systematic search for every possible pattern is necessary for the given shape or spatial description.

8.4.1.2 Abstraction and Re-representation

The DeREP process described above is followed by abstraction and representation (AbREP) which automates the derivation and encoding of two subsequent graph representations from the original diagram. The systematic processing of spatial relations pertaining to topological and mereotopological attributes requires the mapping from physicality to symbol to follow a similar conversion process from the graphic state to the symbolic state as implemented in the DeREP process, i.e., contour traversal, vertex detection, value assignment, contour traversal... etc. AbREP uses the array of symbols describing intersections of line contours and labeling relies on the data structures built from the previous stage.

To encode multiple line attributes, graph diagrams derived from the original contour representation are used as the means by which to parse information in a consistent manner. An "abstract landmark", see Fig. 8.5, is created as an array and labeled according to a vertex's specific characteristics. This is achieved by iterating between each set of new graph vertices and traversing every pair. In this way, graphs provide a notion of hierarchy and support bottom-up development.

There is an important aspect of the AbREP process, whereby sets of arrays describing shapes are analyzed based on the relationship between each shape. At the contact of two or more shapes, specific extraction and embedding relationships relating the intersection of line contours exists [6]. Where this occurs there is a transformation in representation which extends the encoding of two line intersections to include multiple lines. This is a reduction process whereby some structural information about the shape is lost. However shape adjacencies are captured using a description of vertex arrays. Once the new arrays are derived and labeled a representation of adjacencies is captured. At this level, arrays constitute an approximate representation of the topology of shapes.

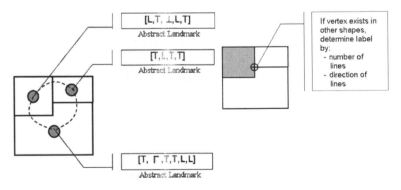

Fig. 8.5 Shape encoding: Abstract landmark and shape adjacency relations

Topology Descriptors

The specification method at the level of topology builds on the previous morphological level and such that it is possible to provide a description of spatial attributes in terms of shape adjacencies and area descriptors. The symbols used to describe edges of graphs concern the disposition of physical intersections of lines which have been used to generate the polygon fields that are subsequently analyzed as graphs. Edges are labeled according to the intersection type of the two vertices belonging to the line contour it crosses creating a "dyad" symbol. In other words the pairs of syntax at the level of morphology are collapsed to create a dyad symbol.

The representation of dyad symbols reveals distinctive topological characteristics that are recognized from syntactic regularities. Once the new set is formed the area of a shape is calculated and compared to the area of the adjacent shape to obtain a description of the relative area. As a result the list of area magnitudes combined with their adjacency types is created for each abstract landmark. Formal definitions are presented in Table 8.2.

Unlike morphological features, topological ones contain variations based on a reference frame. Using the dyad symbols in conjunction with a reference point, three types of adjacency semantics can be defined including: complete adjacency, partial adjacency and offset. These regularities identified in dyad symbols are deemed intermediary shape features, ISF, since the "neighborhood" of the description is based on local attributes as well as information describing topological properties. Like LSF, ISF are identified by matching an existing feature database.

Mereotopology Descriptors

The next level of abstraction describes the mereotopology of the spatial characteristics conveyed in the diagram. Mereotopology describes part, (i.e., a shape) to whole (i.e., overall plan shape) relations. The dual of the graph diagram is used to derive composite symbol values in order to describe part-whole relations. Abstracting the initial graph to its corresponding dual graph ensures that unambiguous mappings can be derived. Once all mappings have been established, the dual is used to derive feature semantics. This results in transformations that are much clearer and easier to understand while still based, by virtue of the mapping, on the original 2D representation. The second dual graph allows further derivation of spatial relationships.

By labeling the new dual-edges, "tuple" codes derived from dyad symbols (defined at the previous level of topology) are created. For each edge of the dual

Table 8.2 Dyad symbols -qualitative syntax for topology

	Angle codes	Area codes
Numeric value range	$0 \leq \theta \leq 2\pi$	$-\infty \leq 1 \leq \infty$
Landmark set	$\{0, \pi\}$	$\{-\infty, 0, \infty\}$
Interval set	$\{[0,0],(0,\pi),[\pi,\pi],(\pi,0)\}$	$\{(-\infty,0),[0,0],(0,+\infty)\}$
Q-code set	$\{L, \Gamma, T, \perp, C\}$	$\{L, \Gamma, T, \perp, C\} \wedge\vee \{-, =, +\}$

Table 8.3 Tuple symbols -qualitative syntax for mereotopology

	Adjacency codes
Numeric value range	$0 \leq \theta \leq 2\pi \wedge \vee 0 \leq \theta \leq 2\pi \wedge \vee -\infty \leq 1 \leq \infty$
Landmark set	$\{0, \pi\} \wedge \vee \{0, \pi\} \wedge \vee \{-\infty, 0, \infty\}$
Interval set	$\{[0,0],(0,\pi),[\pi, \pi],(\pi,0)\} \wedge \vee \{(-\infty,0),[0,0],(0,+\infty)\}$
Q-code set	$\{\mathsf{L, \Gamma, T, \perp, C}\} \wedge \vee \{\mathsf{L, \Gamma, T, \perp, C}\} \wedge \vee \{ >, =, < \}$

graph, labels are derived from the symbol values identified at the previous level. Labeled dual edges allow regularities to be identified and feature semantics describing part-to-whole relationships between two or more shapes are identified. Since dual graphs are undirected, regularities are identified from within the tuple itself and not from a string. Formal definitions of dyads are presented in Table 8.3.

The semantic features identified at this level account more thoroughly for mereotopology. The regularities defined here are similar to Allen's thirteen interval relations for the temporal domain [45]. Mereotopological feature semantics include: meets/met-by, overlaps/overlapped-by, starts/finishes, contains/contained-by, equals and during. Allen's interval calculus has previously been extended to other visual domains [46, 47] unlike previous approaches, here it is not restricted to rectangles and although is strictly based on orthogonal shapes, is still capable of handling arbitrary multi-sided forms.

Like the features identified for morphology and topology, spatial semantics derived from visual patterns are identified and domain semantics are integrated using design concepts that map onto spatial features. Continuing with the example application of the architectural domain, spatial concepts relating to the use or behavior of a space such as corridor, quadrangle, and courtyard are mapped to patterns detected in each tuple. Since all features are derived from higher level spatial primitives they are defined as global shape features, GSF.

The three level schema summarized here is characterized by the class aspect of handling and labeling design concepts and is useful when dealing with different design categorization scenarios. The concession of the approach is that it is essential to have a large database of concept-to-feature mappings.

8.4.1.3 Pre-processing Feature Sets

Each type of feature representation identified using the DeREP and AbREP operations, i.e., morphological, topological or mereotopological, can be used to create a subsets of feature semantics. At this level of implementation the model has two approaches to pre-processing of feature sets, where dimensionality reduction can be undertaken manually by the user or by using a statistical approach.

In manual selection of feature sets, subsets can be created directly by selecting those features of interest to categorization. These may also be based on the feature sets derived from a target diagram (if known). For example, an observer may wish to identify the style of design precedents based on certain topological relationships, such as having complete adjacency, and in conjunction with certain morphological

constraints such as an external or bounding cruciform shape and containing all internal rectangular shapes.

Using the statistical approach, feature subsets can be created automatically using Correlation-based Feature Selection (CFS) [48]. CFS provides a filter based feature selection algorithm that uses correlation among features to select the best features for the given subset. CFS evaluates the worth of a set of attributes by considering the individual predictive ability of each feature along with the degree of redundancy.

8.4.1.4 Unsupervised Categorization

The main advantage of using self-organizing maps (SOMs) in design comparison is that they do not require target values for their outputs and learning occurs unsupervised. Since there is no absolute definition of the commonalities between design artifacts in terms of their spatial descriptions, there is no single definitive exemplar to establish reliable target outputs that can be used to train a supervised network. For this reason, SOMs using unsupervised learning are commonly used to find and construct classifiers. Hence the SOM can provide a continuous topological mapping between the feature space and the 2D mesh of neural units in the competitive layer. This is an important property since it enables the representation of a mapping, which preserves relations in the input space while at the same time performing a dimensionality reduction onto the 2D mesh.

To interpret, categorize and visualize the multi-dimensional datasets of semantic features, the SOM learns unsupervised and initially categorization begins with a corpus of reference diagrams. The map consists of a regular "city-block" grid of neurons and categorization follows three steps: (i) the distances between the input vector x and all reference vectors (i.e., weight vectors) are computed using a Euclidean distance measure; (ii) a winner (i.e., a neural unit for which the corresponding weight vector is at a minimum distance from the input vector) is determined; (iii) the weight vectors corresponding to the winner and the neural units in its topological neighborhood are updated to align them towards the input vector. The SOM then attempts to represent the corpus of diagrams with optimal accuracy using the selected subset of features.

The SOM is able to learn to recognize different patterns in the input data and allocate them to appropriate "bins" (styles) in the output array, each bin representing a specific pattern. Therefore if we see the output as an array of "classification bins" (each representing a specific pattern in the input data) that are arranged in an ordered way such that near neighbors represent similar styles and distant neighbors represent different styles.

Since there does not and will not ever exist one single "correct" answer to the central issue of a definition of design style, the ability to combine the distances calculated in different feature spaces provides the critical point where relevance feedback can be incorporated. The SOM's matching process can therefore also be driven by contextual considerations, where the observer is able to determine the relative importance of distinguishing features by adjusting their weights. When con-

textual information is used for determining the importance of distinguishing features the correlation between the designer's requirements and the styles identified can therefore increase.

8.4.1.5 Relevant Styles

The correspondence between high-level design concepts and lower level physical features can often depend on the context of the observer. Consequently each design categorization may be different due to the hidden conceptions in the relevance of diagrams and their mutual similarity. This is the rationale behind the fourth stage where if the design clusters selected by the observer map closely to each other on the SOM, then the corresponding feature performs well on the present categorization and the relative weight of its opinion is increased. This is known as relevance feedback, or RF, and is the iterative refinement of an initial SOM categorization.

RF is provided using dynamic weight adjustments that allow the SOM to learn the optimal correspondence between the high-level concepts that the observer uses and the feature semantics automatically derived from 2D diagrams. In text and image-based research, RF is an established approach that enables contextual-dependencies to be integrated for document and image retrieval. Recently this approach has been adopted by researchers using SOMs to retrieve information from large databases [38–40].

In an analogous manner, we have aimed at integrating RF with a SOM in the design domain, by treating this process as a form of learning that moves from unsupervised learning to being partially supervised. The model tries to learn the observer's visual preferences by adjusting the feature weights accordingly. Feature weights in subsequent categorizations are adjusted using the information gathered from the observer's feedback. The observer's feedback guides the system in the following rounds of the assessment process to better approximate their present design requirements/preferences.

The task of assigning specific weights which coincide with the observer's perception of each feature set is not feasible and therefore the initial results from the unsupervised clustering are displayed using the topographic map so that weights can be derived from user input. It is crucial that the results from the initial round are categorized in a manner such that a level of visual similarity is evident to the observer—this being the primary objective of integrating qualitative encoding. The observer is not required to explicitly specify weights for different features and instead weights can be formed implicitly from the positive and negative values assigned to a diagram or cluster of diagrams.

This process follows whereby: (i) an unsupervised SOM categorizes a design corpus; (ii) the first round of results are displayed and stored to avoid the system entering a loop; (iii) the observer indicates which diagrams are to some extent relevant to the present design context and which are not and assigns positive and negative values accordingly; (iv) the adjusted weights are utilized in a re-initialized SOM and the design corpus is re-categorized; (v) the second and any subsequent

round of results are displayed to the user and stored; and (vi) the process continues until the observer is satisfied.

By marking on the map, the categories the observer deems relevant, we are able to adjust each unit or node assigned a positive and negative value depending whether the observer has selected or rejected the corresponding design classification. The marking operation indicates correctly classified design clusters as positive. Diagrams are accumulated during the categorization process into sets and weights are adjusted in succeeding iterations, moving from an unsupervised SOM to one which is partially supervised or guided.

8.5 Experiments

Two classes of experiments were carried out to assess the cognitive plausibility and contextual sensitivity strength of our approach to computational stylistics in design. In conducting these experiments, we also aim to test the utility of the model as an aide to designers.

The first experiment tests the discriminatory power of the qualitative schema combined with the SOM's ability to categorize encoded diagrams using specific feature sets, i.e., Q-SOM without RF. The second experiment tests the complete system, i.e., Q-SOM:RF, where the relevance of categorizations is provided by an observer's feedback in the context of a design scenario. As a result we test the model's ability to handle the cognitive-contextual properties and cognitive-psychological properties of style.

The design corpus used in all experiments consists of 2D architectural design diagrams. The Exemplar diagrams from each architect and a sample of the feature sets extracted (as raw unprocessed data) are shown in Table 8.4.

The corpus tested is relatively large, totaling 131 diagrams and representing six architects, namely: Palladio, Frank Lloyd Wright, Mies van der Rohe, Le Corbusier, Louis Kahn, and Mario Botta. The two studies here undertaken use networks that have been trained using 36 diagrams, which comprise six designs randomly selected from each of the six architects.

The number of features extracted from the design corpus totaled 37,367 and there is an average of 287 features from 59 sets associated with each diagram. The characteristics of feature sets in relation to each architect are shown in Table 8.5.

The level of complexity of the corpus is considered to be relatively high since although all diagrams are from a single domain, i.e., architecture, the corpus consists of designs from a number of architects and several different building typologies including small and large scale residential, as well as a variety of public buildings.

8.5.1 Experiment 1: Q-SOM

The first experiment is designed to assess the effectiveness of the derivation of semantic features and ascertain the benefits of dimensionality reduction in diagram

Table 8.4 Exemplar diagrams based on architect

Exemplar Diagram	Exemplar LSF	Exemplar ISF	Exemplar GSF	Architect/ bldg type/ period
	Alternation, symmetry, square, rectangle, chamber, niche	Complete adjacency, partial adjacency,	Meets/Met-by, contains/ contained-by, overlaps/ overlapped-by, starts/finished-by, corridor, portico	Palladio residential public 1528 – 1580
	Indentation, protrusion, iteration, alternation, square, rectangle, "L"-shape, "T"-shape, niche, stepped forward, hearth	Complete adjacency, partial adjacency, offset	Meets/met-by, contains/ contained-by, overlaps/ overlapped-by, starts/finished-by, equals, corridor, Portico	Frank Lloyd Wright residential 1888 – 1959
	Indentation, protrusion, iteration, alternation, symmetry, rectangle, "U"-shape	Complete adjacency, partial adjacency,	Contains/ contained-by, overlaps/ overlapped-by, starts/ finished-by, during, equals, corridor, veranda	Mies van der Rohe residential, public (religious, library, theatre) 1912 – 1958
	Indentation, protrusion, iteration, alternation, symmetry, square, rectangle, "U"-shape, "L"-shape, Niche, Stepped backward.	Complete adjacency, partial adjacency	Contains/ contained-by, overlaps/ overlapped-by, starts/finished-by, during, equals, portico, courtyard	Le Corbusier residential, public:(religious) 1908 – 1965
	Indentation, protrusion, iteration, alternation, symmetry, square, rectangle, "U"-shape, chamber, locked space, niche, gallery, hearth	Complete adjacency, partial adjacency, offset	Meets/met-by, contains/ contained-by, overlaps/ overlapped-by, starts/finished-by, equals, courtyard, quadrangle	Louis Kahn residential, public (religious, library, theatre) 1951 – 1969
	Indentation, protrusion, iteration, alternation, symmetry, square, rectangle, "L"-shape, chamber, locked space	Complete adjacency, partial adjacency, offset	Meets/met-by, contains/ contained-by, overlaps/ overlapped-by, starts/finished-by, equals, courtyard	Mario Botta residential 1969 – 1996

Table 8.5 Characteristics of each feature set based on architect

Type (Architect)	Average no. of features	Total no. of features	No. diagrams
Palladio	254	3810	15
Frank Lloyd Wright	306	18360	61
Mies Van Der Rohe	268	4288	16
Le Corbusier	221	1547	7
Louis Kahn	327	6213	19
Mario Botta	243	3159	13

categorization. This experiment is therefore designed to test the visuo-spatial re-representations of the pictorial content of the diagram as qualitative features and feature sets. We trained, tested and evaluated networks using a variety of network topologies and different feature subsets.

8.5.1.1 Pre-processing

Pre-processing of input data was undertaken using the statistical feature selection method outlined in Sect. 8.4.2., and using CFS we evaluated subsets of features by the correlation among them. In the first study we used only a re-representation of morphology (i.e., the LSF) extracted from the corpus for dimensionality reduction and eight LSF were identified as significant by CFS including: Protrusion_0, Protrusion_3, Iteration_2, Alternation_1, Symmetry, Square, Cruciform and Niche. From this point, we shall refer to all networks created using this subset as SOM_L.

In the second study, dimensionality reduction included all feature sets extracted using the DeREP and AbREP operations and in addition to the eight LSFs identified above, four GSFs: Contains/Contained_by, Overlaps/Overlapped_by, Equals, and Courtyard were evaluated as an optimal subset of attributes for clustering. Interestingly, no ISF were identified. Categorization therefore relies on a combination of feature classes where the ratio of local to global features is 2:1. We shall refer to all networks created using this subset as SOM_{L+G}.

8.5.1.2 Training

For all Q-SOM experiments, two different feature vector models were constructed using the subsets identified in the previous section. In all SOM_L networks, each diagram had an average of 35 features and the final vector model contained 1239 feature instances, which created a unique feature vector for each 2D plan diagram. In SOM_{L+G} networks each diagram contains an average of 50 features and the final vector model contained 1812 feature instances comprising of feature vectors from 1,239 LSF and 573 GSF feature instances.

In addition to the two different feature vector models, training was also varied in terms of the topology of the network and the number of cycles, where 500, 1000 and 1500 training cycles were used. Table 8.6 shows the training variables for each Q-SOM.

A	A	B	B	C
A	A	B	F	F
D	D	D	C	C
E	D	F	F	C
E	E	B	B	E

Palladio | A |
Wright | B |
Van der Rohe | C |
Le Corbusier | D |
Kahn | E |
Botta | F |

Fig. 8.6 Training result: SOM$_L$ clustering

Table 8.6 Characteristics of different Q-SOM networks used in diagram classification

Vector models		Network characteristics	
Feature subset	No. input nodes	Topology	Training cycles
SOM_L	8	$3 \times 3, 5 \times 5, 10 \times 10$	500, 1000, 1200
SOM_{L+G}	12		

Neither SOM_L nor SOM_{L+G} utilize any other information about the diagram, i.e., the architect, building type, period, etc. Since there is no access to prior knowledge regarding the number of clusters in the data, the SOM proceeds unsupervised.

Based on a visual inspection the 5×5 SOM_L, trained for 500 cycles, performed the best and resulted in the clusters as shown in the topographic map in Fig. 8.6. Results show categorization of diagrams can be roughly linked to the architect as indicated by the map and labeled key in Fig. 8.6 showing each architect, where: A ≈ Palladio; B ≈ Wright, C ≈ Van Der Rohe, D ≈ Le Corbusier, E ≈ Kahn, and F ≈ Botta. A node may represent more than one diagram, but with different activation values. In some cases the node contains two architects (approximately 20%) and each label has been assigned on the basis of the dominant feature vector. Also observed from the map, the network appears to have clusters distributed separately corresponding to the same architect, including: Wright (C), Kahn (E) and Botta (F).

The 5×5 SOM_{L+G}, trained for 500 cycles, also resulted in well defined clusters, as shown in Fig. 8.7. Like the results obtained for the 5×5 SOM_L, the results observed in the topographic map show categorization of diagrams can be linked to the architect. The topological ordering of the diagrams in the 5×5 SOM_{L+G} shows a better result than obtained for the 5×5 SOM_L training. This is evident from the separate clusters and the distinctive change of clusters across the map, where Kahn's diagrams, E, are located in the upper left-hand corner of the map and the architect gradually changes towards the bottom-right corner to Le Corbusier, D. Although the 5×5 SOM_{L+G} also distributed two clusters for Wright's designs, B, clustering is more consistent across individual architects.

Significantly, in the 5×5 SOM_{L+G}, all nodes except for the node marked "x" in Fig. 8.7 contain input vectors from the same architect. This can also be observed from the activation weights given to each individual input vector. The SOM_L input vectors have much lower activations when compared to the SOM_{L+G} input vectors. Testing was then carried out to evaluate the clustering effectiveness of the trained networks. The objective of testing is to evaluate the success of each trained network using the two different approaches to constructing feature vectors, i.e., manual versus CFS selection.

8.5.1.3 Testing

The SOM_L and SOM_{L+G} networks were tested and their clustering ability was observed. As in training, the 3×3, 5×5 and 10×10 maps were all tested. To analyze the results of categorization between the topographic maps we utilized techniques from conventional text-based categorization analysis including: Precision [49], the

E	E	B	B
E	C	C	B
F	F	C	D
A	A	D	D
A	A	B	D

Palladio	A
Wright	B
Van der Rohe	C
Le Corbusier	D
Kahn	E
Botta	F

Fig. 8.7 Training results: SOM_{L+G} clustering

Table 8.7 Clustering ability of different map topologies trained on SOM_L Feature subsets

Study 1: Q-SOM	Precision	JAC	FM
SOM_L 3×3	0.49	0.29	0.37
SOM_L 5×5	0.62	0.38	0.45
SOM_L 10×10	0.53	0.32	0.30

Table 8.8 Clustering ability of different map topologies trained on SOM_{L+G} Feature subsets

Study 2: Q-SOM	Precision	JAC	FM
SOM_{L+G} 3×3	0.61	0.46	0.42
SOM_{L+G} 5×5	0.74	0.53	0.50
SOM_{L+G} 10×10	0.60	0.46	0.39

Jacaard or JAC method [50], and the Fowlkes-Mallows or FM method [51]. Since classification is unsupervised it is not possible to apply these evaluation methods directly as would be the case for supervised learning.

To analyze results of testing unsupervised SOMs it is necessary to utilize the most dominant label of each cluster (obtained during training) for all diagrams. For this reason, the labels (architects) identified from training are maintained so as to assign categories. The "micro-averaged" precision matrix method [49] was first used to evaluate each network and the well-established JAC and FM methods were then used to evaluate cluster quality; see [40] for further details of these evaluation methods.

The three topologies of SOM_L were tested and each network's ability to categorize the entire design corpus was analyzed. The 5×5 map was found to have the best results for all evaluation techniques measured, as shown in Table 8.7, with Precision and JAC results being comparable. The results of FM also show how the 5×5 map outperformed both the 3×3 and the 10×10 maps.

Next, we tested Q-SOM_{L+G}, and again the 5×5 map has the best results for all evaluation techniques measured. As expected the 5×5 SOM_{L+G} produced better results for precision, JAC and FM than SOM_L results, shown in Table 8.8.

8.5.1.4 Assessment of Clusters

The nature of the categories produced by the two best performing networks, i.e., 5×5 SOM_L and SOM_{L+G} are difficult to evaluate, except via visual (subjective) processes. Recently, conventional clustering techniques (e.g. K-means, EM, Hierarchical, etc.) have been used to resolve this problem. Ahmad and Vrusias [51] demonstrate the effectiveness of using conventional statistical clustering techniques, in evaluating the output of maps of unsupervised networks. Sequential clustering, i.e., first clustering using an unsupervised network and then clustering the output map, facilitates visualizing clusters that are otherwise implicit in the output map.

We have used a sequential clustering method, Q-SOM followed by K-means, to examine the categories obtained. An application of K-Means clustering on the

Table 8.9 Distribution of plan diagrams using K-Means clustering: (a) SOM_L and (b) SOM_{L+G}, where A = Palladio Residential and Public Bldgs., B = Wright Residential Prairie Bldgs., C = Wright Residential Usonian Bldgs., D = Mies Van Der Rohe Residential Bldgs., E = Mies Van Der Rohe Public Bldgs., F = Le Corbusier Residential Bldgs., G = Le Corbusier Public Bldgs., H = Kahn Residential Bldgs., I = Kahn Public Bldgs., and J = Botta Residential Bldgs

(a)

Clusters by K-Means on SOM_L										
Architect	A	B	C	D	E	F	G	H	I	J
A	9							2	3	1
B	6	19	2		1			5		1
C		7	14		4					
D	1		2	3	1	1				1
E			1		4			1	2	
F				1		3				
G						3	0			
H			2		1			8		
I		1	1	1					5	
J	1		2	1	2					7

(b)

Clusters by K-means on SOM_{L+G}										
Architect	A	B	C	D	E	F	G	H	I	J
A	12			1			1			1
B	1	25	2		1			5		1
C		4	19		1		2	1		
D	1		1	6		1				
E					5			1	2	
F					1	3				
G						1	2			
H							1	10		
I	1		1						7	
J						2				11

output of the 5×5 SOM_L and SOM_{L+G} maps shows how they have found data in proximate types defined by both the architect and building type. Table 8.9a and 8.9b compare K-Means clustering of all 131 plan diagrams for both 5×5 networks.

The two tables show the distribution of plan diagrams where the feature vector models can be used to cluster diagrams according to an architect and their residential or public building types. Using the sequential clustering method Table 8.9a shows clustering of the design corpus based on the LSF subset (SOM_L) has not proven to be as defined. Diagrams associated with both architect and building type (represented using the combined LSF and GSF subset), shown in Table 8.9b, have generally been well clustered except for Le Corbusier's designs where no distinct clusters are distinguishable. Significantly for both SOM_L and SOM_{L+G} networks, Wright's designs are distinguished relative to two periods of Wright's work—the Prairie and Usonian houses—where clustering defines 87% of Wright's Prairie design diagrams and 84% of his Usonian.

8.5.2 Experiment 2: Q-SOM:RF

Based on the results obtained from the 5×5 SOM_{L+G}, the final experiment trains and tests a network's ability to categorize the same corpus using the complete Q-SOM:RF model to obtain clusters which are relevant to some design context. Pre-processing is again used in dimensionality reduction to create feature vectors and categorization proceeds as a sequential process based on manual selection of diagrams. In this experiment, categorization is evaluated in the context of a design

(a) (b)

Fig. 8.8 Design sketch (**a**) original sketch of residential dwelling (**b**) contour vectorization

task where the observer (the author) has provided positive and negative values to the units of the network.

8.5.2.1 Design Context

A simple design task was formulated using a brief specifying the requirements of a residential plan design for a family of four. The brief specifies alterations and additions of an existing residential design to increase sleeping and living spaces, according to the following specifications of building layout: additional sleeping areas to accommodate two children; larger lounge, dining and kitchen areas; and outdoor living area.

A conceptual design sketch was then produced using the systems digital drawing interface which constrains sketching to orthogonal axis. Figure 8.8a presents the design sketch produced as a result of the brief's requirements and Fig. 8.8b shows the sketch as interpreted by the vectorization process of the system. The sketch was encoded (all labels are ignored) and included in the design corpus with the other 131 plan diagrams.

8.5.2.2 Pre-processing

In this experiment, the original (raw) feature set was processed manually. Manual processing is utilized since it enables the selection of a feature subset relevant to the design task. Since it is the aim for categorization to be grounded by the design task, the style of diagrams can be determined based on those features extracted from the design sketch shown in Fig. 8.8. Therefore from the 59 possible feature classes, selection of one or many feature subsets to create vector models is facilitated from the encoding of the design sketch. Salient features were identified from the local, intermediate and global shape features contained within design sketch. All features classes extracted from the design sketch are shown in Table 8.10.

The feature classes within the design sketch were then used to create feature vector models to classify the design corpus. A total of 31 feature classes were extracted from the design sketch, which were distributed between local, intermediate and global feature classes as: 22, 3 and 6 respectively.

Using the reduced feature subset it is possible to identify other feature subsets which may be deemed to be more salient in relation to design requirements. To

Table 8.10 Reduced feature subset and user subset

Features exracted by DeREP & AbREP							Subset			
LSF (Geometry-based)	Indentation	0	1	2	3	✗	✗	✓	✗	
	Protrusion	0	1	2	3	✗	✗	✓	✓	
	Iteration	0	1	2	3	✗	✗	✗	✗	
	Alternation	0	1	2	3	✗	✗	✓	✗	
	Symmetry	0	1	2	3	✗	✗	✗	✗	
LSF (Domain-based semantics)	Stepped forward					✓				
	Niche					✓				
ISF (Geometry-based)	Complete adjacency					✗				
	Partial adjacency					✓				
	Offset					✓				
GSF (Geometry-based)	Contains/contained-by					✓				
	Overlaps/overlapped-by					✗				
	Starts finished-by					✗				
GSF (Domain-based semantics)	Corridor					✓				
	Portico					✓				
	Stepped					✗				

demonstrate the utility of selecting a user-specific subset from the design sketch, a feature subset is shown in the final column of Table 8.10 (shown as ticked), where 11 feature types have been selected based on the preferences of the designer. In addition, three other feature subsets were selected, namely: (i) LSF, (ii) ISF and (iii) GSF.

Five feature vector models were then constructed consisting and network training was also varied in terms of the number of cycles, where 500, 1000 and 1500 training cycles were again used. Table 8.11 shows the final training variables for each of the five qualitative feature-based SOMs.

Table 8.11 Characteristics of the different neural network systems used in diagram classification

Vector model		Network characteristics	
Feature subset	No. input nodes	Topology	Training cycles
All features	31	5×5	500, 1000, 1500
User subset	11		
LSF	22		
ISF	3		
GSF	6		

8.5.2.3 Training and Testing Using Relevance Feedback

All five feature vector models were trained using the 5×5 topography. However, before testing could commence it is necessary to make explicit the targeted

categories. In order to demonstrate and then evaluate the performance of the five feature vector models in conjunction with RF, a category of designs must first be defined within the corpus as the desired target/s. We selected two targets: (i) Wright's Usonian period and (ii) Kahn's residential designs. Each target contains 27 and 11 plan diagrams respectively. Each category was selected simply based on observer preferences. Neither target is necessarily more "correct" or valid than any other potential category of designs. However because Wright's Usonian and Kahn's residential designs can now be explicitly targeted by the observer using RF it is then possible to evaluate how well the system refines sequential categorization.

Based on positive and negative feedback, each SOM tested resulted in a recategorization of the corpus where the iterative process continued until the observer was satisfied. The clustering of each model was produced by returning the best-scoring diagrams in each iteration step from the selections of the relevant designs among them. Results from testing the five networks show that the SOM that utilized "All Features" performed the best, and provided well defined clusters. The remaining networks also resulted in well defined clusters, however the categorizations observed (on visual inspection) in these topographic maps do not, appear to be as well defined.

Formal evaluation methods used here rely on JAC and FM measures to analyze the results of each SOM's. The first map, the "All Features", returned the highest performance and the second map, the "User Subset", also produced comparable results for JAC and FM measures. The performance of the remaining three maps was lower as shown in Table 8.12.

The result of the best performing network, the 5×5 "All Features" is illustrated in Fig. 8.9, which was trained for a total of 1000 cycles. Results observed in the map show categorization of diagrams can be roughly linked to two architects as indicated by the map and labeled key.

The labeled key in Fig. 8.9 indicates each architect, where: A ≈ Wright (Usonian); B ≈ Wright (Prairie) and C ≈ Kahn. Other architects whose dominant feature vectors defined some labels included: D ≈ Palladio; E ≈ Van Der Rohe, F ≈ LeCorbusier, and G ≈ Botta. Unlike previous results shown in Sect. 8.5.2 Experiment 1, there are multiple nodes of the map that contain input vectors from different architects. Significantly, only 5% of the nodes where Wright and Kahn's diagrams are clustered contain another architect whereas the majority of the remaining nodes contain more than one architect (approximately 50%) and include some of Wright's and Kahn's diagrams.

Table 8.12 Clustering ability of different feature vector models

Experiment 2: Q-SOM:RF	JAC	FM
All features	0.53	0.50
User subset	0.46	0.42
LSF	0.46	0.39
ISF	0.38	0.45
GSF	0.32	0.30

Fig. 8.9 Final categorization formed by "all features" for Q-SOM:RF

8.5.2.4 Assessment of Cluster and Feature Subsets

We evaluated the performance of the networks that used the Q-SOM:RF process using a method that resembles "target testing" developed by Cox et al. [52]. Here, instead of a single target, testing evaluates the two targeted categories: Wright's Usonian and Kahn's residential designs. To obtain the performance measure τ, the targeted category TC, of designs defined by the user's requirements r is used. For each diagram in category TC, the total number of different clusters categorized by the network until the final category is reached is recorded. From this data, the average number of clusters formed before the final "correct" response is divided by the total number of diagrams k. The performance measure of the target category is then obtained as:

$$\tau = \left[\frac{\varphi(C, A)}{2}, 1 - \frac{\varphi(C, A)}{2}c \right] \tag{8.1}$$

where $\varphi(C, A)$ is the a priori probability of the category TC, given by TC/k. In general the smaller τ, i.e., $\tau < 0.5$, the better the performance.

The results of the performance measures for all five networks are shown in Table 8.13. The two feature subsets containing "All Features" and the "User Subset" yielded better results than the LSF, ISF or GSF subsets, which can be observed in the first two rows of the table.

The general trend observed from these results shows that using a larger set of features yields better results than using a smaller subset of features. Based on all performance measures we can observe that using more or all feature classes to create feature vectors yields better results than any one single feature class. Thus, a combination of all available morphological, topological and mereotopological features in conjunction with RF has resulted in the highest performance measure.

The implicit weight adjustments based on the relative importance of features contained in diagrams shows that the model is capable of categorization using both geometric and semantic attributes contained in the corpus. This kind of automatic adaptation is desirable as it is generally not known which features would perform best in clustering the complex visuo-spatial information inherent in architectural diagrams.

The experiments demonstrate that utilizing Q-SOM:RF as a system for assessing the similarity of design diagrams to distinguish style not only provides a useful

Table 8.13 Resulting τ values in the Q-SOM:RF experiment

Feature subset	Target cluster	
	Usonian	Kahn (residential)
All features	0.23	0.26
User subset	0.29	0.31
LSF	0.36	0.33
ISF	0.54	0.62
GSF	0.39	0.43

method for initial unsupervised categorization but also provides the flexibility to overcome a variety of problems resulting from context. The approach demonstrated in this experiment provides a robust method for defining the style based on a feature space that is capable of adapting to the contextual relevance of multiple spatial ontologies defined by both lower-level geometric and higher-level semantic features.

8.6 Discussion

In this chapter, we have investigated a conceptualization of style based on the visual and spatial perception of an artifact and tested implementations of an approach to automating the analysis of designs to identify style/s. Thus, as in Chap. 2 by Stiny, our explorations look to uncover how style is defined via observation, where the derivation of style depends on seeing and the process of comparison is not fixed but is subject to adaptations according to the observer's context.

Our approach to automated analysis has therefore focused on modeling and testing (in two separate experiments) a cognitively compatible analysis and a task relevant clustering method for identify style/s significant to a designer's context. We have demonstrated how style is related to the way information is processed. and that the reporting of different design styles is as a meta-cognitive process [16] requiring explicit comparison of design information both prior and subsequent to processing by the system.

8.6.1 Experiments

We demonstrated and tested two systems, namely the Q-SOM and Q-SOM:RF models. The results of our experiments show that the first Q-SOM system was able to provide a mapping from the physicality of the diagram using qualitative re-representation geometric and semantic feature sets are obtained and, as a result, meaningful feature subsets can be analyzed as input to the SOM; and that the second extended Q-SOM:RF system was able to effectively select from sequential and iterative processing by adjusting weights of a SOM to coincide with an observer's conceptual view of a design artifact's style. In other words, initial unsupervised clustering was adaptive in sequential clustering stages and became more relevant according to the designer's intentions.

The strength of the approach lies in its utilization of a multi-dimensional qualitative encoding schema and its ability to simultaneously assess multiple reference design diagrams. Since an individual diagrammatic feature or even a class of features based on any one spatial dimension may not be sufficient for analyzing the style of complex design diagrams the model enables the extraction of information from multiple dimensions so that the adaptation of the boundary of a style is based on a range of visuo-spatial features. In our computational experiments, the model has been shown to be capable of bridging the gap between the low-level visual features extracted from the design artifact and the high-level semantics used

by designers to understand design content. The first experiment of the Q-SOM demonstrates how the approach is capable of overcoming the cognitive properties of similarity-based classification outlined in Sect. 8.2.

Furthermore the significance of features and feature subsets can be identified relative to the comparison's context via feedback. The use of target categories in the final experiment demonstrates that when contextual information is integrated to determine the relative importance of features, the correlation between the system's results and the observer's assessments increases. Significantly, this correlation can be seen to result from the detailed definition, detection and extraction of feature classes and the observer's feedback determining feature salience. In this way, the second experiment of the Q-SOM:RF model shows how the approach is capable of overcoming the contextual properties of similarity-based classification discussed in Sect. 8.2.

8.6.2 Future Work

In design research our approach, and specifically, the relevance feedback technique, differs from existing automated analytical systems of style. Typically existing systems have been based on simple feature-based distances measures, see for example [29, 31]. Yet, despite our model's strengths, the approach to style tested here in relation to visuo-spatial information and its cognition require further exploration in modeling an object viewpoint of style.

The promising results obtained so far require additional studies across a variety of design scenarios and where testing the interactive Q-SOM:RF system is based on multiple users with different level of design experience and knowledge. It is expected that in undertaking human-subject experiments, that the Q-SOM:RF system should perform equally well as demonstrated here when using either expert or novice designers. The performance of the model should not differ substantially between users since their individual assessments will be reflected by the model's flexibility and adaptation to feedback. However a quantitative evaluation of the Q-SOM:RF model's performance in this respect is problematic due to occurrences of an individual preference and unique perceptual biases. Subjectivity is therefore a valid part of the iterative classification processes which takes place over open and variable dimensions of the designs being compared.

Using a multiple user research program, future studies must further test the approach so that two significant questions can be addressed:

1. Is the model superior to existing approaches? And if so, how significant is the performance improvement? The studies reported here highlight the main differences between the Q-SOM:RF model and existing models based on the re-representation of single spatial ontologies and simple metric distance measures. We have also claimed that the Q-SOM:RF model is a good estimator of the similarity among design diagrams across local, intermediate and global levels of visual and spatial information. Future studies must examine whether or not the

performance of our model (under the same set of evaluation criteria) is better than the performance of existing models. Such a study should lead to the conclusion that static linear based models cannot characterize style adequately.

2. Is there a set of well-balanced features which on average, perform as well as possible? That is, are there specific subsets of features that can be used to create feature vector models and which can be inspected relative to defined design styles? The objective of this research question is investigate the idea of feature centrality in the design domain relative to the effects of context and historically defined styles, e.g., Romanesque, Classical, Gothic, etc.

8.6.3 Concluding Remarks

By employing qualitative modeling and a self-organizing map with a relevance feedback, the concept of similarity has been shown to be an effective grouping principle so as to enable a digital characterization of style relative to context. The important and obvious implication of our approach and investigations is that isolated features are insufficient in formulating fixed conclusions about distinctive boundaries or perimeters of design styles. Instead, causality must also be attributed to cognitive and context dependant factors that influence the perception and judgment of a feature, a diagram, a design corpus and as a result a style. Consequently, the perceptual biases of different individuals or the same individual undertaking different design task, will influence classification and thus the boundaries delineating a style may be drawn differently.

Finally, in closing it is important to note the practical value of computational stylistics in design as a tool to facilitate style related tasks during the design process, and where the benefits of such support to designers are manifold. Whilst cognitively, human observers have limited capacity to compute large amounts of visuo-spatial data, the value of automated analysis is also in part due to the capacity of individuals to discriminate and communicate what defines a style. For individuals, whilst the particular features and configurations of features is a determinant of style [53], often what makes up a style is not always easy to identify and articulate even though an observer may be able to recognize an artifact's style with little difficulty.

Using on our approach to analysis, a computational stylistics tool can provide computational support across a range of design stages—from the early planning stages, to the conceptual and schematic design stages, to the specification stages. Consequently larger and more efficient search during design precedent analysis tasks, design inspiration gathering activities, and reuse of design details can be enabled. It is possible to support such design tasks using computational stylistics since visuo-spatial information can be classified and retrieved automatically by accessing large databases of existing design artifacts, including not only 2D diagrams but also potentially 3D models. Consequently, designers would able to actively participate in the definition of existing and new styles– changing, redefining and creating their boundaries as they generate their own designs.

References

1. Stacey M (2006) Psychological challenges for the analysis of style. Artificial intelligence for engineering design, analysis and manufacturing. Special Issue Understand Represent Reason Style 20(3):167–184
2. Knight TW (1994) Transformations in design, a formal approach to stylistic change and innovation in the visual arts. Cambridge University Press, Cambridge, MA
3. Cohn AG (1997) Qualitative spatial representation and reasoning techniques. In: Brewka G, Habel C, Nebel B (eds) Proceedings of KI-97, vol 1303. Springer, Berlin, pp 1–30
4. Gero JS, Park S-H (1997a) Qualitative representation of shape and space for computer aided architectural design. CAADRIA'97, Hu's Publisher, Taipei, pp 323–334
5. Ding L, Gero JS (1998) Emerging representations of Chinese traditional architectural style using genetic engineering. The international conference on artificial intelligence for engineering, HUST Press, Wuhan, pp 493–498
6. Jupp J, Gero JS (2004) Qualitative representation and reasoning in design: a hierarchy of shape and spatial languages. Visual and spatial reasoning in design III. Key Center of Design Computing and Cognition, University of Sydney, Boston, MA, pp 139–163
7. Tversky A (1977) Features of similarity. Psychol Rev 84:327–352
8. Tversky A, Gati I (1982) Similarity, separability, and the triangle inequality. Psychol Rev 89:123–154
9. Love BC, Sloman SA (1995). Mutability and the determinants of conceptual transformability. Proceedings of 17th annual conference of the cognitive science society, Pittsburgh, PA, pp 654–659
10. Sloman SA (1996) The empirical case for two systems of reasoning. Psychol Bull 119:3–22
11. Krumhansl C (1978) Concerning the applicability of geometric models to similarity data: the interrelationship between similarity and spatial density. Psychol Rev 85(5):445–463
12. Rada R, Mili H, Bicknell E, Blettner M (1989) Development and application of a metric on semantic nets. IEEE Trans Sys Manage Cybern 19(1):17–30
13. Egenhofer M, Shariff AR (1998) Metric details for natural language spatial relations. ACM Trans Info Sys 16(4):295–321
14. Miller G, Charles WG (1991) Contextual correlates of semantic similarity. Lang Cogn Process 6:1–28
15. Medin DL, Goldstone RL, Gentner D (1993) Respects for similarity. Psychol Rev 100: 254–278
16. Thomas MSC, Mareschal D (1997). Connectionism and psychological notions of similarity. Proceedings of 19th annual conference of the cognitive science society, Erlbaum, London, pp 757–762
17. Jupp J (2006) Diagrammatic reasoning in design: computational and cognitive studies in similarity assessment. PhD Thesis, Key Center of Design Computing and Cognition, University of Sydney
18. Jupp J, Gero JS (2006) Visual style: qualitative and context dependant categorization. Artif Intell Eng Des Anal Manuf 20(3):247–266
19. Goldstone R (1994) Similarity, interactive activation and mapping. J Exp Psychol Learn Mem Cogn 20(1):3–28
20. Goldstone R (2003) Learning to perceive while perceiving to learn. In: Kimchi R, Behrmann M, Olson C (eds) Perceptual organization in vision: behavioral and neural perspectives. Lawrence Erlbaum, Mahwah, NJ, pp 233–278
21. Marr D, Nishihara HK (1978) Representation and recognition of the spatial organization of three-dimensional shapes. Proc R Soc B 200:269–294
22. Wertheimer M (1977) Untersuchungen zur Lehre von der Gestalt. Psychologische Forschung 4:301–350
23. Tversky B (1999) What does drawing reveal about thinking? Visual and spatial reasoning in design I. Key Center of Design Computing and Cognition, Sydney, pp 271–282

24. Jupp J, Gero JS (2005) Cognitive studies in similarity assessment: evaluating a neural network model of visuospatial design similarity. International workshop on human behavior in designing – HBiD05, Aix en Provence, France
25. Schapiro M (1961) Style. In: Philipson M, Gudel PJ (eds) Aesthetics toda. New American Library, New York, NY, pp 137–171
26. Gould M, Nunes J, Comas D, Egenhofer M, Freundschuh S, Mark D (1996) Formalizing informal geographic information: cross-cultural human subjects testing. Joint European conference and exhibition on geographical information. Barcelona, March 1996, pp 285–294
27. Knauff M, Rauh R, Schlieder C (1995) Preferred mental models in qualitative spatial reasoning: a cognitive assessment of Allen's calculus. Proceedings of 17th annual conference of the cognitive science society, Lawrence Erlbaum Associates, Mahwah, NJ, pp 200–205
28. Gross M, Do E (1995) Drawing analogies – supporting creative architectural design with visual references. 3rd international conference on computational models of creative design, Sydney, pp 37–58
29. Park S-H, Gero JS (2000) Categorisation of shapes using shape features. In: Gero JS (ed) Artificial intelligence in design '00. Kluwer, Dordrecht, pp 203–223
30. Davies J, Goel AK (2001) Visual analogy in problem solving. Proceedings of international joint conference on artificial intelligence. Morgan Kaufmann, Seattle, WA, pp 377–382
31. Gero JS, Kazakov V (2001) Entropic similarity and complexity measures for architectural drawings. Visual and spatial reasoning in design II. Key Center of Design Computing and Cognition, Sydney, pp 147–161
32. Forbus K, Tomai E, Usher J (2003) Qualitative spatial reasoning for visual grouping in sketches. Proceedings of 16th international workshop on qualitative reasoning, Brasilia, pp 79–86
33. Burns K (2004) Creature double feature: on style and subject in the art of caricature. AAAI fall symposium on style and meaning in language, art, music, and design. The AAAI Press, Washington, DC
34. Kohonen T (1995) Self organising maps. Springer, Berlin
35. Colagrossi A, Sciarrone F, Seccaroni CA (2003) Methodology for automating the classification of works of art using neural networks. Leonardo 36(1):69–69
36. Chang N-S, Fu K-S (1980) Query by pictorial example. IEEE Trans Soft Eng 6(6):519–524
37. Salton G, McGill MJ (1983) Introduction to modern information retrieval. McGraw-Hill, New York, NY
38. Honkela T, Kaski S, Kohonen T, Lagus K (1998) Self-organizing maps of very large document collections: justification for the WEBSOM method. In: Balderjahn I, Mathar R, Schader M (eds) Classification, data analysis, and data highways. Springer, Berlin, pp 245–252
39. Oja E, Lassksonen J, Koskela M, Brandt S (1999) Self-organizing maps for content-based image database retrieval. In: Oja E, Kaski S (eds) Kohonen maps. Elsevier, New York
40. Laaksonen J, Koskela M, Laakso S, Oja E (2000) PicSOM – content-based image retrieval with self-organizing maps. Pattern Recognit Lett 21(13–14):1199–1207
41. Jupp J, Gero JS (2006) Towards computational analysis of style in architectural design. J Am Soc Info Sci 57(5):45–61
42. Brown K, Sims N, Williams JH, McMahon CA (1995) Conceptual geometric reasoning by the manipulation of models based on prototypes. Artif Intell Eng Des Anal Manuf 9(5): 367–385
43. Gero JS, Park S-H (1997) Computable feature-based qualitative modelling of shape and space, CAADFutures '97. Kluwer, Dordrecht, pp 821–830
44. Martinoli O, Masulli F, Riani M (1988) Algorithmic information of images. In: Cantoni V, Digesu V, Levialdi, S (eds) Image analysis and processing II. Plenum Press, New York, NY, pp 287–293
45. Allen JF (1984) Towards a general theory of action and time. Artif Intell 23:123–154
46. Güsgen HW (1989) Spatial reasoning based on Allen's temporal logic. Technical Report, TR-89–049. International Computer Science Institute, Berkley, CA

47. Mukerjee A (1989) Getting beneath the geometry: a systematic approach to modelling spatial relations. Proceedings of workshop on model-based reasoning, IJCAI-89, Detroit, MI, pp 140–141
48. Hall M (2000) Correlation-based feature selection for discrete and numeric class machine learning. Proceedings of 17th international conference on machine learning, Stanford University, Stanford, CA, pp 359–366
49. Slonim N, Friedman N, Tishby N (2002) Unsupervised document classification using sequential information maximization. Proceedings of SIGIR'02, 25th ACM international conference on research and development of information retrieval, Tampere, Finland. ACM Press, New York, NY
50. Downton M, Brennan T (1980) Comparing classifications: an evaluation of several coefficient of partition agreement. Proceedings meeting of the classification society, Boulder, CO
51. Fowlkes E, Mallows C (1983) A method for comparing two hierarchical clusterings. J Am Stat Assoc 78:553–569
52. Cox IJ, Miller ML, Omohundro SM, Yianilos PN (1999) Target testing and the PicHunter Bayesian multimedia retrieval system. Proceedings of 3rd forum on research technology advances in digital libraries, Washington, DC, pp 66–75
53. Simon H (1975) Style in design. In: Eastman C (ed) Spatial synthesis in computer-aided building design. Applied Science, London, pp 287–309

Part III
Interaction

Chapter 9
Troiage Aesthetics

Sheldon Brown

Abstract As the world around us is transformed into digitally enabled forms and processes, aesthetic strategies are required that articulate this underlying condition. A method for doing so involves a formal and conceptual strategy that is derived from collage, montage and assemblage. This triple "age" is termed "troiage", and it uses a style of computational apparency which articulates the edges of our current representational forms and processes as the semantic elements of culture. Each of these component aesthetics has previously had an important effect upon different areas of contemporary art and culture. Collage in painting, montage in film, assemblage in sculpture and architecture, are recombined via algorithmic methods, forefronting the structure of the algorithmic itself. The dynamic of the aesthetic is put into play by examining binary relationships such as: nature/culture, personal/public, U.S/Mexico, freedom/coercion, mediation/experience, etc. Through this process, the pervasiveness of common algorithmic approaches across cultural and social operations is revealed. This aesthetic is used in the project "The Scalable City" in which a virtual urban landscape is created by users interacting with data taken from the physical world in the form of different photographic techniques. This data is transformed by algorithmic methods which have previously been unfamiliar to the types of data that they are utilizing. The Scalable City project creates works across many media; such as prints, procedural animations, digital cinema and interactive 3D computer graphic installations.

9.1 Introduction

Developing an aesthetic, manifested as a style, is a culmination of intention, intuition, capability, accidents, history, talent, intelligence, ignorance, resources, education, patience, frustration, passion, acuity and other miscellaneous ingredients from

S. Brown (✉)
Center for Research in Computing and the Arts, University of California, San Diego, CA, USA
e-mail: sgbrown@ucsd.edu

S. Argamon et al. (eds.), *The Structure of Style*,
DOI 10.1007/978-3-642-12337-5_9, © Springer-Verlag Berlin Heidelberg 2010

one's self and ones situation. In this case, the term "aesthetic" is employed. *Troiage style*, as an alternative, is a slightly different shading, a more reflective characterization which might be read as attributing more to personal flair, or building prescriptive rules from personal quirks than I am intending. An aesthetic is a proposition, a theory. A style is a description. The artworks that I attribute to pursuing *troiage aesthetic* qualities are meant to set in motion sets of gestures that are generative with the viewer. This relationship between artwork and viewer is the interactive mode of the work, across all manner of engagements: operational, perceptual and intellectual. The syntactic and structural elements of the work are used to develop this relationship.

I coin the term *troiage aesthetics* as a way to describe my inquiry into the operation of cultural conditions that come from the continuing development of computing. The term connotes a synthesis of multiple domains of visuality—collage, montage and assemblage—and their application to the domains of the still-image, the image in time and the object. However, the meta-medium that emerges from this synthesis is specific to the conditions of computing, obligating an interactive viewer to complete its expression.

Of primary concern for the development of this aesthetic are expressive modes which have efficacy to a set of conceptual concerns. The artwork is meant to be a territory in which the user/viewer is in an active inquiry to these concerns, sorting through primary relationships about how meaning is made and how it is received in the contemporary cultural condition.

A key strategy is the development of systems of generative constraints. The boundaries of these conditions catalyze the elements of the work. The boundaries are crucial markers in creating the "framework" of the art. It is necessary that the systems of constraint have apparency for a viewer, creating a self-conscious engagement with the art experience, engaging in an intellectual interactivity with the work. This interactivity is but one of a set of interactive engagements that the user has with the work, extending to perceptual interactivity and operational interactivity. The aesthetic uses the concept of interactivity as a spectrum of engagement between doing, seeing and thinking, and is the outcome of historical developments in the construction of subjectivity whose antecedents can be traced through painting and literature.

This system of generative constraints can be compared to how "mediums" were previously conceived. With computing, the notion of a medium differs from previous, discrete, media such as painting or photography or cinema. Computing functions as a meta-medium, simulating previous media forms[1] as it becomes a platform for the continuous invention of new "mediums" of expression driven by the interests of its content. While there has always been bi-directional relationships between the evolving structure of mediums and the content of individual works, with digital media we have the opportunity with each new work to create—or at the least make

[1] "Real Art and Virtual Reality" by Sheldon Brown, ACM SIGGRAPH Computer Graphics, Volume 31, Number 4, November 1997.

considered choices about—our own media forms. The media form that is generated might last for 10 years, and million's of works will be created with its expressive attributes, or perhaps only one work will utilize its forms. Examples of this can be seen in such areas of recent digital culture as the CDROM, the web (will it exist in 10 years?), Flash, VRML, the CAVE, Quicktime VR, blogs, etc. Artist created multi-media installations are an extreme example of this, creating novel mixtures of media elements, architectural and sculptural forms.[2]

In this conception of constraints as having a key role in the development of an aesthetic, we must consider how the mutable nature of computing might be operating as a constraint, and thus its catalyzing effects on aesthetic developments.

9.2 Computing As a Medium?

Expressive media erupt from technological and/or socio-cultural developments which enable new modalities of expression—and are then incrementally refined. We can see this in the development of the book (and its transformation by the printing press), painting (its history of development in relationship to such concepts as perspective or modernism), photography and film. Each of these media continues to develop and transform, but there are moments where major modalities were formed by broad strokes at particular points in its history.

The computer has been around for some time; the moment of its invention is a bit contested. For the sake of this argument I'll take the Eniac's operational debut in 1945 as the point of departure for the modern era of computing.[3] At roughly the same time, television was developing.

As mediums for cultural expression television and computing have provided two very different development graphs. When video was deployed, it did so with many of its attributes fixed by government mandate. The form of television still in use today in the U.S.—NTSC—was established in 1941 by the FCC[4] and still operates with significant components fixed from that day. Computing also has some of its major attributes in common with the Eniac, however they aren't fixed by regulatory mechanisms; rather, they became fundamental methods of contemporary computing due to their efficacy. What the Eniac codified is the use of Boolean logic to engage binary representations of data in a Turing machine architecture. These representations are still very much at the heart of today's computers, just as the NTSC TV specification is very much at play in today's televisions. However, the granularity of these computational principles has been doubling every 18 months or so. It has been

[2] See for example any of the works off of my webpage, http://crca.ucsd.edu/sheldon—each of them constructs a mechanism for framing meaning that has content specific derivations from more ubiquitous forms.

[3] The Computer, from Pascal to von Neumann by Herman H. Goldstine Princeton University Press, 1972.

[4] Federal Regulation of the Radio & Television Broadcast Industry in the United States: 1927—1959 by Robert S. McMahon, Arno Pr; Reprint edition (January 1980).

about 700 months since Eniac. Moore's law tells us that "computer power" should have doubled 39 times since then[5]. Two to the 39th power equals 549,755,813,888: Moores' law is rough, but relatively accurate. Our computers are about a billion times more powerful than the Eniac. Furthermore, there was only one Eniac in 1945. Today there are several billion computers of widely varied computational capacity, and a great many of these are connected together, combining computational capacity in complex ways.

Television was invented as a medium for creative expression. From the start it was developed and refined around the combined notions of cinema and radio. Computing was developed to break codes and calculate gunnery tables. In the development of computing, its development wasn't driven by the needs of cultural expression. Those modes would arrive later, and develop slowly, taking decades for computing power to develop to the point that it could process such things as audio streams, images and synthetic environments.

Computing is mutable and continuously extensible, in a manner that is qualitatively different than previous cultural forms. While there can be said to be some quantitative relationships between the growth in the number of electronic pixels and the number of CPU cycles in existence, the quantitative expansion of CPU cycles brings new qualitative modalities under their control. The extent to which is a point of interesting debate: is it infinitely so? Is it at least as much as that of the human brain? Or is it a bound system, forever enticing us with its potentials, but never a culminating effect that quantities of Boolean operations can achieve—they will just make a more and more amazingly complex watch, but they will never be able to actually create time.

Creating art within this situation presents some different considerations than with other historical toolsets. Making art that has an apparent engagement with computing (addresses computing in part as a subject of the work—computing as the medium of the work) means to work with tool that is in a perpetual state of becoming. Whatever the aesthetic or expressive components are that underlie the work, will have their fidelity trumped tomorrow, and possibly extended or combined with a new modal form as well. For instance, it wouldn't be too much of a surprise for a highly effective olfactory interface being invented. So if the modalities and fidelities are at best transitory with computing, are there more essential elements that can be employed to constitute a medium out of which a style or aesthetic can emerge?

[5] The ENIAC could perform 5,000 additions or subtractions or 360 multiplications of two 10-digit decimal numbers in a second.

http://www.upenn.edu/computing/printout/archive/v12/4/crackpot.html

A 3 Ghz Pentium 4 (which weighs considerably less than 30 tons that the Eniac weighed) performs about 6 billion floating point operations per second, or about 16 million times more than the Eniac. At the high end is the Earth Simulator computer, run by several Japanese scientific research agencies in Yokohama, (http://www.top500.org/lists/2003/11/1) which measures about 40 teraflops, or about 100,000,000,000 times faster than Eniac. Somewhere between the Pentium 4 and the current supercomputer champ is this misapplication of Moore's Law, which was actually coined to describe the growth of transistor density on a chip.

9.3 Troiage

Troiage is an aesthetic concept that has evolved through the development of a series of artworks by the author, which engage the ideas and forms of interactive 3D computer graphics.[6] It posits that interactive 3D computer graphics have particular formal and expressive attributes that transform and combine previous cultural codes within cinema and architecture, through computational operations. Fundamentally, these computational operations are the performance of Boolean operations on binary numbers. These numbers represent concepts, images, words, and other numbers. They do so really fast, but they don't do anything else. In fact, each computational state could be statically represented by just tying together a bunch of NAND (Not And) gates. At the base of every computational gesture is this fundamental act. Looking at the edges of the computationally derived forms, at their limits of expressivity, you will find frays of Boolean operations. Thus we have a constraint of computing when seen as a medium, perhaps here we can find some generative energies where meanings fail and the normative and the abnormal exchange places.

Nothing is actually captured and fixed in a computer: the computer operates by simulating all of its representations. (Compare to chemical photography, where light physically transforms the object.) In computing, we can capture these events, but then we can continuously change how we want to interpret them. My digital picture of the Mona Lisa can be turned into a bit stream for playing on a sound synthesizer, or it can form a behavior system for a flock of micro robots or it can be the control code for the Tokyo traffic light system. This protean transmutation is a key attribute of computing's potency. Developing an aesthetic sensibility that effectively comments upon and derives from these attributes is a key aspect of the *troiage* aesthetic. Coining this aesthetic is an explicit nod to its meta-medium operation, and is an engagement of three antecedent forms—the imagistic, the spatial and the temporal.

9.4 Collage: The Imagistic Antecedent

The creation of virtual worlds[7] consists of defining a space. Internal subsets of this space are used to draw pixels which mimic visually the apparent properties of an object inhabiting the space under the rules by which govern that space. Those are a lot of qualifying statements to describe a visual form that typically uses the culturally familiar designations of Cartesian space. But I am explicitly delineating

[6] Artworks that didn't use actual 3D computer graphics, but which used cultural forms that were being created via computer graphics include MetaStasis/MediaStatic 1999 http://crca.ucsd.edu/~sheldon/metastasis/index.html and The Vorkapithulator, 1992 http://crca.ucsd.edu/~sheldon/vork/index.html.

[7] During 90's interactive, 3D graphic environments were called "virtual reality". Now it is thought of primarily as computer gaming environments. The technologies have migrated to the masses and transformed their implications.

components of this to clarify the many contrivances that are utilized to create these synthetic worlds, where a simple approach is executed on a massive scale—geometric surfaces described in 3-dimensional space. Billions of calculations which place forms in spatial relationships, paint them with pixels and then image them to a particular plane are done each frame, and there are on average 30 of these frames created every second. The other dominant characteristic of those surfaces is obtained through the application of simulated lighting effects upon them. Techniques have a range of verisimilitude, from the relatively crude Phong, Lambert or Giroud shading, which simplifies light's subtleties in a few crass characteristics such as specular, diffuse and ambient components, or the more sophisticated simulations which map photonic interactions with material properties.[8]

These polygonal surfaces are carefully constructed to simulate the surface of some consistent and coherent objects. As they are built, particular tricks are employed which utilize a mix of characteristics that can be obtained from the geometric specifications and the object's texture and material definitions to create the final effect. However, using these constructive principles directly and not simply in their illusionistic capacity can provide for a level of engagement that brings more meaning into play. As in any medium, expressive strategies that include artifacts of a medium's functional form bring into a work's discursive range concerns about the history of the medium—how it has been utilized in other expressions and the general representational mechanisms that it involves. It is an acknowledgment that the expressive tools that one is working with have applicability elsewhere, bringing a cultural contextualization into the work.

These faceted forms of spatial pixel maps are readymade containers for collagist strategies. By making more conscious engagements of the combination of spatial form and surface description—one can multiplex these object definitions to create an intermix of referents to occupy their space. Spatial collage overtly brings at least two elements into radical consideration with each other. It isn't just the surface symbols that collide; it is the structures at work beneath them—what is brought together are all of the open-ended forms that are represented by the collaged elements. Collaged elements operate more overtly at the level of sign than do the elements that strive so hard to sit in a normative representational universe. Now there is no reason that the un-collaged can't and won't operate at a meta-syntactic level, it is just that they often don't—sometimes a pipe is just a pipe—and often in our banal world of continuous media consumption, the relationship of signifier to signified is just not as interesting as many of our old school post-modernists would have us believe. Or it is perhaps that, as an artist, the range in which we can work extends beyond the normative strategies of consumer media, allowing us a density of expression in the gestures of our work that make these types of strategies effective.

[8] "Photon Mapping on Programmable Graphics Hardware", Proceedings of the ACM SIGGRAPH/EUROGRAPHICS conference on Graphics hardware. San Diego, California, 2003.

9.5 Assemblage—A Spatial Attitude

Just as we can build the components of objects by considering the meaning of strategies we undertake for each element—the totality of these objects creates a context that provides a reflexive whole onto each element in-situ.

Again we can find ourselves working against normative engagements of media which strive to create illusionistic and banally consistent worlds. Even if the worlds have large transformations that occur in them, they most often do so with a seamless and narratively simple cohesiveness. It is not necessarily simple to do this with computer media: in fact it is very difficult, and thus doing so gives a work a certain virtuosity (motion pictures that pull off a blending of "visual effects" with live actors and sets often gain accolades of critics and the movie industry). However, one should ask "what meaningful ends does this technical virtuosity achieve?" These desires are ways to replace a responsibility for a meaningful engagement with an expressive form and substitute the external reason of believability for engaging an expressive strategy.

For the artist, the use of the tool is the continuous reconciliation of working from the inside out with the desires of the outside in. In doing so, the acknowledgement and embracing of incongruities tells more (and in a more efficient way) than all of the effort of seamless blending. The "making of" features of effects laden films on DVD are always more interesting than the obvious film itself. By laying out the incongruous realms of computer effects, models, live actors and possibly other forms of footage (such as historical or documentary), we see the play of the narrative erupting through multiple layers of human expression—it is completely unnecessary to obliterate their individual character through the process the movie industry tellingly calls "conforming."

9.6 Montage

These ideas about spatial strategy owe their specific usage to the manner in which filmic montage has been theorized. Not that there is as reductive an approach to meaning and effect that early Eisenstienian *montage* theory tried to derive,[9] but simply understanding that radical temporal juxtapositions create a vocabulary of meaning. For computer game/virtual reality forms, this has become significantly utilized of late. However, its general use is simplistic and limiting; trying to extend the primitive first-person shooter into a more "cinematic" look, recognizing that the leap to a third person view aggrandizes the violent acts in a game.

The real opportunity that we have with these types of worlds goes beyond a montage strategy that employs the most flexible camera a cinematographer has ever had (and an infinite number of them). We have a situation where *world* and *camera* and *subject* are completely interchangeable and inter-mutable. We can shift subjectivity,

[9] Sergei Eisenstein, *Film Form: Essays in Film Theory*, Harvest Books 1969.

object structure and world organization as simply as we can cut from camera 1 to camera 2. Montage is no longer just a strategy for the camera and the editor—it is now a strategy for, and between, the actor, the set, the score, the costume, the lighting, etc.

This of course follows upon the translational capacity of the computer. All of its processes are undertaken without any material prejudice. It does not matter that one method describes how time is edited and another strategy is a way space is defined.

As artists who engage in a culturally critical practice we should purposefully "mis" apply these codified forms as an expressive strategy. We need to script our scenes on the basis of lighting algorithms and derive our edits on the basis of sound filter synthesis. By applying these strategies across domains, value systems become apparent and revealed in way that transcends their usage "as intended".

This is important work to do. It is important beyond the expressive boundaries of a single work at a specific time. It is important because it can provoke an examination of our own lived experiences—to look at the ways in which our world is becoming increasingly mediated and directed by algorithmic processes. We need to be able to read those processes in order to survive. We need to be able to hack them and jam them at times—in order to survive. We need to continuously allow our own humanity to transcend their dictates as they become increasingly interesting. At some point they may become more interesting than our humanity and then perhaps our job will be done.

9.7 Interactivity As Reception

If *Troiage* describes the aesthetic operation of elements within these works, interactivity is the way in which they relate to the viewer. Interactivity describes a relationship between artist, artwork and viewer that has a primacy in contemporary cultural forms. This interactivity is an outcome of developments in western culture that have created a new set of relationships between the realms of representations and the realm of the real. In this aesthetic theory I want to reposition all methods of cultural reception to be considered interactive methods—viewing, reading, conversing, operating, etc. This requires us to abandon the simplistic ways in which less expanded notions of interactivity are generally used by contemporary media; critical of these methods as paradoxically producing a more passive consumer of culture, (but with new, voracious appetites) rather than an active participant in meaningful exchanges with cultural forms. Together, these two points of view provide a relationship between audience and experience which can create an active cycle of meaning generation.

The relationship of audience to cultural form has normative modes which tend to stabilize as the semantic structure of a form settles; however, within these forms, this relationship is never completely fixed, and often becomes the site of contention when modes of expression undergo transformation. Briefly, consider some moments in the history of painting. The development of perspective created myriad shifts in

the relationships between artist, subject and viewer. Perspective provided a scheme that had a high measure of verisimilitude with perceptual experiences in the world.[10] These specifically could be related on an almost one to one basis with such things as camera obscura, or camera lucida devices. As Alberti was codifying perspective schemes in his treatise "On Painting,"[11] devices such as mirrors, grids and tubes created a fixed view from which a scene could be rendered. They created an idealized virtual viewer for these works. Actual viewers could occupy the specific convergence spot (although often the schemes were more complex than those that resolved themselves to a singular viewing point, for the general advantage of the operation of the painting as a whole). However, it wasn't necessary to occupy a privileged spot to view the work. We easily projected the spatial scheme to have coherency when our view is off-axis from this spot, perhaps through a type of 3rd person view, projecting our self into the role of the privileged viewer, without having to actually occupy it. The salient aspect of this scheme is that the space of the painting had a relationship to the space that our body occupied. That this worldly space was now able to be a subject of painting is tied up with general social and cultural shifts which revalued knowledge of the world, rather than just that of heaven. In turn, representations of the ecclesiastic became based on this effective schema of the world, and since these representations had to be put somewhere—they were put in the clouds.

With this scheme, our view is directly addressed. It infuses the primary scheme of how the painting is done. While it operates without necessitating our viewing location mapped strictly to the projected location of the painting, this congruity is often exploited to evoke a transcendent experience. An oft used instance of this is in church ceiling murals—for reasons that are both technical and those that are thematic. Several spatial attributes set this up. The distance from the viewer and the expanse of the image plane allow a wide viewing area of perspectival congruence. Many people can occupy a near optimal viewing position, sharing the illusionistic experience of the painting. The expanse of the image at such a distance fills a great deal of the viewer's vision cone, with the distance softening the effects of real world textures and artifacts. The view is also disconnected from the normal view of the ground plane—viewers look up, instilling a slight vertigo. The subject of these church ceilings is the heavens. It reinforces the role of the church as a gateway to heaven, and while perspective provided a means of representing the earthly, the church is quick to turn this into a powerful tool for perpetuating its own worldview.

The act of viewing this type of work is more than just a passive reception of the image. It involves active participation within the logic of the image. We become a subject of the painting. A direct engagement of this is found within Diego Velázquez' *Las Meninas*, in which the viewer occupies a reversed vanishing point:

[10] Perspective schemes are particularly important to current interactive cultural forms such as computer games and virtual reality. As silicon perspective engines have become embedded into all contemporary computers—perspective representations have become the norm for video game activities.

[11] Leone Battista Alberti, *On Painting*, 1435. Florence.

the point of convergence of the gaze's of those depicted in the painting, as we stand in, or with, the King and Queen as the subject of the painting.

Between these two examples, there are differences in how this active engagement of the viewer is utilized. Both create a type "immersion" into the artwork. They collapse the world of the painting with the real world, situating the viewer as the bridge between them. The church mural does so in a way that suspends disbelief in the viewer, enticing them to momentarily cross this bridge and be in the world of the painting. *Las Meninas* prefers to keep the viewer vibrating in the interstitial space between the two. It does so by creating a self-conscious viewer, who intellectually inhabits the conundrum of the painting. This idea of "immersion" is re-invoked in our era interactive, virtual environments. But as we see in these examples from static painting, the immersive mode offers more than just the engagement of the senses, it creates an exchange between the subject, the subjects world and the world of the cultural form. These exchanges are not complete, but further the stakes of the symbolic relationships between the cultural and the real, into one that has quasi-operationality, and the viewers perceptual relationship is now an interactive one.

This folding of the represented into the fabric of the real (or vice a versa) is described in an allegory by Borges:

> On Exactitude in Science . . . In that Empire, the Art of Cartography attained such Perfection that the map of a single Province occupied the entirety of a City, and the map of the Empire, the entirety of a Province. In time, those Unconscionable Maps no longer satisfied, and the Cartographers Guilds struck a Map of the Empire whose size was that of the Empire, and which coincided point for point with it. The following Generations, who were not so fond of the Study of Cartography as their Forebears had been, saw that that vast Map was Useless, and not without some Pitilessness was it, that they delivered it up to the Inclemencies of Sun and Winters. In the Deserts of the West, still today, there are Tattered Ruins of that Map, inhabited by Animals and Beggars; in all the Land there is no other Relic of the Disciplines of Geography.
>
> Suarez Miranda,Viajes de varones prudentes, Libro IV,Cap. XLV, Lerida, 1658[12]

The narrative form that has a self-consciousness of its own operation as a narrative form, creates a role for the reader/viewer as an active subject within the framework of the narrative.

Borges provides other examples from literature which exhibit this self-conscious form: Don Quixote finding a copy of the book "Don Quixote" or Hamlet essentially watching the play "Hamlet". Later on, this type of literary device becomes a structuring element for entire books, as in Italo Calvino's "If on a Winter's Night a Traveler". This is a collapse of the represented with the act of representation. For Borges, the smudging of the boundaries between these two worlds creates an anxiety in the viewer. "Why does it disquiet us to know that Don Quixote is a reader of the Quixote, and Hamlet is a spectator of Hamlet? I believe I have found the answer: those inversions suggest that if the characters in a story can be readers of spectators, than we, their readers or spectators, can be fictitious."[13]

[12] Jorge Luis Borges, *Collected Fictions*, Translated by Andrew Hurley Copyright Penguin 1999.

[13] Jorge Louis Borges, Other Inquisitions 1937–1952, University of Texas Press, 1964.

What good is this anxiety? It engages an ontological narrative of what constitutes the real and how our attempts to investigate, describe, communicate and extend our understandings of the real breakdown into seeming paradox when we examine our conventions. When we create new forms of expression, their ability to create and describe experiences previously unknown tends to create a crisis in our understanding of the boundaries of the real. Moving through the development of 3D interactive computer graphics has reproduced this anxiety. As the elements of interactive 3D computer graphics were becoming apparent, literary and cinematic fantasies extolled foreboding of the effects of this form. Computers were going to construct synthetic mediated worlds, whose perfect fidelity would plug directly into our sensory orifices, distracting those of us who are either lacking in our investment in reality, or are sophisticated meta-reality cowboys, to forego a relationship to the old real world. In the couple of decades that these fantasies gained widespread popular attention (examples would include Gibson's Neuromancer, almost any Phillip K. Dick story, and a series of movies such as Lawnmower Man, the Matrix, Cronenburg's Videodrome and later Existenz, Oliver Stone's Wild Palms, Wim Wenders' Until the End of the World Kathryn Bigelow's and Strange Days, to name just a few), these types of virtual reality experiences have not become culturally prominent, despite massive improvements in their underlying technologies. What has driven this technological development has been something slightly different, the video-game.

With the video game, a model of cultural reception has been codified that operates via an internal interactivity. One of the most popular forms positions the viewer as the first person subject at the center of very violent exchanges with computer graphic representations of extra-human characters. Interactivity is a necessity for these forms to have any expression. If the viewer is not actively operating the game, it simply won't do anything. What the game does specifically is very dependent upon the viewers' actions. However, this interactivity is not a "freedom" of action. It doesn't offer the same type of interactivity as actions in the world have. It is a very highly constrained set of actions that are permitted. These constraints are often part of the game qualities. For example, a character might be limited to one type of behavior; however, to progress to a different part of the game environment they need to have another type of behavior enabled. The way for that to happen is generally to perform the already-existing action in the right sequence, generally found through trial and error.

One of the attributes that an internal interactivity brings to a cultural form is the role of the viewer as complicit in the operation of that form. In some types of these forms, the viewer is seemingly put into the position of some type of author of a sub-genre whose parameters are established by the cultural object. In other instances, the viewer has the visceral reactive response because they have projected their sense of self into the media experience. They have become Ms. PacMan, the Pong paddle, the Master Chief (*Halo*), or Carl "C.J." Johnson (*Grand Theft Auto San Andreas*).

If one requirement of developing a vocabulary of interactivity is the ability of the interactive to rise above the simply operative, then the manner in which the

users plays a role in the semantic form of the media operation is crucial. Modes that are alternative to the empathetic/reactive form are necessary. Creating a space of reflection on ones participation in the interactive from can cause one to become a viewer of ones own self as an actor in the interactive media form. This type of self-conscious participation can then lead to ones view of their interactive gestures as operating within a space of meaning creation, not simply survival reaction. As we have seen, this collapse of viewer as subject has precedence in most antecedent media forms.

These interactive game experiences have become popular, in contrast to how "virtual reality" experiences have not. Tremendous sensory immersion was not in their initial offering (although continuously improving image fidelity drives ongoing replacements of games and computers), but it is their reactive interactivity that produces a catharsis of accomplishment, which underlies their popularity. They have created some of our first syntaxes of interactivity, but as it is with many early media forms, these syntactical structures are limited in their expressive range. It has proven to be a challenge to have an engaged viewer as dependent operator and slippery subject of these media experiences. In order for this interactivity to transcend mere operationalism, and become an active mechanism of meaning construction, it will have to be stylistically engaged.

I'll stretch an analogy to text reading. The functional acts of reading: what are letters? How do they combine to make words? How do words combine to make sentences? Along with the manner in which markings are organized on pages (printed or electronic) and are moved forward by turning or scrolling or clicking. . . if all we were ever concerned about were the "operations" of each of these mechanisms, and whether or not we "successfully" engaged their operations ("I", "n", " ", "t", "h", "e", " " "b", "e", "g", "i", "n", "n", "i", "n", "g", " ","w", "a", "s", " ","t", "h", "e", " ", "w", "o", "r'", "d" ". . ."), we would never get to the point of engaging much meaning via reading. Interactivity as a semantic cultural method must itself reach some discursive level.

Is this possible? As we have seen, one of the dominant modes of interactivity is tied up with reactivity in the video game. This form of interactivity taps deep into our evolutionary wiring, connecting us to survival skills that tuned our sensory apparatus for millennia. Our species survival had some dependency on our abilities to dodge rocks, swing along branches and avoid charging tigers. Engaging this type of reactive interactivity has turned out to be well-suited for the spatial/temporal/cinematic forms afforded by interactive 3D computer graphics and a variety of HCI input devices.

In addition to this reactive interactivity, which becomes the operational structure of the computer game form, there is method of interactivity that has also come to prominence due to computational developments, and perhaps could be ascribed to be even more ubiquitous—that is the interactivity between media forms themselves—the switching between media objects, which contain within them their own syntactic elements. This type of trans-media interactivity is more than just a means of organizing disparate experiences, it creates shifting contextual juxtapositions of media objects; some objects might try and ignore this condition, whereas others might actively exploit it. This condition comes about by quantitative changes

in the media elements, as well as their qualitative heterogeneity, as well as the methods by which the objects are manifest. Methods such as their social construction, algorithmic form or data visualization, create new means by which media objects are derived. Some of these objects also engage interactivity as an internal method of articulation (such as the video games described above). Interactivity as a method for reading across media becomes possible because of the transformation of these media forms to computational elements. It is within this common space of data and algorithms that we can reconfigure any permutation of media elements. These characteristics of the expressive elements of computing are what the Troiage Aesthetic theory is trying to set into motion. An example of how this operates can be seen in the artwork *The Scalable City*.

9.8 The Scalable City

> The city is becoming inputs and outputs of algorithmic processes. The "real world" is an expression of algorithmic desire, conforming itself for optimized algorithmic consumption.

The Scalable City is a series of artworks by Sheldon Brown and his Experimental Game Lab. Members of this lab have included Alex Dragelescu, Mike Caloud, Joey Hammer, Erik Hill, Carl Burton, Kristen Kho and Daniel Tracy. The artworks of *The Scalable City* consist of prints on paper and canvas, computer animated videos, procedural animations, multi-channel video installations, and interactive 3D computer graphic environments. Common to the various manifestations of this work are the data, algorithms and aesthetics of the work. *The Scalable City* is built via a data visualization pipeline. In this pipeline, data is taken from existing cities—satellite imagery, GIS data, statistics, photogrammetry—and is subjected to simple algorithmic transformations, creating a new city whose forms are applicable to our algorithmic future. Each step in this pipeline builds upon the previous, amplifying exaggerations, artifacts and patterns of algorithmic process.

The Scalable City consists of 5 major components—landscape, roads, lots, architecture and vehicles. The process of developing each of these begins with data taken from the real world. The initial real world referent is transformed by an algorithm that imprints its process into the result. In the case of the landscape, this begins with satellite data. The landscape is transformed by a simple process of duplication, rotation, copying and pasting; the process creates a new landscape which retains naturalism in its details, but with a high level of algorithmic decoratism in its large scale structure.

Road systems are then "grown" into this landscape. First, an analysis determines suitable areas for occupation. These areas are demarcated by an encircling roadway and then space-filling curves are grown using an L-system graph. L-systems are recursive, self similar forms and are used for such things as the simulation of plant structure. The curves are derived from Archimedes spirals. The roads only intersect at their branching points, never crossing, ending in cul-de-sacs. The pattern created is a decorative spiral labyrinth, evocative of *art nouveau* iron grates, illuminated manuscripts, and other decorative uses of space-filling patterns. These

curves are turned into roads with appropriate texture maps, including the demarcation of intersections and sidewalks. Each time the road system is generated, the specific end-result is unknown as it grown with the algorithms that simulate plant growth.

While the initial road system was built into areas that were determined to be within a large-scale average height variance, there can still be dramatic changes within the landscape regions. The roads are constrained by how quickly they can rise and fall over distance. Thus, when a road is drawn into a particular area, it will reshape the landscape around it, either cutting through small hills or building up road beds in small valleys. This road construction is done dynamically as one interactively navigates through the landscape in *vehicle systems*.

The *vehicle systems* also begin from real world data—in this case they are constructed from photo modeling processes that derive geometry from image data. This creates a perturbed derivative of an original form, strictly taken from the superficial skin of the image. Image artifacts tend to distort the form in unusual ways i.e., high degrees of specularity, broad contrast ranges etc., create difficult surfaces for the computer vision system to accurately discern object geometry from. What we end up with is form as perceived by the computer. The statement of *The Scalable City* is that the lived environment is a condition of inputs and outputs of algorithmic processes, our real world is an expression of algorithmic desire, and it conforms itself for optimized algorithmic consumption. When computer vision becomes the mechanism of the desiring gaze, we will engage in a seductive tease by transforming to excite its pixilated sensors to maximum capacity.

The *vehicle systems* become our embodied selves within this transformed environment. Each one of them consists not of a single vehicle but a particle system of vehicles that fill the environment with variant copies, swirling in a type of resonance with the spiraling labyrinth of the road forms.

The roads provide the basis by which lots are defined in the world. The lots are built with a computational geometry form called *voronoi*. Voronoi forms are a type of minimal surface that creates equidistant edges from distributed data points. With voronoi forms, each lot can have a boundary condition of equivalency; however the shapes of the lots themselves are irregular. Voronoi forms provide a base geometry type of several computer graphic techniques such as computer vision calculations and level-of-detail transformations of geometric forms.

Each lot becomes the site for architecture. Using a similar process to the one which creates the vehicles, automatic computer vision algorithms create a form laden with artifacts. An inverse kinematic system is placed on the resultant architectural fragments, which self assemble into an algorithmic shanty. Vortices created by navigating the swirling vehicles through the landscape, stir up these architectural fragments. The vortices become the agent of change in the environment, simultaneously ordering and disordering the cultural schemes embedded in the assets.

Throughout this environment, a variety of computer concepts take on physical form, providing both delight and foreboding. They offer a vision of cultured forms that we are rapidly creating, presenting an aesthetic with a heightened apparency of its underlying logic. All processes encode their results with artifacts that express their virtues and shortcomings. Culture has been undergoing a transformation from

analog to digital forms and methods for several decades. These transformative moments produce tensions between speculation and anxiety. In *The Scalable City*, the aesthetic gestures embody the tension between exuberance and foreboding, neither embracing or rejecting an algorithmic world view, but inspiring its expressivity while cautioning of its own logic becoming the dominant determinate of its outcomes.

Installations of *The Scalable City* stage prints, video projections and interactive screens in various spatial/temporal experiences. Large projections of animated elements proceed in various time-frames, from non-interactive, non-cinematic pace, occupying architectural and contemplative zones to fully interactive experiences where the viewer controls a vortex, vehicle system using video-game like techniques, positioning them as a complicit participant in the interplay of elements. Prints from the environment abstract the patterned environment to further extremes. Each of these uses visual strategies that entice the viewer into a visually deep engagement with the forms. Unlike a "game" there is no particular outcome or goal; the participation becomes an extended form of vision. Each manifest form strikes a relationship with the viewer that is an interactive engagement, and in fact considers interactivity is a key strategy of this aesthetic. The visual attributes of this artwork are the *troiage aesthetic's* conflation of collage, montage and assemblage.

As this aesthetic governs the internal relationships of the work's visual elements, it also governs the external relationships of the different modal components of the work in an installation environment. While any of the derivative forms of *The Scalable City* can be exhibited independently, the works engage the more complex notions of subjectivity and interactivity when they are able to be staged in careful relationships to each other, with each element creating different approaches to the choreography of space, time, image and interactivity.

Starting with the seemingly least interactive form, are digital prints of *The Scalable City*. Materially, they are digitally printed onto either photo paper or canvas. They take the initial satellite data of the project, and process it with the algorithmic techniques which are used to create the landscape. The images are further transformed to encompass at least two levels of visual scale, one imagistic in detail and one an abstracted field of color. However, unlike color field painting or neo-geo abstraction, this shift between image and field takes place due to a scale transformation of the data. When the data density reaches a certain level, the viewer reads the data field as not being made up of discrete imagistic elements, but as being a single imagistic element: a field of data.

The prints challenge the sense of visual field and the relationship between viewer and the viewed. The image extends beyond its frame via its use of optical patterns, creating visual conundrums which activate the viewer in relationship to the art. The engagement of perceptual phenomena transforms seeing into a haptic interface to the work—seeing is physical, akin to touching. As these patterns consist of scale that either reveals itself in further levels of detail, or fails to resolve as one moves closer to the images, the physical distance of the viewers position becomes an interactive element in the work. The viewer is the visualization apparatus of these images.

The next temporal stage of *The Scalable City* are animations of these images. Working with the same data and algorithms as are utilized for the prints, several

of the variables are modulated over time. The resulting animation proceeds from barely perceptible shifts in the most abstracted forms of these images, to rapid shifts in the overall frame, as the images become more clearly identifiable with the original data. In this process, the viewer is moved through several states of recognition of the image phenomena. The first state is simply the viewing of a seemingly static image. This state is similar to that of the prints—except that this is no longer a physical object, it is simply light—projected or luminescent. Colors slowly start to shift. After some time, the shifts in color become more pronounced. Soon the stripes of color become more complex, and they then rapidly resolve into recognizable satellite imagery. They reveal more structure in this resolved image, before the entire frame collapses back into the abstracted form.

While this animation is a 2D image phenomenon, the cognitive experience is best compared to architectural experience. The ways in which one discovers spatial structure is the model for how this project creates a temporal structure. This animation is therefore not understood through cinematic vocabulary. However, further algorithmic transformation of these elements is expressed cinematically.

Two types of cinematic experiences have been created. One type is a "movie", a relatively linear, "follow-the-data" narrative, where we witness ongoing transformations of initial data to stylized environment. The other cinematic forms are created as machinima, real-time computer graphic environments that are not interactive with the viewer, but play through scripts of behavior. These are used to show the transformed data in states that function as idealized pre or post conditions of interactive encounters.

The Scalable City culminates in its game-like, interactive 3D computer graphic form. This appears to be its zenith, as it seemingly is the direction to which all of the other data visualization processes lead; it is the most novel form culturally. It has a high level of visual spectacle and it is certainly the most difficult to produce. It is operationally dependent on the type of first person interactivity that is used in contemporary video games. While it can be experienced on a single computer monitor screen, it is typically staged with large projections to emphasize its visual form. It has also been exhibited using multiple stereographic projections. This stereographic form simultaneously pushes towards and pulls away from a collapse of the fictive and the real. The donning of special apparatus implicates one into the scheme of the work, and the stereography addresses the physiological underpinnings of spatial representation. However, when staging 3 separate stereographic images side by side by side, they each contain their own perspectival scheme. What is emphasized are the differences of each scheme, and their difference from the scheme of our own world. So, there is no invasion by the media space into the real space, nor an extension of the real through the media, we rather have the nexus of 4 spatial schemes and a transformation of forms and symbols as they are manifest in each.

The staging relationship of these various elements has to be considered. The hierarchy of attention moves from the interactive, to the cinematic, to the architectural to the image. Staging viewer's experience starts with the static image and moves incrementally through the forms, providing each the space for interaction and contextualization.

The way in which this art "works" is the key to its revelations. While interactivity has been utilized as a concept that encompasses viewing, we could revert the approach and see interactivity operating in this work as an extensive gaze, a necessary approach to a type of visual complexity. Looking at this form of interactivity as a continuation of practices that complicated the art object through the 20th century, we can establish doing as a form of seeing. This work requires interactivity that involves reflective consideration—a cognitive space that extends beyond the moment of the impulse. The challenge for interactive forms is to engage the advantages that the interactive moment provides for viewer-to-artwork engagement, allowing the creation of a social environment for viewers to mediate relations through, while creating the space for reflection and consideration that gestures of contradiction and disruption provide. With 3D computer graphic space becoming the container for the various forms that this expression plays within and across, the operational interactivity of bodies in space is a dominant mechanism for providing initial coherency. Thus, we return to the stylistic conventions of *troiage* as a means for creating semantic interactions between the qualities of forms that contextualize the interactive engagements of the work to its particular social and cultural conditions.

Fig. 9.1 Still from original Scalable City Trailer. This short HD movie was created to work out the technical methods and aesthetic gestures for generating a network of L-system roads into the transformed landscapes. Courtesy of Sheldon Brown

Sheldon Brown is Director of the Center for Research in Computing and the Arts at the University of California, San Diego. He is a Professor of Visual Arts and co-founder of the California Institute of Information Technologies and Telecommunications. Within CRCA and Calit2, Professor Brown directs the Experimental Game Lab, where new cultural forms are created by innovating techniques applicable to the computer gaming and scientific visualization.
crca.ucsd.edu/sheldon crca.ucsd.edu www.calit2.net crca.ucsd.edu/sheldon/expgamelab

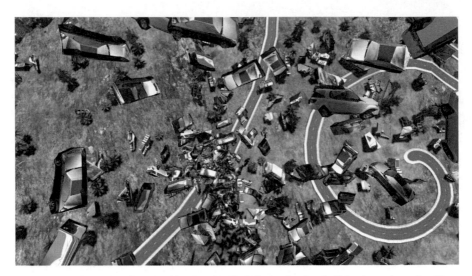

Fig. 9.2 Still from "The Scalable City, New Trailer". In the first "trailer" for the project, algorithms were first designed in the movie and then transferred to the interactive form. Here, data is taken from playing the interactive environment, which is then used to re-render the frames at much higher resolutions, with more complex shading and lighting. This movie is made in 3D at 4K (4000×2000 pixel) resolution. Courtesy of Sheldon Brown

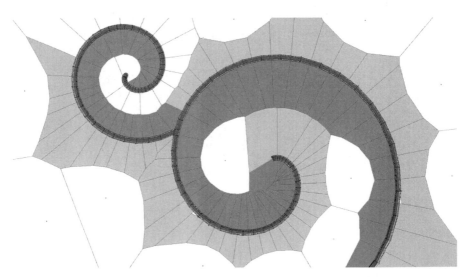

Fig. 9.3 Around each road, Voronoi geometric cells become the basis for "lots" which will site self-organizing architectural pieces. Courtesy of Sheldon Brown

Fig. 9.4 Still from "Scalable City New Trailer". Courtesy of Sheldon Brown

Fig. 9.5 "Scalable City #1", digital print. 2004. Dimensions are various. Courtesy of Sheldon Brown

Fig. 9.6 The Scalable City, installation at Shanghai Museum of Contemporary Art, 2006 (Photo by Sheldon Brown)

Chapter 10
Interaction with Machine Improvisation

Gerard Assayag, George Bloch, Arshia Cont, and Shlomo Dubnov

Abstract We describe two multi-agent architectures for an improvisation oriented musician-machine interaction systems that learn in real time from human performers. The improvisation kernel is based on sequence modeling and statistical learning. We present two frameworks of interaction with this kernel. In the first, the stylistic interaction is guided by a human operator in front of an interactive computer environment. In the second framework, the stylistic interaction is delegated to machine intelligence and therefore, knowledge propagation and decision are taken care of by the computer alone. The first framework involves a hybrid architecture using two popular composition/performance environments, Max and OpenMusic, that are put to work and communicate together, each one handling the process at a different time/memory scale. The second framework shares the same representational schemes with the first but uses an *Active Learning* architecture based on collaborative, competitive and memory-based learning to handle stylistic interactions. Both systems are capable of processing real-time audio/video as well as MIDI. After discussing the general cognitive background of improvisation practices, the statistical modelling tools and the concurrent agent architecture are presented. Then, an Active Learning scheme is described and considered in terms of using different improvisation regimes for improvisation planning. Finally, we provide more details about the different system implementations and describe several performances with the system.

10.1 Interaction, Improvisation and Learning

The aim of early interactive computer pieces, as theorized in the late seventies by Joel Chadabe, was to create a consistent musical style adaptive to the performer. However, when this kind of piece was transported to a real improvisation setup, the goal changed to *composed improvisation* [6]. In this conception, the consistency

G. Assayag (✉)
Ircam-CNRS UMR 9912, 1 Place Igor Stravinsky, 75004 Paris, France
e-mail: assayag@ircam.fr

had to be as much a consistency of style per se as to a consistency with the style of the improviser. One had to recognize the performer throughout the system. The first software to achieve this stricter kind of consistency is probably M by Chadabe and Zicarelli [28]. This early Macintosh MIDI-based environment would *listen* to a musicians performance and build a Markov chain representation of the MIDI stream on the fly, then walk through this representation in order to send a musical feed-back. Other remarkable environments such as the *Voyager* system by George Lewis [17], the *Ramses* system by Steve Coleman, or the experiments carried on by David Wessel [26] using Don Buchlas digital instruments and sophisticated parameter mapping will not be considered here since they do not use machine learning schemes for capturing the style of the performer, and accordingly should be considered under the realms of algorithmic music generation. Another interesting case is the *GenJam* system by John A. Biles [5]. GenJam implements a genetic algorithm that grows a population of musical phrase-like units in a highly supervised mode. The high fitness phrases are played in an interactive manner as a response to the musician in a traditional jazz trading fours dialog.

The interesting thing about M was its ability to send back a stylistically consistent "mirror image" of the performer to herself, which would accordingly as an answer to this feed-back, change her way of playing. We call this process stylistic reinjection. Franois Pachet has explored a related idea under the title *reflexive interaction* [2, 20]. Accordingly, we will focus here on the question of interacting with style models via a virtual musical partner that operates in two modes: (1) it can learn to imitate the musicians playing style in a non supervised manner, and (2) it listens to musician's improvisation and tries to reinforce selection of those musical materials in its repertoire that best fit the jamming session.

This distinction between the two modes hints upon two different musical modalities or cognitive functions that are simulated in the system. In the first mode, the musician's interaction with musical phrases and style can be considered as a sort of selective musical memory where stylistically important relations and novel possibilities of recombination are recorded. This memory structure, if used for generation in an unsupervised manner, produces random associations between musical memories that create a new musical variation with the same style. The second or listening mode is needed to allow interaction with the current flow of on-going music structure by management of the knowledge stored in the memory.

In this chapter, we present two frameworks with first mode in common to both and that differ in how they handle the listening mode. In one framework, the listening functionality is accomplished by a human operator in charge of the virtual musical companion. In the second framework, this functionality is automatically handled by the machine through a collaborative, competitive and memory-based *Active learning (AL)* process.[1]

[1] It should be noted that the use of the term *Learning* in AL refers to the ability to adaptively select the best repertoire for improvisation (we refer to this as second mode), which is different from the learning aspect involved in construction of the musical dynamic memory that is central to the first mode of operation. The term learning refers here to learning of the criteria or the costs involved

In our concept, interaction is a cognitive process underlying an active learning of musical context done with reference to a finite memory of past and previous musical processes. With this distinction, interactivity between the system and musician goes beyond mere triggering and reoccurrence of past musical materials but is a combination of an ongoing acquisition of knowledge and memory of the musical process learned by the system and activated or deactivated through reinforcement by the musician in interaction with the system and vice versa. The underlying design and architectures presented here are inspired by cognitive research on musical expectations and their functionalities in constructing musical anticipations. We shall discuss this approach to operation of the style learning musical robot later in the paper.

In terms of interaction between the virtual performer and live musician, both modes are operational during improvisation, very much like in the case of interaction between human performers who alternate between listening and improvising, and whose improvisation might vary between recalling one's own materials or personal style versus imitating or fusion with other musicians style. In order to consider the musical and cognitive aspects of interaction with virtual performer, we shall term sometimes both modes indistinguishably as *stylistic re-injection*. In Sect. 10.2 we will discuss the idea of stylistic reinjection and relate it to statistical modeling of musical sequences. Next, we will elaborate on one specific sequence representation that is currently used in several of our recent improvisation and composition systems, the Factor Oracle (FO) [1]. We will consider how new stylistically coherent sequences can be produced from FO analysis and representation and will show how the different generative parameters can influence the resulting musical outcomes. Factor Oracle constitutes the first mode mentioned above, i.e. learning and storage of a musical memory with stylistically important relations. After introducing FO, we will discuss the two frameworks presented separately. Section 10.5 discusses the issues of controlling and planning the productions using FO by a human operator. We then introduce the second framework in Sect. 10.6, where an *Active learning* process replaces the human operator for stylistic interactions. We conclude the chapter by reporting some of the different uses of the system and some musical performances.

10.2 Stylistic Re-injection

The musical hypothesis behind stylistic reinjection is that an improvising performer is informed continually by several sources, some of them involved in a complex feed-back loop (see Fig. 10.1). The performer listens to his partners. He also listens to himself while hes playing, and the instantaneous judgment he bears upon what he is doing interferes with the initial planning in a way that could change the plan itself and open up new directions. Sound images of his present performance

in selection of repertoire that would be appropriate for interaction, and it should be distinguished from the learning involved in forming the stylistic memory. The reason for using this term in AL is for its common use in the artificial intelligence literature.

Improvisation as Stylistic Injection/Reinjection

Fig. 10.1 Stylistic reinjection

and of those by other performers are memorized, thus drifting back from present to the past. From the standpoint of long-term memory, these sound images can also act as inspiring sources of material that will eventually be recombined to form new improvised patterns. We believe that musical patterns are not stored in memory as literal chains, but rather as compressed models that may, upon reactivation, develop into similar but not identical sequences: this is one of the major issues behind the balance of recurrence and innovation that makes an improvisation interesting.

The cognitive hypothesis behind stylistic reinjection has its roots in the psychology of music expectations [16]. Brain does not store sounds. Instead, it interprets, distills and represent sounds. It is suggested that brain uses a combination of several underlying presentations for musical attributes. A good mental representation would be one that captures or approximates some useful organizational property of a human's actual environment. But how does the brain know which representation to use? There is good evidence for existence of a system of rewards and punishments that evaluates the accuracy of our unconscious predictions about the world. Our mental representations are being perpetually tested by their ability to usefully predict ensuing events, suggesting that competing and concurrent representations may be the norm in mental functioning. In treating different representations and their expectations, each listener will have a distinctive listening history in which some representations have proved to be more successful than others. Accordingly, the conscious and unconscious thinking of an improvising performer constitutes the interactive level within which an external environment (through listening to others or himself) might influence the competitive and concurrent aspects of representations and learning of new representations. This interaction can be thus regarded as a reinforcement feedback from an external environment onto the system that can activate an active learning process. The idea behind stylistic reinjection is to reify, using the computer as an external memory and leaning scheme, this process of reinjecting musical figures from the past in a recombined fashion, providing an always similar but always innovative reconstruction of the past. To that extent, the virtual partner will look familiar as well as challenging.

10.3 Statistical Music Modelling

Statistical modeling of musical sequences has been the subject of experimentation since the very beginning of musical informatics [8]. This chapter focuses on context models where events in a musical piece can be predicted from the sequence of preceding events. The operational property of such models is to provide the conditional probability distribution over an alphabet given a preceding sequence called a context. This distribution will be used for generating new sequences or for computing the probability of a given one. First experiments in context based modeling made intensive use of Markov chains, based on an idea that dates back to Shannon : complex sequences do not have an obvious underlying source, however, they exhibit a property called short memory propertyby Ron et al [21]; there exists a certain memory lengh L such that the conditional probability distribution on the next symbol does not change significantly if we condition it on contexts longer than L. In the case of Markov chains, L is the order. However, the size of Markov chains given an alphabet Σ is $O(|\Sigma|^L)$, so only low order models are actually implemented.

To cope with the model order problem, in earlier works [3, 4, 13, 14] we have proposed a method for building musical style analyzers and generators based on several algorithms for prediction of discrete sequences using Variable Markov Models (VMM). The class of these algorithms is large and we focused mainly on two variants of predictors - universal prediction based on Incremental Parsing (IP) and prediction based on Probabilistic Suffix Trees (PST).

From these early experiences we have drawn a series of prescriptions for an interactive music learning and generation method. In what follows, we consider a learning algorithm that builds the statistical model from musical samples, and a gencration algorithm that walks through the model and generates a musical stream by predicting the next musical unit from the already generated sequence at each step. These prescription could be summarized as follows:

1. Learning must be incremental and fast in order to be compatible with real-time interaction, and be able to switch instantly to generation (real-time alternation of learning and generating can be seen as "machine improvization" where the machine "reacts" to other playing musicians).
2. The generation of each musical unit must be bounded in time for compatibility with a real time scheduler.
3. In order to cope with the variety of musical sources, it is interesting to be able to maintain several models and switch between them at generation time.
4. Assuming the parametric complexity of music (multi-dimensionality and multi-scale structures) multi-attribute models must be searched, or at least a mechanism must be provided for handling polyphony.

For the frameworks presented here we chose a model named factor oracle (FO) [1] that conforms to points 1, 2 and 4 as the learning and storage for musical memory; described hereafter. Following FOs capacity of representation and storage, we extend the model to address the third point above in Sect. 10.6.4.

10.4 Factor Oracle

The Factor Oracle concept comes from research on indexing string patterns. Such research has application in massive indexation of sequential content databases, pattern discovery in macromolecular chains, and other domains where data are organized sequentially. Generally stated, the problem is to efficiently turn a string of symbols S into a structure that makes it easy to check if a substring s (called a factor) belongs to S, and to discover repeated factors (patterns) in S. The relationship between patterns may be complex, because these are generally sub-patterns of other patterns; therefore the formal techniques and representations for extracting them, describing their relationships, and navigating in their structure are not obvious. However, these techniques are extremely useful in music research, as music at a certain level of description, is sequential and symbolic and the pattern level organization of redundancy and variation is central to its understanding.

Among all available representations (e.g. suffix trees, suffix automata, compression schemes), FO represents an excellent compromise, since

1. It computes incrementally and is linear in number of states and transitions
2. It is homogeneous, i.e. all transitions entering a given state are labeled by the same symbol, thus transitions do not have to be labeled, which saves a lot of space
3. It interconnects repeated factors into a convenient structure called SLT (suffix link tree)
4. Its construction algorithm is simple to implement, maintain and modify.

We will overview properties of FOs that are essential for our musical applications. Reader interested in more details about the algorithm should consult the original FO paper in [1].

Given a stream of symbols $s = \{s_1, s_2, \ldots s_n, \ldots\}$, the FO algorithm builds a linear automaton with (by convention left-to-right) ordered states $S_0, S_1, S_2, \ldots, S_n$. Symbol s_i is mapped to state S_i and S_0 is an initial state (source). As said above, transitions in the FO are implicitly labeled by the symbol mapped to their target state. Forward (or factor) transitions connect all pairs of states (S_{i-1}, S_i), and some pairs (S_i, S_j) with $i < j - 1$. Starting from the source and following forward transitions one can build factors of s, or one can check if a string s is a factor of s. We also consider some construction arrows named suffix links, used internally by the FO algorithm for optimization purposes, which, however, have to be kept for musical applications. These backwards pointing arrows connect pairs of states (S_i, S_j) where $j < i$. A suffix link connects S_i to S_j iff j is the leftmost position where a longest repeated suffix of $s[1..i]$ is recognized. In that case, the recognized suffix of $s[1..i]$ call it u is itself present at the position $s[j - |u| + 1, j]$. Thus suffix links connect repeated patterns of s. Figure 10.2 shows the FO built from the string s =abbbaab. By following forward transitions, starting at the source, one can generate factors, such as bbb or aab. Repeated factors such as ab are connected through suffix links.

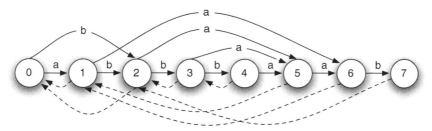

Fig. 10.2 The Factor Oracle for string abbbaab

However, there is a problem with FO's. As can be checked on Fig. 10.2, the *false positive* factor bbaa, which is not present in s, can be generated as well. This is because the FO automaton does not exactly model the language of all factors of a string. They rather model a language that contains it. In other terms, if s' is a factor of s, it will be recognized as such. On the other hand, if s' is recognized, it is probably a factor of s.

Figure 10.3 shows how maximum length repeated factors are interconnected by suffix links. The thickness of the lines represents the length of the repeated factor. This length is computed at no additional cost by the oracle algorithm, and we will see later that it provides a very important clue in the navigation. The colour of the lines (grey or black) separates two disjoint substructures in the set of suffix links, each of which forms a tree. The overall suffix links structure is a forest of disjoint trees, whose roots are the smallest and leftmost patterns appearing in the trees (see Fig. 10.4). A fundamental property of these Suffix Link Trees (SLT) is that the pattern at each node is a suffix of the patterns associated to its descendants (property 0). This way, the SLT capture all the redundancy organization inside the sequence.

Factor links also capture redundancy information, because of the following oracle property: let u a factor of s appearing at position i (position of its last symbol). There will be a factor link from i to a forward state j labelled by symbol a iff (property 1):

- u is the sub-word recognized by a minimal factor link path starting at the source 0 and ending in i.
- u is present at position $j - 1$, forming the motif ua at position j.
- the motif ua at position j is the first occurrence of ua in the portion $s[i + 1, |s|]$.

So a factor link connects two occurrences of a pattern, albeit with some restrictions.

Fig. 10.3 Interconnection of repeated factors by suffix links

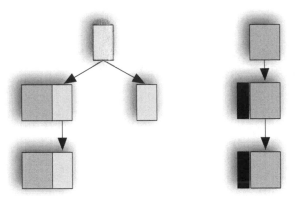

Fig. 10.4 Suffix links form a forest tree

10.5 Knowledge-Based Interaction by a Human Operator

OMax is distributed across two computer music environments: OpenMusic and
MaxMSP (see Fig. 10.5). We will describe in more detail this architecture in last part
of the paper. Here we outline the architecture of the improvisation system, without
going into the implementation details. At this point we should mention that the
Max components are dedicated to real-time interaction, instrumental capture, MIDI
and audio control, while OpenMusic components are specialized in higher level
operations such as building and browsing the statistical model. At the input and the
output, Max handles the direct interaction with the performers. It extracts high level

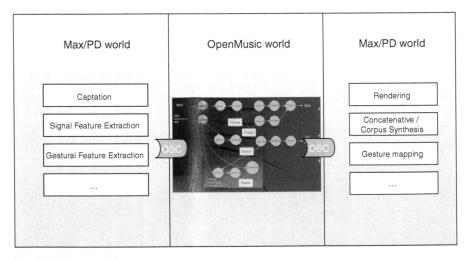

Fig. 10.5 OMax architecture

features from the sound signal such as the pitch, velocity, onset-offset, and streams them to OpenMusic using the OSC protocol [24]. The data flowing in this channel is called "augmented MIDI" because it contains MIDI-like symbolic information, plus any necessary relevant information regarding the original signal. OpenMusic builds up incrementally the high level representations derived from the learning process. Simultaneously, it generates an improvization from the learned model and outputs it as an "augmented MIDI" stream. At the output, Max reconstructs a signal by taking advantage of the augmented data. For example, the signal feature could be the pitch as extracted by a pitch tracker. The augmented information could be pointers into the recorded sound buffer, mapping the MIDI information to sound events. The reconstruction process could be concatenative synthesis that would mount the sound units into a continuous signal in real-time. Figure 10.5 shows a general diagram of this architecture.

Of course, the input could be restricted to MIDI, and the output could be restricted, in any case, to controlling some expander using the MIDI data and ignoring the augmented data, or any such combination. In this paper, we limit our observations to the case of MIDI input and output whereas the underlying concepts can be easily expanded to audio units and structures as discussed in [12] and [10].

Inside the OpenMusic world exists a community of concurrent agents that can be freely instantiated and arranged into different topologies. These agents belong to six main classes: (1) Listener, (2) Slicer, (3) Learner, (4) Improviser, (5) Unslicer and (6) Player.

Figure 10.6 shows a typical topology where the augmented MIDI stream is prepared into some convenient form by the listener and slicer agents and provided to a learner process that feeds the Oracle structure. Concurrently, an Improvizer process walks the oracle and generates a stream that is prepared to be fed into the rendering engine in Max.

The statistical modeling techniques we use supposes the data to be in the form of sequences of symbol taken from an alphabet. Of course, because music is

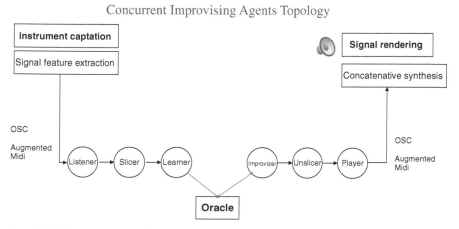

Concurrent Improvising Agents Topology

Fig. 10.6 A simple agent topology

Fig. 10.7 Slicing polyphony

multidimensional, it has to be processed in some way in order for the model to be usable and meaningful. We detail in [14] a method for processing polyphonic streams in order to turn them into a sequence of symbols such that a sequence model can be built from which new generated strings can be easily turned into a polyphony similar in structure to the original. Such "super-symbols", output by the polyphony manager in OM, are "musical slices" associated with a certain pitch content and a duration. Two processes, the "slicer" and the "unslicer" are dedicated to transforming the raw augmented MIDI stream into the slice representation used by the model, then back into a polyphonic stream (see Fig. 10.7).

OMax provides a toolkit for easily setting up different agent topologies in order to experiment with a variety of musical situations.

10.5.1 A Simple OMax Topology

For example, in Fig. 10.8, two musical sources (MIDI or audio) are merged into the same slicer, which means that the sliced representation at the output of the process

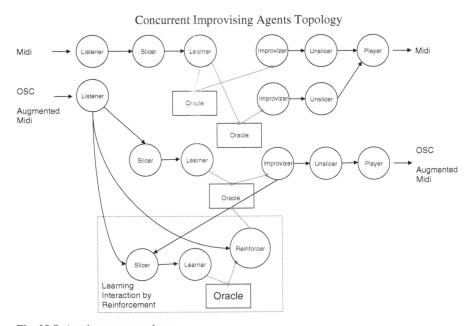

Fig. 10.8 Another agent topology

will account for the overall polyphony of the two sources. In such a case, the Oracle learns not only the pattern logic of both musicians, but also the way they interact. Improvizing on such an oracle will result in generating a polyphonic stream that respects the vertical as well as horizontal relations in the learned material. The learner process here feeds three different Oracles. Such a configuration may prove useful either for splitting the musical information into different points of view (e.g. pitch versus rhythm) or in order to learn different parts of the performance into different Oracles so they are not polluted one by the other. Then the three Oracles are improvized by three independent Improvizers, either simultaneously or in turn. Many interesting comparable topologies can be tested. The agent connectivity is implemented using (invisible) connection agents that provide dynamic port allocation so the program can instantiate communication ports and connect agent input and output.

10.5.2 A Meta-learning Topology

This configurable agent topology is ready for experiments that go well beyond the machine improvization state of the art, by adding a meta-learning level. In Fig. 10.9, the agents in the rectangle at the bottom learn in a separate oracle a polyphony made up from the musical information issued by the listener, and from the states of the first-level oracle just above the rectangle. What the bottom oracle learns really is the correlation between what is played by the musician and by the oracle

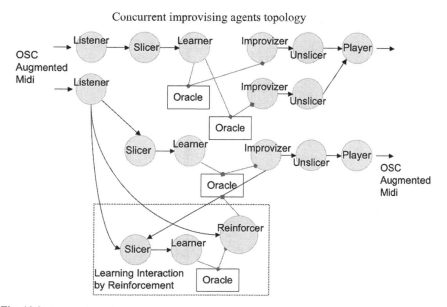

Fig. 10.9 An agent topology with meta-oracle

simultaneously, that is it learns the interaction between them (considering that the musician always adapts his performance with regard to what the oracle produces). Learning the states instead of the output of the oracle means that if the human tries later to recreate the same musical situation, the system is then able, through a new module called a reinforcer, to get back to the original oracle in order to reinforce the learned states. The effect of this architecture would be a better musical control of the global form by the human performer, and the feeling that OMax understands actually the message that is implicitly sent by a musician when he gets back to a previously encountered musical situation : the message in effect could be that he liked the interaction that occurred at that time and would like the computer to behave in a similar manner.

10.6 Knowledge-Based Automatic Interaction

In this section, we present another architecture where the stylistic interaction is automatically controlled by the machine itself and without a human operator. In previous works, interaction between an improviser machine and human performer has been limited to generation of relevant musical sequences by the computer that can be regarded as a continuation of the previous context generated by the human performer. As mentioned earlier, the continuation is assured by a stylistic reinjection of past material (through recombination) that has the most predictive value. In this work, we extend this view, philosophically speaking, by putting forth the concept of *musical anticipation* in the social context of musical improvisation. Within this view, interaction is viewed as the concurrent use of knowledge and memory where the *anticipatory values* of actions replace the predictive values. Knowledge is thus gained by constant interaction between the improvising machine and the performer (or a score in case of pure generation) and also by a constant self-reflection of the system by listening to its own generation. It is evident that such an automatic inter-active procedure requires a second learning module than the structure learning of FO described earlier. The learning procedure described hereafter, updates anticipatory values to relevant memory states stored in the system. These values are thus in constant change during an improvisation session whether the system is generating alone or improvising with a human performer. They enable access to the relevant parts in the memory given the current real-time context. These values are anticipatory rather than predictive since they evaluate the relevance of each state for generating the longest contextually meaningful sequence in the future. Learning is thus memory-based and its access to past structure is done through activation of previous states by evaluating them versus the current real-time context from the environment, thus the term Active learning (AL).

The main inspiration behind this framework comes from cognitive foundations of music expectations as discussed in Sect. 10.2. The complexity of an improvisation process is beyond one's imagination, which makes it impossible to model in terms of computer structures and logics within the structure. In our conception, the complexity of structure, as Simon puts it [22], is not due to the complexity of

the underlying *system* itself but due to the complexity of its environment. Hence, an architecture that aims at modeling the complexity of an improvisation system must be *adaptive* and demonstrate *intelligence* for learning and adopting reactivity between the agents and the environments when desired. The framework presented here is a first attempt in modeling such interactions.

10.6.1 Active Learning

There are two main reasons for our consideration of Active learning (AL) algorithms (to be defined shortly). The first, being an *enactive* view of music cognition, emphasizes the role of *sensory-motor* engagement in musical experience. The enactive view of cognition and the link between perception and action [19] is dominated by concerns with visual experience. If for the sake of simplicity and coherence of this presentation we set aside the visual and gestural aspects of a music performance, the sense of an auditory sensory-motor knowledge becomes less obvious than visual experience. The point here is that perceptual experience is *active* and thoughtful. As Wessel puts it correctly in [25], one can imagine an auditory version of the classic perception action link experiments by Held and Hein [15] where it is shown that that a kitten with a passive exploration experiment of an environment has considerable perceptual impairment compared to the one who was actively transacting with the environment. In the context of an stylistic interaction with a performer, the interaction is nothing but an active exploration and exploitation of the constantly changing environment where the sensory-motor knowledge takes the form of *conceptual understanding* [19].

The second and more technical motivation behind this choice, is the fact that in an improvisation setting and for an agnostic system such as ours with no human intervention, the *learner* should have the ability to influence and select its own training data; hence the general definition of the *active learning* problem. An early landmark research on this topic is the selective sampling scheme of Cohn, Atlas and Ladner [7] which became the main inspiration for many subsequent works in the field.

The Active learning algorithm presented here has close ties to the Reinforcement Learning (RL) paradigm [23] and is a continuation of a previously presented work using RL algorithms in [9]. In a regular RL framework, learning is performed by simulating episodes of state-action pairs and updating the policies in order to obtain a maximum reward towards a defined goal. Therefore, RL systems undergo goal-oriented interaction. In our design, defining a goal would be either impossible or would limit the utility of the system to certain styles. As will be explained shortly, what is traditionally regarded as rewards in an RL framework is termed *guides* in our proposed framework and helps to direct learning updates to relevant states in the memory pertaining to the current environmental context. Note that while the simulation episodes during learning of RL algorithms is a way to solve the burden of unsupervised learning, it does not help the agents to explore the environment actively and would usually require sufficiently large amount of time so that all (relevant) states are visited and updated accordingly. On the contrary, in an Active

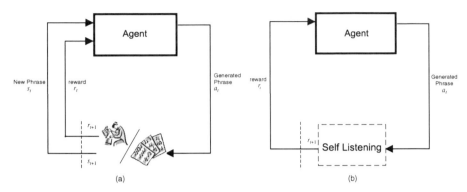

Fig. 10.10 Machine Improvisation modes diagram

learning framework exploration is enhanced by guiding the learning agents to the relevant states in the memory given a context where changes are most probable. A global description of the AL algorithm is shown hereafter.

Figure 10.10 demonstrate block diagrams for two modes of the proposed Active learning algorithm. In the first, referred to as Interaction Mode, the system is interacting with a human performer (or an incremental read of a music score). In this mode, environmental signals consist of musical sequences generated by the human performer (or the last read musical phrase from a score). In the second mode, referred to as self-listening, the system is in the generation phase and is interacting with itself, or in other words listening to itself so that the environmental signals are a feedback of the last generated sequence onto the agent itself.

The interaction mode occurs when external information is being passed to the system from the environment (human improviser). This way the reward would be the manner in which this new information reinforces (positively or negatively) the current stored models in the agent. The self listening mode occurs when the system is improvising new sequences. In this mode, the AL framework would be in a model-free learning state, meaning that the internal model of the environment stays intact but the values of actions are influenced by the latest musical sequence that has been generated by the system itself, thus, the idea of self listening.

Once the *anticipatory values* corresponding to each action in the memory is learned, generation amounts to choosing randomly between the *best* actions on a state weighted by their anticipatory values.

The Active learning framework presented here consists of three main modules each with independent but coherent tasks and is inspired by the *Dyna* architecture [23]. The modules are as follows:

1. *Model Learning:* Constitutes a state-space representation of the past knowledge observed by the system and enables access to previous state-action paths whenever desired by active learning or generation modules.
2. *Guidage:* Responsible for transactions between the environment and the improvisation agent. In other words, *Guidage* guides the agent to *relevant* state-action

pairs stored in previously learned models based on the current environmental context.

3. *Anticipatory Learner:* At each interaction with the environment (through *Guidage*), anticipatory values corresponding to each state-action pair (in each model) is learned through a competitive, concurrent and memory-based learning.

Algorithm 1 shows the main interactive cycle of the Active learning algorithm. This architecture uses learning cycles with multiple agents constituting competitive and concurrent models. These cycles happen at each interaction between the system and the environment and uses an active learning module instead of the traditional reinforcement learning. Upon the arrival of environmental or interactive sequences, the system prepares for learning by (1) calculating *immediate rewards* for stored states in systems memory and (2) selecting relevant states for the anticipatory learning procedure. This preparatory procedure, responsible for interactivity of the system, is referred to as *Guidage* and will be discussed in Sect. 10.6.3. The memory models are based on the FO representation, as described in Sect. 10.4. In order to use these models in the context of reinforcement learning, we will view them as a particular case of so called Markov Decision Processes, described in Sect. 10.6.2. These models are then appropriately learned and updated in case of being in Interaction Mode. After this step, the system is ready to update all the anticipatory profiles of stored states in parallel agents through competitive, concurrent and memory-based learning described in Sect. 10.6.4.

Algorithm 1 Active Learning Interactive Cycle

Require: At each time t: previously learned models (FO_{t-1}), the new environmental sequence
 $A^t = \{A_1, A_2, \cdots, A_N\}$
 1: Obtain active states and guides using Active Selection and A^t and FO_{t-1}s.
 2: **if** we are in *Interaction Mode*, **then**
 3: Update Models through learning (FOs)
 4: **end if**
 5: Perform Competitive, Concurrent and Memory-based Active learning

10.6.2 Model Learning

The agent in both modes consists of a model-based AL framework. It consists of an internal model of its environment and reinforcement learning for planning. This internal model plays the role of memory and representation of environmental elements. Another issue comes from the fact that music information has a natural componential and sequential structure. While sequential models have been extensively studied in the literature, componential or multiple-attribute models still remain a challenge due to complexity and explosion in the number of free parameters of the system. Therefore, a significant challenge faced with music signals arises from the need to simultaneously represent and process many attributes of music information. The ability (or inability) of a system to handle this level of musical complexity can be revealed by studying its ways of musical representations or memory models

both for storage and learning. The main feature of the agent is that it tackles this multi-componential aspect of musical representations (or viewpoints) as separate agents in the architecture. The AL algorithm used would then be a collaborative and competitive learning between viewpoints.

Any representation chosen for this task, should be compact, informative, incrementally learnable and should provide an easy access through memory for later use. Factor Oracles, discussed earlier, have been chosen to represent and store musical structures pertaining to some music features. Here we present the use of FOs in a Markov Decision Process (MDP) framework suitable for learning and generation. An MDP in general is defined by a set of states-action pairs $S \times A$, a reward function $R : S \times A \to \mathbb{R}$ and a state transition function $T : S \times A \to S$. To conform the representational scheme presented before to this framework, we define MDP state-action pairs as FO states and emitted symbol from that state. The transition function would then be the deterministic FO transition functions as defined before.

In order to construct and learn models incrementally, music MIDI signals are first parsed as shown in Fig. 10.11 and multi-dimensional features for each event is extracted as shown in Table 10.1 for this sample. For this experiment, we use pitch, harmonic interval and beat duration and their first derivatives (thus a total of 6) multiple representations.

Fig. 10.11 Parsed pianoroll presentation for the first measure of J.S.Bach's *two-part Invention No.5* (Book II) with quantization of $\frac{1}{16}$ beats

Table 10.1 Time series data on the score of Fig. 10.11 showing features used in this experiment

Event number	1	2	3	4	5	6	7	8	9	10	11	12	13	14	15
Pitch (MIDI)	0	51	63	62	63	0	65	0	67	67	63	68	68	58	60
Harmonic int.	0	0	0	0	24	0	0	0	4	5	0	8	6	0	0
Duration	1	1	1	1	1	1	1	2	1	1	1	1	1	1	1
Pitch diff..	0	0	12	−1	1	0	0	0	0	0	1	−3	0	−4	2
Harm. diff.	0	0	0	0	0	0	0	0	0	1	0	0	−2	0	0
Dur. ratio	1	1	1	1	1	1	1	2	0.5	1	1	1	1	1	1

Once this data is collected, learning Factor Oracle is straightforward as discussed in Sect. 10.4. In our framework, each feature vector (each row in table 10.1) is represented in different FOs as is demonstrated in Fig. 10.12 for four rows corresponding to data in Table 10.1.

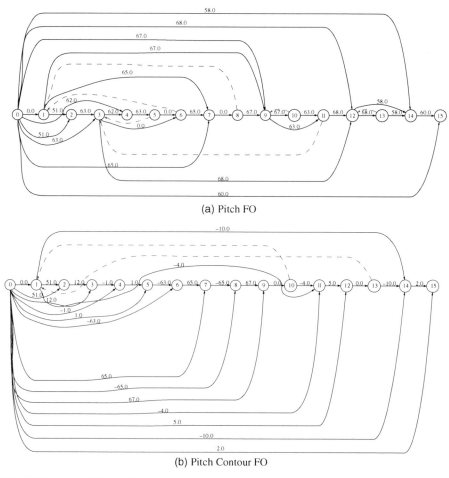

(a) Pitch FO

(b) Pitch Contour FO

Fig. 10.12 Learned Factor Oracles over pitch and duration sequences in table of Table 10.1. Each node represents a state, each solid line a *transition* and dashed line a *suffix link*

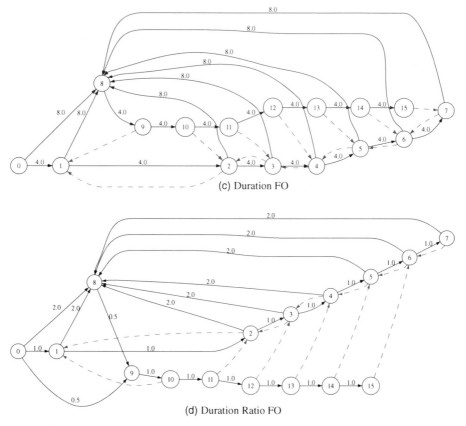

(c) Duration FO

(d) Duration Ratio FO

Fig. 10.12 (continued)

These representations constitute the model-learning for concurrent and collaborative agents at work in the Active learning framework and provide a compact model of the musical memory that will be used during learning and generation. As stated earlier, FO structures can be updated incrementally. Addition and learning of new FO structure happens only during the *Interaction Mode* (Fig. 10.10) and the models stay intact during *self-listening* mode of the system. For a discussion on the compactness and complexity of FO representation compared to other available algorithms we refer the reader to [9].

10.6.3 Guidage

At each interaction of the system with the environment (through reception of a musical sequence or self-listening of previous generated sequence), the system should adapt itself to the current *context* and learn the new behavior. In our Active learning framework, this amounts to selection of relevant states in each memory models discussed previously and assigning appropriate *immediate reward* signals to each

selected state. This process is undertaken upon each interaction with the outside environment and guides the anticipatory learner to appropriate state-action pairs in learned models, hence the name *Guidage*.

In a Reinforcement Learning system, rewards are defined for goal-oriented interaction. In musical applications, defining a goal would be either impossible or would limit the utility of the system to certain styles. The reward signals calculated during the active selection procedure signify not only the immediate reward obtained by performing the appropriate state-action pair, but also *guide* the learning in the next procedures to the appropriate places in the memory where anticipatory values are most likely to change and need adaptation. This way, the *Guidage* procedure becomes a search algorithm adapted to FO structures that assign immediate rewards.

The search algorithm proposed here is based on Dynamic Programming, an algorithm paradigm in which a problem is solved by identifying a collection of subproblems and tackling them one by one, smallest first. Dynamic Programming uses the "answers" to small problems to help figure out larger ones, until the whole of them is solved. In the context of our problem, the "small" problem set amounts to finding musical phrases (or combinations thereof) in the previously learned models, that are *similar* to the ongoing context from the environment *and* can be considered a *continuation* of the previously obtained chained based on the Factor Oracle structure in the memory. We call this step of the procedure the *forward pass*. The "larger" problem, then, becomes finding the *best path* among all recognized that best meets the search criteria when all the small-set problems are solved. This step is referred to as *backward* procedure.

To describe the algorithm in a formal manner, we use the following notations: Input stream from the environment is parsed into individual features represented as $A^k = \{A_1^k, A_2^k, \ldots, A_N^k\}$ where each each A_i^k is the k^{th} feature (or viewpoint) that corresponds to the k^{th} factor oracle with time index i. Similarly, the search target FO is represented by its stored states $s_i : 0 < i \leq M$. Using these notations, the forward pass of *Guidage* returns a structure I, which refers to found indexes on a Factor Oracle structure that can be regarded as an analogy to the score matrix in a dynamic programming paradigm. Within I, subsets $I_i = \{I_i^1, \ldots, I_i^k\}$ contain several paths associated with target FO states and refer to the possible *reconstruction indexes* on the target FO that can reassemble the whole or factors of the environmental sequence.

Having I, finding the *best paths* amounts to a backtracking procedure over subsets I_i, resulting into a *reconstruction matrix* $R_M : N \times \ell$. Here, N refers to the length of the input stream and ℓ is the *search depth* or the longest sequence that has achieved during search operation. Similar to I, each row k in the reconstruction matrix R corresponds to a sub-phrase in the environmental sequence and the contents of that row are index references to the Factor Oracle state-actions stored in the memory. These indexes correspond to state-action pairs in the model that can *reassemble* the "longest possible factor" within the environmental sequence up to frame k. Obviously, in the case of self-similarity for an environmental sequence of length N, the algorithm results to an $N \times N$ symmetric reconstruction matrix R with each M^{th} row ($M \leq N$) in the form $\{M, M - 1, \ldots, 2, 1, 0, \ldots, 0\}$.

Once the reconstruction matrix R_M is obtained, *immediate rewards* to each state indicated in I are assigned as depth of the reconstruction relative to the total input length. For example, the reward for $\{s_{1*}s_{2*} \ldots s_{N*}\}$ would be equal to 1 if the state/transition path $s_{1*} \ldots s_{N*}$ regenerate literally the sequence A^t.

Rewards or guides are calculated the same way for both modes of the system described before with an important difference. We argue that the rewards for the *interaction mode* (Fig. 10.10a) correspond to a *psychological attention* towards appropriate parts of the memory and guides for the *self-listening mode* (Fig. 10.10b) correspond to a *preventive* anticipation scheme. This means that while interacting with a live musician or sequential score, the system needs to be attentive to input sequences and during self-listening it needs to be preventive so that it would not generate the same path over and over. Moreover, these schemes provide the conscious reinforcement required to encourage or discourage useful and useless thinking as mentioned in Sect. 10.2. This is achieved by treating environmental rewards with positive and negative signs appropriately.

In summary, after the arrival of an environmental sequence (either through self-listening or interaction with a musician/score), *Guidage* evaluates the relevancy of past memory states to the new sequence resulting into the reconstruction matrix R_M and also returns immediate reward values or guides for each of those states determining the degree of relevance. These indexed states and their guides will be used during anticipatory learning to adapt the behavior of the system to the current musical context.

10.6.4 Anticipatory Learning

The *Guidage* procedure described earlier, provides *immediate rewards* for undertaking different actions (emitting musical symbols) for each state in the stored memory model. While these values can provide instant continuations for a generative process given a context, they simply fail to maintain a coherent context-based structure in longer temporal structures. In order to maintain this long-term coherency during generation either a human-operator or an external learning agent is needed to optimize the temporal context of the generated sequence. The idea behind *Anticipatory learning* is to further enhance the knowledge of the system by blending the ongoing immediate guides with their values in an infinite future horizon.

Given FO representations as Markov Decision Processes, Active learning procedure aims at finding policies as a mapping probability $Q(s, a)$. This way the policy can be represented as a matrix Q which stores values for each possible state-action pair in a given FO. The Q-learning algorithm proposed here is very similar to its Reinforcement Learning analogy except that we run updates on preselected states from *Active Selection* instead of running simulation episodes.

As discussed in Sect. 10.2, different mental representations of music work in a collaborative and competitive manner based on their predictive power to make

decisions. This can be seen as kind of a *model selection* where learning uses all the agents' policies available and chooses the best one for each episode. This winning policy would then become the *behavior policy* with its policy followed during that episode and other agents being influenced by the actions and environmental reactions from and to that agent.

At the beginning of each learning cycle, the system selects one agent using a Boltzmann equation over the previously learned Q values on the starting state s_0. This way, a behavior policy π^{beh} is selected *competitively* at the beginning of each cycle based on the predictive value of the initial state s_0 among all policies π^i. To verbalize the procedure, the idea here is to efficiently detect the prominent behavior of the latest incoming signal from the environment. For example, if the latest phrase from the environment constitutes a highly rhythmical profile, naturally the agent corresponding to rhythmic feature should be selected as the behavior policy.

During each learning cycle, the agents would be following the behavior policy. For update of π^{beh} itself, we use a simple Q-learning algorithm [23] but in order to learn other policies π^i, we should find a way to compensate the mismatch between the target policy π^i and the behavior policy π^{beh}. Uchibe and Doya [24] use an *importance sampling* method for this compensation and demonstrate the implementation over several RL algorithms. Adopting their approach, during each update of π^i when following π^{Beh} we use a compensation factor based on importance sampling. During Q-learning, the Q value associated with a state-action pair (s_i, a_i) (in viewpoint i) is updated by the following factors: (1) An *infinite horizon reward* factor $R(s)$, different from the immediate reward $r(.,.)$ discussed in Sect. 10.6.3, where the idea comes from our interest in the impact of future predictions on the current state of the system. This means that the reward for a state-action pair would correspond to future predicted states. and (2) a regular RL *Time Difference* update influenced by the mentioned importance sampling between-viewpoints' compensation factor.

This scheme defines the *collaborative* aspect of interactive learning. For example, during a learning episode, pitch attribute can become the behavior policy Q^{beh} and during that whole episode the system follows the pitch policy for simulations and other attributes' policies $Q^i(.,.)$ will be influenced by the behavior of the pitch policy.

In the Q-learning algorithm above, state-action pairs are updated during each cycle and on relevant indexes found by *Guidage*. This procedure updates one state-action pair at a time. In an ideal music learning system, each immediate change should evoke previous related states already stored in the memory. In general, we want to go back in the memory from any state whose value has changed. When performing update, the value of some states may have changed a lot while others rest intact, suggesting that the predecessor pairs of those who have changed a lot are more likely to change. So it is natural to prioritize the backups according to measures of their urgency and perform them in order of priority. This is the idea behind *prioritized sweeping* [18] embedded in our learning. In this procedure, each update is examined through a threshold if the amount of value change is judged

significant, all state-actions leading to that state will be added to a list of further updates in a recursive manner.

10.7 Current Uses and Results

10.7.1 OMax with Sound: Ofon Extensions

The Ofon system was developed in order to use the OMax system with acoustic instruments instead of Midi. Current version only works with monophonic instruments, where a pitch tracker is used to extract the pitch and intensity values represented as Midi, while the real sound of the instrument is recorded into an audio buffer. The system uses the yin pitch algorithm [11] as implemented in MaxMSP by Norbert Schnell, along with some post processing of our own.

Using time stamps at the offset of sound events, a sequence of symbols corresponding to pitch events are learned in the FO in a reference to a sound buffer. When OM performs the reconstruction of an improvisation using the oracle, the time stamps are sent back to Max along with the Midi stream. An Ofon module, the audio montage, is then able to assemble the sound pieces extracted from the sound buffer thanks to the time stamps. So, the music is learned from an audio signal, and the virtual improvisations result in an audio signal reconstructed from that original audio material. It is worth noting that, since we can get several computer-generated improvisations going on at the same time, it becomes possible to create multiple clones of the live player and have him/her play with them. This results, of course, in an exciting interaction situation. For the moment, the system has been extensively used with saxophone players (Philippe Leclerc in France and Tracy McMullen and David Borgo in San Diego), and experimented with student actors of the Thtre national de Strasbourg in a language and sound poetry environment under the direction of the stage director Jean-Franois Peyret. Figure 10.13 shows one such concert.

Fig. 10.13 An Ofon concert at Ircam (SMC05, Workshop on Improvisation with the Computer): *left*, Philippe Leclerc, saxophone. In the center, la Time. *Right*, Olivier Warusfel and Georges Boch

10.7.2 Ofon Video

The principle of *Ofon-video* is the same as in Ofon. The performer is filmed while the learning is performed on the music. Then the filmed extracts are re-edited in real-time, according to the OMax virtual improvisation sequences labeled by time stamps. This creates a recombined improvisations of the music combined with their respective recombination of video sequences. The system was developed by three students of University of StrasbourgII (Anne-Sophie Joubert, Vincent Robischung and milie Rossez) under the direction of Georges Bloch. Ofon-video has been programmed with jitter, an extension of the Max programming language aiming primarily at video control.

One of the main interests of Ofonvideo is to allow improbable encounter between musicians. For example, the saxophonist Philippe Leclerc can meet Thelonius Monk, improvise with him, and each musician influences the improvisation of the other. The filming ends up in a bottomless mirror, in which Leclerc watches Leclerc who watches Monk who watches Leclerc see Fig. 10.14.

More examples (audio, midi and video) can be found at

http://recherche.ircam.fr/equipes/repmus/OMax/.

Fig. 10.14 A picture of an Ofonvideo session, with Philippe Leclerc, saxophone, watching himself watching Monk. This very picture may appear seconds later on the screen

10.7.3 Active Learning Generation

There are many ways to generate or improvise once the policies for each attribute are available. We represent one simple solution using the proposed architecture. At

this stage, the system would be in the *self listening mode* (Fig. 10.10b). The agent would generate *phrases* of fixed length following a behavior policy (learned from the previous interaction). When following the behavior attribute, the system needs to *map* the behavior state-action pairs to other agents in order to produce a complete music event. For this, we first check and see whether there are any common transitions between original attributes and, if not, we would follow the policy for their derivative behavior. Once a phrase is generated, its (negative) reinforcement signal is calculated and policies are updated as in Sect. 10.6.1 but without updating the current models (FOs).

Audio results of automatic improvisation sessions on different styles can be heard on the internet.[2] As a sample result for this paper, we include analysis of results for style imitation on a polyphonic piece, *two-part Invention* No.3 by J.S. Bach. For this example, the learning phase was run in *interaction mode* with a sliding window of 50 events with no overlaps over the original MIDI score. After the learning phase, the system entered *self listening* mode where it generates sequences of 20 events and reinforces itself until termination. The generated score is shown in Fig. 10.15 for 240 sequential events where the original score has 348. For this generation, the *pitch* behavior has *won* all generation episodes and direct mappings of *duration* and *harmonic* agents have been achieved 76 and 83% in total respectively leaving the rest for their derivative agents.

Fig. 10.15 Style imitation sample result

[2] http://cosmal.ucsd.edu/~arshia/

Fig. 10.16 Improvisation space vs. original space

While both voices follow a polyphonic structure, there are some formal musicological structures that can be observed in the generated score. Globally, there are *phrase* boundaries in measures 4 and 11 which clearly segment the score into three formal sections. Measures 1–4 demonstrate some sort of exposition of musical materials which are expanded in measures 7 to the end with a transition phase in measure 5 and 6 ending at a week cadence on G (a fourth in the given key). There are several thematic elements which are reused and expanded. For example, the repeated D notes appearing in measures 2 appear several times in the score notably in measure 7 as low A with a shift in register and harmony and measure 9 and 15. More importantly, these elements or their variants can be found in the original score of Bach. Figure 10.16 shows the pitch-harmony space of both the original MIDI and the generated score. As is seen, due to the collaborative and competitive multi-agent architecture of the system, there are new combinations of attributes which do not exist in the trained score.

10.8 Future Perspectives

In this chapter we showed two views and models with respective results in music settings of interaction with musical style. In the first view, interaction is enhanced by a human performer controlling musical outputs of a learning automata over incoming music signals from a live musician, and in the second, the human controller is left out and temporal controls are handled automatically by the system employing an active learning strategy. In both designs, we have emphasized the role of reflexive interaction and stylistic injections as dynamical parameters during interaction, driven by cognitive constraints of musical expectations.

Results demonstrate a degree of autonomy of agents with regards to interaction and production and the presented systems are in use by the music community. However, the presented models represent a first approach to the complex problem of musical interaction between artificial systems and human musicians, and address the peak of an iceberg regarding the complexity of music improvisation. Despite this, the active learning architecture was conceived to leave space for further consideration of complex interactions due to its memory-based and concurrent and competitive learning modules. This leaves us with many opportunities for integration of more cognitively driven aspects of musical interaction, such as different schemes of musical anticipation, into the system.

References

1. Allauzen C, Crochemore M, Raffinot M (1999) Factor oracle: a new structure for pattern matching. In: Proceedings of conference on current trends in theory and practice of informatics, Springer, London, pp 295–310
2. Assayag G, Bloch G, Chemillier M (2006) Improvisation et réinjection stylistique. In: Yann O (ed) Actes des recontres musicales pluridisciplinaires. Grame, Lyon
3. Assayag G, Dubnov S (2004) Using factor oracles for machine improvisation. Soft Comput 8–9:604–610
4. Assayag G, Dubnov S, Delerue O (1999) Guessing the composer's mind: applying universal prediction to musical style. In: ICMC: international computer music conference, MIT Press, Beijing, China, October 1999
5. Biles JA (2003) Genjam in perspective: a tentative taxonomy for genetic algorithm music and art systems. Leonardo 36(1):43–45
6. Chalot X, Dannenberg R, Bloch G (1986) A workstation in live performance: composed improvisation. In: International computer music conference (ICMC). MIT Press, The Hague, pp 537–540
7. Cohn DA, Atlas L, Ladner RE (1994) Improving generalization with active learning. Mach Learn 15(2):201–221
8. Conklin D (2003) Music generation from statistical models. In: Gervas P, Colton S (eds) Proceedings of symposium on AI and creativity in the arts and sciences. Aberystwyth, Wales, pp 30–35
9. Cont A, Dubnov S, Assayag G (2007) Anticipatory model of musical style imitation using collaborative and competitive reinforcement learning. In: Butz MV, Sigaud O, Pezzulo G, Baldassarre G (eds) Anticipatory behavior in adaptive learning systems, vol. 4520 of *LNAI*. Springer, Berlin, pp 285–306
10. Cont A, Dubnov S, Assayag G (2007) Guidage: a fast audio query guided assemblage. In: Proceedings of international computer music conference (ICMC), MIT Press, Copenhagen, September 2007
11. de Cheveign A, Kawahara H (2002) YIN, a fundamental frequency estimator for speech and music. J Acoust Soc Am 111:1917–1930
12. Dubnov S, Assayag G, Cont A (2007) Audio oracle: a new algorithm for fast learning of audio structures. In: Hallam B, Floreano D, Hallam J, Hayes G, Meyer J-A (eds) Proceedings of international computer music conference (ICMC), Copenhagen, September 2007
13. Dubnov S, Assayag G, El-Yaniv R (1998) Universal classification applied to musical sequences. In: Proceedings of ICMC, Grame Michigan, pp 322–340
14. Dubnov S, Assayag G, Lartillot O, Bejerano G (2003) Using machine-learning methods for musical style modeling. IEEE Comput Soc 36(10):73–80

15. Held R, Hein A (1963) Movement-produced stimulation in the development of visually guided behavior. J Comp Physiol Psych 56:872–876
16. Huron D Sweet anticipation: music and the psychology of expectation. MIT Press, Cambridge, MA
17. Lewis G (2000) Too many notes: computers, complexity and culture in voyager. Leonardo Music J 10:33–39
18. Moore A, Atkeson C (1993) Prioritized sweeping: reinforcement learning with less data and less real time. Mach Learn 13:103–130
19. Noë A (2004) Action in perception. MIT Press, Boston, MA
20. Pachet F (2006) Interactions réflexives. In: Yann O (ed) Actes des recontres musicales pluridisciplinaires. Grame, Lyon
21. Ron D, Singer Y, Tishby N (1996) The power of amnesia: learning probabilistic automata with variable memory length. Mach Learn 25(2–3):117–149
22. Simon HA (1969) The science of the artificial. MIT Press, Boston, MA
23. Sutton RS, Barto AG (1998) Reinforcement learning: an introduction. MIT Press, Cambridge, MA
24. Uchibe E, Doya K (2004) Competitive-cooperative-concurrent reinforcement learning with importance sampling. In: Schaal S, Ijspeert AJ, Billard A, Vijayakumar S, Hallam J, Meyer JA (eds) Proceedings of international conference on simulation of adaptive behavior: from animals and animats. Los Angeles, CA, pp 287–296
25. Wessel D (2006) An enactive approach to computer music performance. In: Yann O (ed) Actes des recontres musicales pluridisciplinaires. Grame, Lyon
26. Wessel D, Wright M (2001) Problems and prospects for prospects for intimate musical control of computers. In: New interfaces for musical expressions (NIME). International Computer Music Association, San Francisco, CA
27. Wright M (2005) Open sound control: an enabling technology for musical networking. Organis Sound 10(3):193–200
28. Zicarelli D (1987) M Jam factory. Comput Music J 11(4):13–29

Chapter 11
Strategic Style in Pared-Down Poker

Kevin Burns

Abstract This chapter deals with the manner of making diagnoses and decisions, called strategic style, in a gambling game called Pared-down Poker. The approach treats style as a mental mode in which choices are constrained by expected utilities. The focus is on two classes of utility, i.e., money and effort, and how cognitive styles compare to normative strategies in optimizing these utilities. The insights are applied to real-world concerns like managing the war against terror networks and assessing the risks of system failures. After "Introducing the Interactions" involved in playing poker, the contents are arranged in four sections, as follows. "Underpinnings of Utility" outlines four classes of utility and highlights the differences between them: economic utility (money), ergonomic utility (effort), informatic utility (knowledge), and aesthetic utility (pleasure). "Inference and Investment" dissects the cognitive challenges of playing poker and relates them to real-world situations of business and war, where the key tasks are inference (of cards in poker, or strength in war) and investment (of chips in poker, or force in war) to maximize expected utility. "Strategies and Styles" presents normative (optimal) approaches to inference and investment, and compares them to cognitive heuristics by which people play poker—focusing on Bayesian methods and how they differ from human styles. The normative strategy is then pitted against cognitive styles in head-to-head tournaments, and tournaments are also held between different styles. The results show that style is ergonomically efficient and economically effective, i.e., style is smart. "Applying the Analysis" explores how style spaces, of the sort used to model individual behavior in Pared-down Poker, might also be applied to real-world problems where organizations evolve in terror networks and accidents arise from system failures.

K. Burns (✉)
The MITRE Corporation, 202 Burlington Road, Bedford, MA 01730, USA
e-mail: kburns@mitre.org

S. Argamon et al. (eds.), *The Structure of Style*,
DOI 10.1007/978-3-642-12337-5_11, © Springer-Verlag Berlin Heidelberg 2010

11.1 Introducing the Interactions

Strategic style is a manner of making diagnoses and decisions under uncertainty. Pared-down Poker is a gambling game that presents players with cognitive challenges of diagnoses and decisions in a scaled-down simulation of real-world situations.

A diagnosis is the *perception* of a situation and how it may unfold with time, which in poker entails the inference of hand strength and pot size. A decision comes from *projection* of one or more options and their outcomes, which in poker implies the investment of chips with a chance to win the pot. Any action or inaction is a *production* that leads to *interaction* as other actors react and respond, which in poker is a competition between players to win the most chips with the hands they are dealt.

In analyzing the interaction of styles in poker, this chapter relates to previous chapters on perception and production of style in other domains. But here the emphasis is on projection of what might happen—which lies between perception of events that have happened and production of actions that are taken.

11.1.1 Diagnoses and Decisions

Central to the study of diagnoses and decisions are *probabilities* (chances) of possible events and *utilities* (values) of eventual outcomes. More specifically, *expected utility*, defined as probability * utility, is the foundation of behavioral decision theory [29, 30] in mathematical modeling of the preferences and purposes that drive decisions. A preference is modeled as a utility and the purpose is modeled as maximizing expected utility, which may include a variety of attributes for utility [31].

Because poker is a form of gambling, as are many other choices in life, the algorithmic approaches of this chapter will revolve around representation and computation of probabilities (odds) and utilities (stakes). The detailed treatment begins in a section titled "Underpinnings of Utility," which highlights four classes of utility (Table 11.1) called *economic utility*, *ergonomic utility*, *informatic utility*, and *aesthetic utility*. Here for poker the story is largely a balance between two types of utility, economic and ergonomic, inside the mind of one player as he competes against another player who has the same two types of utilities in mind.

The analysis of utility in this chapter complements earlier chapters in two ways. One way is by addressing the *interaction* between economic utility and ergonomic utility. These two types of utility, especially economic utility, were not explicitly

Table 11.1 Four classes of utility

Economic utility	a measure of *money*
Ergonomic utility	a measure of *effort*
Informatic utility	a measure of *knowledge*
Aesthetic utility	a measure of *pleasure*

addressed in other chapters because economics play little role in language, music, and design. For example, although a poem may be sold and bought for money, the main concern of the creating artist and consuming audience is *meaning*, which is informatic utility—and *feeling*, which is aesthetic utility—not money, which is economic utility. Nevertheless, as other authors have noted (Chap. 12 by Goguen and Harrell, Chap. 6 by Karlgren), *style* in language or any other medium can be seen as a *choice* on the part of the producer. Here I would add that there is always some basis for choice, and this basis determines the structure of style. Thus with respect to *production: the structure of style is expected utility*.

Likewise other authors have argued that producers' choices are based on constraints (Chap. 4 by Reiter and Williams, Chap. 9 by Brown) or *rules* (Chap. 2 by Stiny, Chap. 1 by Cohen) that allow perceivers to agree on what products are alike and what products they like. But this is only part of the story, because it begs the question of what lies beneath the rules. Here again decision theory answers with expected utility. For example, even when the rules are apparently simple they can lead to emergence (Chap. 1 by Cohen) of productions that are surprising (Chap. 2 by Stiny) and in that sense creative. But not all surprises are perceived as creatively novel, and not all surprises are perceived as aesthetically pleasing [15]. Thus the rules of a shape grammar (Chap. 2 by Stiny) or art program (Chap. 1 by Cohen) must be purposeful rules of thumb that generate productions with aesthetic utility for artists and audiences—which is why artists use them. In short, the purpose of the rules is to produce aesthetic utility, and the result is perceived as good art to the extent that aesthetic utility is actually produced in the mind of the perceiver (who may also be a producer). Thus with respect to *perception: the structure of style is experienced utility*.

In the case of poker, like artwork, we will see style can be boiled down to rules that govern choices via *productions* that maximize *expected* utility—and styles (rules) may change based on *perceptions* of actual *experienced* utility. The main difference is that in poker the "art" of winning is aimed at economic utility rather than aesthetic utility—and in poker the interaction between players is competitive rather than cooperative.

Besides highlighting the roles of expected and experienced utility in production and perception of style, this chapter also complements previous chapters by distinguishing between different classes of utilities in order to gain a more unified understanding of style across domains. For example, in the language "game" played by speakers and hearers there is nothing actually bought or sold, and hence no economic utility per se. But still as in other interactions there are at least three other utilities at work, namely: ergonomic utility, or the effort it takes to produce and perceive; informatic utility, or the meaning that is encoded and decoded; and aesthetic utility, or the feeling that is expressed and evoked.

A *style* of language can then be seen as arising from cooperative-competitive [12] interactions that optimize an overall measure of utility. One elegant demonstration of this situation [24] has shown that simultaneous minimization of effort (ergonomic utility) for speaker and hearer can explain a well-known structure of language, namely Zipf's Law—where the frequency of a word decays as a power

Table 11.2 Three levels of style [15, 77]

Characteristics	concerned with *patterns*
Semantics	concerned with *meaning*
Aesthetics	concerned with *feelings*

function of its ambiguity. In short, treating word frequency as a feature of language, the structure of this feature can be computed by assuming that word choices are made to optimize a joint speaker-hearer utility—in this case the ergonomic utility or *effort* needed to communicate unambiguously. And because unambiguity is a measure of informatic utility or *meaning*, the analysis implicitly includes informatic utility as well as ergonomic utility.

Of course style in language or any other medium involves more than just characteristic *patterns* like word frequency (Chap. 5 by Argamon and Koppel), as communication conveys semantic *meaning* (Chap. 6 by Karlgren) and evokes aesthetic *feelings* (Chap. 12 by Goguen and Harrell), see Table 11.2. A challenge for style research (Chap. 13 by Burns and Maybury) is to implement models of other utilities and analyze them at deeper levels—especially informatic utility at the level of meaning and aesthetic utility at the level of feelings. This chapter takes a small step in that direction by analyzing utilities in the context of poker—focusing on economic utility and ergonomic utility but touching on informatic utility and aesthetic utility.

The next section on "Underpinnings of Utility" sets the stage for dissecting "Inference and Investment," which are the cognitive challenges of "command and control" in real-world domains like business and war [60]. It is shown why poker is a good game for research on strategic style, and why Pared-down Poker [18] is especially advantageous for analyses and experiments. Then "Strategies and Styles" is the main section in which several algorithmic approaches are computed and contrasted. First and foremost among these is Bayesian belief, which provides the normative standard for making inferences (diagnoses) and investments (decisions) to maximize economic utility. This normative-economic strategy is then pitted against cognitive-ergonomic styles [16], in pair-wise face-offs [19], from which the main insights of this chapter are drawn. To close, "Applying the Analysis" considers some real-world implications of this research on strategic style.

11.1.2 Insights and Implications

The findings from the face-offs will reveal several surprises. One surprise is that ergonomic utility is perhaps even more important than economic utility, even though poker is often thought to be a money game. Another surprise is that some styles are not only good ergonomically, but also good economically—i.e., style can be smart.

We will see it is possible to play ergonomically, with style, and still win economically, with skill, at levels that approach or even equal those of optimal strategies that require orders of magnitude more effort. We will also see that the game-theoretic

notion of an *equilibrium* strategy offers little insight into how people play poker. The reason is that there is no such thing as a single best strategy to play, because the best strategy for one player always depends on the strategy (style) of other players—and there is often *much* to be gained by *not* playing the equilibrium strategy.

Thus we will see that playing poker actually entails two tasks in a *style space*, namely: (i) *detecting* the style of one's opponent, and (ii) *adapting* one's own style accordingly. The former is a problem of perception; the latter is a problem of production; and together they are a problem of interaction.

Both (i) and (ii) are important in poker or any other inter-actor competition, which may sound obvious. Nevertheless this duality is often obscured by the game-theoretic notion of a Nash equilibrium, where the two tasks are collapsed into one by assuming that all actors have unbounded abilities for cognitive calculations. In short, algorithmic approaches like the Nash equilibrium that ignore ergonomic utility cannot serve as good models of how people play games [23] or make choices in life [64].

The approach of this chapter, which highlights advantages of cognitive styles over normative strategies, is clearly different from other research in game theory and artificial intelligence [9, 51]. This other research has made important advances in solution algorithms, using games like poker as test beds for modeling and measuring performance. But the findings have done little to advance a computational understanding how people play games, with style [16], and hence how machines might be built to play games more effectively against and along with people in real-world applications of artificial intelligence (Chap. 13 by Burns and Maybury).

Here by *effectively* I do not mean AI than can beat the best humans, which has already been done in games of "perfect information" like checkers [75] and chess [40]. I also do not mean AI that might someday come close to beating humans in games of "imperfect information" like hold'em poker [9]. These AI's are effective in the realm of economic utility, because they can win, but they are ineffective in the realms of ergonomic utility, informatic utility, and aesthetic utility—because they do not model these additional utilities and hence cannot play like people play, with style.

Now some might argue that style does not matter as long as one wins. And they would be right if economic utility were all that mattered. But there is much more that matters, especially aesthetics [72]—for even if AI is or might be *effective* in winning it can never be *affective* in playing until it addresses the real reason why most people play games—which is for *fun* [13]. Winning is not everything, even in poker, which we know because amateurs often play without money (just chips) and because professionals can make money in other ways—most of which would bring more economic utility (money) for the same level of ergonomic utility (effort). In short, people *choose* to play poker because they *like* to play poker.

Thus although the old challenge for AI may have been *skill in winning* against people, the new challenge for AI is *style in playing* against and along with people—in ways that resemble how people play against and along with each other. This is important for improving AI-human interaction in the real-world where people live, work, and play—with style.

11.2 Underpinnings of Utility

Money is not everything, so the saying goes. But then what is everything? This question is addressed below by looking at four classes of utility that encompass many things, though of course not *everything*.

11.2.1 Economic Utility

Contrary to the above saying, money is everything in economics. In fact the advantage of economics lies largely in reducing all things to a common unit (money) by which options can be weighed and choices can be made in a consistent manner. To an economist, a chip is a chip and the value of a chip in poker is given by some fixed amount of money, e.g., 1 chip = 1 dollar. But to a poker player a chip is not a chip, as a player holding ten chips will regard each with more care than a player holding ten thousand chips. This psychological reality, called *marginal discounting*, is a blatant violation of economic rationality in which all $1 chips are worth $1.

The concept of marginal discounting is a central tenet of "Prospect Theory" [44, 88], which is the most widely-accepted theory of how cognitive choices differ from normative standards in gambling games. In Prospect Theory, the effects of marginal discounting are captured by non-linear "value functions" in which the subjective utility m of objective utility M (money) is modeled by a power function $m \sim M^{\mu}$, where $0 < \mu < 1$.

A rational basis for this psychological bias has not been and cannot be established *economically*, because in fact a chip (dollar) is a chip (dollar) when it comes to its buying power. But *ergonomically*, marginal discounting seems to make a lot of sense as noticed at least several hundred years ago [7]. That is, if one has a lot of chips but limited energy for managing those chips, then logically one would pay less attention to each additional chip such that the subjective attention to (or value of) each chip would decrease as the number of chips is increased. And that would be marginal discounting, modeled by a power function with $\mu < 1$.

Thus we can see how ergonomic utility might help explain a well-know (but otherwise unexplained) anomaly of economic utility exhibited by human beings. In poker this phenomenon can be important, as it can cause a player to change his style of play depending on how his own chips stack up against those of his opponents. This is especially true for elimination tournaments with "no limit" betting, where players with short stacks must "go all in" (betting all chips) against opponents who can call the bet with little risk to their tall stack. Nevertheless, the analysis in this chapter will treat all chips as equal, such that the subjective value of money m is equal to the objective value of money M. This assumption is justified somewhat by the fact that the version of Pared-down Poker analyzed here is a "fixed limit" (small bet) game between two players, so the pot size is not too large compared to the bet size—and one player's chip stack is not too large compared to his opponent's. The advantage of this assumption is that it will allow us to focus on another aspect of

ergonomic utility that appears to be much more significant than limits of *attention* (which presumably cause marginal discounting), and that is limits of *computation*.

11.2.2 Ergonomic Utility

Besides effort in attending to chips, there is also effort in computing odds and stakes—needed to make a choice at each stage of a poker game. This effort can vary enormously between various strategies, where "enormously" means several orders of magnitude by any plausible measure. A precise measure is difficult to establish because the cost of computation depends on the device that is doing the calculation and the manner in which that device does its calculation. For example, effort might be measured by FLOPS (floating point operations per second) for digital computation in bits, but it is not clear that this is the appropriate measure for analog cognition in brains.

 This chapter will avoid the problem of precisely quantifying ergonomic utility (effort) for three reasons. One, because doing so will allow us to focus on quantifying economic utility (money), which can be computed precisely. Two, because the ergonomic utilities of various strategies can vary so much that order-of-magnitude estimates will suffice. Three, because it is not clear to what extent human beings actually choose to compute efficiently versus being forced to do so by mental limits. In fact it can be argued that *constraints* on one's memory and thought processes, more than *choices* based on probability and utility, are what govern the effort expended in playing poker.

 In short I will simply assume that effort is a fixed cost within which economic utility is then maximized. This makes the analysis easier and does not affect the eventual insights we will draw about how ergonomic utility (in this case forced by mental limits) is important as it combines with economic utility to shape the styles of poker players.

11.2.3 Informatic Utility

Closely related to economic utility in *gambling* is a notion of informatic utility in *foraging* [70]. The difference is that foraging requires *learning* the values of the game parameters (e.g., odds and stakes), as well as *earning* in light of these values— whereas pure gambling requires only earning. The learning is important in games like poker where opponents do not have all parameters of their behavior printed on their faces as the "House" does in slot machines and lotteries.

 The difference between foraging and gambling is directly related to the two tasks of perception and production noted above, namely: (i) *detecting* the style of one's opponent, and (ii) *adapting* one's own style accordingly. A player is foraging when he tries to *learn* which style his opponent plays at the same time he tries to *earn* chips given what he knows about his opponent. Pure gambling applies only to the

latter task where the player's task is to *earn* given all parameters of the gamble, i.e., probability * utility. Thus gambling can be seen as involving first-order probabilities and utilities, whereas foraging adds the dimension of second-order probabilities (i.e., probabilities of the first-order probabilities and utilities). This added dimension is what makes playing poker, as well as real-world choices (where the parameters are hardly ever known for sure), more like foraging than pure gambling.

Like ergonomic utility, the informatic utility of foraging can cause apparent anomalies in choices to maximize utility if the analysis considers only economic utility. But here again I would argue that anomalies of economic utility may be better modeled as regularities of other utilities. A similar sentiment has been advanced in response to the whole paradigm of "heuristics and biases" [45] by neo-Brunswikians [39] and others [67] who stress the *ecologic* advantage of heuristics—saying that rules of thumb are good (smart) not bad (flawed).

Likewise my view here is that *heuristics* (rules) can be extremely efficient in maximizing a *strategic* (total) measure of utility—which includes economic, ergonomic, informatic, and aesthetic utilities. Being simple is good for ergonomic utility, and this must be considered along with economic utility (and other utilities) by any animal or agent that seeks to optimize its overall utility.

An example that illustrates the difference between *foraging* and gambling, and addresses both *informatic* utility and economic utility, is a game task commonly referred to as "Iowa Gambling" [4–6]. Here the name of the game is a misnomer because Iowa Gambling is actually more like foraging than gambling. In this game, a player chooses cards one at a time from four decks that are "stacked" (face down) by experimenters. On the face of each card are dollar amounts; always a positive utility $W (win) but sometimes (with probability $Q < 1$) a negative utility $L (loss) as well. The parameters W, Q, and L of the four decks are such that two decks are "bad," meaning that they have negative expected utility ($\Psi = W - Q^*L < 0$), while two decks are "good," meaning that they have positive expected utility ($\Psi = W - Q^*L > 0$).

An interesting finding from experiments [20] is that, near the end of the game (last 20/100 turns), players continue to select cards from the "bad" decks. In fact they do so at a rate of around 40% (on average)—even though at this point in the game they "know" (as we know from verbal reports and physiological measurements, see [4–6]) that these decks are bad! The question is: Why do normal people sometimes (indeed very often) choose bad decks over good decks even after they know these decks are bad?

The most plausible explanation is that, although a player knows the bad decks have *been* bad, he is not sure that these decks will *stay* bad. In fact the decks are actually stacked such that a player experiences a big change near the start of the game—when apparently good decks turn out to be actually bad, and vice versa. Thus the basic problem is one of balancing the need to learn, by sometimes picking from bad decks (to see if they have turned good), with the need to earn, by mostly picking from good decks (i.e., those that have been good).

Using entropy modeling, it has been shown that the *optimal* strategy for balancing these two concerns is "probability matching," where each deck is chosen at a frequency equal to the probability that it is thought to be the best deck [20]. Moreover,

this mathematical optimum has also been shown to give a good fit to the behavioral deck choice frequencies observed in experiments on Iowa Gambling [20]—and the same strategy has also been observed in numerous experiments on animal foraging [43].

In short, players in Iowa Gambling who choose bad decks can be seen as not only reasonable but *optimal* as they make choices in accordance with their beliefs about the probability that each deck is the best deck. This will be a non-zero frequency for each deck, even the bad decks, as long as the player thinks there is some chance that a bad deck may turn out to be a good deck in the future.

The point of this example is to highlight the fact that informatic utility (learning) goes hand-in-hand with economic utility (earning) in any world where the relevant parameters are not know for sure and might change with time. Iowa Gambling is this kind of world, as is Pared-down Poker, and of course the real-world. Therefore to explain and predict human choices in games or life will require models of informatic utility that address foraging, which is more than gambling.

In poker a gain of informatic utility will cause a player's style to *change* with time, as he learns about his opponent's style (which may change with time) and as he learns about the effectiveness of various styles that he himself might adopt against his opponent's style. Nevertheless, as a simplification the remainder of this chapter will focus on *states* of style—not the *change* from style-to-style that may occur in time. This will allow us to ignore informatic utility in foraging and instead focus on economic utility in gambling, where the problem is one of maximizing expected utility given the parameters of probability * utility.

Even with this simplifying assumption, the problem is far from trivial for a poker player because the odds and stakes are not "given" up front but must be "inferred" in play. But this is a "within-game" issue of ergonomic utility (mental effort) and strategic ability, rather than a "between-games" issue of informatic utility. In short, we will focus on fixed styles rather than how styles change in time, analyzing economic utility (money) quantitatively and ergonomic utility (effort) qualitatively— and informatic utility (learning) only within rounds of a game. This leads us to the last utility, which will not be analyzed explicitly in this chapter, namely aesthetic utility (pleasure).

11.2.4 Aesthetic Utility

Compared to informatic utility (above), aesthetic utility is even harder to model— plus aesthetic utility can affect the steady *state* of style as well as a *change* from style-to-style. Thus it is a simplification to ignore aesthetic utility, and this is an important limitation of the present study (currently being explored in follow-up experiments).

The reason is that people play poker for pleasure as well as for money—indeed one might argue that all utilities can be reduced to aesthetic utility. This is of course opposite to the economic perspective where all things, including enjoyment, can

be reduced to money. But an aesthetic perspective seems to make as much if not more sense, because the value of money is ultimately based on the pleasure it brings people in the saving or spending of it.

Similarly it could be that effort (ergonomic utility) and knowledge (informatic utility) may ultimately be reduced to the effect that they have on feelings (aesthetic utility). For example, it feels good to expend effort (avoid boredom), but not too much (which is stressful), in a balance known as "flow" [26]. Moreover, as discussed elsewhere [13, 15, 22], the fun or flow of gambling can be modeled as a gain in knowledge, measured by an information-theoretic notion of entropy [77]—which is another way of saying that aesthetic utility (feeling) can be seen as arising from informatic utility (meaning). Thus although aesthetic utility is currently the least understood of all, it may also be the most important of all (Chap. 13 by Burns and Maybury).

In addition, there is also a dark side to aesthetic utility, namely an anti-fun known as *the tilt*. The tilt is famous in poker (and business and war), and in fact some would argue that the best way to win any competitive game is to get your opponent(s) to go on tilt, which is anti-fun for them, which is fun for you. The tilt relates to style because by definition the tilt is a *change in style*—i.e., typically a tilt refers to when a player "loosens" his style after a "bad beat," which is a losing outcome that was *unexpected*. Here the key word is *unexpected*, because a bad beat is more than just a beat (loss)—it is a beat that is especially disappointing.

In economics there can be no tilt because a beat is a beat, so a loss of x chips is equally bad when it is expected or unexpected. But in aesthetics this is not the case because expectation fuels enjoyment and disappointment [13, 15], so outcomes not only include an economic consequence but also evoke an emotional experience. Assuming the tilt does indeed come from an emotional experience that is negative fun, it would be reasonable (if not rational) for a player to play "looser" after a "bad beat"—seeking a gain in fun to recoup his loss of fun. And in fact this is exactly the sort of style change that poker players often report [61] when they see their opponents go on tilt.

The economic literature notes a similar increase in risk-taking after a loss, commonly called the "break-even effect" [71]. To economists this behavior is irrational, because the economics of a gamble are the same regardless of whether the gamble is offered after a win or a loss. But that logic considers only economic utility, and if one also considers aesthetic utility then the tilt seems to make some sense. That is, assuming a person is playing for pleasure as well as money, and assuming the person is trying to maintain a minimal level of pleasure, then it is logical when pleasure drops below this level for the person to respond with an action aimed at bringing pleasure back to above the threshold.

As noted earlier, the tilt and fun will not be explicitly analyzed below. Instead this discussion of aesthetic utility, like that of informatic utility above, is intended only to acknowledge the importance of these non-economic utilities—even in an economic game like poker. And with that caveat we now move to the study of style in poker, focusing on a combination of economic utility and ergonomic utility.

11.3 Inference and Investment

The game of poker has long been regarded as a micro model of business and war [60], and it remains so today as authors continue to draw analogies between the game and the real-world [63]. From a mathematical perspective, full-scale poker was further pared-down in the simple pokers that we find at the forefront of game theory [89]. To these pioneers it was apparently obvious how poker paralleled the real-world and hence why it was useful to study the game, as von Neumann is quoted [41]:

> Real life consists of bluffing... deception... of asking yourself what is the other man going to think I mean to do... this is what games are about in my theory.

Nevertheless it is important to identify explicitly how poker relates to the real-world if research studies are to be generalized and hence applied outside the lab. Likewise, from an experimental perspective, it is important to ensure that those features of poker that do parallel the real-world are preserved in any pared-down poker for lab work.

An experimental environment known as Pared-down Poker [16, 18, 19] was designed specifically to meet the objectives noted above. The design basis is reviewed below, beginning with a discussion of how poker poses cognitive challenges of *inference and investment* much like those of *command and control* in military, business, and other domains.

11.3.1 Command and Control

In military operations, "command and control" is defined as follows:

> a process... [that] begins with assessing the battlefield situation from available information. Following this assessment, the commander decides on a course of action. The commander then implements this decision by directing and controlling available forces. The final step... is evaluating the impact of the action on both friendly and opposing forces. This evaluation then serves as an input into an updated assessment of the situation, and the process continues. [59], p.4.

By this definition, command and control can be seen as a progression of four steps, as follows: (1) *inference*—in assessing a situation; (2) *investment*—in allocating one's resources; (3) *implementation*—in acting out the allocation; (4) *iteration*—in adapting to the consequence.

Strategically, the same four steps are also found in poker, as follows: (1) A poker player must make *inferences* about the relative strength of his forces (cards and chips) relative to his opponents'—and he must do so with only partial information obtained from exposed cards and others' bets. (2) A poker player must then make *investments* (of chips) in order to achieve a desired outcome—where his purpose may be to win the current pot or set up wins in future hands. (3) In *implementation*, a poker player must act in a manner that conveys minimal information about his forces and strategies—while at the same time in a manner that conveys maximal

deceptive information. (4) Then *iteration*, based on outcome, allows a poker player to adapt to what he has discovered—and what he expects of opponents in the future.

This *structure mapping* [21] shows that, from a *strategic* perspective focused on *cognitive* challenges, playing poker is indeed the essence of command and control. Of course the stakes are vastly different, as poker is played with chips and war is fought with lives. But as far as a lab task that captures the mind game of command and control, poker is about as good as it gets.

Clearly the mapping applies only to strategic and cognitive challenges, because the tactical and physical challenges of command and control are very different. For example, real-world command and control is accomplished by teams of individuals working together in distributed organizations, and modern warfare poses many challenges of communication and coordination between these individuals and organizations. Nevertheless, tactical command and control applies to *implementation* in support of strategic objectives—and strategically an organization can be seen as an individual player (discussed later in "Applying the Analysis").

The bottom line is that, from a strategic perspective, poker poses cognitive challenges much like those of command and control—and that makes the game a useful test bed for research studies. The two main tasks are *inference and investment*; hence these are the focus of Pared-down Poker below.

11.3.2 Pared-down Poker

A practical consequence of standard pokers (played with 5–7 cards in each hand, dealt from a 52-card deck, at a table of 8–10 seats) is that they are not tractable to mathematical solution of optimal strategies. On the one hand this complexity makes full-scale poker a challenging test bed for research on computational algorithms [9, 51]. On the other hand the complexity makes full-scale poker an onerous test bed for analytical solution, which is why game theorists have typically focused on simplified pokers.

Additionally, because of its complexity and intractability, full-scale poker is not well-suited to psychological experiments that require controlled stimuli and performance standards. In particular, mathematical solutions of optimal strategies are needed to benchmark human skill and style, and this is what motivated development of *Pared-down Poker*. It is much like the simplified pokers analyzed previously by game theorists, but with some important differences as discussed below.

Pared-down Poker [18] is actually a suite of pokers, but here I will discuss only the most pared-down version called *One Card High*. This game is integer poker played with a deck of 11 cards (numbered 0–10) from which each player (here two players) is dealt one card. As such, One Card High is a discrete version of the zero-to-one pokers (where a hand can be any real number between zero and one) analyzed by Borel [11], von Neumann [89], and others [32, 33]. The rules of One Card High are similar to the AB game of Borel, in which one player (A) starts by betting or folding and the second player (B) must then call or fold.

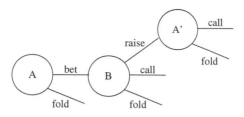

Fig. 11.1 ABA' game tree for One Card High, showing branches for low stakes (A bet and B call) as well as high stakes (B raise and A' call)

The critical difference is that One Card High is an ABA' poker (Fig. 11.1), where the second player (B) can raise—and if he does so then the first player (A') must call or fold.

Notice from Fig. 11.1 that the ABA' structure of One Card High captures both dimensions of style that are commonly referred to by poker players [42, 62, 76]. One dimension is "loose-tight," which refers to a player's propensity to bet or call a bet (if he is loose) versus fold (if he is tight)—where the stakes are relatively *low*. The other dimension is "aggressive-passive," which refers to a player's propensity to raise or call a raise (if he is aggressive) versus fold (if he is passive)—where the stakes are relatively *high*. Even though full-scale pokers can involve many rounds of betting, poker players and theorists rarely if ever talk about any more than two dimensions, which implies that these two are enough for scaled-down research in mathematical analyses and psychological experiments. Moreover, these two dimensions are one more than most studies of human judgment and decision making, which are typically limited to a distinction between "risk seeking" and "risk averse" [44, 45].

Both dimensions of style can be seen as a difference between conservative and non-conservative tendencies, just occurring at different stakes in stages of the game. Therefore it is interesting that "mixed" styles (i.e., loose-passive and tight-aggressive) are observed in human players. This means that a simple distinction between risk averse (conservative) and risk seeking (non-conservative), as is commonly made in the literature on judgement and decision making as well as in experimental psychology, is not enough to capture the thinking and feelings of human beings. Evidently there are effects arising from the magnitude of stakes and/or temporal sequence of play, which affect whether a person will be risk averse or risk seeking at each stage of the game [71].

Notice that both dimensions of style are *not* captured by poker games that do *not* allow a raise, like Borel's AB game and some other simplified pokers analyzed by game theorists. This is important, as discussed further below. Note also that a similar game but of the continuous zero-to-one variety that *does* allow a raise has been analyzed elsewhere [33]; however that game is more complex in that it also allows "checking," which is passing. In that case, when player A checks it becomes a BAB' game in which player B can bet, and if B bets and A raises then B' must call or fold. This is the same as ABA' except with the roles reversed, so the option to check does not do much to change the basic structure of the game tree. The one thing

it *does* do is give A an opportunity to "bait" B by checking (where a check by A implies his hand is weak) in hopes that B will bet with a hand that he might otherwise have folded. In this maneuver, called a check-raise, player A would then raise the bet by B and B' would be forced to either call the raise to a showdown (which he would likely lose) or fold his hand (which guarantees his loss). The check-raise is not allowed in Pared-down Poker, which prohibits checking for several reasons.

One reason is that the strategic component added by checking is the *baiting* maneuver of a check-raise, and this is basically a *bluffing* maneuver. That is, in baiting, A checks to trick B into betting. Likewise, in bluffing (which is allowed in Pared-down Poker), A bets to trick B into folding, and/or B raises (after A bets) to trick A' into folding. This bluffing (much like baiting) is done to deceive an opponent—it is simply done with low cards faked as high instead of high cards faked as low, in hopes of causing a fold rather than in hopes of causing a bet. Thus the essence of baiting, which is a deceptive ploy, is captured by the action of bluffing, which is a deceptive ploy.

Another reason that checking is not allowed in One Card High is that checking doubles the size of the game tree, adding BAB' to ABA'. This makes it more difficult to compute optimal strategies and more difficult to teach novices to play, without adding much strategic complexity (because baiting is strategically similar to bluffing anyway, see above). A final reason why checking is not allowed in Pared-down Poker is to highlight the fact that historically in game theory the role of checking in poker has been somewhat mischaracterized—in a way that becomes important when it comes to scaling up insights to real-world applications.

11.3.3 Basics of Bluffing

To support this last claim, it is useful to review the logic and findings of von Neumann's seminal work on poker [89]. His was an AB game (continuous zero-to-one) that did not allow raising but did allow checking. The problem with not allowing raising is that the game then fails to capture the fundamental structure of real poker and real warfare, because a raise option is needed to get the *two* dimensions of style noted above.

The problem with allowing checking is that the rules of von Neumann's game do not reflect the basic structure of checking logic in real poker (or war). In fact it appears that by adding checking in the way that he did von Neumann actually made his game *less* like poker than a game without checking! To see why, note the checking logic in von Neumann's game was as follows: If player A checks then that takes the hand directly to showdown. This is different from standard poker where the hand goes to showdown only if player B also checks, i.e., player B is given the opportunity to bet after player A checks.

This difference is important because it led von Neumann to the finding that it is *best* to bluff (meaning to bet rather than check with a hand that is not likely to win in a showdown) with the *worst* hands (near zero in the zero-to-one continuum of

hands). This finding, which at first seems somewhat counter-intuitive, is one of the most highly touted insights of game theory [74]. The finding is typically rationalized as follows [41]:

> The reasoning is simple enough... A bad hand will only win anything if the opponent folds, so bad hands should be played aggressively or not at all.

Well maybe, but this does not mean that one should bluff with one's *worst* bad hands. In fact the hand one holds is practically irrelevant to the decision of whether to bluff or not, because the objective of a bluff is to get your opponent to fold his hand—and in that case there is no showdown, so the hand you hold does not matter! If anything there is an argument to be made for bluffing with the best bad hands, i.e., the highest hands that you would otherwise fold, because this increases your chances of winning a showdown if your opponent does not fold his hand. But more importantly your hand does not matter much, which means that bluffing should be driven by what does matter—which is the likelihood that your opponent will fold his hand in response to your bluff. This depends on many factors, some of which you can never know (like the card that he holds). But it also depends on some things that you can know, or at least guess, like the emotional state of your opponent. For example, if an opponent is "on tilt" from a "bad beat" in the previous hand, then he may be more likely to *not* fold—in which case you should probably *not* bluff (especially not with your *worst* bad hands).

Returning to von Neumann's result, that it is best to bluff with one's worst bad hands, some thought reveals that this is an artificial consequence of his game rules. To see why, suppose you are player A and you want to bet with a low hand (i.e., bluff) at least sometimes—in hopes that player B will fold his hand in response. All other times that you hold a low hand you will check (because von Neumann's game allows A only to check or bet) and this check will take the game to a showdown. Well in the set of all low hands it is obvious you should bluff (make a bet) when you are dealt the lowest of the low—because there is *some chance* that B will fold and you will win—whereas if you check there is *no chance* that you will win as your check takes the game to a showdown.

So of course you should bluff (not check) with your lowest low hands! But this is only because the game rules are such that a check by A takes the hand to a showdown—and the same logic does *not* apply to real poker or war. For example, consider a poker or war in which both sides are competing for a pot (resources)—and one player must make the first move in a contest to win the pot. If this player passes (checks) then he has not acted, so he should not get a chance at the pot until *after* his opponent has also had a chance to act. In short, checking should lead to a showdown only if *both sides* agree to check, because that is how it works in poker, and that is also how it works in war.

On this point it should be noted that von Neumann himself did not tout his bluffing result as highly as some followers have. In fact he wrote:

> Bluffing has a very complicated 'fine structure,' which however secures only an extremely small advantage to the player who uses it... This phenomenon is possibly typical, and recurs in much more complicated real games. It shows how extremely careful one must be

in asserting or expecting continuity in this theory. But the practical importance—i.e., the gains and losses caused – seems to be small, and the whole thing is probably terra incognita to even the most experienced players. [89], p.209.

11.3.4 Return to the Real-World

The point here is that, in paring-down poker for study in the lab, it is vital that the structure of the game match the structure of the world along the dimensions that matter. In the case of von Neumann's poker, there were two problems with the *structure mapping*. One problem was the checking logic, described above—where it is not clear that the game insights would extend to real poker or real war. The other problem was that there was no raising option. This is a crucial aspect of poker or war, because an initial bet in poker or attack in war is *always* made with the risk that an opponent might raise the stakes to escalate the conflict. Ultimately it is this threat of retaliation that makes poker poker and makes war war. Without it we have lost the mind game—and to get it we need *at least* an ABA' game tree. That is why ABA' is the basic structure of the simplest game (One Card High) in Pared-down Poker. It can be made more complex, but it cannot be made any simpler or else it is not really poker.

Besides the game tree, the complexity (number of game states) to be dealt with in poker will depend on the number of cards in the deck and in each hand. Here the game-theoretic literature on simplified poker includes continuous zero-to-one games (noted above) as well as integer pokers played with one-card hands dealt from a three-card deck [53]. And actually the continuous case is simpler to solve mathematically. But psychologically an infinite number of hands from zero-to-one is awkward for human experiments, as people do not think infinitely.

Thus One Card High uses a deck of 11 cards, for three reasons. One reason is that when people play zero-to-one, or any other poker with many possible hand ranks, they divide the possibilities into discrete bins of hand ranks anyway (Straight Flush, Full House, etc.)—typically around a dozen or so [79]. From a cognitive perspective, zero-to-one poker and 5-card hands in full-scale poker tend to introduce variance in that different players might be binning differently. Another reason for a deck of 11 cards is that 10 is a familiar number for binning and counting, like fingers or toes. The use of just three cards, as in some other studies, would make the game more tractable mathematically but not too interesting psychologically. A final reason for using 11 cards (e.g., rather than 10 or 12) is that this makes it easy to estimate the odds of a win, at least initially in a two-person game—which allows participants and experimenters to focus on how the odds change after an opponent has bet or raised, as discussed below under *Bayesian Belief*.

At this point and before embarking on the mathematical modeling of Pared-down Poker, it is useful to restate why we are researching scaled-down poker at all—i.e., why we are not researching full-scale poker like the game of Texas hold'em that is so popular these days. The answer is twofold. First, as noted above, full-scale pokers still have not been solved for optimal strategies that are needed for measuring

performance, and the algorithmic challenges of finding such optimal solutions (with huge efforts) will not shed much light on how people play more ergonomically—with style. Second, in paring-down poker to a game like One Card High we have not only *preserved* the basic structure of poker and war—we have actually *improved* the structure mapping between the game task and the real-world.

How can this be? Well the fact is that much of the skill in full-scale poker comes from estimating the probabilities of random 5-card combinations (millions of them) dealt from a 52-card deck. And although the real-world is complex it is not random, so combinatoric calculations like this play little role in commonsense reasoning. Plus these days when such calculations are required and important they are done by computer programs anyway. More relevant and more difficult are the *causal* [68] probabilistic inferences that must be made in any domain, and this hard work is still performed mostly by humans in their heads. [Even when it is done by computers, most of the input numbers still come from people's heads.] In poker the analogous inferences are assessments of relative hand strength *given* opponent behaviors, where the opponent's hand strength (and his inference of your hand strength) is the causal factor at work. Thus Pared-down Poker is relevant to the real-world *because* it is pared-down to focus on causal inferences, thereby reducing the role of reasoning about random events that merely serve to complicate the mathematical models and add variance to the psychological data. In short, One Card High is simple and useful—and most useful because it is simply aligned with the cognitive challenges of real-world command and control.

11.4 Strategies and Styles

This section examines algorithmic approaches for playing poker, drawing a distinction between the game-theoretic notion of a *strategy* and the more ergonomic notion of a *style*. We begin with *Bayesian Belief*, which is the basis for normative diagnoses and decisions to maximize economic utility. After that we address ergonomic utility, and consider the tradeoff between minimizing ergonomic utility (effort) and maximizing economic utility (money).

11.4.1 Bayesian Belief

As noted earlier, *inference* and *investment* are the crux of playing poker, as well as command and control in any domain. Both tasks can be analyzed in an integrated fashion using the mathematical machinery of Bayesian belief. This approach [3] has become standard in statistics and economics, and has also been applied to cognitive models [50, 85] as well as affective models [13, 15]. Here I will focus on economics, in the context of Pared-down Poker, where a Bayesian basis underlies the normative strategy for inference and investment [16, 18, 19].

Conceptually, the basic problem of *inference* in poker begins when a player (denoted "I") is dealt a hand from which he gets a *prior* (before any additional information) probability that he has the higher hand. For example, in One Card High, if player I is dealt an 8 then he knows that his opponent (denoted U) must hold 0, 1, 2, 3, 4, 5, 6, 7, 9, or 10. Because there are 8 cards lower than 8 and 2 cards higher than 8, player I knows that his win:loss odds are 8:2, i.e., his win probability if the hand goes to a showdown is 80%. Thus player I starts with the prior $P(U_{card<8}) = 80\%$.

Further inferences can be made if and when player I receives additional information via a bet (or raise) by player U. However to do so I needs a causal model of U, which specifies the likelihood that U would take some action (e.g., make a bet) in light of the possible hands U might hold. This is a *causal* model because the hand is the cause and the bet is the effect. For example, the causal model (e.g., based on past observation of U or other speculation by I) may be that there is a 70% chance U would make a bet if U has a card less than 8. Mathematically, the *likelihood* is $P(U_{bet}|U_{card<8}) = 70\%$.

Notice that this causal model encodes knowledge about how the world works, from cause to effect, because the likelihood expresses a probability of effect (U_{bet}) given cause ($U_{card<8}$). The problem I faces now is that he has two pieces of knowledge about $U_{card<8}$, in the form of a prior and a likelihood, and he needs to put them together somehow. This is not trivial because the likelihood is backwards in the sense that it expresses a probability of U_{bet} (given $U_{card<8}$) rather than a probability of $U_{card<8}$ (given U_{bet}). The difference is critical because $P(U_{card<8}|U_{bet})$ does *not* equal $P(U_{bet}|U_{card<8})$, and yet the former is what player I needs in order to decide whether or not he should make any further investment in his hand. Thus the problem for I is he *needs* to make an inference of $P(U_{card<8}|U_{bet})$ from the knowledge he *has* of $P(U_{card<8}) = 80\%$ and $P(U_{bet}|U_{card<8}) = 70\%$.

The answer to I's problem comes from Bayes Rule, which allows him to make the inference [50] he needs in light of what he knows. Per Bayes Rule, the *posterior* probability $P(U_{card<8}|U_{bet})$ can be obtained from the *prior* $P(U_{card<8})$ and the *likelihood* $P(U_{bet}|U_{card<8})$ as follows:

$$posterior = prior * likelihood / normalizing factor,$$

which in this case is as follows:

$$P(U_{card<8}|U_{bet}) = P(U_{card<8})^* P(U_{bet}|U_{card<8})/$$
$$[P(U_{card<8})^* P(U_{bet}|U_{card<8}) + P(U_{card>8})^* P(U_{bet}|U_{card>8})]$$

Notice that this equation contains two terms for which numbers were not specified above. One term is $P(U_{card>8})$, which can be computed as $1 - P(U_{card<8}) = 100 - 80\% = 20\%$ because U's card is either < 8 or > 8. However we *cannot* compute $P(U_{bet}|U_{card>8})$ as $1 - P(U_{bet}|U_{card<8})$ because in fact the two are not related mathematically, although they are related psychologically [17]. For example, the

causal model of player U might be that there is a 70% chance he would raise with card < 8 (see above) and a 95% chance (or some other %) that he would raise with card > 8.

Here I will assume $P(U_{bet}|U_{card>8}) = 95\%$, and this along with the other numbers noted above yields the following result from Bayes Rule:

$$P(U_{card<8}|U_{bet}) = 80\%*70\%/[80\%*70\% + 20\%*95\%] = 75\%$$

To gain more insight into this calculation, it is useful to note that the formula for Bayes Rule follows from the fact that there are two equivalent ways to express the joint probability of two things, e and C_n:

$$P(e, C_n) = P(e)^* P(C_n|e) = P(C_n)^* P(e|C_n) = P(C_n, e)$$

where C_n is a cause and e is the effect. Bayes Rule comes from rearranging this equation and noting that $P(e)$ is the sum of $P(C_n)^* P(e|C_n)$ over the N possible causes C_n of e. Thus Bayes Rule in the form noted above is obtained as follows:

$$P(C_n|e) = P(C_n)^* P(e|C_n)/P(e)$$

where $n = 1$ and $n = 2$ are the two possible causes ($U_{card<8}$ and $U_{card>8}$) of the effect (U_{bet}).

Notice that in the above example the posterior $P(U_{card<8}|U_{bet}) = 75\%$ is *not* equal to the likelihood $P(U_{bet}|U_{card<8}) = 70\%$, which is why the order of terms in parentheses for conditional probability is critical. This is the practical advantage of Bayes Rule, i.e., it allows one to make a posterior inference from prior knowledge and causal likelihoods. This inference is important because I needs to know the chance that U has a lower hand, which is $P(U_{card<8}|U_{bet})$, not just the chance that U would have bet with a lower hand, which is $P(U_{bet}|U_{card<8})$.

Here by Bayes Rule we see that $P(U_{card<8}|U_{bet}) = 75\%$ is less than $P(U_{card<8}) = 80\%$, which means that U's bet reduces the chances that I has the higher card. This is how player I can use his causal knowledge about player U to update his beliefs about whether he (I) actually has the better hand or not—and that is the first problem of poker, i.e., making an *inference* of hand strength in light of evidence given by cards that are dealt and bets that are made. But that is only half the story as there is then the second problem of poker, which is to make an *investment* (or not) of chips in light of the inference about hand strength. The first problem is a "card" problem of estimating one's *probability* of having the higher hand, while the second problem is a "chip" problem of estimating one's expected *utility* for bets or raises (or calls to bets or raises) given the inference made in the first place. Luckily the investment problem is also amenable to a Bayesian approach where the answer is simply to choose the action (e.g., fold, bet, call, or raise) that *maximizes expected utility* (probability * utility).

For example, assume the pot contains 7 chips and a player at node A' (see Fig. 11.1) is faced with the choice between folding (and giving up the pot) or

calling the raise by player B and taking the hand to a showdown. The fold will cost zero chips, so the expected utility of this option is zero: $\Psi_{fold} = 0$. The call will cost 1 chip but it gives player A' the chance to win a pot of 7 chips, so the expected utility of this option is follows: $\Psi_{call} = -1^*(1 - P) + 7^*P = -1 + 8^*P$, where P is the probability of winning the showdown (having the higher hand). Thus the choice that will maximize expected utility depends on the stakes as well the odds. In this case a Bayesian player A' would call the raise (not fold) when $\Psi_{call} = -1 + 8^*P > \Psi_{fold} = 0$, i.e., when $P > 1/8$.

Notice here a good choice (call) does not necessarily require that the player be favored to win (P > 1/2) because expected utility entails both odds and stakes. In the above example, the cost:pot stakes of 1:7 will make the call a good bet (expected utility > 0) whenever the win:loss odds given by P:1-P are better than 1:7, i.e., whenever P > 1/8. Thus the win:loss odds needed to justify adding money to the pot, sometimes called "pot odds" by poker players [80], are determined by the cost:pot stakes. And this is the same as saying that a good choice in poker is based on the *expected utility* given by probability * utility.

Now in practice things get much more complex, even in the simplest Pared-down Poker. For example, in One Card High the odds and stakes outlined above apply only at node A', because earlier (at node B) player B does not know for sure what his opponent will do in response (at node A'). And even earlier (at node A) player A must consider what his opponent might do at node B, as well as what he himself would then do in response at node A'. For example, in his decision (at node A) player A must consider that his opponent might fold at node B, which means that A can win even if the probability that his hand is better than B's hand is low or zero! This is, of course, what leads to bluffing—where player A will sometimes bet with a weak hand in hopes that player B will read it as a strong hand and fold, thereby giving A the pot even though A has a worse hand than B. Similarly, player B might bluff by raising with a low card after A has bet, and A must consider this possibility when he makes his initial decision to bet or fold at node A.

Thus although the investment decision at the final node A' is rather simple, the investment decisions at earlier nodes B and A can be quite complex—requiring inferences based on a *causal model* of opponent behavior [10]. This model is important, and it is implicit (if not explicit) in every choice made by a poker player even if the player is not consciously aware of it. Similarly the mathematical machinery of Bayesian belief is behind every inference a player makes about hand strength even if the player is not consciously aware of it. Said another way, a Bayesian basis is the optimal way to play poker [52, 82], so to the extent that poker players are skillful in winning they are acting in accordance with this Bayesian basis even if they are not aware of the fact that they are doing so.

This insight is interesting because few if any poker players would say that they are actually implementing Bayesian calculations as outlined above. And yet they are, at least approximately and implicitly if they play well, regardless of the heuristic rules-of-thumb that they might consciously know and be able to tell us. So the point here is not that skillful players are explicitly thinking like Bayesians, but rather

that they are implicitly acting like Bayesians regardless of what they are explicitly thinking. And that begs the question: What are players thinking, anyway?

11.4.2 Style is Simple

To start, it is doubtful that human beings are thinking through the Bayesian equations, because these equations are remarkably complicated even for the simplest Pared-down Poker of One Card High (see Table 11.3). And yet these equations (for One Card High played against *just one* opponent) are actually simplified in that they assume the opponent's strategy *is known*, i.e., they assume that the causal model (discussed above) specifying what action (e.g., fold, bet, call, or raise) an opponent will take given any card (0–10) he holds is known with certainty. In reality the causal model is rarely if ever known with certainty, which introduces second-order uncertainty and makes poker intractable to analytic solution. Thus as a practical matter one must assume a causal model (or at least a probability distribution for causal models) in order to get any answer, and even when one assumes a causal model it is not easy to compute the answer (see Table 11.3) about what is the best choice to make at each stage of the game.

In classical game theory [27] this problem is skirted by adopting the notion of a Nash equilibrium [66]. That approach is different because there is no explicit Bayesian analysis of inference and investment with time. Instead the approach is to exhaustively enumerate all possible strategies for each player in a payoff matrix, where a strategy is a complete sequence of choices leading to the end of the hand. To get the equilibrium solution, player I selects the strategy that maximizes

Table 11.3 Bayesian equations for expected utility (Ψ) against a known style. Each P is computed from knowledge of the opponent's style, and updated via Bayes Rule after the opponent acts. The ante amount is a. The bet amount is b

Node A

$$\Psi_{A,bet} = \quad P_{B,fold}{}^*[(b + 2a) - b] +$$
$$\qquad\quad P_{B,call}{}^*[P_{A,win|B,call}{}^*(2b + 2a) - b] +$$
$$\qquad P_{B,raise}{}^*[P_{A',call|B,raise}{}^*\{P_{A',win|B,raise}{}^*(4b + 2a) - 2b\} - P_{A',fold|B,raise}{}^*b]$$
$$\Psi_{A,fold} = \quad 0$$

Node B

$$\Psi_{B,raise} = \quad P_{A',call|bet}{}^*[P_{B,win|A',call}{}^*(4b + 2a) - 2b] +$$
$$\qquad\quad (1 - P_{A',call|bet})^*[(3b + 2a) - 2b]$$
$$\Psi_{B,call} = \quad [P_{B,win|A,bet}{}^*(2b + 2a)] - b$$

$$\Psi_{B,fold} = \quad 0$$

Node A'

$$\Psi_{A',call} = \quad [P_{A',win}{}^*(4b + 2a)] - b$$
$$\Psi_{A',fold} = \quad 0$$

his winnings (averaged over all possible games states) *under the assumption* that player U will do the same to maximize his own winnings (which would minimize player I's winnings). Likewise in the equilibrium solution, player U selects the strategy that maximizes his winnings (averaged over all possible game states) *under the assumption* that player I will do the same to maximize his own winnings (which would minimize player U's winnings). The advantage of this equilibrium, called *minimax*, is that it specifies how two optimal opponents should make choices in head-to-head competition for *economic utility*.

The disadvantage, however, is that a Nash equilibrium ignores all but economic utility. This makes the approach ill-suited to analyzing temporal influences like fun and tilt discussed earlier under *aesthetic utility*, and it also ignores learning about opponents in the form of *informatic utility*. More important to the current study, the Nash equilibrium ignores all aspects of *ergonomic utility* as well as key aspects of *economic utility*.

With respect to economic utility, a player *should play* the minimax strategy only when *he knows* his opponent will also do so. For example, if U does not play the minimax then I can exploit him, i.e., minimax is no longer optimal for I as I may win more chips with a different strategy. With respect to ergonomic utility, a player *can play* the minimax only if he can *compute* it. But normal people cannot compute it even in simplified pokers, as the effort to do so is even greater than that of solving the Bayesian equations noted above.

For example, in One Card High one must compute the entries of a 77×77 payoff matrix, because each player has 77 possible strategies in the game-theoretic sense of this word—where a strategy is a unique vector that specifies the action a player will take at each node of the game (A, B, A') for a given card he might hold. Each cell of this matrix must then be computed over the 10 possible cards that his opponent might hold, and these computations must be averaged to get the value of the cell. Then to top it all off, even when all $77 \times 77 = 5927$ cells are computed, the minimax is not just one best strategy for each player, but rather it is a mixture of strategies to be played at various frequencies—and the mixture itself is not easy to compute as it requires solving systems of simultaneous linear equations.

Thus at this point we might ask: What calculations *can* people perform, in the their heads, via *rules* that define their *styles*, and how do these cognitive styles stack up against normative strategies—ergonomically in terms of playing effort as well as economically in terms of poker winnings?

With respect to the ergonomic question, we know that cognitive heuristics are a far cry from the minimax solution or Bayesian equations used to compute normative strategies. Although it is not clear exactly what rules are used by human players, or how these rules differ between players, it appears that the rules are remarkably simple and similar between people. Support for this comes from players' reports in pilot studies of One Card High, where most people say they make their choices based on if-then rules like: "I'll bet or call a bet if I have an x or higher card," and "I'll raise or call a raise if I have a y or higher card." Of course players also report more complex rules, the most common of which involves "sometimes mixing it up" in order to "catch opponents off guard." But mathematically this is just a

probabilistic version of the deterministic rule, much like a "mixed" strategy of game theory—where the action (e.g., to bet or call a bet) is taken with some probability when the "if" part of the rule is satisfied.

Players' reports are also interesting because they sometimes involve much more complex chains-of-thought like: "If I do this then he will probably do that, in which case I will do thus..." This reasoning is more like an abbreviated version of the Bayesian equations, whereas the rule-based logic (above) is more like an abbreviated version of the payoff matrix. But both "modes" of cognitive processing are extremely simplified compared to normative solutions. And interestingly, the more complex chains-of-thought are typically replaced by the simpler rules-of-thumb as a player gains experience in playing the game.

Ergonomically speaking, the [x, y] rules noted above are at least orders of magnitude simpler than the Bayesian equations (or minimax solution). Economically speaking, this suggests that cognitive *styles* based on such rules would be far less effective in winning poker than normative *strategies* given by Bayesian equations (or minimax solutions). For example, a player's deterministic rules could easily be detected and then exploited by a Bayesian—simply by observing the [x, y] card thresholds at which bets and raises are made by the player. This would be harder against an opponent who "mixes it up" with probabilistic rules, but the [x, y] probabilities could still be computed and exploited by collecting statistics on a player's actions. The case of deterministic rules is an easier case to analyze and it offers a bounding measure of how much a Bayesian strategy could ever exploit a human style, in order to address the question of interest here, namely: How skillful is style?

11.4.3 Style is Skillful

Before answering this question it is useful to define slightly more complex rules in the form of a quadruple $[x_A, y_A, x_B, y_B]$, where x and y are card thresholds for betting/calling a bet (x) and raising/calling a raise (y), and the subscripts A and B refer to whether the decision is made in role A or role B. The distinction between A and B is important (from a Bayesian perspective) because A acts before B and B acts before A', so A is acting with less information than B and B is acting with less information than A'.

Now returning to the question (How skillful is style?), all possible style vectors $[x_A, y_A, x_B, y_B]$ for a stylish player (I) were played against a Bayesian player (U) in pair-wise face-offs. Each face-off was a tournament of 220 games that was complete and balanced in the following respect: Because a player can be dealt one of 11 cards, and his opponent will be dealt one of 10 remaining cards, there are 11*10 possible deals to play. Because each player might play the same deal in the role of A or B, there are 2*110 = 220 possible deals-and-orders. Because the stylish player is assumed to use deterministic rules based on the thresholds $[x_A, y_A, x_B, y_B]$, and the Bayesian always plays optimally against these threshold rules, each of the 220 deals-and-orders need be played only once to get an exact measure of winnings.

The face-offs were computed for the ABA' game of One Card High with betting amounts fixed as follows: ante = 2 chips, bet = 1 chip, and raise = 2 bets (2 chips).

The results are shown as net chips per hand (average over 110 games) won by various A styles $[x_A, y_A]$ in Fig. 11.2a, and net chips per hand (average over 110

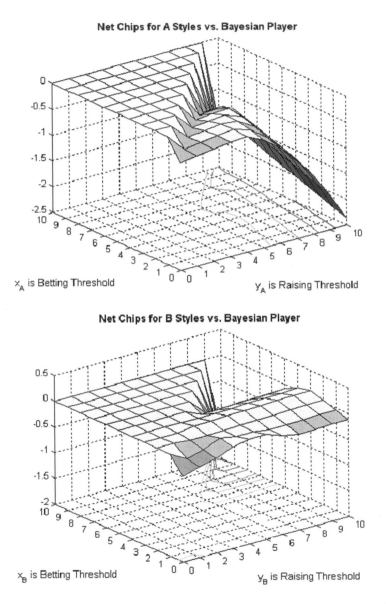

Fig. 11.2 Net chips won (lost) by various styles $[x_A, y_A, x_B, y_B]$ against Bayesian player, for One Card High: ante = 2 chips, bet = 1 chip, raise = 2 bets. The best style is $[x_A, y_A, x_B, y_B] = [1, 4, 3, 10]$. (**a**) A styles $[x_A, y_A]$ vs. Bayesian. (**b**) B styles $[x_B, y_B]$ vs. Bayesian

games) won by various B styles [x_B, y_B] in Fig. 11.2b. The net chips per hand
(average over 220 games) for a style [x_A, y_A, x_B, y_B] is obtained as the average of
[x_A, y_A] and [x_B, y_B]. The best style is [1, 4, 3, 10], and the net chips per hand
(average over 220 games) is -0.06, which means that the best style lost by $220 *$
$0.06 = 13.2$ chips in the 220 game tournament.

Here it is not surprising that even the best style lost to the Bayesian player, who
maximally exploits all styles. But what is surprising is that the best style lost by
only 6% of one chip per game, especially because this small loss of economic utility
comes with a huge gain—at least orders of magnitude—in ergonomic utility (effort
saved). Also surprising is that there are many styles that are almost as good as the
best style [1, 4, 3, 10] against the Bayesian. That is, in Fig. 11.2a there is a large
patch of A styles with net chips nearly as high as for [1, 4]; and in Fig. 11.2b there
is a long ridge of B styles with net chips nearly as high as for [3, 10].

From these results it seems fair to conclude that *style is skillful*—at least many
styles are skillful—in the sense that these styles lose very little to a Bayesian player
who is assumed to know their style with certainty and exploit it maximally.

Of course these results are dependent on the ante/bet amounts of the game, and
one might ask if similar results hold true for other cases. For example, the above
tournament was played with ante $= 2$ and bet $= 1$, and the small bet size is what
makes a "loose" style ($x_A=1$ and $x_B = 3$) so effective—i.e., there is little to lose
from a bet (1 chip) and much to be gained from the antes in the pot (4 chips) so one
should bet and call bets with almost any card. But what if the bet size is much more,
say 10 chips (and a raise is still 2 bets, which is now 20 chips)?

The results for this case are shown in Fig. 11.3. As expected, the best style is a
"tight" style, with numbers [7, 9, 8, 10]. This style loses only 0.08 chips per game
(on average over 220 games) to the Bayesian—which as a percentage of the bet
amount is much less than the previous case (Fig. 11.2). However here (Fig. 11.3)
with higher bet and raise amounts we see that there are fewer good styles because
the net chips fall off more quickly as one deviates from the best style. Nevertheless
the main finding is much the same, i.e., that the best style is not only ergonom-
ically efficient—it is also ergonomically efficient in the sense that it can hardly
be exploited by a Bayesian player who plays as well as anyone or anything could
possibly play against it (without cheating).

11.4.4 Style is Super-Optimal

When one considers ergonomics, where the best style is orders of magnitude better
than the Bayesian player, along with economics, where the Bayesian player is only
slightly better, then one might say that style is even more optimal than the Bayesian
strategy. Of course this assumes one plays with the best style, or at least close to the
best style, and finding a good style is also a problem that must be solved. Some have
used machine learning techniques [2, 46] to show that this problem can be solved,

Net Chips for A Styles vs. Bayesian Player

Fig. 11.3 Net chips won (lost) by various styles $[x_A, y_A, x_B, y_B]$ against Bayesian player, for One Card High: ante = 2 chips, bet = 10 chips, raise = 2 bets. The best style is $[x_A, y_A, x_B, y_B] = [7, 9, 8, 10]$. (**a**) A styles $[x_A, y_A]$ vs. Bayesian. (**b**) B styles $[x_B, y_B]$ vs. Bayesian

at least in principle, but these techniques take many thousands of learning trials to converge and hence are not good models of how people adapt their styles.

Instead it is likely that people adopt styles based more on commonsense reasoning, much like that discussed above with respect to the difference in "best style" between games with a low bet amount and high bet amount. That is, when the bet is relatively small (compared to the ante) then one should play loose; and when the bet is relatively large (compared to the ante) then one should play tight. Similarly, by common sense one should play tighter in role B than in role A because at node B player B has gained information about A's hand, i.e., A's bet implies that he likely has a decent hand. Finally, in roles A and B, common sense suggests that one should require a better hand for raising than for betting, especially in role B (because A' is likely to call with any decent hand), such that $y_A > x_A$ and $y_B >> x_B$. Notice that all of this common sense is satisfied by the styles [1, 4, 3, 10] and [7, 9, 8, 10], which are the best styles against the Bayesian in low bet and high bet games noted above. Thus we see that common sense puts strong constraints on the best style to play in a given game (ante and bet amount), and this helps explain how humans can find a good style relatively quickly.

Now besides the bet size (relative to the ante) there is another important aspect of the game to which a player must adapt—namely the style of his opponent. In the above analysis a stylish player was faced-off against a perfect Bayesian, and this is not the sort of opponent that one will encounter in the real-world. Instead one will encounter other human beings who also play with various styles, and the question then is: What is the best style to play against other styles?

To answer this question, pair-wise face-offs (220 games, as discussed above) were held for four proto-styles against one another. As a benchmark of how well any style could possibly do against a given style, a Bayesian player was also played against each of the four styles. Referring to Fig. 11.4, the calculations were done for four "animal" styles [42] in an x-y *style space*. For simplicity, the A and B numbers for x and y (see Fig. 11.4) were assumed to be the same for a given animal style. The game was the same as that played in Fig. 11.2, i.e., One Card High with ante = 2 chips, bet = 1 chip, and raise = 2 bets (2 chips).

Figure 11.5 illustrates the results with arrows pointing to the winning style in each pair-wise face-off. The number next to each arrow indicates the magnitude of win (loss). The results show that the Mouse beats all other styles, and he does so by about the same margin of 0.06 chips per game as the Bayesian beat the least exploitable style. This suggests that, when one is a stylish player and playing against other stylish players, then one should play like a Mouse—to maximize one's winnings. But in fact the answer is not so simple, as we see from the Lion's winnings of 0.15 against the Jackal. That is, even though the Mouse beats the Lion by 0.06, and the Mouse beats the Jackal by 0.06, the Lion wins 0.15 against the Jackal. This illustrates the importance of adapting one's style to the style of one's opponent— highlighting the fact that there is no single best style to play at all times because the best style depends on the style of one's opponent.

Finally we might ask how well *any* style can do against a given style—if one does detect the opponent style and adapts accordingly. Here the benchmark for

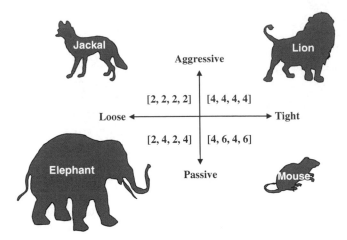

Fig. 11.4 Four animal styles prototypical of poker players. The x-axis is loose-tight; the y-axis is passive-aggressive. Numbers in brackets are $[x_A, y_A, x_B, y_B]$, where minimum cards for bet (x) and raise (y) are assumed to be the same in roles A and B

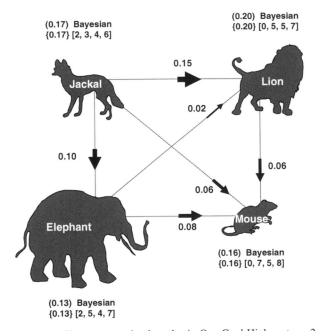

Fig. 11.5 Results of face-offs between animals styles in One Card High: ante = 2 chips, bet = 1 chip, raise = 2 bets. Arrows point to winning style. Numbers are net chips won (lost) per game. Brackets [] show the "best style" and braces { } show the best style's earnings against each animal style

performance is a Bayesian player (who is assumed to know the opponent style) because he exploits a stylish player to the maximum extent possible. These results are reported parenthetically in Fig. 11.5, where we see that the Bayesian wins 0.13, 0.16, 0.17, and 0.20 chips per game (in 220 games) against the Elephant, Mouse, Jackal, and Lion, respectively. Here it is interesting that neither the Mouse nor the Lion (see above) are the best style, as the Elephant lost the least against the Bayesian.

Now to answer the question of how well *any* style can do against each of the four animals styles, all possible style vectors $[x_A, y_A, x_B, y_B]$ were faced-off against each of the animals to find the best style against each animal. These results are also reported in Fig. 11.5, where braces { } give the net winnings for the best style in brackets [] against each animal. The results are remarkable.

Against each stylish animal we find a stylish optimum—i.e., a style vector $[x_A, y_A, x_B, y_B]$ that does *exactly* as well as the Bayesian player does against the same animal. This is remarkable because, as noted above, each style is merely a statement of the minimum card at which one will *always* "play" at low stakes (bet or call a bet, per the x number) or at high stakes (raise or call a raise, per the y number) in role A or B. In this respect, when one considers the combination of ergonomic utility (far less for a stylish player than a Bayesian player) and economic utility (exactly equal for the best style and a Bayesian player), one might say that style is super-optimal.

Of course this holds true only for the best style against a given style, and a stylish player must still find the best style against his opponent. But this may not be so hard when the player is guided by common sense as discussed above. Moreover, considering the balance between ergonomics (effort) and economics (earnings), a close-to-best style may be good enough and easy to find. As an example, Fig. 11.6 plots the performance of all possible styles against the Elephant [2, 4, 2, 4].

Figure 11.6a shows that there is a large patch of A styles near [2, 5] that are close-to-best, and Fig. 11.6b shows that there is a long ridge of B styles near [4, 7] that are close-to-best.

Figure 11.7 shows how the Elephant [2, 4, 2, 4] is exploited by the Bayesian, as well as by the best style [2, 5, 4, 7] against the Elephant. Here we see that the Bayesian (Fig. 11.7a) and the best style (Fig. 11.7b) do not play exactly the same on each deal (I card, U card) against the Elephant, although they are extremely close and the net chips won in a complete set of 220 games are *exactly* the same.

11.5 Applying the Analysis

11.5.1 Intelligent Interactions

The above analysis of strategic style in Pared-down Poker showed that styles are simple, and hence ergonomically advantageous, but also skillful, and hence economically advantageous. Moreover, when both ergonomics and economics are considered together we saw that styles might even be considered super-optimal, relative

Net Chips for A Styles vs. [2 4 2 4]

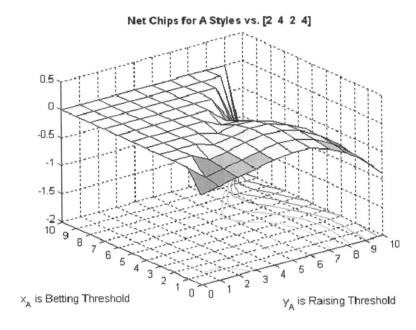

x_A is Betting Threshold y_A is Raising Threshold

Net Chips for B Styles vs. [2 4 2 4]

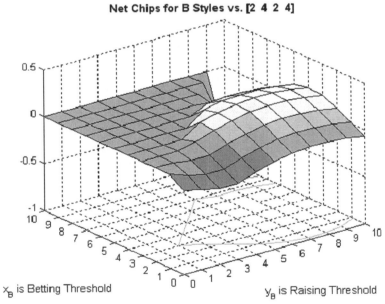

x_B is Betting Threshold y_B is Raising Threshold

Fig. 11.6 Net chips won (lost) by various styles [x_A, y_A, x_B, y_B] against the Elephant style [2, 4, 2 ,4], for One Card High: ante = 2 chips, bet = 1 chip, raise = 2 bets. (**a**) A styles [x_A, y_A] vs. [2, 4, 2, 4]. (**b**) B styles [x_B, y_B] vs. [2, 4, 2, 4]

Net Chips for Bayesian (U) vs. Style I [2 4 2 4]

Net Chips for Style U [2 5 4 7] vs. Style I [2 4 2 4]

Fig. 11.7 Net chips won (lost) by Bayesian and best style [2, 5, 4, 7] against the Elephant style [2, 4, 2, 4], for One Card High: ante = 2 chips, bet = 1 chip, raise = 2 bets

to the money-conquering but effort-consuming strategy of a Bayesian player. So style is smart.

We also saw how the best style or close-to-best style against any given opponent (Bayesian or stylish) might be ascertained by a thinking player based on common-sense reasoning in *style spaces* [35, 36] of [x, y] numbers for A/B players. The reason for this is that the payoff landscape exhibits regularities stemming from the betting structure of the game (ABA'), and these "modes" [73] can be captured by rules (in styles). The complicated calculations needed to compute Bayesian solutions, as well as the even more extensive enumerations needed to compute equilibrium solutions, are avoided by playing with style—without sacrificing much if any economic utility and at the same time saving vast amounts of ergonomic utility. To repeat, style is smart.

Although this analysis was limited to a simplified game of Pared-down Poker, the findings suggest answers to questions like: How can human beings, who have such limited overt computing ability, still beat sophisticated AI poker programs? The answer, simply stated, is that style scales. To start we saw how a distinction between conservative (risk averse) and non-conservative (risk seeking) behavior might be made along two dimensions of the game that differ in the level of *investment* (low stakes versus high stakes)—which yields the 2-D *style space* (Fig. 11.4) defined by an x-axis (loose-tight) and a y-axis (passive-aggressive). We then saw how a further distinction between [x, y] styles might be made based on the player's role as A or B, where these two roles differ in how much information is conveyed by an action and hence in the strength of inferences that can be drawn.

Now it is easy to imagine how the same sort of style-based logic could be extended to full-scale poker where there are more rounds (hence more than x and y axes); and more seats (hence more than A or B players); and more cards (hence more than 0–10 hand ranks). Although the styles (rules) will obviously get more complex, they are still just variations on the same themes and hence amenable to commonsense reasoning along the main lines of Pared-down Poker. And actually this is exactly how experts give lessons in full-scale poker [42], teaching rules-of-thumb about what "pocket cards" (like 0–10) one should possess to bet or raise with (like x or y) and how it depends—on "position" (like A or B) as well as the playing style of opponents and the betting amounts in the game (e.g., low or high, see Figs. 11.2 and 11.3).

Thus this study of Pared-down Poker sheds light on *why* simple styles can work so well, even in full-scale poker, and *how* they might be learned in lessons and practice.

11.5.2 Asymmetric Adversaries

As noted earlier, the cognitive challenges of playing poker are similar to those of other domains, like business and war. From a practical perspective this suggests that our findings might be scaled up beyond poker games to real-world concerns, hence

one might ask: How can Pared-down Poker be applied to problems of inference and investment in the real-world of command and control?

The answer to this question is again rooted in the [x, y] and A/B structures of *style spaces* discussed above. That is, extending the insights depends on relating key aspects of the real-world to those of the game task—in a technique known as *structure mapping* [21, 37, 38]. This enables the transfer of knowledge from one domain to another domain, by analogy or metaphor (Chap. 12 by Goguen and Harrell).

Toward that end, it is interesting that military theorists often speak of war as a "game." One example is the current war on terror, which is *asymmetric* in the sense that we are at war with adversaries whose beliefs and values (expected utilities) are radically different from our own. These differences in style make it difficult for us to make sense of their actions and *infer* what they might do next so that we can best *invest* in our defense. Thus it is not surprising that some attempts to make sense of these asymmetric adversaries are remarkably similar to the style spaces used to make sense of animal styles in Pared-down Poker.

For example, in a recent study Shapiro [78] notes it is puzzling that Al Qaeda has, after 9/11, evolved differently from the way that terrorist groups have previously evolved in response to government pressures. In an attempt to understand this evolution he characterizes the interaction as a game between players (terrorists and governments) who are:

> myopically adaptive... [where] their decision process takes the state of the world as given... anticipate the other player's reactions but only one step down the game tree... [and] attempt to take the optimal action given reality as they see it.

In other words he is saying that the war on terror can be seen as a repeated ABA' game, much like Pared-down Poker, between players with different styles—where both sides are constrained by cognitive limits (ergonomic utilities) as they attempt to maximize values (economic, informatic, and aesthetic utilities).

The same study goes on to focus on the style (although the author does not use this term) of one player, who is actually a network (terrorist organization), and how it might change in response to various actions taken by the other player (government organization). To begin the author notes that "connectedness" (networking) and "centralization" (hierarchy) are two different but related dimensions of organizational design, both of which vary along a continuum that ranges from low to high (Fig. 11.8). This is analogous to the x and y dimensions of style in poker (Fig. 11.4), which both vary along a continuum that ranges from low to high but differ in the context—where x applies at lower stakes and is concerned with *initiation* of activity (betting), and y applies at higher stakes and is concerned with *escalation* of activity (raising).

In the x dimension, more connectedness will increase communication between terror units but also increase their vulnerability to detection as captured individuals may share information about those to whom they are connected. Likewise, in the x dimension of poker there may be economic utility to be gained by playing tight but

Fig. 11.8 A style space for terror organizations, adapted from [78]

this comes at the cost of some informatic utility—as a tight player gives away more information about his hand whenever he bets (because he bets with fewer hands).

Also terror organizations presumably get pleasure (aesthetic utility) from discussing objectives and plans to achieve them, so a tight network might be adopted for this reason as well—even though it increases the risk of detection (hence the loss of informatic utility). But notice this would be different from poker, where presumably playing a hand is more fun than folding, such that aesthetic utility favors a loose style (not tight). In contrast, a contribution from aesthetic utility may tend to drive an organization's adoption of a tighter (more connected) style.

In the y-dimension, an analogy between terror and poker is that more centralization will tend to increase the coordination between terror units, which might be like an aggressive poker player who plays to the hilt whenever he plays. But again the analogy is limited, because more centralization can also exercise more control and hence make an organization more passive (less aggressive) under certain conditions.

Figure 11.8 shows how the organizational styles of three terror networks have changed with time in response to government pressures. The movement has been different for Al Qaeda than Hamas or P-IRA, and Shapiro [78] argues that this must reflect differences in costs and benefits to the players (terrorists and governments). He also suggests that these behaviors can be analyzed more quantitatively, but leaves this for further work.

Thus we see that, although poker is played between *individuals*, the same sorts of style spaces might shed light on conflicts between *organizations*. To do so we merely need to change the level and focus of analysis from one of individual conservatism (in poker players) to organizational communication (in terror networks). However, like we saw for poker style, a fundamental understanding of terror networks will require more quantitative modeling of the underlying utilities (costs and benefits), and these may be similar but they are certainly not identical between poker and terror.

This structure mapping between poker and terror is along the lines of the *metaphoring* [81] that typically occurs in *sensemaking* [57, 90]. As noted by Smith [81], the principal fault for which the 9/11 Commission chastised the United States Government in general and its intelligence community in particular was for a lack of *imagination*, e.g., where terrorists could see airliners as analogous to missiles while our analysts apparently did not. The power of structure mapping is that it allows insights from one domain (like poker) to be applied via analogy to another domain (like terror). The drawback is that because such mappings are intuitive they are not always accurate, i.e., the analogies do not capture all realities.

11.5.3 Understanding Utilities

As a practical matter, structure mapping in style spaces can help us see the war on terror as a high-stakes game of poker in which actions are shaped by asymmetric utilities. To win the game (war) we must work to maximize our expected utility—as our adversaries will work to maximize their expected utility. At a deeper level, the challenge is to ascertain exactly what utilities are at stake and to quantify these values so we know what our adversaries (and we ourselves) are trying to maximize in the game. In this regard it is important to note that potential differences in primary utilities between asymmetric adversaries might actually be the key to success—in a win-win solution where each side gets what they want most, much like the win-win of economics-aesthetics for casinos-customers in gambling.

In the case of terror, Shapiro [78] conjectures that Al Qaeda has adopted a connected but *decentralized* configuration in order to *"reduce government ability to identify a definite adversary. . . and develop metrics to measure the conflict"*—even though this may actually reduce the terror network's effectiveness in conducting operations that inflict violence, and even though the connected configuration may actually increase some informatic vulnerabilities. This conjecture may or may not be true, and as Shapiro notes it will require further study.

For example, an *informatic* utility associated with thwarting government attempts to show progress may be, as Shapiro claims, the primary type of utility valued by our current adversary. But how can this utility be modeled and measured? Also, the *aesthetic* utility associated with casualties and property losses may actually be more important than the *economic* utility of this violence. After all it is a war on terror—and terror is an emotional "affect." But how can this utility be modeled and measured? Although some steps toward answering these sorts of questions have been suggested [15], at this point all we can say for sure is that standard metrics used to gauge success in war, which are akin to economic utility, are not the right things to measure when it comes to fighting and winning the war on terror. The problem now is to find the right things to measure, and that is why it is so important to understand utilities of all types. Clearly one important type is aesthetic utility —in the *art of war* [1, 84].

A concrete example comes from the military operation known as "time-sensitive targeting," in which sets of weapons are assigned "on the fly" to sets of targets "to be hit" in order to maximize a strategic utility. To do this the utilities of all targets and assets, as well as *collateral* objects and events, must be identified and quantified—before any algorithm can compute the optimal weapon-target pairings [21]. Yet the former concern has received very little attention in the engineering community, where the focus has instead been on optimization algorithms.

The underlying utilities have received much more attention in the operational community, but there they are dealt with by assigning rank order priorities (e.g., A, B, C, etc.) to targets and assets in order of perceived importance. The problem with this is that these ordinal priorities must somehow be converted to numerical utilities (e.g., 100, 78, 54, etc.) in order to solve the optimization problem—and typically the programmers of computer systems *assume* these numbers rather than *extract* them from the heads of the commanders who are calling the shots. Here there is a need for better structure mapping to ensure that the computer system and cognitive user have the same structure of style in the form of expected utilities. The upshot is that current systems have implemented algorithms that find the best answers to the wrong problems, as the machine works to optimize utilities that do not match the expected utilities in the human heads it is supposed to support.

Thus the need is not so much for better algorithms but rather it is for better representations, so the machine gets the "right" utilities as input to its algorithms, and so the human "gets" the right understanding of output from system calculations [21]. This is a problem of AI-human interaction and its solution requires that the system "know" the underlying utilities, which are the *structure of style*, so it can optimize operations in a fashion that "feels" right to humans using the system.

A related challenge is what military theorists call Effects-Based Operations [28, 57, 81], in which missions are planned to optimize desired outcomes. Here the fundamental limitation of current systems is that their computed "effects," akin to economic utilities, do not consider various "affects," akin to aesthetic utilities. Thus although we often hear talk of things like "shock and awe," it is mostly just talk because these and other feelings are not quantified in any current measures used to plan and act in war. As stated by one commander [47]:

> We talked much about the battle for hearts and minds, but frankly we do little to have practical effect... and so it is with this war on terrorists and in information operations. We need to be able to probe and test for strengths and weaknesses and exploit opinion differences... distrust, discord, and disorder. We need to create panic, corrupt, and confuse—why do the terrorists get all the fun?

Here the value of this study on poker is to show that science is still in its infancy when it comes to quantifying informatic and aesthetic utilities like discord and panic, even in simple games let alone in complex wars. The value of future work on Pared-down Poker is that the game provides a test bed for advancing a science of style, to gain a computational understanding of affects like *fun* and *tilt* in the game—and by analogy in a war.

Thus although this chapter does not solve the problem of how to win the war on terror, or any other real-world problem, it does take a small step beyond the current state of the art by at least showing what the problem entails and how it might be addressed. The problem is not really new, as it is still just to maximize expected utility [29, 30]. The new thrust is to realize that we must shift our focus to non-economic utilities, including aesthetic utility, because that is what affects how we feel and how our adversaries feel—and deep down these feelings are what war is all about. In short, the challenge is not Effects-Based Operations. Rather, it is *Affects*-Based Operations.

11.5.4 Rational Risk Assessment

To conclude this chapter it is useful to consider the role that various utilities—and especially aesthetic utility—might play in risk assessment at large. War is a particularly difficult domain because the game is played (war is fought) against intelligent adversaries. But there are also many other domains where a similar game is played "solitaire" against the gods of chance [8] as human beings deal with inanimate adversaries like natural disasters and industrial accidents.

Formal assessments of risk [54] are commonplace these days in aerospace, nuclear, chemical, and other hazardous industries. But like military assessments in war (noted above), formal risk assessments in other industries are also limited by what science can define as *input* to the calculations—which thus far has been only economic utility. As a practical matter, the government implicitly (if not explicitly) assigns dollar values to human lives, e.g., in setting the safety goals and operating criteria by which licensees of hazardous technologies like nuclear power plants are regulated [87].

And actually the government must do this because it is the only way for them to make strategic decisions in cases where the tradeoff is between economics (dollars) and other factors like safety or comfort or beauty. The problem is that there has been little progress in quantifying these other factors [86], which are also utilities, and the upshot is that the tradeoffs of interest cannot be resolved. As a result there is still a large gap between the conclusions of formal (mathematical) risk assessments made by the "experts" and mental (psychological) risk assessments made by the "public" [65].

This gap severely limits the applicability of formal risk assessments, because the public is in fact considering many non-economic utilities in their mental judgments of risk. Until formal risk assessments can quantify these utilities there is little hope of reconciling with mental risk assessments. Again the need is not so much for advanced algorithms to combine probabilities and utilities, but rather the need is to better represent the utilities (and probabilities) needed as input to these algorithms in the first place.

For example, in the case of nuclear power plants we know that "dread" [58] dominates people's expectations (in risk assessments) as well as their experiences

(after accidents). *"The worst disease here is not radiation sickness. The truth is the fear of Chernobyl has done more damage than Chernobyl itself."* [83]. Fear or dread, like terror, greatly affects the way people think about risk [34], and yet these effects are not currently part of the equation in any formal risk assessment. This creates a disconnect between the experts and the public, much like that noted above between the machine and its user in military operations of time-sensitive targeting. The answer to both problems hinges on a better understanding of utility, in the *structure of style*. And because style-based reasoning is how people make sense of complex systems, style spaces might provide a useful framework for understanding and aiding reasoning in risk assessments.

As an example of this, it is interesting to note that a 2-D style space analogous to *poker* and *terror* has also been proposed by Perrow [69] to study *failure*—in "normal accidents" involving high-risk technologies. Perrow's main claim is that risk can be characterized along two dimensions, as illustrated in Fig. 11.9, and that this framework can then be used to make policy decisions. Referring to Fig. 11.9, the x and y axes are remarkably similar to those of the style spaces discussed above, where like poker and terror the two dimensions are related but differ in an important respect—namely how an accident is *initiated* (x-axis) versus how an accident is *escalated* (y-axis).

Perrow even uses the terms "tight" and "loose," except that he uses these terms to refer to the characteristics of the system in escalating an accident sequence, which corresponds to the y-axis (not the x-axis, as in Pared-down Poker). In this framework, Perrow argues that there are different styles (although he does not use this term) of systems that present different hazards. The ones with the most potential for disastrous consequences are, not surprisingly, those that rank high in complexity (x-axis) and high in coupling (y-axis)—to initiate (x) an accident as well as to escalate (y) the sequence of events.

Clearly the mapping is not exactly the same as in poker or terror. But the similarities are striking and this suggests that *style spaces* are mechanisms by which people

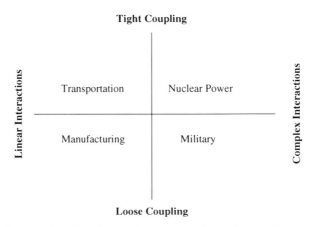

Fig. 11.9 A style space for failures in complex systems, adapted from [69]

intuitively make sense of things, much like the notion of an "idealized cognitive model" [55] in metaphorical reasoning [56]; see Chap. 12 by Goguen and Harrell. Unfortunately Perrow does not propose methods by which the two dimensions can be quantified, although others have attempted to do so [91]. This makes Perrow's [x, y] framework much like Shapiro's, which is also intuitive but wanting of more formalized calculations.

Both of these [x, y] style spaces, for terror networks and system failures, are similar to the style space of Pared-down Poker. The major difference is that in analyzing Pared-down Poker we explicitly identified and quantified various utilities (economic and ergonomic), as well as the interactions between these utilities, so that intuition could be compared to and supported by calculations. Here I would suggest that the same approach might also improve intuitions via calculations in other domains—like managing the war against terror networks and assessing the risk of system failures.

In conclusion: The fundamental contribution of this chapter is to illustrate how a *style space* can be computed as well as intuited, and how the two can be related—to gain insight into when intuition is effective and where it might break down. A practical contribution is to demonstrate how *structure mapping* between style spaces might be used to extend insights from one domain to another domain via analogical reasoning. These sorts of style spaces are how natural intelligence makes sense of complex systems, often effectively, but at the same time they are simplifications that can limit thinking, sometimes dangerously.

A future challenge for artificial intelligence is to leverage human powers [48] while at the same time supporting human limits in AI-human interaction (Chap. 13 by Burns and Maybury). Style spaces might be a good way to do this, as a device to help people comprehend the structure of style calculated from expected utilities and potential interactions. This approach could help close the gap [14] between the camp of "intuition" in Naturalistic Decision Making [92] and the camp of "computation" in Judgment and Decision Making [25]—and thereby improve the design of decision support systems [49].

But a caution: The practical reality of this chapter is to acknowledge that any style space is only as good as the underlying utilities on which it is based. To advance a science of style we must dig deeper into style spaces by characterizing and calculating varieties of utilities: economic, ergonomic, informatic, and aesthetic, especially the latter ones that have thus far been ignored. Together these utilities shape the structure of style, and until they are integrated in formal frameworks—perhaps even implemented in support systems—we will remain somewhat lost in style space.

References

1. Apostolico D (2005) Tournament poker and the art of war. Lyle Stuart, New York, NY
2. Barone L, While L (1999) An adaptive learning model for simplified poker using evolutionary algorithms. In: Proceedings of the congress on evolutionary computation, Washington, DC, July 6–9, pp 153–160

3. Bayes T (1763) An essay towards solving a problem in the doctrine of chances. Philos Trans R Soc Lond 53:370–418
4. Bechara A, Damasio H, Tranel D, Damasio A (1997) Deciding advantageously before knowing the advantageous strategy. Science 275:1293–1295
5. Bechara A, Damasio H (2002) Decision-making and addiction (Part I): impaired activation of somatic states in substance dependent individuals when pondering decisions with negative future consequences. Neuropsychologia 40:1675–1689
6. Bechara A, Dolan S, Hindes A (2002) Decision-making and addiction (Part II): myopia for the future or hypersensitivity to reward. Neuropsychologia 40:1690–1705
7. Bernoulli D (1738) Exposition of a new theory of the measurement of risk (trans: Sommer L (1954)). Econometrica 22:23–26
8. Bernstein P (1996) Against the gods: the remarkable story of risk. Wiley, New York, NY
9. Billings D, Davidson A, Schaeffer J, Szafron D (2002) The challenge of poker. Artif Intell 134:201–240
10. Billings D, Papp D, Schaeffer J, Szafron D (1998) Opponent modeling in poker. In: Proceedings of the conference on artificial intelligence, Madison, WI, July 26–30, pp 493–498
11. Borel É (1938) Traité du calcul des probabilités et ses applications Volume 4, Fascicule 2, Applications aux jeux des hazard. Gautier-Villars, Paris
12. Brandenburger A, Nalebuff B (1996) Co-opetition. Doubleday, New York, NY
13. Burns K (2007) EVE's entropy: a formal gauge of fun in games. Stud Comput Intell 71:153–173
14. Burns K (2007) Dealing with probabilities: on improving inferences with Bayesian boxes. In: Hoffman R (ed) Expertise out of context. Lawrence Erlbaum, New York, NY
15. Burns K (2006) Atoms of EVE': a Bayesian basis for aesthetic analysis of style in sketching. Artif Intell Eng Des Anal Manufac 20:185–199
16. Burns K (2006) Style in poker. In: Proceedings of the IEEE conference on computational intelligence in games, Reno, NV, May 22–24, pp 257–264
17. Burns K (2006) Bayesian inference in disputed authorship: a case study of cognitive errors and a new system for decision support. Info Sci 176:1570–1589
18. Burns K (2005) Pared-down poker: cutting to the core of command and control. Proceedings of the IEEE conference on computational intelligence in games, pp 234–241
19. Burns K (2004) Heads-up face-off: on style and skill in the game of poker. Papers from the AAAI symposium on style and meaning in language, art, music, and design, FS-4-07. AAAI Press, Menlo Park, CA, pp 15–22
20. Burns K, Demaree H (2009) A chance to learn: On matching probabilities to optimize utilities. Info Sci 179:1599–1607
21. Burns K, Bonaceto C (2006) Structure mapping in visual displays for decision support. Paper presented at the 11th international command and control research and technology symposium, San Diego, CA, June 20–22,
22. Burns K, Dubnov S (2006) Memex music and gambling games: EVE's take on lucky number 13. In: Proceedings of the AAAI workshop on computational aesthetics, WS-06-04. AAAI Press, Menlo Park, CA, pp 30–36
23. Camerer C (2003) Behavioral game theory: experiments in strategic interaction. Princeton University Press, Princeton, NJ
24. Cancho R, Solé R (2003) Least effort and the origins of scaling in human language. Proc Natl Acad Sci USA 100(3):788–791
25. Connolly T, Arkes H, Hammond K (eds) (2000) Judgment and decision making: An interdisciplinary reader. Cambridge University Press, Cambridge, UK
26. Csikszentmihalyi M (1991) Flow: the psychology of optimal experience. Harper Collins, New York, NY
27. Davis M (1997) Game theory. Dover, New York, NY
28. Davis P (2001) Effects-based operations: a grand challenge for the analytical community, MR-1477-USJFCOM/AF. RAND Corporation, Santa Monica, CA

29. Edwards W (1954) The theory of decision making. Psychol Bull 41:380–417
30. Edwards W (1961) Behavioral decision theory. Ann Rev Psychol 12:473–498
31. Edwards W, Newman J (1982) Multi-attribute evaluation. Sage, Beverly Hills, CA
32. Ferguson C, Ferguson T (2003) On the Borel and von Neumann poker models. Game Theory Applications 9:17–32
33. Ferguson C, Ferguson T, Gawargy C (2004) Uniform (0,1) two-person poker models. UCLA Department of mathematics. http://www.math.ucla.edu/~tom/papers/poker2.pdf. Accessed 15 Mar 2006
34. Finucane M, Alhakami A, Slovic P, Johnson S (2000) The affect heuristic in judgments of risks and benefits. J Behav Decis Mak 13:1–17
35. Gärdenfors P (2004) Conceptual spaces: the geometry of thought. MIT Press, Cambridge, MA
36. Gattis M (2001) Spatial schemas and abstract thought. MIT Press, Cambridge, MA
37. Gentner D (1983) Structure mapping: a theoretical framework for analogy. Cogn Sci 7: 155–170
38. Gentner D, Markman A (1997) Structure mapping in analogy and similarity. Am Psychol 52(1):45–56
39. Gigerenzer G, Todd P (1999) Simple heuristics that make us smart. Oxford University Press, New York, NY
40. Hamilton S, Garber L (1997) Deep Blue's hardware-software synergy. IEEE Comput 30(1):29–35
41. Harford T (2006) The poker machine. Financ Times Mag 6 May 2006:16–21
42. Hellmuth P (2003) Play poker like the pros. Harper Collins, New York, NY
43. Herrnstein R (1997) The matching law: papers in psychology and economics. In: Rachlin H, Laibson D (eds) Harvard University Press, Cambridge, MA
44. Kahneman D, Tversky A (1979) Prospect theory: an analysis of decision under risk. Econometrica 47(2):263–291
45. Kahneman D, Slovic P, Tversky A (eds) (1982) Judgment under uncertainty: heuristics and biases. Cambridge University Press, Cambridge
46. Kendall G, Willdig M (2001) An investigation of an adaptive poker player. In: Proceedings of the Australian joint conference on artificial intelligence, LNAI-2256, Adelaide, SA, Australia, Dec 10–14, pp 189–200
47. Keys R (2007) Address to the air force association. Air warfare symposium, Lake Buena Vista, FL, 8 Feb 2007
48. Klein, G. (1998) Sources of power: how people make decisions. MIT Press, Cambridge, MA
49. Kleinmuntz B (1990) Why we still use our heads instead of formulas: toward an integrative approach. Psychol Bull 107:296–310
50. Knill D, Richards W (eds) (1996) Perception as Bayesian inference. Cambridge University Press, Cambridge
51. Koller D, Pfeffer A (1997) Representations and solutions for game-theoretic problems. Artif Intell 94(1):167–215
52. Korb K, Nicholson A, Jitnah N (1999) Bayesian poker. In: Proceedings of the conference on uncertainty in artificial intelligence, Stockholm, Sweden, July 30–August 1, pp 343–350
53. Kuhn H (1950) A simplified two-person poker. In: Kuhn H, Tucker A (eds) Contributions to the theory of games, Vol. 1. Princeton University Press, Princeton, NJ, (pp 97–103)
54. Kumamoto H, Henley E (1996) Probabilistic risk assessment and management for engineers and scientists. IEEE Press, New York, NY
55. Lakoff G (1987) Women, fire, and dangerous things: what categories reveal about the mind. University of Chicago Press, Chicago, IL
56. Lakoff G, Johnson M (1980) Metaphors we live by. University of Chicago Press, Chicago, IL
57. Leedom D (2004) The analytic representation of sensemaking and knowledge management within a military C2 organization, AFRL-HE-WP-TR-2004-0083. United States Air Force Research Laboratory, WPAFB, OH
58. Loewenstein G, Weber E, Hsee C, Welch N (2001) Risk as feelings. Psychol Bull 127(2): 267–286

59. Mandeles M, Hone T, Terry S (1996) Managing command and control in the Persian Gulf war. Praeger, Westport, CT
60. McDonald J (1950) Strategy in poker, business, and war. Norton, New York, NY
61. McKenna J (2006) Beyond bluffs: master the mysteries of poker. Kensington, New York, NY
62. McKenna J (2005) Beyond tells: power poker psychology. Kensington, New York, NY
63. McManus J (2003) Positively fifth street: murderers, cheetahs, and Binion's world series of poker. Farrar, Straus, & Giroux, New York, NY
64. Montague R (2006) Why choose this book? How we make decisions. Dutton, New York, NY
65. Morgan M, Fischhoff B, Bostrom A, Atman C (2002) Risk communication: a mental models approach. Cambridge University Press, Cambridge, UK
66. Nash J (1950) Equilibrium points in N-person games. Proc Natl Acad Sci 36(1):48–49
67. Payne J, Bettman J, Johnson E (1993) The adaptive decision maker. Cambridge University Press, Cambridge, UK
68. Pearl J (2000) Causality: models, reasoning, and inference. Cambridge University Press, Cambridge, UK
69. Perrow C (1984) Normal accidents: living with high-risk technologies. Basic Books, New York, NY
70. Pirolli P (2007) Information foraging theory: adaptive interaction with information. Oxford University Press, New York, NY
71. Post T, Van den Assem M, Baltussen G, Thaler R (2008) Deal or no deal? Decision making under risk in a large-payoff game show. Am Econ Rev, 98(1):38–71
72. Postrel V (2003) The substance of style. Harper Collins, New York, NY
73. Richards W (ed) (1988) Natural computation. MIT Press, Cambridge, MA
74. Samuelson P (2004) Heads, I win, and tails, you lose. In: von Neumann J, Morgenstern O (1944) Theory of games and economic behavior, sixtieth-anniversary edition. Princeton University Press, Princeton, NJ, pp 675–676
75. Schaeffer J (1996) One jump ahead: challenging human supremacy in checkers. Springer, New York, NY
76. Schoonmaker A (2000) The psychology of poker. Two Plus Two Publishing, Las Vegas, NV
77. Shannon C, Weaver W (1949) The mathematical theory of communication. University of Illinois Press, Urbana, IL
78. Shapiro J (2005) Organizing terror: hierarchy and networks in covert organizations. Paper presented at the annual meeting of the American political science association, Washington, DC, 1 Sep 2005
79. Shi J, Littman M (2000) Abstraction methods for game-theoretic poker. In: Proceedings of the 2nd international conference on computers and games, Hamamatsu, Japan, October 26–28, pp 333–345
80. Sklansky D (1987) The theory of poker. Two Plus Two Publishing, Las Vegas, NV
81. Smith E (2006) Complexity, networking, and effects-based approaches to operations. CCRP Publication Series, DoD Command and Control Research Program, Washington, DC
82. Southey F, Bowling M, Larson B, Piccione C, Burch N, Billings D, Rayner C (2005) Bayes bluff: opponent modeling in poker. In: Proceedings of the conference on uncertainty in artificial intelligence, Edinburgh, Scotland, July 26–29, pp 550–558
83. Specter M (1996) 10 years later, through fear, Chernobyl still kills in Belarus. New York Times, p 1
84. Sun-tzu (2002) The art of war (trans: Minford J). Viking Penguin, New York, NY
85. Tenenbaum J, Griffiths T, Kemp C (2006) Theory-based Bayesian models of inductive learning and reasoning. Trends Cogn Sci 10(7):309–318
86. Tetlock P (2003) Thinking the unthinkable: sacred values and taboo cognitions. Trends Cogn Sci 7(7):320–324
87. True D, Leaver D, Fenstermacher E, Gaertner J (2003) Risk characterization of the potential consequences of an armed terrorist ground attack on a U.S. nuclear power plant. EPRI Report for the Nuclear Energy Institute

88. Tversky A, Kahneman D (1992) Advances in prospect theory: cumulative representation of uncertainty. J Risk Uncertainty 5:297–323
89. von Neumann J, Morgenstern O (1944) Theory of games and economic behavior. Princeton University Press, Princeton, NJ
90. Weick K (1995) Sensemaking in organizations. Sage, Beverly Hills, CA
91. Wolf F, Berniker E (1999) Validating normal accident theory: chemical accidents, fires, and explosions in petroleum refineries. Paper presented at the high consequences system surety conference, Sandia National Laboratory, Albuquerque, NM, 11–14, Nov 1999
92. Zsambok C, Klein G (1997) Naturalistic decision making. Lawrence Erlbaum Associates, Mahwah, NJ

Chapter 12
Style: A Computational and Conceptual Blending-Based Approach

Joseph A. Goguen and D. Fox Harrell

Abstract This chapter proposes a new approach to style, arising from our work on computational media using *structural blending*, which enriches the conceptual blending of cognitive linguistics with structure building operations in order to encompass syntax and narrative as well as metaphor. We have implemented both conceptual and structural blending, and conducted initial experiments with poetry, including interactive multimedia poetry, although the approach generalizes to other media. The central idea is to generate multimedia content and analyze style in terms of blending principles, based on our finding that different principles from those of common sense blending are often needed for some contemporary poetic metaphors.

12.1 Introduction: Motivations and Goals

James Meehan's 1976 TALE-SPIN [32] was perhaps the first computer story generation system. It explored the creative potential of viewing narrative generation as a planning problem, in which agents select appropriate actions, solve problems in the simulated world, and output logs of their actions using syntactic templates. Here is a sample:

> Henry Squirrel was thirsty. He walked over to the river bank where his good friend Bill Bird was sitting. Henry slipped and fell in the river. Gravity drowned.

The logic behind this non-sequitur is impeccable: Gravity is pulling Henry into the river, and it has no friends, arms, or legs that can save it from the river; therefore Gravity drowns. But *we* know Gravity is not something that can drown; there is a startling type check error here. Subsequent systems were better, but still mainly followed "Good Old Fashioned AI" (GOFAI), which assumes human cognition is

D.F. Harrell (✉)
Digital Media Program, School of Literature, Communication and Culture,
Georgia Institute of Technology, Atlanta, GA, USA
e-mail: fox.harrell@lcc.gatech.edu

J.A. Goguen: Deceased

S. Argamon et al. (eds.), *The Structure of Style*,
DOI 10.1007/978-3-642-12337-5_12, © Springer-Verlag Berlin Heidelberg 2010

computation over logic-based data structures, and which largely ignores (or even denies) the embodied and socially situated nature of being human. Such systems lack elegance and style. But how can we do better? And what is style anyway?

The word "style" has many different meanings in different contexts. This ambiguity cannot be dispelled by the use of computational technology alone. Statistical methods and/or formal descriptions of features must be augmented by knowledge of human context and experience to capture a more "true" notion of style than subjective human opinion. Still, we believe that computational techniques can make important contributions to the understanding, analysis, and generation of style.

It is not generally intuitive to both embrace technology and some of its methods at the same time as stressing human values and the limitations (even technical limitations) of the underlying values behind much of current computing. This is our stance however. We propose to analyze and generate works in particular styles by choosing appropriate principles for blending computational structures representing concepts, and more broadly by considering the human conceptual blends that might correspond to the computational structures. On its own this approach is open to some of the same criticisms as other formal top down technical approaches (as in GOFAI). But our claims and theoretical underpinnings are quite different; the formalisms used are not taken to exist explicitly in human cognition and we recognize meaning as embodied, situated, and contextual. Our methods are different as well, for formalization is used as a tool only within the context of human subjectivity, experience, and social interaction.

12.1.1 Style in Interactive and Generative Narrative and Poetry

Our creative experiments have primarily been concerned with new genres of interactive and generative narrative and poetry. Fox Harrell's GRIOT system provides a framework for implementing expressive computational works in which media elements are composed on-the-fly based upon formal semantic representations and user input [23]. Initial works were text-based, however, the GRIOT framework is meant to generalize for multimedia content. The work "The Griot Sings Haibun" uses a graphical user interaface (GUI) interface and the "Generative Visual Renku Project" by Fox Harrell and Kenny Chow uses GRIOT to generate poetic landscapes of iconic images populated by transforming calligraphic human characters [25]. The formal semantic representation framework allows an author to describe the high level structure of the work, e.g. narrative or poetic structure, and more fine grained conceptual content to provide a knowledge base containing information about the narrative or poetic world. User input is used to select particular domains of conceptual content from which new content is composed. For example, a mouse click can select an image that another image should match conceptually as well as visually, or a keyword can select themes from which new descriptive phases are generated to be integrated into a prewritten textual template. The input mechanisms invoked thus

far are relatively simple such that an author can construct a robust GUI or game-like interface atop GRIOT via which the system presents a dynamically structured narrative new events, characters, metaphors, or other creative elements based upon user actions.

These open-ended goals regarding semantically-based content interaction and generation led naturally to questions of style. Primarily, the question arose of how formal methods can yield richly expressive works that adequately represents an author's goals in light of the variability and generativity that GRIOT allows. We sought to allow authors to maintain coherence at multiple grain sizes, e.g. appropriate metaphors, narrative transitions, conceptual themes, while allowing the system to algorithmically manipulate content in light of user interaction. An algorithm for conceptual blending is a central generative component. The conceptual blending algorithm, called Alloy, integrates conceptual spaces using mappings between and their shared structure to direct the process to produce "optimal" blended spaces and mappings to them. This optimal blending can lead to structural and conceptual coherence in the generated content. The optimality principles we implemented can be tuned in order to achieve different aesthetic effects depending on an author's goals. Our approach is amenable to a wide range of perspectives on style, for example, Kevin Burns's decision theoretic approach to style (detailed in Chap. 12 of this book) describes various utilities that an artist or game player may give importance to given a goal at hand. Our research provides a formal approach for an author to implement such aesthetic utilities and maintain them coherently. This search for structural and conceptual coherence, in light of structural and conceptual interactivity and generativity, led us to the formulation of style as a choice of blending principles in this chapter. Though we do not seek to highlight the autonomy of systems created with GRIOT, as in Harold Cohen's notorious autonomous painting system *AARON* [4] or George Lewis's *Voyager* [30], our goals overlap with such works that involve tuning algorithmic function to produce a body of works with certain variable attributes and certain invariant notions of "style." We hope that this chapter provide a useful theoretical lens for analyzing such phenomena across computational media works with similar goals.

12.1.2 Technical Style Versus Human Style

For clarity it is important to express specifically what we have been able to accomplish technically with our approach so far. At the core of our work is the generation and analysis of content using partial composition of sign systems (represented using algebraic semiotics). Secondarily, we combine templates (pre-structured content) according to formalized narrative structures. The strength of our approach is that conceptual blending (the generation component) and structural blending (the media composition component) can be accounted for by the same theoretical underpinnings (algebraic semiotics) and that the work is in sympathy with, and inspired by, recent insights from cognitive science in metaphor theory, embodied cognition, con-

ceptual blending theory, and situated cognition. Finally, the approach is useful for both analyzing media (e.g. user-interfaces) and generating media (e.g. in multimedia artwork or computer games).

Some specific technical contributions of this work (all to be discussed later in the chapter) are:

1. Data structures for sign systems and semiotic morphisms (mapping between sign systems);
2. An algorithm for conceptual blending that is efficient and exhaustive;
3. Four structural optimality principles for conceptual blending;
4. Media morphisms to map conceptual data structures to output in a particular medium (e.g. text or graphical images);
5. Data structures for templates (artist created content resources) that include variables that can be replaced by generated content;
6. An automaton useful for implementing recursive structuralist narrative models (it arranges templates into a particular discourse structure);
7. An interpreter that reads user input and outputs generated content;
8. A scripting format that allows an author to create "improvisational" media.

But can these technical contributions tell us much about style? Have we accounted for style in a structural way that avoids the pitfalls of top-down artificial intelligence, structuralist cultural theory, and cognitivist psychology? We believe so. Though we are inspired technically by some of the approaches above, our approach includes being very forthright about the limitations of computational techniques and to introduce human judgment, subjectivity, and social context at appropriate points in the design, development, and output processes. Thus, for us:

• Style is understood in the interpretation of sign systems via dialogic interaction with media.
• Style is determined by the particular executions of human concepts in media.
• Style is created by developing sign systems and artifacts for both of the above.
• Style exists in the context of interpreting sign systems.
• Style exists in the context of use of artifacts.
• Style is inherent in any knowledge encoded in a sign system by a human.

Implementations based on theories of conceptual blending and semiotic representation are useful for expressing and analyzing style, but are not sufficient. Technically, we systematically examine how humans compose sign systems with particular attention to regularities such as hierarchies, preservation between mappings, information lost or gained, changes of classification of symbols (type casting), and other similar structural features. Computational methods are very good for these purposes. At the same time we pay close heed to the way that humans encode knowledge that is not amenable to computational analysis or manipulation, and we explicitly require human input and judgment in design processes. Our approach is a combination of formal methods, awareness of their limitations, and strategies to partially surmount those limitations.

12.1.3 Overview

As mentioned above, most story generation systems are based on approaches in GOFAI, which focus on logic and planning. They are in line with a tradition inspired by the Russian formalism of Vladimir Propp [34], implementing a discourse level syntax with a fixed set of textual templates plus rules for combining and instantiating those templates, although there are certainly differences in the theoretical foundations they propose for templates and rules, in the generalizability and soundness of those foundations, and in the success of the experiences they generate. In contrast, cognitive linguistics does not focus on syntax, but on mental spaces, prototypes, blending, metaphor, etc.

The subsections below show how such a cognitive view of language can be implemented and applied to various kinds of text; in particular, we report some initial experiments on poetry. We focus on text-based works as they are the most developed applications created using GRIOT and thus they allow us to highlight the issues of style raised most clearly as opposed to challenges raised by working in multiple modalities.

This chapter is especially concerned with how concepts are combined (blended), the principles underlying the different ways that concepts can be blended, and how a computational account of blending can be used to implement and analyze various styles in interactive media. But we believe computer implementations such as the GRIOT system can also contribute to cognitive science as simulations of precise mathematical theories. Section 12.2 reviews some basic linguistic research used in our approach. Section 12.3 reviews our prior work on semiotic spaces, semiotic morphisms, and structural blending; a rather detailed example is also given. Section 12.4.2 discusses our work on interactive poetry generation, and Sects. 12.4 and 12.4.1 discuss the blending algorithm at its core. Section 12.4.3 considers some interesting blends that appear in recent poetry, and finds that very different principles from those proposed in [7] for conventional, common sense blends are needed. This motivates our analysis in Sect. 12.4.4 of style in terms of the blending principles used to generate works in various media.

12.2 Linguistic Foundations

This section reviews some linguistics research that serves as a foundation for our work on style, including certain topics from cognitive linguistics, sociolinguistics, and narratology. This research is aimed at understanding human cognition, rather than at computer simulation and mathematical precision, as is our own research.

12.2.1 Metaphor and Blending

Gilles Fauconnier and Mark Turner have developed a theory within cognitive linguistics known as *conceptual blending* or *conceptual integration* [7]. Here *con-*

ceptual spaces are relatively small, transient collections of concepts, selected from larger domains for some purpose at hand, such as understanding a particular sentence; this basic notion builds upon Fauconnier's earlier notion of mental spaces, which are formally sets of "elements" and relation instances among them [6], as in Fig. 12.3. George Lakoff, Mark Johnson, and others [27, 28] have studied metaphor as a mapping from one conceptual space to another, and shown that metaphors come in families, called *image schemas*, having a common theme. One such family is MORE IS UP, as in "His salary is higher than mine," or "That stock rose quite suddenly." The source UP is grounded in our experience of gravity, and the schema itself is grounded in everyday experiences, such as that having more beer in a glass, or more peanuts in a pile, means the level goes up. Many image schemas, including this one, are grounded in the human body, and are called *basic image schemas*; these generally yield the most persuasive, and perhaps even universal, metaphors, and are also useful in other areas, such as user interface design [11–13].

Blending two conceptual spaces yields a new space that combines parts of the given spaces, and may also have emergent structure [7]. Simple examples in natural language are words like "houseboat" and "roadkill," and phrases like "artificial life" and "computer virus." Blending is considered a basic human cognitive operation, invisible and effortless, but pervasive and fundamental, for example in grammar and reasoning [7]. It also gives a new way to understand metaphor. For example, in "the sun is a king," blending the conceptual spaces for "sun" and "king" gives a new *blend space* together with *conceptual mappings* to it from the "king" and "sun" spaces. Although there is no direct mapping between the two original spaces, there are *cross space* identifications, certainly including the identification of the "sun" and "king" elements, so that they are the same element in the blend space. *Metaphoric blends* are *asymmetric*, in that the *target* of the metaphor is understood using only the most salient concepts from the other *source* space [21]. For example, aspects of "king" may be *blocked* from mapping to the blend space – usually the sun does not wear a crown or charge taxes. Additional information needed to construct a coherent blend may be recruited from other spaces, as well as from *frames*, which encode highly conventionalized information. *Conceptual integration networks* are networks of conceptual spaces and conceptual mappings, used in blending the component spaces for situations that are more complex than a single metaphor. These are of course the norm in literary texts, and in a great deal of everyday conversation, as well as humor.

12.2.2 The Cognitive Optimality Principles

Below are five of the 29 optimality principles from the list in Chap. 15 of [7] and discussed in [21]; these cognitive optimality principles are used to determine which among many possible conceptual blends is most appropriate for a given situation. We refer to them here as *cognitive* optimality principles to distinguish them from the *structural*, or *computational*, optimality principles that we have implemented in the Alloy conceptual blending algorithm:

1. *Integration:* The scenario in the blend space should be a well-integrated scene.
2. *Web:* Tight connections between the blend and the inputs should be maintained, so that an event in one of the input spaces, for instance, is construed as implying a corresponding event in the blend.
3. *Unpacking:* It should be easy to reconstruct the inputs and the network of connections, given the blend.
4. *Topology:* Elements in the blend should participate in the same kinds of relation as their counterparts in the inputs.
5. *Good Reason:* If an element appears in the blend, it should have meaning.

These principles apply to common sense blends, such as are typically found in ordinary language, in advertisements, etc.; an important inspiration was use in literary criticism, as in [36]. But Sect. 12.4.3 will show that they do not apply to generating some less conventional language, such as certain metaphors in Pablo Neruda poems. All five of these cognitive optimality principles require human judgement, and so cannot be implemented in any obvious way. However, when the relations involved are identities, the Topology Principle does not involve meaning, and so can be implemented; indeed, it is one of the structural optimality principles used by Alloy blending algorithm described in Sect. 12.4. Likewise, the Unpacking Principle holds for the most optimal blended spaces generated by our algorithm.

12.2.3 Narrative

In many games and art works, narrative provides a deeper and more satisfying sense of involvement. Temporal and causal succession are essential for narrative, but values also play a key role, by connecting events in the story to the social worlds and personal experiences of users. These two aspects of narrative provide the sense that a work is "going somewhere" and "means something," respectively. Sociolinguists, e.g. [26, 31], have done extensive empirical study of narratives of personal experience, which are told orally to a group of peers under natural conditions. The following briefly summarizes this research:

1. There is an optional *orientation section*, giving information about the setting (time, place, characters, etc.) for what will follow.
2. The main body is a sequence of *narrative clauses* describing the events of the story; by a default convention called the *narrative presupposition*, these are taken to occur in the same order that they appear in the story.
3. Narrative clauses are interwoven with *evaluative material* relating narrative events to values.
4. An optional *closing section* summarizes the story, or perhaps gives a moral.

The interpretation of narrative also employs the *causal presupposition*, which says that, other things being equal, given clauses in the order A, B we may assume that A causes B. (For example, "You touch that, and you die.") An additional principle is *accountability*, that the person telling such a story must establish to the audience the

relevance of the actions reported. This is accomplished by the evaluative material, which relates narrative events to social values shared by the narrator and audience; it provides a warrant for inferring the values involved.

The above assertions are thoroughly grounded in empirical research on contemporary American small groups, but appear to apply more broadly to contemporary Western languages.[1] Although developed for oral narratives of personal experience, the theory also yields insight into many other media and genres, such as novels and human computer dialogues, because their structure has a basis in oral narratives of personal experience.

It may be surprising that values are an integral part of the internal structure of stories, rather than being confined to a "moral" at the end; in fact, values pervade narrative, as justifications for the narrator's choice of what to tell, or a character's choice of what to do, as well as via modifiers such as "very" or "slightly." The default narrative presupposition can be overridden by explicit markers of other temporal relations, such as flashbacks and flashforwards, so that even narratives that involve multiple times, multiple places, or multiple narrators, are still composed of subsequences that conform to the above structure.

The purely structural aspects of this theory can be formalized as a grammar, the instances of which correspond to the legal structures for narratives. The following uses so-called EBNF (for extended Backus Naur Form):

```
<Narr> ::= <Open> (<Cls> <Eval>*)⁺ [<Coda>]
<Open> ::= ((<Abs> + <Ornt>) <Eval>*)*
```

where [...] indicates zero or one instance of whatever is enclosed, * indicates zero or more instances, infix + indicates exclusive or, superscript + indicates one or more instances, and juxtaposition of subexpressions indicates concatenation. Here <Narr> is for narratives, <Cls> for narrative clauses, which potentially include evaluation, <Eval> for stand-alone evaluative clauses, <Open> for the opening section, which may include an orientation and/or abstract, and <Coda> for the closing section.

Of course, EBNF is far from adequate for describing many other aspects of narrative, e.g., coherence of plot, development of character, and dialogue. The above grammar also fails to address the variety of ways in which evaluation can occur. Some alternatives to explicit evaluative clauses include repetition of words or phrases (which serves to emphasize them), noticeably unusual lexical choices (which may serve to emphasize, de-emphasize, or otherwise spin something), and noticeably unusual syntactic choices (which also may serve to emphasize or de-emphasize).

[1] However, they do not necessarily apply to non-Western langauges and cultures; for example, Balinese narrative does not follow the narrative presupposition [3].

12.3 Algebraic Semiotics

Before briefly discussing algebraic semiotics, it may be helpful to be clear about its philosophical orientation. The reason for taking special case with this is that, in Western culture, mathematical formalisms are often given a status beyond what they deserve. For example, Euclid wrote, "The laws of nature are but the mathematical thoughts of God." Similarly, "situations" in the situation semantics of Barwise and Perry, which are similar to conceptual spaces (but more sophisticated – perhaps *too* sophisticated) are considered to be actually existing, ideal Platonic entities [2]. Somewhat less grandly, one might consider that conceptual spaces are directly instantiated in the human brain. Our point of view is different: we believe that all such formalisms are constructed by human researchers in the course of particular investigations, having the heuristic purpose of facilitating consideration of certain issues in that investigation. Under this view, all theories are situated social entities, mathematical theories no less than others. Of course, this does not preclude their being accurate representations of reality.

12.3.1 Semiotic Spaces

Whereas conceptual spaces are good for concepts, they are inadequate for structure, e.g., how a particular meter combines with a certain rhyme scheme in a fixed poetic form; music raises similar issues, which again require an ability to handle structure [14]. Thus, to use blending as a basis for stylistic analysis, we must generalize conceptual spaces to include structure. Algebraic semiotics captures some major insights of the founders of semiotics, Charles Saunders Peirce [33] and Ferdinand Saussure [5]. Peirce emphasized (among other things) that the relation between a given token and its object is not just a function (as in denotational semantics), but a relation that depends on the situation in which the token is interpreted, while Saussure emphasized (among other things) that signs come in systems. Semiotic systems capture Saussure's insight, while the blending of semiotic systems captures (and extends) Peirce's insight.

Algebraic semiotics uses algebraic semantics [19] to describe the structure of complex signs, including multimedia signs (e.g., a music video with subtitles), and to study the blending of such structures. Its basic notion is a (loose algebraic) *theory*, which consists of type and operation declarations, possibly with subtype declarations and axioms; it is usual to use the word *sort* instead of "type" in this area. A (loose algebraic) *semiotic system* (also called a *semiotic space* or *sign system*) [11] is a (loose algebraic) theory, plus a *level ordering* on sorts (having a maximum element called the *top sort*) and a *priority ordering* on the constituents at each level. Sorts classify the parts of signs and the values of attributes of signs (e.g., color and size). *Signs* of a certain sort are represented by terms of that sort, including but not limited to constants. Among the operations are *constructors*, which build new signs from given sign parts as inputs. Levels express the whole-part hierarchy

of complex signs, while priorities express the relative importance of constructors and their arguments; social issues play a key role in determining these orderings. Conceptual spaces are the special case with only constants and relations, only one sort, and only axioms asserting that certain relations hold on certain instances. Many details omitted here are given in [11–13].

The grammar for narratives in Sect. 12.2.3 can be described as a semiotic system. Its top level sort is of course <Narr>; the second level sorts are <Cls>, <Eval>, <Open>, and <Coda>, while <Ornt> and <Abs> are third level sorts. It should not be thought that this semiotic system will be blended with conceptual spaces to give a story; this would not be appropriate because narrative structure is at a different level of abstraction from that of narrative content. However, it would be appropriate to blend a narrative structure space with another space that described some other structure, such as the scene/shot/etc. structure of cinema.

Some other examples of semiotic systems are: dates; times; bibliographies (in one or more fixed format); tables of contents (e.g., for books, again in fixed formats); newspapers (e.g., the *New York Times* Arts Section); and a fixed website, such as the CNN homepage (in some particular instance of its gradually evolving format). Note that each of these has a large space of possible instances (i.e., models), but all these instances have the same structure.

Semiotic systems, like the algebraic theories that they build upon, are *formal* in the precise sense that changing the names used in them does not change their space of models, but only the way that parts of the models are named. Thus, these formal descriptions do not even attempt to capture meaning in any real human sense; however, we do try to choose names that can help the reader's intuition.

Semiotic spaces, like conceptual spaces, are static. Though they describe blends as being dynamic and in some examples carefully describe temporal sequences of blending, Fauconnier and Turner do not attempt to capture the behavior of dynamic entities, with changeable state, in their theory. However (given the necessary mathematics), it is not so difficult to extend semiotic spaces to include dynamic structures; in fact, such an extension is needed for applications to user interface design, and is carried out in detail, with examples, in [13], using so called hidden algebra [20]. Also the conceptual blending theory of Fauconnier and Turner does not assign types to elements of conceptual spaces; this makes sense, due to the very flexible way that blends treat types, but it also represents a significant loss of information, which in fact can be exploited in some interesting ways, such as being able to characterize some metaphors as "personifications" (see the discussion in Sect. 12.3.3 below) and being able to generate more striking and unusual blends by identifying sorts known to be far apart (see the discussion in Sect. 12.4.3 below). Another difference from classical conceptual blending is that we do not first construct a minimal image in the blend space, and then "project" it back to the target space, but instead, we build the entire result in the blend space. Using theories for semiotic systems is better for our purposes than concrete model-based approaches (i.e. an approach based in syntax rather an approach such as in [9]) because it is much more natural to treat levels and priorities in the context of theories, and because defining spaces of models with theories makes it convenient to use axioms to possible the allowable models.

12.3.2 Semiotic Morphisms and Structural Blending

Mappings between semiotic systems are uniform representations for signs in a source space by signs in a target space, and are called *semiotic morphisms*; user interface design is an important application area for such mappings [11–13]. Because sign systems are formalized as algebraic theories with additional structure, semiotic morphisms are formalized as theory morphisms that also preserve this additional structure. A theory morphism consists of mappings from one theory to another that preserves the basic constituents, which are sort declarations, operation declarations, and axioms; semiotic morphisms in addition preserve levels and priorities. However, these mappings may be *partial*, because some sorts, constructors, etc. are not preserved in the intended applications. For example, the semiotic morphism from the conceptual space for "king" into the blend space for the metaphor "The sun is a king" discussed above does not preserve the throne, court jester, queen, and castle (unless some additional text forces it to do so).

Semiotic morphisms are used in structural blending to establish connections between semiotic spaces that indicate which elements should be identified. The simplest form[2] of blend is shown in Fig. 12.1, where I_1 and I_2 are called *input spaces*, and G is called a *base space*.[3] We call I_1, I_2, G together with the morphisms $I_1 \rightarrow G$ and $I_2 \rightarrow G$ an *input diagram*. Given an input diagram, we use the term *blendoid* for a space B together with morphisms $I_1 \rightarrow B$, $I_2 \rightarrow B$, and $G \rightarrow B$, called *injections*, such that the diagram of Figure 12.1 *commutes*, in the sense that both compositions $G \rightarrow I_1 \rightarrow B$ and $G \rightarrow I_2 \rightarrow B$ are "weakly equal" to the morphism $G \rightarrow B$, in the sense that each element in G gets mapped to the same element in B under them, provided that both morphisms are defined on it. In general, all four spaces may be semiotic spaces; the special

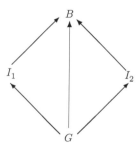

Fig. 12.1 Blend diagram

[2] This diagram is "upside down" from that of Fauconnier and Turner, in that our arrows go up, with the generic G on the bottom, and the blend B on top; this is consistent with the basic image schema MORE IS UP, as well as with conventions for such diagrams in mathematics. Also, Fauconnier and Turner do not include the morphism $G \rightarrow B$, and G plays a different role.

[3] The term "generic space" is used in cognitive linguistics [7], but the term "base space" better describes the role of this space in our approach to interface and active multimedia design.

case where they are all conceptual spaces gives conceptual blends. Since there are often very many blendoids, some way is needed to distinguish those that are desirable. This is what optimality principles are for, and a *blend* is then defined to be a blendoid that satisfies some given optimality principles to a significant degree. The blending algorithm of Sect. 12.4 uses a set optimality principles based only on the structure of blends (hence referred to as *structural* optimality principles), rather than their meaning; these include degrees of commutativity, type casting, and preservation of constants and axioms.

12.3.3 The House/Boat Example

We illustrate blending with the concepts "house" and "boat" shown in Fig. 12.2. Each circle encloses a conceptual space, represented as a graph, the nodes of which represent entities, and the edges of which represent assertions that a certain relation, the name of which labels the edge, holds between the entities on its nodes. As in Fig. 12.1, the bottom space is the generic or base space, the top is the blend space, and the other two are the input spaces, in this case for "house" and "boat." The arrows between circles indicate semiotic morphisms. In this simple example, all four spaces have graphs with the same "V" shape, and the five morphisms simply preserve that shape, i.e., each maps the bottom node of the "vee" in its source space to the bottom node in its target. To avoid clutter, types are not shown, but in this case, it happens that the types correspond to the entity names in the generic space.

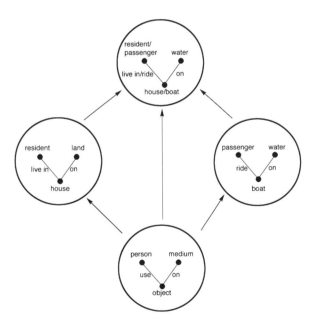

Fig. 12.2 Houseboat blend diagram (semiotic spaces and semiotic morphisms between them)

For this blend, the two triangles commute for all three sorts in the base space; similarly, the two base constants `object` and `person` are preserved. Thus we have commutativity for this blend, so that corresponding elements of the input spaces are identified in the blend; e.g., `house` and `boat` are identified in "houseboat", and the merged element is named `house/boat`. Similarly, the two relations in the base space map to the same relation in the blend via the three paths, so that the relations `live-in` and `ride` are identified. Finally, for each pair of elements in the base space for which a relation holds, the corresponding elements in the blend space satisfy the corresponding relation, which means that all three paths preserve the axiom in the same way.

Figure 12.3 shows a second blend of the same two concepts, which in English is called a "boathouse".[4] In it, the boat ends up in the house. Notice that mapping `resident` to `boat` does not type check unless `boat` is "cast" to be of type `person`; otherwise, the boat could not live in the boathouse. This is the kind of metaphor called *personification* in literary theory, in which an object is considered a person. For this blend, neither triangle commutes, because the base element `object` is mapped to `boat` in the blend by the right morphism, and to `house` by the left morphism, but is not mapped to `boat/house` in the blend. Similarly, the central morphism cannot preserve the base element `person`, and the same goes for the base `use` operation. On the other hand, the base relation `on` goes to the same place under all three maps. A third blend is similar to (in fact, symmetrical with) the above "boathouse" blend; in it, a `house/passenger` ends up riding in the boat. (There are real examples of this, e.g., where a boat is used to transport prefabricated houses across a bay for a housing development on a nearby island.)

A fourth blend is less familiar than the first three, but has very good preservation and commutativity properties, and hence is very pure, even though its physical existence is doubtful. This is an amphibious RV (recreational vehicle) that you can live in, and can ride on land and water. A fifth blend has an even less familiar meaning:

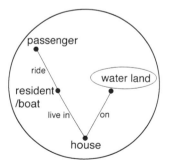

Fig. 12.3 Boathouse Blend Space (in which "boat" is "type cast" to sort "Person" and identified with "resident.")

[4] Since 'water' and 'land' are data elements they are handled specially (both are preserved in the blended space and they are not identified – see [11] for details about the handling of datasorts).

a livable boat for transporting livable boats; perhaps only an algorithm could have discovered this counter-intuitive blend. Finally, a sixth blend gives a boat used on land for a house; it omits axioms that a house/boat be on water and a passenger ride a house/boat. There are 48 blends where all preservation properties hold, and also 736 less perspicuous blendoids.

We can see in this example that the extent to which a blend preserves the structure of an input space corresponds very well with our intuitive sense of how closely the blend resembles that input space. *Quantative* preservation measures include the number of triangles that commute for the elements of a space, the number for its relations, and the number of type casts required, but *qualitative* measures which are partial orders based on these factors seems even closer to our intuitions [11, 13, 17]. This is a very encoraging result with regard to our plan to use these purely formal optimality criteria in our blending algorithm, though we do not expect it to work as well a it did here in all possible situations.

It may be an interesting exercise for readers to consider blends of "ice" and "house"; this is similar to the "house" and "boat" example, but a bit simpler.

12.4 Blending and the GRIOT System

Our blending algorithm ALLOY is programmed in LISP, and given an input diagram, it can compute one good blend, or else compute all blendoids over the diagram. It does a depth first traversal over two binary trees, which describe possible ways to identify relations and to identify constants. Different elements from the same input space are never identified. Data sorts and data constants are never identified. Non-data sorts are identified only if required by being mapped to from a common sort in the base space. Elements of the input spaces that are not mapped to from the base space are included in the blend space. When constants of different sorts are identified, both choices for the sort of the blended constant are considered acceptable. [16] gives more detail on the implementation.

Even for simple inputs, the number of blendoids is so large that it is difficult for humans to find them all. Since for the houseboat example, the algorithm computes 48 blends where every axiom is preserved, and 736 that fail to preserve some axioms, it follows that efficient techniques for computing high quality blends are necessary for the algorithm to be useful for content generation and analysis. There are three distinct ways that one can go about this; all are needed. The first is just to optimize a given procedure, e.g., by using more efficient data representations. The second is to improve the procedure to reduce the search space, so that low quality blendoids are neither generated nor examined (as opposed to finding and then ranking all blendoids). The third is to use more discriminating measures of quality, which we hereafter also call *optimality principles*.

The optimality principles of [7] are powerful, but not computationally effective. Our blending algorithm currently uses degree of commutativity, degree of constant preservation, degree of axiom preservation, and amount of type casting for con-

stants, as *structural* optimality principles. A *type cast* means that a constant in the blendoid has been given an unnatural type; without type casting, blended items must have compatible types (i.e., the same type, or else one a subtype of the other). In ALLOY, each optimality principle is measured on a numerical scale and given a weight (possibly negative), to yield a single weighted sum. Thresholds can be set for component measure and for the sum, to avoid processing low quality blendoids. Though currently we have implemented poetry only using optimal blends, in future work this may change based upon the style of poetic metaphor we wish to achieve. A fascinating result is that some metaphors in the Neruda poem in Sect. 12.4.3 require valuing type casts positively rather than negatively; this seems also to happen in other contemporary art forms.

12.4.1 Syntax as Blending

This subsection develops an approach to text generation inspired by cognitive grammar and based on structural blending; it is illustrated by the Labov narrative syntax of Sect. 12.2.3. This material does not apply the ALLOY algorithm of Sect. 12.4, which is for conceptual blending. Also, issues of saliency discussed here have not yet been implemented in GRIOT. The approach assumes a context free grammar, so we first convert the two EBNF Labov rules to this form; this yields many rules, one of which (depending on how it is done) is:

<Narr> → <Open> <Cls> <Eval> <Coda>

Next, convert the right sides of rules to terms that denote lists of strings (assuming these data structures are in the data algebra); then construct an axiom asserting this term has sort <Narr> and saliency[5] 1:

[<Open> <Cls> <Eval> <Coda> :: <Narr>, 1]

where [_::_,_] is a 3-place relation constructor interpretaed as above. Terms in such axioms are called **templates**. The set of all such axioms is the Labov space, call it L.

To get an actual narrative, we need a domain space D for phrases to instantiate the bottom level non-terminals in L. These are asserted as axioms, just as above, e.g.:

[Once upon a time, :: <Ont>, 1]

A more sophisticated approach, taken by the system of Sect. 12.4.2, uses more cognitively oriented domains with axioms for relationships, which are then converted to syntactic templates for instantiation. Note that templates may contain variables that call for a conceptual blend produced by the algorithm of Sect. 12.4, drawing on conceptual domains different from those used for syntax. Next, the generic space G contains: a constant of sort NT for each non-terminal in the grammar; variable symbols of sort Var; the above relation constructor [_::_,_] ; and another relation constructor [_:_] that is explained below.

[5] For such rules, our saliency is similar to entrenchment in the sense of [29]; we assume saliency values are in the unit interval $0 \le v \le 1$, and that they follow the fuzzy logic of [10].

The last ingredient is a set of deduction rules to enable instantiation, also given as axioms, one of which is:

[X : s'] & [t(X) :: s,v] & [t' :: s',v'] ⟹ [t(t') :: s,vv']

where [X : s'] indicates that variable X has sort s', t(t') indicates substitution of t' for X in t, and where vv' indicates multiplication of real numbers v and v'. Intuitively, the axiom says that if X has sort s', and if t has sort s and contains X, and if t' has sort s', then the substitution of t' into t for each instance of X has sort s (and saliency vv'). The generic space (and hence all input spaces) should also contain versions of this rule for templates t(X,Y) with two variables, for templates with three variables, etc., up to the maximum arity in any domain (alternatively, an inference space could be defined and imported into every space). The data algebra should include the operation for substituting lists into lists.

Finally, we blend the input spaces L and D over G, with the evident morphisms, and consider the deductive closure of the blend space B, which contains all axioms that can be deduced from the given ones. Those axioms with terms of sort <Narr> containing no variables are the narratives. When several templates are available, a random choice is made; saliencies can be used to compute probabilities, and the saliency of a template can be reduced after it is used, to help avoid repetitions. All this is easily coded in Prolog, to both produce and parse narratives (but declarative coding will require setting all saliencies to 1, since Prolog cannot reason with real numbers). A practical system like that described in Sect. 12.4.2 can just take the above as a semantic specification and implement it using standard tricks of the trade. A different formalization also seems possible, in which rules are constructors and processing is done at the basic level, instead of though axiomatization at the meta-level.

More complex blending than instantiation can use constraints as axioms, e.g., for tense and number agreement, or to handle anaphoric coreference of a noun phrase and pronoun. This seems a new approach, considering syntax as emergent from real-time processing and integrated with conceptual processing. It is technically similar to unification grammar ([35] gives a good introduction) and can be made even closer without much effort, and it is philosophically similar to the cognitive grammar of [29]. Of course, this formalism cannot do everything one might like (see the first pragraph of Sect. 12.3), but it seems more than adequate for our project of generating interesting new media objects.

12.4.2 Interactive Poetry

This section describes technology for implementing interactive and generative narratives, with an emphasis on its use in creating interactive poetry systems. We have coined the phrases "polymorphic poems" and "polypoems" to describe such works. This research is not intended as part of a project producing a comprehensive model of the human mind or the human process of poetry generation. Instead, our motivation is to improve the algorithms, the theory, and our understanding of blending, as well as to produce interesting texts; but this does not just mean that one

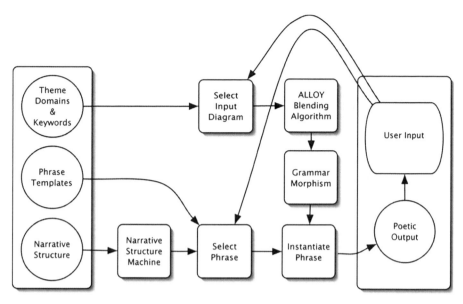

Fig. 12.4 The GRIOT framework as used for polymorphic poetry

cannot draw inferences about human poetry based on the successes and failures of various approaches. The GRIOT implementation has the following components (see Fig. 12.4):

1. Theme Domains: Themes are represented as ontologies consisting of sets of axioms expressing properties specific to a particular polypoem theme. Associated with each theme domain is a list of keywords that access that theme domain.
2. ALLOY Conceptual Blending Algorithm: This generates new concepts and metaphors from input spaces selected from the theme domains. ALLOY uses structural optimality principles inspired by those from conceptual blending theory [7]. These principles use a measure that quantifies optimality according to: (1) commutativity of mappings from elements in the input spaces to the blended space, (2) type coercions in the input spaces, (3) the number of constants from the input spaces that are preserved in the blended space, and (4) the number of axioms from the input spaces that are preserved in the blended space.
3. Media Morphisms: These map conceptual blends to representations in particular media, such as natural language and graphics. *grammar morphisms* are a special case of media morphisms that provide a mapping from a conceptual space to a representation in natural language text.
4. Phrase Templates: These are sets of text fragments organized by clause type and featuring *wildcards* that will be replaced by generated content upon each execution of the polypoem.
5. Narrative (or Event) Structure: This defines how phrase templates can be composed. A polypoem author inputs her or his choice of narrative structure; initial experiments used a version of the Labov narrative structure of personal

experience. The templates are selected using a new type of automaton that we invented, called a "probabilistic bounded transition stack machine," or more simply a "Narrative Structure Engine," or "Event Structure Engine" in the general case.

Using these components, the output of executing a polypoem is generated according to the rules and themes defined by a polypoem author. Many poetic texts can be output that feature systematic thematic and structural constraints, while at the same time exhibiting great variety in their actual phrases and metaphorical and aesthetic content. This is illustrated in Fox Harrell's polypoem "The Girl with Skin of Haints and Seraphs" [24], which draws upon a set of theme domains such as skin, angels, demons, Europe, and Africa.[6] After processing a user-input keyword such as "europe," entered after a ">" prompt, the first line could be:

her tale began when she was infected with white female-itis

or

she began her days looking in the mirror at her own pale-skinned death-figure face

or any of a number of alternate phrases (there are fourteen templates for such opening phrases). As an example of variation within a particular phrase due to wildcard replacement, among many other possibilities the first example above could have also been either:

her tale began when she was infected with tribal-warrior spectre-itis

or

her tale began when she was infected with black demon-itis

depending on how the phrase template was instantiated.

The discussion of template instantiation in the text grammar of Sect. 12.4.1 gives a theoretical basis for describing wildcard replacement in GRIOT. In the example above, one set of phrase templates contains "(her tale began when she was infected with (* g-singular-noun)-itis)" in the LISP syntax of the implementation, where the inner parenthesis is a wildcard variable that gets replaced with a noun cluster or a noun paired with a modifier. Exactly how the wildcard is replaced is determined by a combination of user input and the content of the wildcard itself. Ã wildcard consists of two or more parts including a "*" marker that indicates it is a wildcard, and a variable that determines whether it is to be replaced by another phrase (denoted by the prefix "p⁻" attached to a clause type name) or by content generated using the ALLOY algorithm (denoted by the prefix "g⁻" attached to a grammatical form name such as "singular-noun"). Optional variables can be used additionally to constrain domains or axioms selected as input to the ALLOY blending

[6] This work is a commentary on racial politics and the limitations of simplistic binary views of social identity. The dynamic nature of social identity is also reflected in the way the program produces different poems with different novel metaphors each time it is run (though it is unlikely that any one user would read a large number of these).

algorithm (denoted by "d-" and "a-" prefixes respectively, though in practice we have not had to use axiom determining variables). Optional variables can also be used for structural effects such as forcing repeats of wildcard replacement text from earlier in the poem. User input plays a role in wildcard replacement, since the user entered keywords determine one of the domains to be used in constructing the blends that will be used in template instantiation.

In most of the polypoems implemented so far, phrase templates have been most commonly instantiated by replacing the wildcard with an English language mapping from conceptual blend produced by the algorithm of Section 12.4. After user input and/or optional wildcard variables have been used to select theme domains, conceptual spaces are selected from the chosen domains as follows:

1. Axioms are chosen from the first domain. An axiom is a relation represented as a list such as:

```
(axiom ''devours''
  ((constant ''evil'' ''emotion'' demons-space 0)
   (constant ''hope'' ''emotion'' demons-space 0))
```

The "0"s are initial values of the blend optimality measure, which is updated as execution proceeds; note that users do not see this internal representation.
2. A subdomain is formed from the second domain that consists only of axioms of sorts that match the chosen axioms, axioms are selected randomly from the subdomain.
3. These spaces are used to create an input diagram (a generic space, two input spaces, and morphisms between the spaces).
4. The input diagram is passed to the ALLOY algorithm, which returns a conceptual blend with the two morphisms to it.

After the blend is generated, a grammar morphism (the set of grammar morphisms is implemented as a hash table of Lisp closures) is consulted and used to generate the English text used to instantiate the template.

The above discussion summarizes material introduced in [22]. A complete sample poem generated by one user's interaction with "The Girl with Skin of Haints and Seraphs" polypoem is given below, where ">" is the prompt, which is followed by the user input:

> evil
every night she wakes covered with hate, awe sweat
> europe
imperialist and girl thoughts taunted her as a teen
serious times were here
> africa
drum spiked-tail vapor steamed from her pores when she rode her bicycle
in the rain
> angel
when twenty-one she was a homely woman
that was nothing lovely
> skin

tears ran relay races between her girl and european eyes and her ignorance, longing earlobes
and back
she could laugh
> angel
her dreams were of cupid epidermis
life was a sight gag
> demon
so she resolved to find bat-wings and pointed-nose passion and be happy

The selection of particular phrase templates, i.e., structuring the narrative progression of the polypoem, is accomplished by the Event Structure Engine. The Event Structure Engine has the following format (in a modified BNF notation in which simple phrases (without < >) indicate informal descriptions of atomic elements):

```
<Event Structure Engine> ::= ''('' structure <clauses> '')''
<clauses> ::= <clause> {<clauses>}
<clause> ::= ''('' <name> <number> <subclause> <exit-to-clause> <read-flag> '')''
<name> ::= an atomic clause name
<number> ::= ''('' <minimum-number> <maximum-number> '')''
<subclause> ::= ''('' an atomic clause name '')'' | ''()''
<exit-to-clause> ::= ''('' an atomic clause name '')'' | ''()''
<minimum-number> ::= a positive integer
<maximum-number> ::= a positive integer
<read-flag> ::= read | n
```

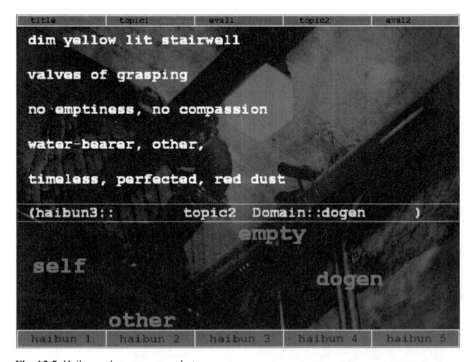

Fig. 12.5 Haibun polypoem screenshot

The functionality of the Event Structure Engine can be described using the example of the polypoem "The Griot Sings Haibun," developed by both authors and based on a poem entitled "November Qualia" by Joseph Goguen [15]. It extends the system by allowing the passing of user input to the system via a graphical or game-like interface (future examples could be navigating a game map or selecting objects in a virtual environment). In "The Griot Sings Haibun" the system was used with a graphical interface (see Fig. 12.5) to generate "(neo)haibun," a combination of prose, haiku, and beat poetry used to narrate personal everyday experiences in a live performance with free jazz musicians [18]. A simple haibun poem can be defined with the following structure:

```
(structure
  (orient (2 2) () (poem) n)     (poem (3 5) (intro) () n)
  (intro (1 1) (topic1) () n)
  (topic1 (2 2) (eval1) (topic2) n)
  (eval1 (1 1) () () n)
  (topic2 (1 2) (eval2) () n)
  (eval2 (1 1) () () ) n))
```

One possible poem output by such an automaton would have the following structure (with clause names standing in for actual clauses):

```
orient
orient
poem,
    intro,
        topic1,
            eval1,
        topic1,
            eval1,
        topic2,
            eval2
poem,
    intro,
        topic1,
            eval1,
        topic1,
            eval1,
        topic2,
            eval2,
        topic2,
            eval2
poem,
    intro,
        topic1,
            eval1,
        topic1,
            eval1,
        topic2,
            eval2
```

This consists of 3 short poems, preceeded by two orientation clauses, where each poem has topic and evaluation clauses; Figure 12.5 shows part of one poem from an actual performance [18].

The most important structure in the description of this format is the `<clause>`, and the functioning of the Event Structure Engine can be understood by examining these components. A clause consists of a name, pair of integers, subclause name, exit-to clause name, and a read-flag. A clause is processed as follows:

1. The number of times the clause will be repeated is determined. The first of the pair of numbers indicates the minimum number of repetitions and the second number represents the maximum, hence the automaton is "bounded." A number, called the "repeat number," between the minimum and maximum is chosen at with some user-defined probability (the default is equal probability for each integer in the interval), hence the automaton is "probabilistic."
2. If the read-flag is on (i.e. it is the atom "read") a prompt is given and user input is accepted.
3. A phrase template of the type indicated by the clause name is selected and output.
4. If the subclause is not the empty list then the clause with the same name as the subclause name is processed.
5. If the exit-to clause is not the empty list then the clause with the same name as the exit-to clause name is processed.
6. If the current clause has not been processed a number of times equal to the repeat number then the clause is processed again.

An interesting philosophical issue is raised by this program: human input might be considered cheating by traditional AI practitioners, since most AI text generation projects are oriented towards total automation and Turing test competence. But our quite different goal is to use the blending algorithm in a human designed system that generates poetry containing novel metaphors in real-time; just as with computer games, it is desirable and necessary for humans to provide rich content. For such projects, artistic freedom takes precedence over dogmatic Turing test reductionism. A related point is raised by Espen Aarseth's analysis [1] of text generation systems, which takes relationships among programmer, system, and reader as a basis for critical analysis. The hypotheis is that readers' authorial models affect their interpretations of works, causing the approaches of traditional literary criticism to fail when computers are putative authors. Our view is that an instantiation of the poetry generation system with domains should be viewed as a work of art, produced by the designer, programmer and instantiator of the system, and judged by the corpus of poems produced by that instance; we consider it entirely wrong to view an individual poem as produced by "the computer."

12.4.3 Unconventional Blends

The poem "Walking around" by Pablo Neruda has the form of a narrative. Its first stanza serves as an orientation, introducing the protagonist, the place, and the time

(the latter two in a condensed poetic form); the location is perhaps a small city in Chile. Each subsequent stanza explores aspects of some area within that city, using metaphors that are often quite striking. The general theme of the poem is weariness induced by consumerism. Here are its first two stanzas (out of ten, from [8]):

It so happens that I am tired of being a man.
It so happens, going into tailorshops and movies,
I am withered, impervious, like a swan of felt
navigating a water of beginning and ashes.
The smell of barbershops makes me weep aloud.
All I want is a rest from stones or wool,
all I want is to see no establishments or gardens,
no merchandise or goggles or elevators.

Neruda's metaphors often blend concepts in unconventional ways that require optimality principles quite different from those of [7]. For example, the phrase "water of beginning and ashes" violates the first three principles (and thus requires much effort to satisfy the fourth and fifth) of Sect. 12.2.2, by combining things of enormously different type, so that casting to very remote types is required. It follows that to generate such metaphors, type casts would have to be valued positively rather than negatively. A less drastic example in the same text is "swan of felt." Similar reversals of optimality principles are needed to generate some images in Rilke's *Duino elegies*, e.g., "cheap winter hats of fate" in the fifth elegy. Neruda's imagery, objects, and cultural contexts can be implemented using domains, e.g., a Town-location is a place such as a tailorshop, movie theater, or barbershop, which has town-objects, such as goggles, elevators, wool, and stones, where attributes of wool might be heavy and impervious. For us, blending is a multi-level and multi-faceted process, since for example, evidence from poetry suggests that unconventional principles are also necessary at the structural as well as the conceptual levels.

12.4.4 Style as Blending Principle Choice

The GRIOT system, when used for poetry generation, invokes blending at three different levels: (1) large grain structure (e.g., Labov narrative), where structural blending combines clausal units, which are in turn produced by (2) structural blending of phrasal elements, some of which result from (3) conceptual blending. Different choices of constructors at the top two levels can produce very different styles, such as a randomized "postmodern" ordering, or a deeply nested narrative structure (as in *A Thousand and One Nights*), or a sonnet; constructors at these levels could also be used to control transitions among such styles (these would correspond to conditional rules). Other stylistic parameters at the second level include syntactic complexity, and tense and mood of verbs; different domains for themes, places, etc. can also be selected at different times. In addition to blended metaphors, the phrasal level includes noun clusters, verb phrases, etc., again potentially taken from different domains at different times. At each level, different optimality principles can be

used for making choices, and these too can be different at different times (note that randomization is an optimality principle in our broad sense of that phrase).

This gives rise to 12 parameters for controlling style: each of the three levels has (1) a set of available domains, (2) items in those domains, (3) optimality principles for choosing among blends, and (4) controls for changing domains. Since the content of domains may include not just constructors and relation instances, but also axioms for templates and for semantic relationships, if we count these as parameters, then we get 18 parameters. Of course, we could cut this cake more finely or more coarsely to get different numbers, and we may later find other parameters that are also important for style. Every parameter can be considered a principle that controls blending, but by far the most interesting and least explored are non-classical optimality principles. The narrative, causal, and accountability principles of Sect. 12.2.3 are also interesting to consider. It is clear that all principles must be carefully tuned to achieve a reasonable approximation to an existing style, but it is also clear that the results are unlikely to be close to the genius of a great poet like Neruda. (The situation for comprehension is presumably roughly dual to that for generation, in that here one seeks to understand what principle Neruda may (unconsciously) have used to obtain some typical classes of remote type casts for his blends.)

12.5 Conclusions and Future Work

A surprising result of our experiments is that a combination of conceptual and structural blending can produce interesting poetry, which some critics have even considered superior to prior computer generated works. Another is that both large grain structure and syntax can be handled by blending in ways that are close to, but extend, what has been done in prior text generation programs; this use of blending also gives rise to a somewhat novel view of grammar as emergent from processes of blending, rather than fixed in advance. A third result is that it is easy to extend this approach to interaction, to media other than text, and to forms other than poetry or narratives. We were also surprised that the optimality principles proposed by [7] for conventional, common sense blends like "houseboat" often fail for generating poetry; on the contrary, what might be called *dis*optimization principles are needed to generate some metaphors in the Neruda poem in Sect. 12.4.3. This led us to consider a range of different principles, and to analyze style in terms of the principles used for blending texts, where "text" is understood in a broad sense to include cinema, video games, and even living. The resulting view of style differs radically from views based on estimating parameters in statistical models of media objects. Our theory of style as blending principles will be further developed in future work, and has the potential to be applied to a variety of media and genres, ranging from magazine design, film, music and architecture, to new interactive multimedia narrative forms, e.g., video games with nuances and powerful expressive dimensions. In fact, one major application area for this work is developing narrative computer

games. Many computer games are based in narrative, but despite the fact that users act dynamically within the game worlds, the stories are either static, or else feature simplistic branching narrative structure. Providing games with the potential to generate story elements on the fly, constrained stylistically and thematically by the game developer's narrative model, can add value to games, in the forms of greater salience for the users' actions, and greater replayability.

References

1. Aarseth EJ (1997) Cybertext: perspectives on ergodic literature. Johns Hopkins, Baltimore, MD
2. Barwise J, Perry J (1983) Situations and attitudes. MIT, Bradford
3. Becker A (1979) Text-building, epistemology, and aesthetics in Javanese shadow theatre. In: Becker A, Yengoyan A (eds) The imagination of reality: essays on Southeast Asian symbolic systems. Ablex, Norward, NJ, pp 211–243
4. Cohen H (1995) The further exploits of Aaron, painter. Palo Alto 4(2):141–158
5. de Saussure F (1976) Course in general linguistics (trans: Harris R) Duckworth, London
6. Fauconnier G (1985) Mental spaces: aspects of meaning construction in natural language. MIT, Bradford
7. Fauconnier G, Turner M (2002) The way we think. Basic, New York, NY
8. Fitts D (ed) (1941) Anthology of contemporary Latin-American poetry. New Directions, Norfolk, CN
9. Gentner D (1983) Structure-mapping: a theoretical framework for analogy. Cogn Sci 7(2): 155–170. http://www.cognitivesciencesociety.org/journal_csj.html
10. Goguen J (1969) The logic of inexact concepts. Synthese 19:325–373
11. Goguen J (1999) An introduction to algebraic semiotics, with applications to user interface design. In: Nehaniv C (ed) Computation for metaphors, analogy and agents. Springer, pp 242–291. Lecture notes in artificial intelligence, vol. 1562
12. Goguen J (1999) Social and semiotic analyses for theorem prover user interface design. Formal Asp Comput 11:272–301. Special issue on user interfaces for theorem provers
13. Goguen J (2003) Semiotic morphisms, representations, and blending for interface design. In: Proceedings, AMAST workshop on algebraic methods in language processing. Conference held in Verona, 25–27 August, 2003. AMAST Press, pp 1–15
14. Goguen J (2004) Musical qualia, context, time, and emotion. J Conscious Stud 11(3/4): 117–147
15. Goguen J (2005) November Qualia. Journal of Conscious Stud 12(11):73
16. Goguen J, Harrel DF Foundations for active multimedia narrative: semiotic spaces and structural blending, to appear. Interaction studies: social behaviour and communication in biological and artificial systems. http://www.benjamins.com/cgi-bin/t_seriesview.cgi?series=IS
17. Goguen J, Harrel DF (2004) Information visualization and semiotic morphisms. In: Malcolm G (ed) Multidisciplinary studies of visual representations and interpretations. Elsevier, London, pp 93–106
18. Goguen J, Harrel DF (2005) The GRIOT sings haibun. Performance at UCSD CalIT2 opening celebration, 28 Oct 2005. Music by David Borgo, Ryoko Goguen and Bertram Turetzky
19. Goguen J, Malcolm G (1996) Algebraic semantics of imperative programs. MIT press, Cambridge, MA
20. Goguen J, Malcolm G (1997) A hidden agenda. Theor Comp Sci 245(1):55–101 Also UCSD Dept. Computer Science & Eng. Technical Report CS97–538, May 1997
21. Grady J, Oakley T, Coulson S (1999) Blending and metaphor. In: Gibbs R, Steen G (eds) Metaphor in cognitive linguistics. Benjamins, Amsterdam

22. Harrell DF (2005) Shades of computational evocation and meaning: the GRIOT system and improvisational poetry generation. In: Proceedings, 6th digital arts and culture conference, Copenhagen, pp 133–143
23. Harrell DA, Jr (a.k.a. Fox HD) (2007) Theory and technology for computational narrative: an approach to generative and interactive narrative with bases in algebraic semiotics and cognitive linguistics, Department of Computer Science and Engineering. PhD Thesis, University of California, San Diego, 2007
24. Harrell DF (2008) Algebra of Identity: skin of wind, skin of streams, skin of shadows, skin of vapor. In: Kroker A, Kroker M (eds) Critical digital studies. University of Toronto Press, Toronto, pp 158–174
25. Harrell DF, Chow KKN (2008) Generative visual renku: linked poetry generation with the GRIOT system. In: Proceedings, electronic literature organization conference, Vancouver, Washington, DC
26. Labor W (1972) The transformation of experience in narrative syntax. In: Language in the Inner City, University of Pennsylvania, PA, pp 354–396
27. Lakoff G (1987) Women, fire and other dangerous things: what categories reveal about the mind. University of Chicago Press, Chicago
28. Lakoff G, Johnson M (1980) Metaphors we live by. University of Chicago Press, Chicago
29. Langacker R (1999) Foundations of cognitive grammar. Stanford University Press, Stanford
30. Lewis GE (2000) Too many notes: computers, complexity and culture in Voyager. Leonardo Music J 10:33–39
31. Linde C (1993) Life stories: the creation of coherence. Oxford University press, Oxford
32. Meehan J (1981) TALE-SPIN. In: Roger S, Christopher R (eds) Inside computer understanding: five programs plus miniatures. Erlbaum, Hillsdale, NJ, pp 197–226
33. Peirce CS (1965) Collected papers. Harvard University press, Harvard. In 6 volumes; see especially vol. 2: Elements of logic
34. Propp V (1928) Morphology of the Folktale. University of Texas Press, Austin, TX Reprinted 1968
35. Shieber S (1986) An introduction to unification-based approaches to grammar. CSLI, Stanford
36. Turner M (1996) The literary mind. Oxford University Press, Oxford

Chapter 13
The Future of Style

Kevin Burns and Mark Maybury

Abstract Previous chapters have addressed a variety of ways in which style can be expressed and evoked—in production, perception, and interaction. The present chapter explores the future of style in interactive applications of artificial intelligence (AI). To do so we dissect style along various dimensions, including *functions*, *levels*, *domains*, and *uses*, in a survey of current applications and a roadmap for future innovations. We conclude that major advances will require a shift in focus from the function of production to the function of perception—and from the level of semantics to the level of aesthetics.

13.1 Functions of Style

Three *functions* of style are *production*, *perception*, and *interaction*:

I. Production—the generation of style in actions and artifacts.
II. Perception—the recognition of style in actions and artifacts.
III. Interaction—the combination of production and perception.

It is useful to distinguish between these three functions because current AI is typically limited to either production or perception, with fewer cases where the two are combined in interactive applications [30].

Especially in the arts, AI and computing in general seem to have focused more on production [4, 28] than perception. This is apparent in the work of many "Algorists" [56] who exploit the generative capabilities of algorithmic computation in their aesthetic "experimentation" (e.g., transformations, permutations, etc.). These are productions by a computer, without perception by a computer, and that severely limits the potential for AI-human interaction.

For example, the program named AARON (Chap. 1 by Cohen) can produce wonderful paintings but cannot perceive even its own paintings. This AI is an assistant [32], whereas the artist is the programmer who chooses those paintings

K. Burns (✉)
The MITRE Corporation, 202 Burlington Road, Bedford, MA 01730, USA
e-mail: kburns@mitre.org

S. Argamon et al. (eds.), *The Structure of Style*,
DOI 10.1007/978-3-642-12337-5_13, © Springer-Verlag Berlin Heidelberg 2010

that he wants to save and then changes the program for subsequent production. To become an artist itself, the AI must be capable of comprehension and adaptation—in the context of a culture that includes other artists and audiences who are also producing and perceiving (Chap. 2 by Stiny).

Outside the arts AI has made great strides in pattern recognition, including the perception of motion, objects, faces, gestures, and even affect (see below). But these modes of perception are at a superficial level in that *patterns* are recognized with limited understanding of the *meanings* they convey or the *feelings* they evoke in human beings. The differences between pattern, meaning, and feeling are discussed further below under "Levels of Style."

With respect to the difference between production and perception, it is interesting that the situation for natural intelligence is reversed from that of artificial intelligence. That is, although a person can *perceive* many different styles, he can typically only *produce* one or a few styles. Consider drawings [8], where humans can readily recognize an artist's sketch of a dog as that of the artist (person or school) and subject (type or breed), and yet most of these same humans would be hard pressed to generate a drawing that looks much like a dog. Instead people typically draw using some familiar schema, often in the style of a stick figure [29, 55]. A similar situation exists in music and language, where most humans are able to perceive style much better than they can produce style, and audiences outnumber artists by a wide margin.

With respect to the relation between style and affect, advances in *affective computing* [22, 43] have addressed the perception of emotions (e.g., from facial expressions) via pattern matching algorithms like those used in other AI (discussed above). Here it is important to note that this is *not* perception of style. Rather, it is perception of a person's response to her perception of style—because perception of style still happens in the human's head as *feelings* arise from *meanings* conveyed by *patterns* observed in a media experience. The computation of feeling from meaning from pattern is the problem of perceiving style, and it differs from the problem of perceiving a human's response to the style that she perceives.

Although computational models for *perception of style* are relatively rare, there are many theories of affective processing that might be implemented [34]. Several are surveyed by Picard [43], where we see that current implementations are mostly rule-based systems like those used in production of style. This brings us full circle to see the main problem that now limits interactive applications of AI: it is not production of artifacts; it is not perception of affect; it is *perception of style*.

Most theories that might be applied to *perception of style* consider different levels of mental function. For example, Sloman [52] mentions three types based on neurological layers, which he calls: Reactive, Deliberative, and Self-Monitoring. Similarly, Picard [43] highlights three types of psychological response, which she calls: Physiological Awareness, Cognitive Awareness, and Subjective Feelings. More recently, Norman [40] outlines three types of emotional design, which he calls: Visceral, Behavioral, and Reflective.

These and other theories differ in their focus (e.g., neurological, psychological, emotional), but they all share a notion of *levels*. In a similar approach, below we propose three levels of information processing for computation of style.

13.2 Levels of Style

Three *levels* of style are *characteristics* (pattern), *semantics* (meaning), and *aesthetics* (feeling), labeled A, B, and C as follows:

A. Characteristics—the pattern observed—a mode.
B. Semantics—the meaning conveyed—a genre.
C. Aesthetics—the feeling evoked—a style.

Others have made similar proposals, including Aristotle's distinction between ethos, logos, and pathos in rhetoric; also the linguistic distinction between syntax, semantics, and pragmatics [37]. Here we are concerned with more than language, so our levels are adapted [7] and our labels are adopted (A, B, C) from the following passage in Weaver's introduction to Shannon's "Mathematical Theory of Communication" [50]:

Level A: How accurately can the symbols of communication be transmitted? (The technical problem.)
Level B: How precisely do the transmitted symbols convey the desired meaning? (The semantic problem.)
Level C: How effectively does the received meaning affect conduct in the desired way? (The effectiveness problem.)

As an example, consider the levels of style in a sketch. At Level A, which is concerned with *pattern*, one might refer to the characteristic features as being jagged or curvy. At Level B, which is concerned with *meaning*, one might refer to the semantic content as being a cat or a dog. At Level C, which is concerned with *feeling*, one might refer to the aesthetic response as being one of tension or pleasure.

Notice that a feeling may "move" a person even if there is no observable conduct (action) from it. Also conduct can relate to patterns or meanings or feelings. Thus we reserve the deepest Level C for aesthetics [36], and highlight the role of "desire" and other "affects".

Weaver's ABCs were and still are important in framing Shannon's theory, which addressed only Level A. As Shannon stated on the first page of his paper: *"Frequently the messages have meaning... These semantic aspects of communication are irrelevant to the engineering problem."* Today in AI our "engineering problem" has grown to include the semantic meaning (Level B) that symbols encode as well as the aesthetic feeling (Level C) that their meaning evokes. Weaver's vision was to see that Shannon's theory was important and yet just the tip of the iceberg (Level A). Weaver also saw that Shannon's approach might be extended and applied by others at the deeper Levels B and C, as it has—see Chap. 7 by Dubnov, also [2, 7, 36].

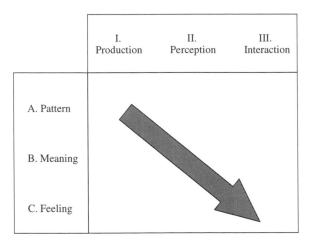

	I. Production	II. Perception	III. Interaction
A. Pattern			
B. Meaning			
C. Feeling			

Fig. 13.1 A frontier for interactive applications of AI, based on *levels* of style (A, B, C) and *functions* of style (I, II, III)

Each of these three levels (A, B, C) applies to each of the three functions (I, II, III) noted above, although the deeper levels of semantics (B) and aesthetics (C) seem especially important to perception (II) and interaction (III). As seen in early AI, some useful productions are possible without addressing the deeper levels much if at all. But those productions are effective and affective only insofar as a human perceiver reads between the lines to create the meaning and feeling herself.

Referring to Fig. 13.1, AI style began in the upper left and is now moving toward the lower right. Although progress is both horizontal and vertical, it is clear that getting to the furthest function of interaction (III) will require the deepest level of intelligence (C).

In this vein AI cannot really claim that its productions have *style* if they are produced by a Level A program that has no Level B semantics or Level C aesthetics. Instead such a program is only producing a characteristic *mode*, i.e., some regular (modal) pattern. In that case all the style at deeper levels is created by perceivers. Similarly, a program may have the ability to produce or perceive semantics at Level B, but if the program does not have the ability to produce or perceive aesthetics at Level C then at best it can produce or perceive a *genre*—not a *style*.

In this view the term *style* would be reserved for the deepest level, but of course the term is used for much more—simply because people cannot help but perceive style even when there was none at Level C in the program that produced it. The danger is that this common usage can create the illusion that deeper problems have been solved by shallow programs. For example, a program that can recognize and generate characteristic patterns of linguistic discourse might be thought by some to have captured a *style* of language communication [54]. And in one sense it has, but only at the superficial level of pattern—not at the deeper level of meaning, let alone at the deepest level of feeling. The bottom line is that such a program really has no style, at Level C.

Thus in its most general sense the term *style* is now and will continue to be used by us and others to refer to all three levels. But in a more specific sense the terms *mode*, *genre,* and *style* will serve to highlight the fact that most work in AI has been at the Level A of *mode*, or at the Level B of *genre*, and there is still much to be done at the Level C of *style*. As defined elsewhere [7]: **Style is an aesthetic agreement in a cultural context.**

Besides grounding style in aesthetics, this statement highlights the fact that style is always produced and perceived in a social setting (Chap. 8 by Jupp and Gero) with some common culture. The question of *just what* aspects of a culture must be shared remains to be answered, and of course it will depend on the application. Our point here is merely that this question *must be* answered if AI is to have style at the deepest level.

An even more restricted use of the term *style* goes beyond the notion of *levels* to constrain the *process* by which styles (aesthetics) are perceived and produced:

> Hence, aesthetics differs from entertainment that requires cognitive engagement with narrative, word play, or complex intellectual allusion. While the sound of poetry is arguably aesthetic, the meaning is not. . . The effects are immediate, perceptual, and emotional. They are not cognitive, although we may analyze them after the fact. . . Aesthetics conjures meaning in a subliminal, associational way, as our direct sensory experience reminds us of something that is absent, a memory or idea. [45, p. 7].

But this statement seems to go too far in narrowing the scope of aesthetics, at least for AI. For example, perceiving the meaning of a poem (Chap. 12 by Goguen and Harrell) is an aesthetic experience that can bring much pleasure—probably more pleasure than is gained from the sound pattern itself.

Postrel also writes that: *"Aesthetics offers pleasure, and it signals meaning."* [45, p 10]. Here she implies that aesthetics come before semantics. Well a good argument can be made that aesthetics come first in importance, because ultimately what matters most is not how one looks or thinks but how one feels. That is why we place aesthetics at the deepest Level C. But a good argument cannot be made that emotions come before cognition, because the two operate in parallel as a person tries to make sense of what she is sensing.

And actually in the realm of information processing, like that accomplished by natural intelligence (as well as AI), the main flow appears to be from cognition to emotion—as we make sense cognitively to get sense affectively. According to "appraisal theories" of affective responses [16, 25], *"emotions are elicited and differentiated on the basis of a person's subjective evaluation or appraisal of the personal significance of a situation, object, or event on a number of dimensions or criteria"* [49, p. 637]. The key dimensions include "primary appraisals" of event significance (e.g., surprise and valence) as well as "secondary appraisals" of coping ability (e.g., intent and constraints).

This view does not imply that all or even most of cognition happens in the realm of consciousness [18]. Indeed it may be that much and perhaps most cognitive processing happens unconsciously. But still there is always some meaning inferred or assumed as a basis for the feeling we get. For example, even when the unconscious brain responds to a "surprising" event with a "fight or flight" response, this response

is based on the meaning of the event, i.e., the fact that the event was surprising, which "means" it was not expected.

Because such responses are so rapid, they may feel as if they are direct. But first there must be some perception of meaning, even if the meaning is as rudimentary as "unexpected," or else the unconscious could not know what to feel. By this view both cognition and emotion are both unconscious and conscious, where cognition may range from unconsciously assumed meaning to consciously appraised meaning, and emotion may range from unconsciously reactive feelings to consciously reflective feelings.

From a neurological perspective, this view is consistent with Damasio's [12] distinction between primary (pre-conscious) and secondary (post-conscious) processing; also LeDoux's [26] "low road" (fast track) via sensory thalamus and "high road" (slow track) via sensory cortex, where the low road and high road both lead to the amygdala, which is a center for emotion. For both Damasio and LeDoux, the main distinction is between unconscious (fast track) and conscious (slow track), because both cognition and emotion [44] occur in each realm (unconscious and conscious).

In addressing the same issue, Lazarus [25, p. 8], writes:

Does this suggest that cognition always comes first in the cognition-emotion relationship? Not at all... Depending on where one begins one's entry into the flow, which is arbitrary, any response can also be a stimulus, but not at the same instant... In other words, although *emotion is a response to meaning* [emphasis added], it can also occur prior to the next thought, which is, in its turn, a response to the experienced emotion...

Thus we acknowledge the importance of feedback from emotion to cognition, and in our framework the flow goes both ways: mostly $A \rightarrow B \rightarrow C$ but also $C \rightarrow B \rightarrow A$.

Another feature of our framework that may differ from others is that we take the term *semantics* (at Level B) to have a much broader meaning than it does in linguistics. For example, in music the characteristic patterns of notes in a song do not (usually) refer to objects or events in the world outside the song. But even then, when the meaning cannot be put into words, there is still meaning in the form of "implications" and "realizations." [39]

Listeners are forming "expectations" [23] and "explanations" [10] as they hear music, and clearly this is meaningful to them. Without such meaning there would be little feeling, because the feeling in music comes from basic structures that run deeper than just the surface patterns of notes [27, 47]. Likewise in graphics, the characteristic patterns of lines in a sketch may be non-referential and hence more like music than a picture. But still there is meaning and that meaning is what gives rise to feelings [41, 51].

The problem for AI is to explicate the algorithms that underlie aesthetic experiences in the interaction between attention, cognition, and emotion. This is a two-way street running from patterns to meanings to feelings—and then back again [21]. To the extent that some processing may be pre-conscious or not conscious and hence thought (felt?) to be purely affective, the challenge for AI is to explicate these

processes as well. This is the only way that machines can ever be endowed with what they need to form meanings and get feelings of the sort needed to deal with humans in AI-human interaction.

To recap, three *functions* (I, II, III) and three *levels* (A, B, C) define a frontier for the future of style in AI, as shown in Fig. 13.1. In this figure, current applications are more numerous near the upper left and less numerous at the lower right. But these trends are not uniform across all *domains* and *uses* of style, as discussed further below.

13.3 Domains of Style

Four **domains** of style are: *language, music, design,* and *gaming.* Language covers discourse and poetry, where the latter if not the former includes meter and pitch and other features of music. Music applies to playing, singing, listening, and dancing, which also includes bodily kinesics. Design covers graphic arts and architecture, which are mostly spatial but vary in their dimensionality (2-D to 3-D, static to dynamic) and functionality (pure decoration to practical use). Gaming covers gambling as well as athletics and other amusements [48].

These four domains provide a relatively independent and reasonably comprehensive coverage, although multi-media can combine one or more domains. For example: TV, the web, cinema, and theatre each include language, music, design, and gaming. Perhaps not coincidentally, these somewhat-independent domains of artificial intelligence correspond to somewhat-independent domains of natural intelligence, categorized by psychologists [17] as follows:

Linguistic Intelligence
Musical Intelligence
Spatial Intelligence
Logical-Mathematical Intelligence
Bodily-Kinesthetic Intelligence
Inter-Personal Intelligence
Intra-Personal Intelligence.

The two Personal Intelligences are concerned with interactions (between people and within a person), whereas the other intelligences are concerned with production and perception of actions and artifacts in specific domains. Bodily-Kinesthetic Intelligence plays little role in the chapters of this book, but the remaining intelligences are aligned with four domains of style research, as follows:

Language: Linguistic Intelligence
Music: Musical Intelligence
Design: Spatial Intelligence
Gaming: Logical-Mathematical Intelligence.

This correlation suggests that the computational representations and algorithms needed for dealing with style in each domain are quite different—or at least different enough for domain experts to be segregated from each other. This sort of segregation can be good for AI, to speed progress in each domain. But it can also be bad because it fosters *isolation* when in fact the greatest impact may come from *integration*.

Humans themselves possess each type of intelligence to varying degrees, and there is often a great deal of interaction between these intelligences. For example, in discussing Musical Intelligence, Gardner [17] relates it to all the other Intelligences: Bodily-Kinesthetic dance is performed to musical song; Logical-Mathematical analysts are often musical composers [47]; Spatial arts like painting are sometimes based on musical analogies [15]; and Linguistic Intelligence may have evolved (if not remained) in concert with Musical Intelligence [35].

Some initial efforts to integrate style research across domains of AI include a comparison of music and sketching using Shannon information theory and Bayesian decision theory [7]; also a connection between music and gambling [10] based on common notions of probability [53] and utility (Chap. 11 by Burns). But in general most studies are focused within a single domain.

The point here is that human style crosses domains, hence AI style might benefit from such crossings as well. In fact as a practical matter, interactive applications of AI might be most useful when AI that is strong in one area can help humans who are weak in that area. This will require more integration within AI, in order to support interactions between artificial intelligence and natural intelligence. In the spirit of such integration, below we examine uses of style research across the four domains.

13.4 Uses of Style

Four **uses** of style are: *comfort, money, knowledge, and pleasure*. These uses are based on four values or utilities, noted earlier with respect to strategic style (Chap. 11 by Burns):

> Ergonomic Utility—comfort
> Economic Utility—money
> Informatic Utility—knowledge
> Aesthetic Utility—pleasure.

All four are related, e.g., when one gets pleasure from the comfort that one buys using money gained from knowledge. In fact, depending on one's point of view, each utility can be seen in terms of another utility. For example, in economics all things (even pleasure) are reduced to money.

Although not independent or exhaustive, these four utilities are relatively distinct and practically useful in highlighting four industries, with associated activities, for interactive applications of AI. These industries and *activities* are the categories we use to survey style applications below, in four sections as follows:

Comfort Industries—*socialization*
Money Industries—*customization*
Knowledge Industries—*representation*
Pleasure Industries—*gratification.*

Comfort Industries include healthcare and defense, where people are concerned with survival and security. A key activity for these industries is *socialization*, as interpersonal relations can be leveraged to improve health, and cultural differences can fuel war.

Money Industries include manufacturing and marketing, where people are engaged in buying and selling. A key activity for these industries is *customization*, as sellers tailor products and services to the individual likes and needs of buyers.

Knowledge Industries include schooling and scholarship, where people are striving to improve and invent. A key activity for these industries is *representation*, as the manner in which information is presented can improve understanding and foster innovation.

Pleasure Industries include arts and leisure, where people create and compete. A key activity for these industries is *gratification*, as desires to look good and feel good are at the heart of being human.

Taken together, these four *uses* along with the four *domains* noted above suggest a space in which there are $4 \times 4 = 16$ areas for applications of style research. This space and the 16 areas within it are illustrated in Fig. 13.2. In this figure, the darkness of each area represents the current extent (in our judgment) of style applications, i.e., dark areas have seen many applications and light areas have seen fewer applications.

Fig. 13.2 A space of uses (*rows*) and domains (*columns*) for AI style. The darkness of an area denotes the extent of current applications (dark is more)

Below we discuss these areas in four sections that follow the four rows of Fig. 13.2. As a practical matter our discussion cannot be exhaustive, so instead we attempt to summarize what we have seen in current applications and what might be done in future innovations.

13.4.1 Socialization: Comfort Industries

Comfort industries are exemplified by healthcare and defense, where *socialization* is the operative word. In healthcare we find clubs for weight loss and coping with conditions like alcoholism and diabetes. In defense, minimizing risks to citizens and property requires social interactions among national forces (civilian and military) and international allies. The challenges include keeping peace as well as fighting wars, often in asymmetric operations like counterinsurgencies. When cities are battlefields and civilians are implicated, culture and style can be obstacles to success as well as vehicles for success.

Language is especially important in comfort industries, where communication arises from the way words are said as well as the words that are said. A manner conveys meaning, so style contains substance (Chap. 5 by Argamon and Koppel). In healthcare, the choice of words and tone of voice can carry valuable information to aid in diagnosis and treatment decisions [19]. In defense, foreign language translation plays a key role in global intelligence and military operations as analysts and commanders need to address the content (Level B) as well as the intent (Level C) of communications. Advances in automated information extraction have achieved some success at the semantic level of events, entities, attributes, and associations. However semantic extraction is still quite limited, and beyond that we have only begun to see the first commercial tools for sentiment detection that approach the Level C of aesthetic style.

Gaming is also important to comfort industries, as in the "serious games" [1] that have recently been fueled by advances in digital computing. In healthcare such games are being used to help patients cope with physical conditions like children's cancer as well as psychological conditions like elderly loneliness. In defense there is a long history of war gaming, including simulations to test strategic options and train tactical operations. Recently the use of video games has even been extended to recruiting, in *America's Army*. For non-combat applications, new games are aimed at problems like teaching the languages and customs of foreign cultures that soldiers will face when they are deployed. But the immersive and interactive advantages of these games depend on designs that address both semantics (learning) and aesthetics (pleasure). The notion of fun or "flow" [11] is just as important for serious games as for any other game, and yet currently we lack formal measures of fun in games [6]. Moreover, what is fun for one person may not be fun for another person, so individual differences [13] in style must be addressed if serious games are to achieve their potential for practical applications.

Design and *Music*, too, present opportunities for *socialization* in comfort industries. For example, architectural designs can contribute to the functionality of healthcare facilities and ultimately to feelings of well-being; and graphic designs can be powerful mechanisms for enhancing the geographic maps and bullet-briefing charts used in defense. Also, music has traditionally been used to help cope with sorrow, e.g., in religious services; and to build strong armies, e.g., in regimental marching.

13.4.2 Customization: Money Industries

Money industries are exemplified by manufacturing and marketing, including financial services, where *customization* is the operative word. It seems that everyone wants to get personal service and make personal statements—and we see it in everything from colored laptops to cell phone ring tones.

Design is especially important in money industries, as it applies to the architecture of physical plants for manufacturing as well as to the apparel, appliances, and other artifacts manufactured in these plants. Architectural designs can influence inhabitants' behaviors, e.g., using shared spaces to build teams and natural light to boost moods. Buildings can also be inspirational in their form, like skyscrapers, or in their function, like "green" structures. Likewise the artwork in a corporate collection serves as more than just decoration, by stimulating conversation and projecting vision. This is getting to Level C, where style promotes an image by evoking feelings, in applications like corporate logos and advertising graphics.

Music is also important to money industries, as people spend large amounts of money on concerts and recordings for everything from entertainment to exercise routines. Recent advances in signal analysis and music synthesis allow AI to perceive and produce timbres, pitches, and rhythms (Chap. 3 by Dannenberg, Chap. 10 by Assayag et al.). Applications of these algorithms include machine improvisations that complement human artists, and modifying karaoke music to match the pitch of a (typically off pitch) performer. Music is also used to create or enhance mood in advertisement and entertainment (radio, TV, theatre, and film), but further advancing these affective applications will require a better understanding of how music works in the mind and brain [23, 27] at Level C.

Language and *Gaming*, too, present opportunities for *customization* in money industries. With logos come slogans, where key words express style. Also in customization of language, on-demand publishing and purchasing may help connect authors and audiences more efficiently, but only if automated mechanisms are developed to match genres and styles. Likewise for gaming, customization could allow a player to be himself on the screen, backed by his favorite music, rather than the graphics and sound tracks imposed generically. Even the real-life games of automated trading and market regulation, played in financial industries, are governed by stylistic nuances of personal and corporate behavior—and a better understanding of these behavioral styles could help in forecasting and forensics.

13.4.3 Representation: Knowledge Industries

Knowledge industries are exemplified by schooling and scholarship, in training and research, where *representation* is the operative word. Knowledge must be represented in some format (pattern), which shapes the genre (meaning) as well as style (feeling). Although the purpose of knowledge discovery is semantic, the "eureka" experience is aesthetic. Similarly for training, recent advances in intelligent tutoring have been used to teach mathematics, sciences, and other subjects—based on models that represent what a student might "know" (Level B). But to be truly effective such systems must also model what a student might "feel" (Level C), because ultimately it is the student's interest and effort that make for successful instruction.

Language is especially important in knowledge industries, as it is the medium most often used for factual statements as well as arguments and inferences. Today's language processing algorithms can accomplish extraction of some content and to a lesser degree some intent. The content can then be captured and manipulated by expert systems for argument structuring, automated diagnoses, and other applications. But thus far AI, although successful at Level A, has not been so successful at Level B—especially when it comes to human interaction with system automation. Most systems cannot "talk" like a person, so while the machine may be able to express a result it cannot explain the reasons in a manner that the human can understand [9]. Moreover, current systems are severely limited in that they have no style at Level C, so they cannot address the emotional experience of a person who has to deal with the system. Often the result of a system's calculation does not correspond to the user's belief, and in such cases the machine must be able to expect (compute) what the person will feel if it is to support that user in resolving violations of his/her expectations [7].

Design is also important to knowledge industries, as learning and discovery are often improved by casting problems and solutions into visual representations rather than verbal representations. There are many historical examples showing that imagery and creativity go hand in hand [33], with visualizations aiding discovery in data mining of biological structures, social networks, and other complex systems. AI offers promise for interactive visualizations that "show" results in graphic formats that are intuitive to users. But again, like intelligent tutoring and expert systems, this requires models of users (i.e., what is intuitive?), and these models must go beyond what the user thinks to consider what the user feels [5, 42]. To be more effective such systems might evoke feelings of satisfaction rather than the feelings of frustration that we often get in human-machine interactions [20].

Gaming and *Music*, too, present opportunities for *representation* in knowledge industries. Games can be a particularly effective medium for learning [46], as in the simulators used to train air traffic controllers, nuclear power plant operators, emergency management responders, and other professionals. Even in games intended solely for entertainment, designers have acknowledged the importance of learning. A popular game designer sums up his message by saying: *"That's what games are, in the end. Teachers. Fun is just another word for learning."* [24, p. 46]. Music also plays a central role in almost every computer game made for entertainment or any purpose. Much like its use in theater and movies, music is used to enhance the

affective game thrill we call fun or flow. But to do this well requires that the style of the music work in concert with the style of the game, and further research is needed to better establish the connections between these domains. Further research is also needed to establish how genres of games can be matched to the styles of the people who will play and learn from these games. Currently there is a large literature on personality differences and learning styles [38], but it is not clear if or how the dimensions of these style instruments relate to the dimensions of a gaming experience [14].

13.4.4 Gratification: Pleasure Industries

Pleasure industries are exemplified by the arts and leisure, which focus on entertainment, where *gratification* is the operative word. People want to feel good, and people want to look good because that feels good. We see this in fine art and pop art, as well as in TV, movies, concerts, and gambling. In fashion and humor we like to be "be chic" and "get it" because these things make us feel good [3].

Gaming is especially important in pleasure industries, as almost all entertainment seems to involve some element of play [48]. This includes interactive play (or watching it), with other people or machine agents. In the latter case, a key problem for AI is how to design agents that interact with the styles of human teammates and opponents. As discussed earlier, it is easy to build agents that appear to *act* human, simply because humans tend to personify. Much harder is the job of building agents that can recognize human styles at all three levels, and then *interact* to optimize the entertainment experience of human beings at the deepest level of aesthetics. Beyond the psychological aesthetics of gambling and video games, a frontier for AI lies in the physical games of sports and athletics. Today's homes and gyms are full of exercise machines that offer mechanisms for exertion, some emulating sports like track and crew. But real sports are played along with and against other players who also have styles. Ideally exercise machines would provide interactive gaming experiences, like real sports, rather than merely feedback on heart rate, calories burned, etc.

Music is also important to pleasure industries, as it brings enjoyment all by itself as well as in multimedia. A recent development in video games has moved music from the background to the foreground in new titles like *Guitar Hero*. In this game the player scores points for hitting targets, much like in other video games. But added is another dimension where a hit also sounds good, musically, and this aesthetic experience amounts to a personal score that a player feels along with the official score. Such games tap into a different style of player, i.e., one who gets a thrill out of accomplishing a good music performance that is more than just a good shooting performance. Here as in other games and sports, players value the "style points" that are implicit but important and summed up by the adage, "... it's how you play the game." Clearly style points are a big part of sports, or else fans would not watch long soccer and hockey games that end in scoreless ties. And pushing this same notion a step further, we might say that the arts and music are games where *all points are style points*. On that score AI can enrich a human's playing experience with machine partners for practicing and performance (Chap. 10 by Assayag et al.),

but only if the AI includes machine critics that think and feel like human critics. These machine critics can also serve the interests of non-musicians who are merely perceivers and not producers, i.e., those who just like to listen to music. Many people are unaware of much music that they might like to hear, unless they are told of it by friends, and AI might befriend them by performing style searches over large databases.

Design and *Language*, too, present opportunities for *gratification* in pleasure industries. Movies and TV are arguably the most popular media for art in our age, and they are also important from a research perspective because they combine elements of language and design with those of music and gaming. With respect to style perception, current AI has capabilities for automated detection and extraction of genre in audio-video advertisements and broadcast news [31]. Likewise for style production, AI techniques can support computer graphics in animation and "machinima" using game engine software. However these applications in language and design, like music and gaming, have yet to reach very far into aesthetics at Level C.

In fact it might be argued that the central problem for pleasure industries is to create machine critics—who can serve as automated perceivers of style at all three levels (pattern, meaning, and feeling). Human critics play a key role in any art and even sports, where fans seem to pay as much or more attention to the sportscasters' commentaries (style points?) as they do to the scores of games. Critics' ratings of movies, music, and other artwork clearly shape what audiences buy and what artists make. If AI were equipped with the cultural aesthetics needed for critical analysis, then applications would be numerous and obvious—ranging from in-line correction of amateur performances to aiding decisions of museum curators.

13.5 The Status of Style

This chapter has surveyed the state of style research and applications in a framework of levels and functions. Our survey suggests that the major challenge for the future of style is at the level of *aesthetics*—and especially in the function of *perception*. This is because machines cannot really produce style unless they can perceive style—not just the pattern and the meaning but also the feeling.

Within this framework of functions and levels, we also surveyed various domains and uses of style research. We found that language and design appear to be the dominant domains, which suggests that the future holds further opportunities for music and gaming. Upon reflection this should come as no surprise, because semantics (Level B) are especially important in language and design, whereas aesthetics (Level C) are especially important in music and gaming. Therefore, as the frontier of style research is pushed further from Level B into Level C, we expect a growing number of applications in music and gaming. At the same time, we expect that multimedia applications like cinema and machinima will continue to offer opportunities for extending style research from domain to domain, thereby deepening style research within each domain.

References

1. Abt C (1970) Serious games. Viking, New York, NY
2. Bense M (1965) Aesthetica: einführung in die neue aesthetik. Agis-Verlag, Baden-Baden
3. Berns G (2005) Satisfaction: the science of finding true fulfillment. Henry Holt, New York, NY
4. Boden M (1991) The creative mind: myths and mechanisms. Basic Books, New York, NY
5. Böhm G, Brun W (2008) Intuition and affect in risk perception and decision making. Judgm Decis Mak 3(1):1–4
6. Burns K (2007) EVE's entropy: a formal gauge of fun in games. Stud Comput Intell 71: 153–173
7. Burns K (2006) Atoms of EVE': a Bayesian basis for aesthetic analysis of style in sketching. Artif Intell Eng Design Anal Manuf 20:185–199
8. Burns K (2004) Creature double feature: on style and subject in the art of caricature. Papers from the AAAI symposium on style and meaning in language, art, music, and design, FS-04-07, AAAI, Menlo Park, CA, pp 7–14
9. Burns K (2004) Painting pictures to augment advice. In: Proceedings of the working conference on advanced visual interfaces, Gallipoli, Italy, pp 344–349
10. Burns K, Dubnov S (2006) Memex music and gambling games: EVE's take on lucky number 13. In: Proceedings of the AAAI workshop on computational aesthetics: artificial intelligence approaches to beauty and happiness, WS-06-04, AAAI, Menlo Park, CA, pp 30–36
11. Csikszentmihalyi M (1991) Flow: the psychology of optimal experience. Harper Collins, New York, NY
12. Damasio A (1994) Descartes' error: emotion, reason, and the human brain. Grosset/Putnam, New York, NY
13. Demaree H, DeDonno M, Burns K, Everhart D (2008) You bet: how personality differences affect risk-taking preferences. Pers Individ Dif 44:1484–1494
14. Doyle J, Radzicki M, Rose A, Trees W (1998) Using cognitive styles typology to explain individual differences in dynamic decision making: much ado about nothing. Center Qual Manag J 6(3):1–15
15. Düchting H (1997) Paul Klee: painting music. Prestel-Verlag, Munich
16. Ellsworth P, Scherer K (2003) Appraisal processes in emotion. In: Davidson R, Scherer K, Goldsmith H (eds) Handbook of affective sciences. Oxford University Press, Oxford, pp 572–595
17. Gardner H (1983) Frames of mind: the theory of multiple intelligences. Basic Books, New York, NY
18. Goguen J (ed) (1999) Art and the brain. J Conscious Stud: Controvers Sci Humanit 6: 5–175
19. Groopman J (2007) How doctors think. Houghton Mifflin, New York, NY
20. Hoffman R, Hayes P (2004) The pleasure principle. IEEE Intell Sys January/February:86–89
21. Hogan P (2003) Cognitive science, literature, and the arts. Routledge, New York, NY
22. Hudlicka E (2003) To feel or not to feel: the role of affect in human-computer interaction. Int J Human-Comput Stud 59:1–32
23. Huron D (2006) Sweet anticipation: music and the psychology of expectation. MIT Press, Cambridge, MA
24. Koster R (2005) A theory of fun for game design. Paraglyph, Scottsdale, AZ
25. Lazarus R (1999) The cognition-emotion debate: a bit of history. In: Dalgleish T, Power M (eds) Handbook of cognition and emotion. Wiley, New York, NY pp 3–19
26. LeDoux J (1996) The emotional brain: the mysterious underpinnings of emotional life. Simon & Schuster, New York, NY
27. Levitin D (2006) This is your brain on music. Dutton, New York, NY
28. Malina R (2006) A forty-year perspective on aesthetic computing in the Leonardo Journal. In: Fishwick P (ed) Aesthetic computing. MIT Press, Cambridge, MA, pp 43–52

29. Marr D (1982) Vision: a computational investigation into the human representation and processing of visual information. W. H. Freeman, New York, NY
30. Maybury M, Stock O, Wahlster W (2006) Intelligent interactive entertainment grand challenges. IEEE Intell Sys 21(5):14–18
31. Maybury M, Greiff W, Boykin S, Ponte J, McHenry C, Ferro L (2004) Personalcasting: tailored broadcast news. Int J User Model User-Adapt Interact 14(1):119–144
32. McCorduck P (1991) Aaron's code: meta-art, artificial intelligence, and the work of Harold Cohen. W. H. Freeman, New York, NY
33. Miller A (1996) Insights of genius: imagery and creativity in science and art. Springer, New York, NY
34. Minsky M (2006) The emotion machine: commonsense thinking, artificial intelligence, and the future of the human mind. Simon & Schuster, New York, NY
35. Mithin S (2006) The singing Neanderthals: the origins of music, language, mind, and body. Harvard University Press, Cambridge, MA
36. Moles A (1966). Information theory and esthetic perception (trans: Cohen J). University of Illinois Press, Urbana, IL
37. Morgan J (1977) Linguistics: the relation of pragmatics to semantics and syntax. Ann Rev Anthropol 6:57–67
38. Myers I, McCaulley M (1985) A guide to the development and use of the Myers-Briggs type indicator. Consulting Psychologists Press, Palo Alto, CA
39. Narmour E (1992) The analysis and cognition of melodic complexity: the implication-realization model. University of Chicago Press, Chicago, IL
40. Norman D (2004) Emotional design: why we love (or hate) everyday things. Basic Books, New York, NY
41. Parsons M (1987) How we understand art: a cognitive developmental account of aesthetic experience. Cambridge University Press, Cambridge, MA
42. Peters E, Västfjäll D, Gärling T, Slovic P (2006) Affect and decision making: a "hot" topic. J Behav Decis Mak 19:79–85
43. Picard R (1997) Affective computing. MIT Press, Cambridge, MA
44. Plutchik R (1985) On emotion: the chicken-and-egg problem revisited. Motiv Emot 9:197–200
45. Postrel V (2003) The substance of style: how the rise of aesthetic value is remaking commerce, culture, and consciousness. Harper Collins, New York, NY
46. Prensky M (2001) Digital game-based learning. McGraw Hill, New York, NY
47. Rothstein E (1995) Emblems of mind: the inner life of music and mathematics. Avon, New York, NY
48. Salen K, Zimmerman E (2004) Rules of play: game design fundamentals. MIT Press, Cambridge, MA
49. Scherer K (1999) Appraisal theory. In: Dalgleish T, Power M (eds) Handbook of cognition and emotion. Wiley, New York, NY pp 637–663
50. Shannon C, Weaver W (1949) The mathematical theory of communication. University of Illinois Press, Urbana, IL
51. Silvia P (2005) Emotional responses to art: from collation and arousal to cognition and emotion. Rev General Psychol 9(4):342–357
52. Sloman A, Croucher M (1981) Why robots will have emotions. In: Proceedings of the 7th International Conference on AI, Vancouver, BC, pp 197–202
53. Temperley D (2007) Music and probability. MIT Press, Cambridge, MA
54. Weizenbaum J (1976) Computer power and human reason: from judgment to calculation. W. H. Freeman, San Francisco, CA
55. Willats J (1997) Art and representation: new principles in the analysis of pictures. Princeton University Press, Princeton, NJ
56. Wilson S (2002) Information arts: intersections of art, science, and technology. MIT Press, Cambridge, MA

Index

S. Argamon et al. (eds.), *The Structure of Style*,
DOI 10.1007/978-3-642-12337-5, © Springer-Verlag Berlin Heidelberg 2010